CINEMATOGRAPHY

BEHIND
THE SILVER
SCREEN

BEHIND THE SILVER SCREEN

When we take a larger view of a film's "life" from development through exhibition, we find a variety of artists, technicians, and craftspeople in front of and behind the camera. Writers write. Actors, who are costumed and made-up, speak the words and perform the actions described in the script. Art directors and set designers develop the look of the film. The cinematographer decides upon a lighting scheme. Dialogue, sound effects, and music are recorded, mixed, and edited by sound engineers. The images, final sound mix, and special visual effects are assembled by editors to form a final cut. Moviemaking is the product of the efforts of these men and women, yet few film histories focus much on their labor.

Behind the Silver Screen calls attention to the work of filmmaking. When complete, the series will comprise ten volumes, one each on ten significant tasks in front of or behind the camera, on the set or in the postproduction studio. The goal is to examine closely the various collaborative aspects of film production, one at a time and one per volume, and then to offer a chronology that allows the editors and contributors to explore the changes in each of these endeavors during six eras in film history: the silent screen (1895–1927), classical Hollywood (1928–1946), postwar Hollywood (1947–1967), the Auteur Renaissance (1968–1980), the New Hollywood (1981–1999), and the Modern Entertainment

Marketplace (2000–present). *Behind the Silver Screen* promises a look at who does what in the making of a movie; it promises a history of filmmaking, not just a history of films.

Jon Lewis, Series Editor

CINEMATOGRAPHY

Edited by Patrick Keating

RUTGERS
UNIVERSITY PRESS
New Brunswick, New Jersey

Dedicated to two inspiring teachers,
David Bordwell and Lea Jacobs

Library of Congress Cataloging-in-Publication Data
Cinematography / edited by Patrick Keating.
pages cm. — (Behind the silver screen ; 3)
Includes bibliographical references and index.
ISBN 978–0–8135–6350–3 (hardcover : alk. paper) — ISBN 978–0–8135–6349–7 (pbk. :
alk. paper) — ISBN 978–0–8135–6351–0 (e-book : alk. paper)
1. Cinematography—History. 2. Digital cinematography—History. I. Keating,
Patrick, 1970–
TR848.C53 2014
778.5'3'09—dc23
2013037742

CONTENTS

ACKNOWLEDGMENTS

I owe my first and foremost thanks to Rutgers University Press, the Academy of Motion Pictures Arts and Sciences, and series editor Jon Lewis for inviting me to edit this volume. Jon has been a patient and encouraging editor, and it has been my privilege to work with him. I also extend my deep appreciation to Leslie Mitchner and the team at Rutgers University Press for all that they did, with their kind and capable hands, to shepherd the Behind the Silver Screen series.

I have enormous admiration and gratitude for the authors collected here—all of whom I am honored to consider friends both on and off the page. Thank you for your deep thinking and timely revisions, and for giving me cause to revisit so many wonderful movies.

Closer to home, I wish to acknowledge the support I received for this project from my institution, Trinity University; grants from Academic Affairs and the Department of Communication enabled the inclusion of color illustrations in this volume. Research funds from Trinity University enabled me to travel to Los Angeles and review documents in the Margaret Herrick Library.

I've been fortunate to have many excellent teachers in my life, including David Bordwell, Lea Jacobs, Judy Irola, and Woody Omens, all of whom have taught me much about cinematography. My warmest thanks go to my wife, Lisa—for reading chapters and keeping me fueled with positivity. I'm so lucky that we get to spend our lives sitting shoulder-to-shoulder watching movies together.

ABBREVIATIONS

The main text uses the following abbreviations:

ASC American Society of Cinematographers
d.p. Director of Photography, another term for cinematographer

The endnotes use the following abbreviations:

AC *American Cinematographer*, the ASC's trade journal, still in print
MPW *The Moving Picture World*, a trade journal from the silent period

CINEMATOGRAPHY

INTRODUCTION Patrick Keating

The craft of cinematography brings together a range of distinct but comple-
mentary tasks, such as the planning of the lighting, the composition of the film
frame, the orchestration of the camera movement, and the manipulation of the
negative in the laboratory. Through these tasks, the cinematographer, in close
collaboration with the director and other crew members, adds structure and
nuance to a film's visual style. For decades, cinematographers have insisted on
the artistic nature of their craft. Back in 1931, James Wong Howe wrote, "With
the early films, lighting merely meant getting enough light upon the actors to
permit photography; today it means laying a visual, emotional foundation upon
which the director and his players must build."[1] Decades later, Vittorio Storaro
proposed an even bolder definition: "Photography means light-writing, cinema-
tography means writing with light in movement. Cinematographers are authors
of photography, not directors of photography. We are not merely using technol-
ogy to tell someone else's thought, because we are also using our own emotion,
our culture, and our inner being."[2] For both cinematographers, cinematography
is an expressive art, whether the goal is to express the shifting moods of the
story, as in Howe, or to express a more personal set of concerns, as in Storaro.
This admittedly romantic definition of cinematography must be contextualized,
qualified by our awareness that this is after all an industrial craft, made within

1

a system based on hierarchy, mass-production, and the commercial imperative. Keeping both sides of cinematography in mind, this book will tell the story of cinematography in American cinema, explaining how this complex art and craft changed across the decades—a process that began with minimal crews hand-cranking the camera under the midday sun and continues into the present day with a wide array of technical advances and an industry-wide conversion to digital imagery.

As we turn our attention to the men and women responsible for these images, we encounter several historiographic challenges. One of the issues facing any historian of cinematography is the fact that cinematographers themselves have been telling the history of their craft for decades. This is no doubt true of most Hollywood crafts, from editing to costume design, but the point seems especially salient for cinematography. The group's honorary organization, the American Society of Cinematographers, has been publishing a magazine, *American Cinematographer*, since 1920, using the magazine and other publications to shape a public narrative of the craft's rise, its transformation over time, and its persistence in the face of technological and institutional change. Starting in the 1970s, an assortment of published interviews, featuring both veterans from the studio period and more contemporary figures, provided an additional forum for the members of the craft to tell their own history.

This preexisting self-curated history provides enormous benefits to the scholarly historian seeking to understand the field, and yet those benefits also bring risks. On the one hand, the trade journals and the interviews provide an enormous wealth of material for the historian to consider, regarding specific technologies, collaborations with directors, artful solutions to particular storytelling problems, and more philosophical accounts of guiding aesthetic ideals. All six of the essays in this book rely extensively on these invaluable sources. On the other hand, the historian must remember that the ASC is hardly an unbiased source; its excellent magazine occasionally passes over important developments, and it usually frames existing debates in ways favorable to its mission. As is usual in any form of history, all primary evidence must be interpreted in order to be understood.

To put this another way, the historian of cinematography must go beyond simply summarizing the pages of the trade journals and offer some broader explanatory framework to help us understand how the field of cinematography developed and changed, both onscreen and off. Fortunately, there exist several exemplary works of film scholarship to help guide this process, even if cinematography has not received as much attention as other fields, most notably directing. By reviewing a few of these previous works, we can get a better sense of the larger ongoing questions that have guided research into the history of cinematography: in particular, the question of technology, the question of authorship, and the question of classicism.

The Question of Technology

One challenge facing the historian of cinematography is the problem of technology. To what extent does technology drive stylistic change? It seems plausible to suppose that many stylistic shifts can be explained most efficiently by pointing to proximate changes in technology. The arc light helps explain the presence of hard shadows in films from the 1920s. To understand the rise of deep-focus cinematography in the 1940s, we might point to faster film stocks. The availability of the Steadicam provides a ready explanation for certain elaborate camera movements in the 1980s. Indeed, it is difficult to see how one might explain these stylistic developments, or related trends, without pointing to technology at some point in the account.

On the other hand, there are good reasons to be wary of technological determinism. For one thing, it should be clear that the causal relationship between technology and style can go both ways. Just as a new technology might spark cinematographers to explore a new style, the stylistic preoccupations of cinematographers might push the industry to invest in certain technological research likely to have market potential. More importantly, we must balance the accounting of technological change with the awareness that technology is never the only determining factor in stylistic history, since the history of technology must itself be located within a broader institutional and social context. Any technology can be charged with multiple, sometimes contradictory, cultural meanings.

Cinematographers themselves have often proposed a "toolkit" model of technological change. In an oft-quoted 1942 response to *Citizen Kane* (Orson Welles, 1941), Charles Clarke criticized *Kane*'s cinematographer Gregg Toland for using deep-focus too often, instead proposing that deep-focus should be seen as "something which rounds out our assortment of artistic tools, so that we have a better way of meeting the dramatic requirements of any story-situation."[3] This attitude toward technological transformation—embracing a new technique as progress only so long as it extends the number of tools a cinematographer can use to match the style to the story—would recur again and again over the years, from CinemaScope to the digital intermediate. However, when cinematographers are forced to accept a new technology as a requirement and not one option among many, they often push back.

One of the most indispensable works in the study of cinematography is Barry Salt's *Film Style and Technology: History and Analysis*. As the title suggests, Salt puts the relationship between technology and style at the center of his concerns. Drawing on a careful examination of trade journals like *American Cinematographer* and the *Journal of the Society of Motion Picture Engineers*, Salt details all the relevant changes in technology from the 1890s to the present, from camera designs to laboratory practices, while offering an equally rigorous account of statistically measurable changes in film style. Though Salt's volume sometimes is criticized as

a work of technological determinism, Salt explicitly denies that technology drives stylistic change; instead, he emphasizes the determining power of filmmakers' intentions, praising the filmmakers who innovate the most influential styles.[4]

By contrast, in *Production Culture*, John T. Caldwell focuses less on the look of the films than on the culture of the workers who make them—workers who have developed complex ways of theorizing their own practice, including their use of technology. Film technologies take on significant connotations within this culture, supported by the discourse of the practitioners who use them. For instance, cranes, high-powered lamps, and Panavision lenses might connote "big-screen production value," and the concomitant sense that crew members are there to allow these expensive machines to do their work, while a handheld low-resolution DV camera shooting in available light might carry very different connotations: the sense that the crew is using its machines to keep up with an "unfolding documentary-like reality."[5] This is not just a matter of what a film style might mean onscreen, but also a matter of how the technologies sustain cultural ideas about value, artistry, and the agency of film workers. Rejecting the "instrumental" view that technologies like cameras and lamps are simply tools that filmmakers use to make pictures, he insists that Hollywood's own production culture works to theorize those technologies, giving them meanings that in turn shape production practices.

The Question of Authorship

All three of these examples—Clarke, Salt, and Caldwell—raise questions of authorship, another longstanding issue in the historiography of cinematography. Though some cinematographers might bristle at the idea that the director is the sole "auteur" of the film, most cinematographers are comfortable describing their job as assisting the director in the realization of his or her vision. In the pages of *American Cinematographer*, one can find a range of ideas about authorship. For instance, one issue in 1991 offered some brief profiles of cinematographers who had recently made the switch to directing. Cinematographer-turned-director Ernest Dickerson said, "I'd like to tell my stories but I'd like to help other directors tell their stories as well," thereby granting the director the status as primary author.[6] But a year later, the same magazine profiled Dickerson again after he had resumed his role as cinematographer one more time, on Spike Lee's epic *Malcolm X* (1992). Here, the article emphasizes collaboration, crediting the film's complex three-part color scheme (shifting from vivid colors to monochrome to muted realism) to the work of Dickerson and production designer Wynn Thomas, guided by Lee's influence as both director and co-screenwriter.[7] Such an emphasis on collaboration positions the cinematographer as one of several creative interpreters of the story.

Though few film historians endorse the auteur theory in its pure form, it is still the case that many works of film scholarship are strongly oriented toward the director. One of the purposes of a volume such as this is to help correct this imbalance by calling attention to the contributions of other crafts. And yet such a revisionist approach might posit a range of responses along a continuum. One option here would be to elevate certain cinematographers to the role of auteur, perhaps by pointing to the distinctive and influential styles of major figures like Toland or Storaro. Another approach would be to question the idea of the auteur on a more fundamental level. In an early (1973) critique of the auteur theory, Graham Petrie wrote, "It is no longer going to be enough to assume that the director's contribution is automatically of major significance; equally, it will be necessary to avoid the dangers of replacing one culture hero by another and launching into 'The Cameraman as Superstar' and solemn studies of the personal vision of Sol Polito or James Wong Howe."[8] Instead, Petrie proposes other categories (such as "scene-stealers" and "harmonizers") that might include cinematographers with recognizable styles. By the 1980s, the influence of the auteur theory already had waned considerably in academic film studies, and many scholars of the industry adopted as a working assumption the idea that film authorship was inevitably collaborative, especially in a mass-production system like Hollywood. Such scholars often supported this hypothesis with archival research into how specific films got made. Here, Robert Carringer's in-depth study of the making of *Citizen Kane* provides an exemplary model, using archival evidence to explain how director Orson Welles, cinematographer Gregg Toland, associate art director Perry Ferguson, optical printer Linwood Dunn, and many others worked together to craft the film's extraordinary images.[9]

Carringer's approach is based on the close study of an individual film. At the other end of the scale, a scholar might examine a large cluster of films. For instance, a fascinating recent study by a team of Cornell psychologists has found that Hollywood cinematography has grown recognizably darker from 1935 to the present.[10] The pattern appeared in a sample of 160 films, across a range of decades, with a measurable linearity. This argument does attribute some agency to cinematographers: the authors note that the director, cinematographer, and editor have the most power to shape a film's visual style, and that this "relatively small community of filmmakers has gradually changed their craft," constantly refining their methods of holding the audience's attention. Yet the pattern itself has emerged with a consistency that no individual filmmaker intended, since no filmmaker was even aware of the long-term subtle progression at this level of detail, even if some may have had a conscious personal preference for darker images. As this example suggests, one need not study particular authors to develop fine-grained observations about stylistic change.

The Question of the Classical Style

The most influential analysis of Hollywood cinema as a group style is *The Classical Hollywood Cinema*, by David Bordwell, Janet Staiger, and Kristin Thompson. While many of the 100-plus films selected for this study share visible commonalities, it should be noted right away that the authors do not claim that all Hollywood films look the same. Quite the contrary, Thompson's careful account of the techniques of the "soft style" in the 1920s and Bordwell's discussion of deep-focus cinematography in the 1940s both detail important shifts in the visual texture of Hollywood films. It is by moving up a level of abstraction that one can find the factors constituting a group style. Hollywood filmmakers, they argue, were committed to an ideal of clear narration, using the tools of film style to make the story (in particular, the goal-driven actions of the characters) comprehensible to large audiences. To that end, Hollywood cinematographers often worked hard to make their techniques as unobtrusive as possible. This ideal remained a guiding principle from the early years of the feature film to the end of the studio system and beyond.[11] When considering how to adopt a new technology, from the soft-focus lens to CinemaScope, the cinematographer's first question was, "How can I use this device to tell the story?"

Trade journals and interviews provide ample evidence that many filmmakers continue to espouse "classical" principles. The respected cinematographer Roger Deakins once said, "It's about the script and the story. The best cinematography, I'm afraid, is the photography which doesn't get any mention."[12] And yet it seems clear that the films of today differ greatly from the films of seventy years ago. As one way of addressing this intermingling of continuity and change, Bordwell has proposed that contemporary Hollywood cinema follows principles of "intensified continuity," using faster editing rates and increased camera movement to amplify a film's visceral impact, without abandoning the commitment to broadly comprehensible storytelling. In this way, the classical principles remain relevant, even if Hollywood has modified its aesthetic in significant ways.[13]

However, many scholars would argue that this proposal does not go far enough, failing to account for the increasing role of spectacle in a Hollywood cinema increasingly dominated by blockbusters for global audiences, sequels, and action spectaculars that seem stitched together for the primary purpose of launching a theme park ride. For instance, Scott Bukatman has argued that the apparent persistence of classical technique only serves to mask the otherwise obvious decline of narrative in the New Hollywood: "While Hollywood cinema continued to revel in the sensational, sensual realm of visual, auditory, and kinesthetic effects, the devaluation of narrative was hidden within a desperate overvaluation of overly explicit storytelling; a denial of its own undeniable supersession."[14] Others make the related argument that style itself has become spectacle, with an appeal that goes well beyond storytelling.[15]

Indeed, one might push this skepticism even farther, wondering just how classical films were, even in the period from the 1920s to the 1960s. My own previous work has offered some proposals along this line. While reaffirming the value of the classical model, I also consider how cinematographers defined "storytelling" very broadly, placing special emphasis on the use of expressive lighting to suit the mood of the story, and I argue that even this broader conception of classical storytelling cannot fully account for the value that the system placed on other functions, most notably glamour lighting, which studios insisted cinematographers practice independent of narrative motivation.[16] Other scholars point to particular genres or cycles that appear to break from the clarity of Hollywood norms. In a landmark essay on film noir, originally published in 1974, Janey Place and Lowell Peterson showed how noir cinematography systematically departed from Hollywood conventions, favoring off-balance frames, hard-to-read compositions, and unglamorous lighting schemes.[17] These stylistic traits remain significant, given how influential the neo-noir style has been on Hollywood lighting since at least the 1980s. Most generally, this scholarly debate forces us to consider carefully the relationship between cinematography and storytelling. How can visual style serve the story, and how might cinematography push beyond the limits of classical norms?

Chapter Preview

Of course, this brief survey cannot do justice to the wide range of ideas developed in cinematography scholarship in the field of film and media studies, but it has served to highlight some of the key issues that this book's six chapters discuss. All six contributors wrestle with these questions—technology, authorship, and the persistence or decline of classical norms—though they do not always come to the same conclusions.

My own chapter examines cinematography in the silent era, from the 1890s to the late 1920s. Following Tom Gunning, I draw a distinction between the "cinema of attractions," which directly appeals to the spectator's attention through a series of exciting moments of spectacle, and the subsequent "cinema of narrative integration," which subordinates those sensory appeals to the logic of an unfolding story.[18] Many important cinematographic devices, from the close-up to the pan, appeared in former period, which thrived until around 1907. The cinema of attractions puts the cinema itself on display, including the devices of cinematography, offering special effects, electric lighting, and the spectacle of movement as attractions to be enjoyed for their own sake. Significantly, the attraction does not go away during the cinema of narrative integration; its energy persists in many forms, from the glamorous close-ups of classical Hollywood stars to the spectacular digital effects of today. The rest of my chapter argues that narrative

integration was one of three interlocking processes that shaped Hollywood cinematography in the silent period and beyond, the other two being industrialization and aestheticization. Just as Hollywood grew into an evermore efficient mass-production system, Hollywood cinematographers developed a public identity as artists, using their pictorial skills to shape the moods of the stories being told. These three processes—narrative integration, industrialization, and aestheticization—could complement one another, but they could also produce tensions, tensions that would shape the theory and practice of Hollywood cinematography for years to come.

In chapter 2, Chris Cagle examines the studio period, from the transition to sound to 1946. While acknowledging that this was a period of stability overall, he points to several layers of innovation and difference operating within the steady studio context. Moving from the general to the specific, those layers can be found at the industry-wide level, at the level of the studio, and at the level of the individual cinematographer. At the industry level, photography grew sharper, focus deeper, and the lighting darker over the course of the 1930s and 1940s. Though we might point to certain films as the culminations of these changes, and to other films as notable exceptions to the trends, both arguments must rest on a prior recognition that the industry as a whole was exploring new stylistic ideas. Within this industry-wide context, we can locate the specific "house styles" of the studios. After interrogating and clarifying the notion of "studio style" as a theoretical concept, Cagle proceeds to examine three case studies: the polished style of MGM in the 1930s, the more realistic approach to glamour of Warner Bros. in the early 1940s, and the prestige realist style of Twentieth Century–Fox throughout the 1940s. A final level of specificity considers the style of the individual cinematographer. Though almost all cinematographers were skilled professionals in full command of industry and studio norms, a handful of cinematographers brought distinctive visual sensibilities to their projects. As examples, Cagle considers the realism of James Wong Howe, the romanticism of George Barnes, the modernism of Rudolph Maté, and the artful minimalism of Leon Shamroy.

In chapter 3, Lisa Dombrowski considers the postwar decades, when Hollywood filmmakers confronted declining theatrical audiences due to the impact of television, suburbanization, and other sociocultural factors. Dombrowski argues that many changes in the period's cinematography were driven along two seemingly contrasting tracks: realism and spectacle. A key example here is the rise of location shooting, which served as a form of realism in the case of the postwar semi-documentaries like *The Naked City* (Jules Dassin, 1948, d.p. William Daniels), and yet provided extravagant spectacle in the case of runaway productions shot in foreign locales in the 1950s.[19] Similarly, cinematographers pursued realism by breaking with longstanding norms of glamour lighting, while new technologies in color and widescreen put cinematic imagery itself on display. Though Dombrowski stresses that most cinematographers retained

classical values, using style to support clear and engaging storytelling, she points to a number of cinematographers who pushed the envelope, testing the limits of cinematographic stylization with deep noir shadows, as in the work of John Alton, or with bombastic color palettes, as in certain musicals from the 1960s. Her chapter ends in 1967, often seen as an important transitional year for Hollywood, with the rule-breaking *Bonnie and Clyde* (Arthur Penn, 1967, d.p. Burnett Guffey) pointing the way toward the new look and attitude of the 1970s.

That decade is the primary subject of Bradley Schauer's chapter on the "Auteur Renaissance." Just as a new generation of directors like Martin Scorsese and Robert Altman revitalized Hollywood filmmaking with fresh ideas about film drawn from art cinema, so too did a new generation of cinematographers like Gordon Willis and Vilmos Zsigmond emerge to refresh the field with new approaches to image-making. Many of these young cinematographers introduced techniques to deliberately soften the image, such as flashing the negative to reduce contrast, placing diffusion over the lens to give pictures a subtly hazy quality, and using long lenses and open apertures to create a shallow depth of field. This new soft style is an excellent example of how the cultural meanings of a device might shift over time; in the silent period, the same set of devices carried connotations of ethereal aestheticism; now, a soft image might connote naturalism just as much as aestheticism, a naturalism borne out of a visible rejection of the crisp professional polish that had become the Hollywood norm. Schauer also considers how mainstream Hollywood cinematographers adapted visual ideas from other sources, borrowing handheld camerawork from cinéma vérité and split-screen photography from World's Fair exposition films. For the Auteur Renaissance generation, the challenge was to take these highly expressive new forms and make them function within the context of what was still a storytelling cinema.

In chapter 5, Paul Ramaeker covers Hollywood cinematography from 1981 to 1999. In the 1980s, Hollywood abandoned the narrative experiments with art cinema that had characterized many of the most innovative films of the 1970s, instead adopting a blockbuster-driven strategy designed to maximize profits for companies that increasingly functioned as global corporations. Although this business strategy entailed a conservative return to classical genre stories most likely to bring box office success, cinematography pushed away from classicism, placing a new priority on spectacular visual impact. The Steadicam and other devices allowed cinematographers to incorporate more mobile framings; the example of Storaro inspired experimentation with carefully controlled color palettes; and the rise of neo-noir sparked a revival in high-contrast photography with deep shadows. Ramaeker proposes three frameworks to help us understand cinematography in the New Hollywood. First, cinematography became hyperbolic, taking traditional devices like the tracking shot or low-key lighting scheme and amplifying them for maximum visual impact. Second, filmmakers made knowing references to preexisting styles and films, from the musical to

the documentary. Even the diffuse style of the Auteur Renaissance became just another style to be quoted through visual citation. Third, just as the rise of the auteur theory had helped make some directors of the 1970s become recognizable names with signature oeuvres, soon cinematographers began to cultivate greater public recognition as authors in their own right by putting their own personal stamp onto the films they shot. Together, these frameworks—hyperbolism, referentiality, and authorship—work to characterize the period as an amplification of trends that began in the previous period.

In the last chapter, Christopher Lucas examines Hollywood cinematography from 2000 to the present, rightly starting out with the observation that this was (and is) a period of radical change. The adoption of digital technologies, which started in the previous period, accelerated considerably in these years, with profound and still unresolved consequences for the field of cinematography. Though some of these changes are visible onscreen, from the "low-resolution realism" of certain films shot with digital video cameras to the bold hues of films that received color correction through the use of a digital intermediate, Lucas's primary concern is offscreen, in a shifting division of labor that appeared increasingly precarious for the cinematographer. Earlier technologies, such as CinemaScope or the Steadicam, required some adjustments in technique but did not constitute a threat to the cinematographer's job. By contrast, the apparent ease and automation of digital tools led some cost-cutting producers to consider making films without the cinematographers' input on increasingly important tasks like color grading, and even to fantasize about making films without cinematographers at all. In response, cinematographers would need to reaffirm their status, either by championing the continuing relevance of film-based photography, or by asserting their own value as experts whose command of the art and craft of image-making was undiminished in the context of the new digital workflows. In this way, Lucas shifts the traditional focus on authorship to a newly relevant focus on authority.

As these six chapters illustrate, the history of Hollywood cinematography is remarkably complex, encompassing not only the ever-changing patterns of visual style, but the production culture of the cinematographers who produce those images, a production culture shaped by shifting notions of technology and technique, craft and commerce, authorship and art. Although many current debates surrounding the implications of cinematography's transition to an increasingly digital medium have yet to be resolved, the historical patterns of discourse and practice that have molded the field for over a century will continue to find contemporary relevance and shape the artfully complex ways cinematographers think about and create moving images.

1

THE SILENT SCREEN, 1894–1927 Patrick Keating

Over the first few decades of the moving picture industry, cinematographers established patterns of visual storytelling that would shape Hollywood cinema for decades to come, while also exploring stylistic possibilities that would persist as potential alternatives to the classical model. Some of the period's most notable changes in cinematography are visible on the screen, such as the increasing reliance on artificial light and the shift from the crisp focus of the early years to the hazy imagery of the late silents, but equally important changes happened in the industry itself, from the initial definition of the responsibilities of the cinematographer to the formation of a professional organization to articulate the craft's norms and ideals. These rapid changes (and underlying continuities) can be situated productively within the context of three larger processes. First, the transition from a cinema of attractions to a cinema of narrative integration shaped the cinematography of this period, as filmmakers increasingly used lighting and camerawork to serve the needs of storytelling, even if they never fully abandoned the idea that the image itself might prove an attraction in its own right. Second, the craft of cinematography grew more industrialized, as cinematographers (initially known as cameramen) adopted technologies and organizational structures to help them produce images more efficiently. Third, over the course of the silent period cinematographers grew to think of themselves as artists, self-consciously

drawing on the related arts of photography, theater, and painting for inspiration. These three factors—narrative integration, industrialization, and aestheticization—interact in complicated and unexpected ways, mutually reinforcing in some cases, contradictory in others.

Cinematography as an Attraction

Although inventors in many different countries were responsible for the development of cinematic technologies, historians such as Charles Musser often point to the films made by Edison employee W.K.L. Dickson and his associates as the first American moving pictures to be shown commercially. Unlike the films of the Lumière brothers, these films initially were viewed through a stand-up peepshow device rather than projected on a screen.[1] Many of the first Edison films were photographed in the Black Maria, the boxlike studio built at Edison's laboratories in West Orange, New Jersey. The playing space was walled off from the outside, and there was a large glass window in the ceiling to allow sunlight to illuminate the subject. Dickson cleverly placed the entire studio on wheels, so it could be rotated to better capture the sun.[2] Though it is unlikely that the filmmakers thought of themselves as storytellers or artists at this date, we can still appreciate how they crafted a simple visual style well suited to their films' purpose: the display of the new technology's capabilities. In figure 1.1, shot in 1894, we see an image of two vaudeville performers—the Glenroy Brothers—boxing playfully. The sun, shining down from

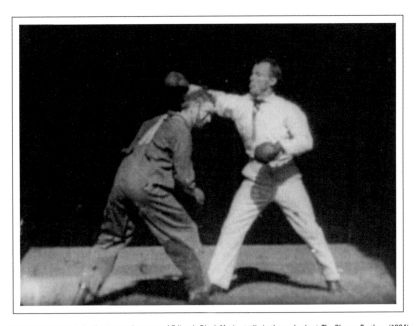

FIGURE 1.1: Hard sunlight illuminates the space of Edison's Black Maria studio in the early short *The Glenroy Brothers* (1894).

above, models the features of the two figures, while creating a strong sense of sep-
aration between the foreground and the black background. By isolating the men
from the surrounding space, the filmmakers, Dickson and his assistant William
Heise, concentrate attention on the movement of the figures, thereby putting the
camera's capacity to capture that movement on display. The overhead sunlight also
produces a hard shadow underneath the men's feet; the movement of these dancing
shadows provides an additional point of visual pleasure in the film.

While noting that Dickson typically worked with the performers on these
early films as Heise operated the camera, Musser cautions against the tempta-
tion to see the former as a director and the latter as a cinematographer. Instead,
he suggests that collaboration was a common working arrangement in films
before around 1908.[3] In later years, the mode of production would become more
hierarchical and the division of labor more rigidly defined, with the cinematog-
rapher working for a director while managing the technical crew. Still, it was not
uncommon for cinematographers to work in pairs into the 1920s, collaborating
under the authority of the director.

The issue of narrative integration had not yet become a central concern for
these early filmmakers. Most of the initial Edison shorts show figures, such as the
dancer Annabelle or the bodybuilder Eugene Sandow, who are performing openly
for the camera, not unlike the way they might mug for an audience on a vaude-
ville stage. In a landmark essay, Tom Gunning has proposed the term "cinema
of attractions" to describe the first decade or so of film production. "The cinema
of attractions," he writes, "directly solicits spectator attention, inciting visual
curiosity, and supplying pleasure through an exciting spectacle—a unique event,
whether fictional or documentary, that is of interest in itself."[4] Although there is a
hint of fictional narrative in *The Glenroy Brothers*, since the two brothers are pre-
tending to be boxers with different levels of skill, it is not yet essential to ask how
the cinematography tells a story. Instead, the primary function of cinematography
is to capture and display different kinds of movement for our sensory enjoyment.

Filmmakers continued to rely on daylight for the next two decades, but they
also expressed an interest in electric light very early on. In 1901, Edwin Por-
ter and James White shot several short films at Buffalo's exposition. Since the
exposition had been designed originally to celebrate the electrification of the
city through the harnessing of the nearby Niagara Falls, it is appropriate that
one of their films, *Pan-American Exposition at Night*, put the power of artificial
light on self-conscious display.[5] At first, we see a daytime view of the exposition
space, the camera panning from right to left across the skyline of the fairgrounds.
As the camera approaches the center of the fairgrounds, the shot changes to a
night view, and we see the rest of the space illuminated by electric light (figure
1.2). Over a hundred years later, the effect is still astonishing: the film's picture
of the nighttime fairgrounds is a semi-abstract study in black and white, as the
solid architecture of the daytime scene is transformed into a pattern of glowing

FIGURE 1.2: The camera's ability to capture electric lighting is put on display in *Pan-American Exposition at Night* (1901).

electric dots outlining the shapes of the buildings, their sturdy walls disappearing into the surrounding blackness. From the tallest building, the bright beam of a searchlight pours down, traversing the frame.

Whereas a later film might use light unobtrusively to help tell a story, this 1901 film puts light itself on display, encouraging viewers to gasp in wonder at what was still a relatively new technology for the majority of Americans. Indeed, two technologies are put on display simultaneously: electricity's ability to light up a nighttime space and the camera's ability to capture the result. The camera's own movement offers an additional attraction. Though panning was relatively common in the actuality genre, the device normally functions to draw our attention to the reality of the space before the camera.[6] Here, one of the film's many delights is the opportunity to notice how a pan initiated in the daytime appears to be completed at night. This presupposes a spectator willing to notice the work of the camera itself. The fact that the pan is not following anyone in particular helps make the movement itself all the more salient.

Other films from this period offer even more striking examples of early camera movement. The year before, White himself had photographed the Paris Exposition of 1900. In addition to the usual panoramas, White photographed one film from the elevator of the Eiffel Tower. As the city slowly recedes below, the ironwork of the tower whizzes by in the foreground. Gunning has long argued that the cinema of attractions shared an affinity with the culture of modernity, and that affinity is on vibrant display here: both the tower itself and the camera share the ability to offer the viewer a new, dynamic experience of urban space.

Similarly, in 1904, the great Biograph cameraman Billy Bitzer photographed

a Westinghouse factory from an overhead industrial crane that sweeps over the floor, stressing the vastness of that industrial space not by showing the entire location at once in long shot, but by allowing the space to unfold sequentially before our eyes. The same year, Bitzer photographed one of the most astonishing films of this period, *Interior New York Subway, 14th Street to 42nd Street* (1904). The effort involves the coordination of three different trains: the train that is the subject of the film, another train (following the first) to hold the camera, and a third train (running parallel to the first) to house the electric lighting necessary to illuminate the subject as it travels through the darkened tunnels. Photographed from behind, the subway train looks like a square that gets larger and smaller as the camera car moves closer and farther away, an effect complicated and enriched by the shadow play from the mobile light source. Charles Musser reports that sections of this film were incorporated into a 1904 narrative film, about a country rube struggling to find his way in a subway station.[7] Although by this time the story film was already on its way to becoming the dominant product of the American film industry, filmmakers could still conceive of their works as modular constructions, the attractions alternating with narrative scenes, rather than subsuming the attractions into a larger narrative whole.

More than any other genre, the trick film put cinematography itself on display. Borrowing many ideas from the films of the French cinema pioneer Georges Méliès, filmmakers experimented with superimpositions, matte shots, dissolves, time-lapse photography, and other effects. Many effects that were later handled in postproduction were executed initially by camera operators. For instance, to produce a dissolve, an operator would close down the aperture at the end of a shot, then rewind the film and shoot the next shot while opening up the aperture. The exercise required attention to detail and some physical skill, since the camera had to be cranked at a relatively consistent speed. Barry Salt suggests that some early fade-in/fade-out effects may have been botched attempts at a dissolve.[8] Other tricks were even more elaborate. In 1906, Porter and his collaborator Wallace McCutcheon spent almost two months shooting the painstaking effects in *Dream of a Rarebit Fiend* (1906), one of the most famous trick films.[9] Figure 1.3 represents a matte shot: Porter and McCutcheon first exposed the bottom half of the frame while blocking off the top. Then they rewound the film, matted off the bottom half, and exposed the top half. The result is a striking contrast in scale, showing the unfortunate dreamer tormented by three miniature devils. This mixture of scales evokes the playful transformations of the film's ostensible source, a series of phantasmagorical comics by Winsor McKay.

Although *Dream of a Rarebit Fiend* is a narrative film, using visual style to reveal a character's interior mental state, the story is ultimately an excuse for a series of spectacular effects, and the camerawork functions as an attraction to be enjoyed for its own sake. Soon, as narrative began to assume an even more important role, filmmakers were challenged to consider how camerawork and

FIGURE 1.3: During the cinema of attractions, trick films like *Dream of a Rarebit Fiend* (1906) foreground cinematic special effects.

lighting might be put in service of telling a coherent story. Meanwhile, the collaborative production model of early cinema was replaced by a stricter division of labor, with the cameraman placed under the supervision of the director but in charge of an increasingly large team of technicians. By the 1920s, the cameraman, grown weary of being considered a "crank-turner," had adopted a new name, "cinematographer," and a new set of professional ambitions, defining cinematography as both a craft and an art.

On one level, there is certainly a correlation between the rise of narrative integration and industrialization. Adopting the fictional narrative as an organizing principle allowed film producers to create films on a regular basis, first as one-reel films produced on a highly standardized schedule and eventually as features. But, on another level, the relationship between film form and mode of production is more nuanced, as Janet Staiger has argued: the rationalizing impulse toward standardization was balanced by the need for product differentiation, encouraging filmmakers to vary the formulas periodically.[10] To complicate matters further, the trends toward industrialization and narrative integration were themselves impacted by a third trend: aestheticization. Just as the industry was shifting to a more rationally organized mode of production, with the narrative film assuming its place as the dominant product, cinematographers increasingly came to define themselves as artists, an ideal that pulls away from the industrial norm of efficiency by valorizing creative innovation. Keeping these three potentially conflicting trends in mind can help us make sense of some striking changes that came to cinematography over the next several years.

Before considering the cinema of narrative integration in more detail, it is important to note that the concept of the attraction will remain relevant for an understanding of cinematography, both in the silent period and beyond. Initially, Gunning proposed that the attraction went "underground," allowing narrative concerns to dominate while emerging from time to time in avant-garde practices and in the more spectacular moments of certain Hollywood films, such as musical numbers or stunts.[11] More recently, Gunning has refined this argument, proposing that the cinema of attractions and the cinema of narrative integration can both be seen as two dialectical aspects of modernity: "The new systematic organization through narrative dominance does not eliminate the anarchic energy of the cinema of attractions and modernity; rather it sublates this energy, using and transforming it."[12] If dynamism and shock represent one aspect of modernity, then rationalism and organization represent another. As the cinema grew more industrialized, leading eventually to the Hollywood studio system, filmmakers learned to incorporate camera effects, close-ups, panning shots, electric lighting, and other techniques that first appeared in the early years into a larger and more rationalized system of visual representation, using narrative as the dominant organizing principle.

From Diffused Daylight to Electric Lighting

Perhaps the most large-scale technical change impacting silent-period cinematography was the electrification of film lighting. Around the turn of the century, most films were shot in bright daylight. When a filmmaker wanted to simulate a lighting effect, it might be painted into the set, as in Porter's *Uncle Tom's Cabin* (1903), where one set creates the impression of moonlight with shadows daubed directly onto the floor. By the 1920s, virtually all interior scenes were shot under artificial lighting, and even some nominally exterior scenes had been moved into the enclosed indoor studios. Industrialization's demand for efficiency provided a powerful impetus for this widespread shift: as the commitment to mass production grew more systematic, filmmakers turned away from unreliable daylight and adopted controllable electricity. Still, for all its apparent inevitability, it is important to recall that many filmmakers resisted the switch for many years. As late as 1915, an article on lighting might include the remark, "Mr. Electric Lamp cannot yet compete with the fellow who runs the sun."[13] This preference was partly due to daylight's technical advantages (daylight was very bright and had a blue color temperature well suited to orthochromatic film stocks), but the naturalness of daylight also gave it an independent aesthetic appeal that was bolstered by the fact that painters and still photographers had long used natural lighting to craft their own works.

Instead of shifting rapidly from daylight to artificial light, the industry made the change gradually, first exploring several intermediate steps. The first films,

such as Dickson's shorts for Edison, had been shot under hard daylight beaming through the glass ceiling of the Black Maria. Around the turn of the century, as Barry Salt notes, filmmakers borrowed an idea from their peers in still photography, diffusing the sunlight in order to soften the light.[14] Stretching sheets over the windows gave the filmmaker a plethora of options: a black cloth would produce a shadow, a muslin sheet would diffuse the light, and no sheet at all could produce a bright highlight effect. Frontal lighting remained an option, but many filmmakers preferred a soft sidelight for its ability to model the subject's features, and by the 1910s filmmakers were experimenting with using the sun as a backlight, already a popular technique in outdoor shooting. During this early period, editing within a scene was still somewhat rare, and the diffuse daylight style allowed filmmakers to stage the action in depth, often with a remarkable degree of precision.[15]

We cannot assume that cinematographers who relied on daylight lacked aesthetic ambition. Quite the contrary: painters had employed natural light for centuries, and the best portrait photographers often preferred to use a large window to re-create the appearance of an Old Master painting.[16] In the hands of a good cinematographer, the diffuse daylight system was capable of producing some remarkable effects. In Griffith's *One Is Business, the Other Crime* (1912), cinematographer Billy Bitzer artfully combines diffuse and direct sunlight. In figure 1.4, the bulk of the set is lit indirectly, producing even illumination all over the room, but the actor on the right (Charles West) has stepped into a foreground position

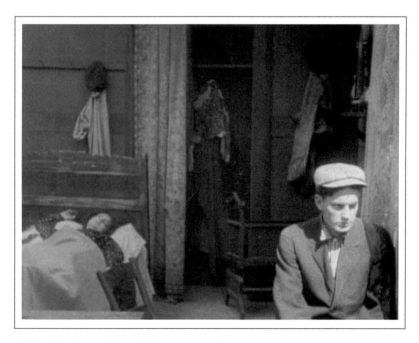

FIGURE 1.4: A combination of hard and diffuse sunlight separates foreground and background in *One Is Business, the Other Crime* (1912).

just in front of the right wall, and the result is a striking natural "spotlight" effect, with direct sunlight isolating the alienated protagonist from the rest of the space. Barry Salt points out similarly striking effects from *Regeneration* (Raoul Walsh, 1915), in which cinematographer René Guissart opens up small cracks between the diffusing sheets, letting direct sunlight peep onto the set to pick out an actor's face, while allowing the soft daylight to provide general illumination.[17]

Although diffuse daylight was indeed a powerful creative tool, the convenience of electric light, which could work day or night, winter or summer, was hard to ignore. During the 1910s, many studios employed daylight as the primary source while offering an array of artificial sources for use in "emergency" situations, such as a cloudy day.[18] Biograph, which had been one of the first studios to equip a stage with Cooper Hewitt mercury vapor tubes back in 1903, also favored a versatile approach.[19] In 1910, the company adopted the practice of sending D. W. Griffith and his team to Los Angeles for filming in the winter months (January to June); there, cinematographer Billy Bitzer relied on daylight as the primary source, as in the previously mentioned example from *One Is Business, the Other Crime*.[20] Meanwhile, the company's New York building continued to provide filmmakers with the option of using artificial lighting in an enclosed space, as in *Friends* (Griffith, 1912, d.p. Bitzer).[21] From a stylistic perspective, it is important to note that films lit by electric light and films lit by the sun often looked quite similar, especially before 1915, when filmmakers began using carbon arcs more frequently. Unlike the hard arc lamp, the Cooper Hewitt was valued precisely for its ability to imitate the soft overall appearance of diffuse daylight.[22] Apart from occasional effects, Bitzer typically illuminated every corner of the set, whether he was working on the sunlit West Coast or the electrified East, using bright illumination to present a crisp, legible space.

Winter posed a number of problems for filmmakers in cold-weather cities like New York, Philadelphia, and Chicago. Not only did the cold produce damaging static in the cameras; short days and cloudy skies made it difficult to mass-produce films on a reliable schedule. Like Biograph, many studios solved this problem by sending crews to warm-weather locations, such as Florida and Southern California.[23] The resulting construction boom in the Los Angeles area produced a mixture of daylight and electric studios. When Universal City opened in 1915, the facilities included one open-air stage, one artificial light studio, and glass stages with diffusion systems.[24] Universal soon invested more heavily in artificial lighting, and Edison himself was asked to lay the cornerstone for a new electric studio built in late 1915, drawing on the inventor's mythical status as the father of electric light and the father of cinema, two children reunited once again.[25]

Daylight's natural advantages declined in importance as electric lights grew more powerful, and as the increasing role of analytical editing made staging in depth a less popular option. By 1918, studios were painting over their glass roofs, committing fully to the artificial light aesthetic. According to an article

on Goldwyn's Fort Lee studio, "Natural light, the cameramen say, only interferes with proper artificial lighting, and since they cannot have proper natural lighting at all times they prefer to have it wholly shut out."[26] Though many filmmakers had been relying on a hybrid system for years, artificial lighting was becoming the symbol of a mature, technologically advanced industry, and studios were competing with each other to invest in electricity more heavily. For a time, the competition was geographical: New York–based producer Pat Powers argued that the shift to artificial light had eliminated California's natural advantage in sunshine and called for a return to shooting based in the East.[27] By then Powers was fighting a losing battle, as the Los Angeles studios were investing in electricity on a massive scale, a process that would continue throughout the 1920s. When Powers had built his studio in the Bronx in 1910, it was equipped with a state-of-the-art Cooper Hewitt system that could produce 100,000 candlepower worth of light.[28] In 1927, the First National studio in Burbank (now the home of Warner Bros.) reported that its newly built facilities could produce an even more astonishing amount of light, measuring the candlepower at 20 billion.[29]

If industrial efficiency were the only concern, then filmmakers might have been content with the soft light of mercury-vapor tubes, but aestheticization and narrative integration encouraged filmmakers to experiment with a wider variety of lamps. Throughout the 1910s, filmmakers increasingly relied on the carbon arc to produce strong highlights, isolating the subject from the general background lighting provided by the softer Cooper Hewitts. Carbon arcs were particularly well suited to producing "effect lighting," imitating the appearance of a table lamp or moonlight streaming through a window. Early examples appeared in D. W. Griffith's films *A Drunkard's Reformation* (1909) and *Pippa Passes* (1909), both credited to Bitzer, though Barry Salt argues that Arthur Marvin may have been responsible for the lighting effects.[30] A few years later, the Jesse Lasky Company hired the art director Wilfred Buckland, who had experience designing both sets and lighting effects for the theater director David Belasco. A contemporary article about Buckland emphasized his aesthetic goals, reporting that he hoped "to produce a film which will stand out for its superior art."[31] Soon, the company became known for "Lasky lighting," employing floodlights and spotlights to produce images with strong contrasts, most notably in the films of Cecil B. DeMille and his cinematographer Alvin Wyckoff, with Buckland serving as art director. Their films from the middle of the decade feature several remarkable examples of effect lighting, as in the fireplace and flashlight shots from *The Golden Chance* (1915). In figure 1.5, an arc light to the left of the camera illuminates the two subjects, imitating a flashlight and casting a hard shadow on the side wall. As Lea Jacobs points out, the fact that these are motivated lighting effects should not lead us to conclude that the filmmakers have adopted the norm of classical unobtrusiveness. These are spectacular effects, intended to be appreciated as bold dramatic touches in the manner of a Belasco play.[32] Indeed, much of the film is

FIGURE 1.5: An arc light imitates the effect of a flashlight in a dramatic scene from *The Golden Chance* (1915).

shot in a more diffuse style, with the most dramatic effects saved for key turning points, as in this scene, when the brutal husband is surprised to find his wife sleeping at the house he is trying to rob.

In a 1922 interview, Wyckoff reflected on the first few decades of cinematography and proposed a three-stage history of early film lighting. His remarks, though hardly impartial, serve to illustrate how cinematographers were beginning to situate their own work within an emerging historical narrative of the growth of cinematic art. Wyckoff calls the first stage the "commercial period," implying that cameramen had not yet come to think of films as artworks: "Straight, flat photography unrelieved by highlight or shadow was the invariable rule."[33] Next came "continuity lighting," the stage when cinematographers designed their lighting to imitate the appearance of a specific source, as in the effect lighting just described. Wyckoff rightly argues that technology did not drive this transition, since it long had been possible to create lighting effects through the clever arrangement of diffusing screens and sunlight. By rejecting technological determinism, Wyckoff affirms the cinematographer's status as a creative artist in control of a proliferating collection of tools. Wyckoff then suggests that his most recent work on DeMille's films was commencing a new stage in lighting: "lighting for temperament." Here, a cinematographer might ignore the question of plausible motivation and light each space solely according to the mood of the story. As an example, we might point to the climactic scene of DeMille and Wyckoff's *Affairs of Anatol* (1921, co-photographed with Karl Struss), where the characters are lit from below to create a demonic atmosphere, regardless of realistic concerns.

Wyckoff's historical distinctions are certainly not clear-cut. The example from *The Golden Chance* is quite expressive, even if Wyckoff himself would put it in his second category, and cinematographers never abandoned the goal of obtaining a good exposure on the important details. Instead, Wyckoff's categories demonstrate that cinematographers were already thinking of their work in multifaceted terms: as an industrial product manufactured with concern for efficiency; as a form of storytelling communicating information about time, space, and character; and as an art form offering new pictorial possibilities.

Perhaps the most important strategy missing from Wyckoff's list was figure lighting, the use of light and shadow to shape the subject's face. Fittingly, this technique grew in importance as the continuity system placed increasing emphasis on the close-up. Around the middle of the 1910s, when films often were lit with a combination of diffuse daylight and soft Cooper Hewitt units, cinematographers often preferred to illuminate the subject from the side, allowing the large soft source to produce gentle gradations of shadow on the subject's face. In figure 1.6, from *Hell's Hinges* (Charles Swickard, 1916, d.p. Joseph August), notice the simplicity of the lighting scheme: there is no backlight, and no glaring fill light to blow out the shadows. Yet the lighting is still quite effective, modeling the woman's face and drawing our attention to her eyes, which feature a bright point of light reflecting the soft side source. Cinematographer Joseph August would go on to have a long career in Hollywood, commanding megawatts of electricity in films like *The Hunchback of Notre Dame* (William Dieterle, 1939), but he never surpassed the elegant simplicity of this soft-key style.

FIGURE 1.6: Figure lighting with diffuse illumination from the side and no backlight in *Hell's Hinges* (1916).

Soon, figure lighting became so important that directors were hiring cinematographers with training in portrait photography to create flattering close-ups of the stars. Wyckoff's arc light effects could be strikingly unflattering, and, to compensate for his deficient skills in portraiture, soon he was paired with the renowned photographer Karl Struss, just as Billy Bitzer was asked to collaborate with portraitist Hendrik Sartov.[34] Tony Gaudio, Arthur Edeson, and Charles Rosher also joined the ranks of cinematographers after beginning their careers in photography studios.[35] Although these portraitists were skilled at using diffuse daylight to model features in a gentle fashion, they also embraced the opportunity to experiment with more electric lamps than any still photographer could possibly afford.

By the late 1910s, three-point lighting was becoming the dominant norm, using a key light to model the subject's face, a fill light to control the resulting shadows, and a backlight to separate the subject from the background.[36] Figure 1.7 is from Frances Marion's *The Love Light* (1921), co-photographed by Rosher and Henry Cronjager. Mary Pickford is lit with a key light to the right of the camera, but the fill light just to the left of the camera is of almost equal brightness, resulting in relatively flat modeling on Pickford's face, drawing attention to her eyes and mouth. Meanwhile, two backlights brighten Pickford's famous blonde hair, which registered darker than normal on the orthochromatic film. Perhaps the most remarkable detail is the way the key and fill lights produce little points of light in Pickford's eyes, amplifying her welling tears. Rosher was Pickford's regular cinematographer, and he took pride in his attention to detail, claiming in an interview with Kevin Brownlow that he often arranged her hair and selected her makeup.[37]

FIGURE 1.7: Three-point lighting on Mary Pickford's face in *The Love Light* (1921).

FIGURE 1.8: Expressive lighting from below in the horror film *The Magician* (1926).

Though three-point lighting would continue to be a default figure-lighting option for cinematographers, they began to tinker with the technique right away, perhaps by adding an extra backlight or by varying the ratio between key and fill light. In *Four Horsemen of the Apocalypse* (Ingram, 1921), John F. Seitz would use two sidelights to produce a distinct shadow in the middle of a subject's face, a technique Salt has called "core-lighting."[38] Later, in *The Magician* (Ingram, 1926), the genre of the story (horror) gave Seitz the opportunity to make the villain, German star Paul Wegener, look as grotesque as possible, a feat accomplished with a mixture of top lighting and lighting from below. In figure 1.8, a light from below distorts Wegener's features, emphasizing the circles under his eyes and the creases on his forehead, while also emphasizing the actor's nose with a long shadow stretching up across his face.

This example raises the question of German Expressionism's influence on the Hollywood style in the 1920s and beyond. Expressionism was certainly a proximate influence on *The Magician*. Not only was the film shot in Europe; Wegener himself had co-directed and starred in *The Golem* (1920), often considered an Expressionist classic. Still, as Barry Salt and Marc Vernet remind us, Hollywood filmmakers had been using light expressively for years, so expressive lighting by itself is not necessarily a marker of Expressionism in a strong sense of the term.[39] One can find examples of elaborate shadow play throughout the 1910s, not only in films by self-consciously artistic directors like Cecil B. DeMille (*The Cheat*, 1915, d.p. Alvin Wyckoff) and Maurice Tourneur (*Victory*, 1919, d.p. René Guissart), but also in comedic films like *Fatty and Mabel Adrift* (Roscoe Arbuckle, 1916, d.p. unknown) and *Haunted*

Spooks (Hal Roach and Alfred Goulding, 1920, d.p. Walter Lundin). In all these examples, it can be useful to follow Salt's advice and use the term "expressivist" for a wide range of mood-enhancing effects, reserving the term "Expressionist" for cases where the influence of the German movement is more direct.[40]

Technological factors also had an influence on the emerging styles of figure lighting. Toward the end of the silent period, cinematographers began the switch from orthochromatic to panchromatic film stock, which was much more sensitive to reds and yellows.[41] Not only did this new stock allow cinematographers to capture certain traits, such as blond hair, more easily; panchromatic stocks encouraged cinematographers to abandon the arc lamp in favor of the incandescent, since the warmer color temperature of the latter was better suited to the new stock. Incandescents produce light that is generally softer than that produced by arc lamps, further encouraging cinematographers to explore the creative possibilities of gentle lighting on a star's face. With the conversion to sound, cinematographers had an additional reason to favor the incandescent, since arc lamps initially produced an unacceptable level of noise, and the "inkie" became the cinematographer's dominant lamp throughout the next decade.

While adopting the tools of electric lighting, cinematographers had developed a diverse set of visual strategies to satisfy both narrative and aesthetic goals and still meet the standards of efficiency that an industrial system required. Yet the cinema of attractions has by no means disappeared, as both Ingram's pictorialism and Pickford's portraits were both attractions in their own right. Cinematographers further pursued this complex task of integrating competing demands by adopting an additional repertoire of strategies involving camerawork and other visual techniques.

Camerawork, Color, and Processing

As the film industry grew larger and more systematic, cinematographers developed their own trade organizations, most notably the American Society of Cinematographers. Emerging out of clubs formed in the 1910s, the ASC was an honorary organization for elite cameramen rather than a union.[42] Although it did lobby on behalf of the interests of cinematographers, one of the society's main functions was to develop a publicly known professional identity for the cameraman, defining him not as a laborer turning the crank on the camera but as a thoughtful creative leader whose knowledge of science and art provided a valuable contribution to the craft of filmmaking. The organization's magazine, *American Cinematographer*, which began publishing in 1920, consistently articulated this theme, even insisting that the term "cameraman" be replaced by the higher-sounding term "cinematographer."[43] Still, the ASC's artistic ambitions operated within the context of other trends, such as industrialization and narrative integration. This tension is often

apparent in the organization's discourse. For instance, in a 1926 interview, ASC president Dan Clark made the case for the value of the cinematographer by stressing efficiency: a professional cinematographer can save money by working quickly.[44] A few years later, the same cinematographer wrote an essay for an ASC publication, arguing that cinematographers should study paintings to learn the principles of "dynamic symmetry," thereby adding beauty and compositional clarity to the picture.[45] While these articles do indicate the appeal of potentially contradictory ideals, one of the purposes of the ASC was to resolve these tensions by helping cinematographers develop standards that could be widely shared, allowing the most artful techniques to be executed efficiently.[46]

"Painting with light" soon became a common metaphor for cinematography, but it is important to remember that lighting was only one of the cinematographer's responsibilities.[47] Throughout the silent period, the cinematographer typically operated the camera personally, sometimes manipulating the speed for comic or expressive effect. Many special effects were still executed in camera, and some cinematographers built a name for themselves by inventing new techniques. Around the time he was shooting *The Magician*, John F. Seitz applied for a patent on a new device for creating matte shots, and peers like Karl Struss and Joseph Walker were acknowledged experts in lens technology.[48] Cinematographers no longer developed and printed the film themselves, since they could rely on studio labs, but the laboratory itself was a common training ground for future cinematographers, who could rely on this training to work closely with the lab on refining the levels of brightness and contrast in the prints.[49]

One of the most aesthetically extravagant trends in late 1910s and 1920s was the "soft style," Kristin Thompson's term for a variety of techniques cinematographers and lab workers used to soften a film's images.[50] By opening up the aperture, a cinematographer could decrease the depth of field, allowing a sharply focused subject to stand out against a softer background. Alternatively, a cinematographer might put gauze in front of the lens, perhaps burning a hole in the center to allow crisp focus on the subject while softening the margins, or drape a theatrical scrim behind the actor to mimic the effect of aerial diffusion in a Renaissance painting. Another option was to set the focus "incorrectly," allowing the subject to go soft, or to use a special lens with slight imperfections to degrade the image in a self-consciously artistic way. Lab work could soften the image further, since careful developing and printing could produce an image with gentle gradations of gray instead of strong contrasts. In the already mentioned example from *The Love Light* (figure 1.7), the focus on Pickford's face is relatively crisp, but the bright center gradually turns to darkness, due to the use of a vignette mask with blurred edges. Whereas this example uses soft edges and shading to separate center from periphery, *The Magician* (figure 1.8) uses shallow focus to separate foreground from background, as the relatively sharp figure of Wegener stands out against the blurry objects behind him. Pictorial photography was a proximate

inspiration for many of these experiments; indeed, some cinematographers, such as Arthur Miller, practiced still photography on the side, submitting their work to galleries and salons.[51] All the techniques, used individually or in combination, made the artistry of the cinematographer more visible.

The soft style complemented contemporary changes in film technique. The crisply focused imagery of the diffuse daylight style was well suited to staging in depth during the 1910s. By the last decade of the silent period, most Hollywood directors were dissecting narrative action into shorter and closer shots. The soft style contributed toward this trend of isolating the spectator's attention on specific details by separating the subject from the background and periphery of the image. Most cinematographers agreed that gauze and other softening techniques were suitable for some stories more than others, as when Stephen Norton recommended using gauze for "pathetic" or sad scenes, but not for "action."[52] Excessive softness ran the risk of distracting the spectator with aesthetic beauty, thereby conflicting with the demands of narrative integration.

Film color is another area where aestheticization came into productive conflict with competing ideals, such as industrialization. There were several experiments with color photography, but silent-era color was typically applied to a black-and-white image in postproduction. During the cinema of attractions period, a film might be painted by hand, the color providing an appeal independent of any narrative contribution it might make. Such a painstaking process was incompatible with the efficiency required by mass production, and various companies experimented with alternatives, such as the stenciling process adopted by the French company Pathé, and the lithography-based Handschiegl process used for *Joan the Woman* (DeMille, 1916, d.p. Wyckoff) and *Greed* (Erich Von Stroheim, 1924, d.p. Ben Reynolds and William Daniels).[53] Still, both alternatives were also laborious, and for the bulk of the silent period the most common way to apply color to an image was through the more streamlined systems of tinting and toning. As Paul Read explains, the former process adds color to the entire film base and is most visible in the highlights; the latter process colors the "black portion of the monochrome silver image" and is most visible in the darker areas of the image.[54] It was not uncommon to combine the two processes, producing multiple colors in the same image. In his autobiography, Bitzer's camera assistant Karl Brown tells the story of how he worked with the laboratory to produce an image in the style of a sketch provided by Charles Baker for *Broken Blossoms* (Griffith, 1919, d.p. Bitzer and Sartov). Referring to the names of specific people working in the lab, Brown writes:

> I gave the film to Abe Scholtz, who lavished his tenderest attention on it. Joe Aller did the printing himself, personally. It was good but not good enough. Not to suit him. So he toned the image to a luminous, translucent blue, stained the highlights a fine light orange, and there it was, Charlie

Baker's painting reproduced in terms of a living, moving picture. Griffith watched it through with leaning-forward attention, his eyes sharpened to detect any flaw. . . . He delivered his judgment slowly. "It's a painting—a painting!—that moves!"[55]

Tinting and toning were supposed to be more efficient than alternatives like hand-painting and stenciling, but they still required careful attention if one wanted to produce artful results. As color historian Joshua Yumibe notes, Griffith's fascination with color would lead him to experiment with various other processes, including the use of additional lamps to cast colors onto the screen during projection.[56] Less ambitious and more efficient filmmakers simply would ask the lab to rely on fairly predictable conventions, such as the norm of using blue for nighttime scenes.

Brown excludes Bitzer and Sartov from this section of his tale; while it is possible that he is aggrandizing his own role, it is not implausible that the application of color was left to an assistant and the laboratory. The cinematographer was responsible for lighting and camerawork, but the lab may have had a great deal of autonomy when it comes to color. Recent scholars have stressed that we still have much to learn about color in the silent period: both about who made the relevant choices, and about why those choices were made. Summarizing this research, Kim Tomadjoglou lists a range of "overlapping and sometimes contradictory functions," with some functions classified as aesthetic, such as enhancing the realism of a scene, acting as a storytelling device, or appealing to the senses, and others classified as commercial, such as providing product differentiation or marketing a film as "high class."[57] Looking at both American and European examples, Nicola Mazzanti stresses the point that color's wide range of appeals discouraged excessive standardization, especially during the middle period between the cinema of attractions and the fully developed classical style of the 1920s.[58] Films might be colored differently for different markets, or they might include strikingly discontinuous shifts in color, as in a sudden shift to a red sepia tone for just one shot in the middle of a scene that is otherwise tinted yellow in the surviving print of John Ford's 1917 film *Straight Shooting* (d.p. George Scott).[59] By the end of the silent period, as the functions of color were taken over by other devices, such as editing and lighting, applied color became increasingly redundant, ready to be abandoned once the conversion to sound made tinting more difficult, since the process interfered with sound-on-film technology.[60]

Joshua Yumibe's recent book on early color processes directly addresses one of the ongoing concerns of this chapter: the contrasts and continuities linking the cinema of attractions and the cinema of narrative integration. Color's sensory appeals made it well suited to the exhibitionist aesthetic of the former, but later filmmakers worried that color might distract from the narrative, or upset the genteel tastes of the middle-class viewers whom the cinema of narrative integration

was attempting to court.[61] During the 1910s, filmmakers often preferred unobtrusive colors, supporting the experience of narrative absorption without drawing attention to the technology itself.[62] Still, filmmakers never abandoned color's sensory pleasures, instead taking the attraction's appeal and systematizing it. Indeed, one recurring idea in the discourse of color at the time was an appeal to the logic of synesthesia to explain how colors might work through the senses to shape the spectator's emotional response. In this way, the most classical and unobtrusive films share a surprising affinity with the more explicitly synesthetic works of modernist abstraction.[63]

Most of the color technologies of the silent period would not survive the coming of sound, with the notable exception of Technicolor. Although the perfection of its three-strip system would not occur until the 1930s, even in the silent period the company was engaged in a tight competition to develop a workable system of "natural" color photography. In the 1920s, Technicolor's two-color subtractive system was capable of producing images with visible and occasionally vibrant reds and greens but insensitive to blues.[64] Color plate 1, in the color section, is drawn from a DVD of the restoration of *The Phantom of the Opera* (Rupert Julian, 1925, d.p. Charles Van Enger, color photography supervised by Edward Estabrook), and it gives us some idea of two-color Technicolor's capacity for spectacular effects, showing us the Phantom in a flowing red cape that bursts off the screen when juxtaposed against the green outfits in the background. Here we see the ongoing productive tension between storytelling and display. The red cape rivets our attention to the demented protagonist and amplifies connotations of death that are perfectly suited to the mood and theme of the story, all within the context of an image that puts the technology itself on extravagant exhibition.

While cinematographers may have left much of the color work to the laboratory, they were more actively involved in another important stylistic technique, camera movement, especially since cinematographers typically operated their own cameras in the silent period. Camera movement was already common during the cinema of attractions, as in the previously mentioned films of the Paris and Buffalo expositions. One popular genre was the "phantom voyage," in which a camera was placed on a moving train. In *The Georgetown Loop* (1903), the train winds its way through a Colorado mining community, the movement of the camera itself becoming one of the attractions. Similar shots will later appear in more integrated films, the attraction becoming narrativized without losing its power to delight. For instance, in Griffith's *The Girl and Her Trust* (1912, d.p. Bitzer), there is an extended chase scene in which the protagonist, Grace (Dorothy Bernard), jumps onto a handcar operated by two thieves who have stolen a safe she is guarding; meanwhile, Jack (Wilfred Lucas), the man who loves her, commandeers a train speeding to catch up with the handcar. The camera is static for the first half of the film, but once the chase starts, Griffith and Bitzer employ a series of well-executed shots with the camera in motion. First, the camera is attached

to the front of the handcar, looking back at Grace and the two villains. After the handcar picks up speed, the film introduces a new angle, with the camera placed on a vehicle driving parallel to the tracks. From this angle, Grace calls out to the train behind her, and in the next shot we see the train photographed from a parallel vehicle. The shot is extraordinarily dynamic: trees and buildings zip past in the foreground as the camera car struggles to keep up with the speeding train. Initially, the editing pattern is a version of Griffith's trademark cross-cutting, and we follow two simultaneous lines of action in two distinct spaces, but soon the two spaces converge, as the train catches up with the handcar and the villains make a brief, failed effort to escape. The last shot of the film offers a clever variation of the shots we have just seen. As the romantic couple sits on the front of the train, the train starts to move backward, away from the camera. At first glance, the shot appears to be a dolly, with the train static and the camera in motion. It is only after a brief moment that we realize that the camera is static and the train is in motion. In this way, Griffith and Bitzer call our attention to our own perceptions, rendered momentarily unstable by our inability to figure out whether it is the subject that is moving or the point of view.

Griffith and Bitzer continued to experiment with the moving camera, most notably by building an elaborate dolly-elevator contraption for *Intolerance* (1916). In Bitzer's description, "The dolly was 150 feet high, about six feet square at the top and sixty feet wide at the bottom. It was mounted on six sets of four-wheeled railroad-car trucks and had an elevator in the center. . . . This great dolly was moved backward and forward by manpower; twenty-five workers pushed it smoothly along the rails."[65] Not surprisingly, few filmmakers had the resources to follow this expensive example. Indeed, after a burst of experimentation with camera movement in the mid-1910s, perhaps as a result of the popularity of the Italian spectacular *Cabiria* (Giovanni Pastrone, 1914, shot by several cinematographers), the technique quickly grew unpopular with filmmakers and critics. *Wid's Films and Film Folk* (the precursor to *Film Daily*) printed several reviews denouncing the technique, citing its eye-catching instability. After a largely positive review of Raoul Walsh's *Regeneration*, the critic lamented, "The annoying 'freak trick' of moving the camera about was also used in several places with the inevitable result that the illusion was broken."[66] Reviewing another film in the same issue, the critic suggested that "some well-wisher [should] go out with a big axe and break up the apparatus by which the camera man working on this production moved his camera all over the place while taking scenes."[67] Big axes aside, many filmmakers heeded this advice; in the late 1910s and early 1920s, it is quite common to see a Hollywood film with no camera movement at all.[68] Instead, filmmakers used the newly refined tools of editing (matching on action, eyeline matches) to navigate through space.

The slapstick comedy was an exception to this trend, since many slapsticks include some surprisingly elaborate moving-camera shots. Articles in *American*

Cinematographer from the 1920s point out that comedy cinematographers were distinguished by their technical skills, including their ability to photograph complicated stunts.[69] For instance, the climactic scene of the Harold Lloyd comedy *Girl Shy* (Newmeyer and Taylor, 1924) cross-cuts between shots of Lloyd speeding through town on a horse-drawn carriage and shots of the wedding he is hoping to prevent. Though the story situation looks ahead to *The Graduate* (Mike Nichols, 1967, d.p. Robert Surtees), the style looks back to *The Girl and Her Trust*. Cinematographer Walter Lundin photographs the carriage from many angles, sometimes perched on the carriage itself, sometimes standing on another vehicle running alongside. The resulting sequence is a remarkable study in contrasts, alternating between gauzy static images of the bride in tears and energetic, almost chaotic images of Lloyd scrambling through the city.

Attitudes toward the moving camera changed after the American release of two German classics, F. W. Murnau's *The Last Laugh* (1924) and E. A. Dupont's *Variety* (1925), both photographed by Karl Freund. *Film Daily*, which had rejected the moving camera the previous decade, celebrated the new films, encouraging American cinematographers to aspire to the boldness of the Germans.[70] In the already mentioned example from *The Magician* (figure 1.8), the camera is dollying back, preceding Wegener as he walks slowly toward his victim. Significantly, the technique of the moving camera has become thoroughly narrativized. Not only is the movement itself a simple follow shot; it also appears in a climactic scene, as if Ingram had been saving this special device for a significant narrative moment.

Soon, Murnau and Freund were invited to Hollywood, and Murnau's *Sunrise* (1927, photographed by Rosher and Struss) became one of the most influential films of the late silent period, using the moving camera for stylized and occasionally quite subjective effects. In one famous shot, the camera moves through the marshes to discover the city woman waiting for her lover. The shot was influential on a technical level, as other filmmakers soon borrowed the idea of suspending the camera from the ceiling to increase its ability to move through space, but on a deeper level the shot demonstrated new ways of integrating the camerawork with the narrative. Whereas the camera in *Girl Shy* follows the protagonist in a predictable way, moving alongside the frantic hero, Murnau's camera takes a more unexpected trajectory. First the camera follows George O'Brien's character (called simply "the Man") from behind while keeping an even distance. When the Man turns to his right, the camera continues forward, panning to keep him in frame as he walks in profile behind some trees. The Man pauses to step over a fence, and the camera glides over the railing effortlessly, flaunting its power to go anywhere. The Man then walks straight toward the camera, which pans to the left and dollies through some branches to discover the city woman. For a moment, it appears that the camera has shifted from an objective to a subjective mode of presentation, as if assuming the Man's point of view when he pushes through the marsh. However, the fact that we see the Woman from the City waiting before the Man enters from

offscreen left several seconds later suggests that the camera has instead detached itself from its initial subject and exercised its capacity to present events that the Man himself cannot yet see. This tension between a subjective reading and an objective reading of the camerawork is evident in Struss's own account of the shot. At one point in a 1928 lecture, Struss states, "Here we move with the man and his thoughts," suggesting that the camera provides special access to the character's subjectivity; Struss later comments, "We seem to be surreptitiously watching the love scenes," a phrase suggesting that the camera has adopted the perspective of an omniscient observer.[71] No matter how we read the camera's movements, it is clear that Murnau and his cinematographers have made the movement itself one of the film's subjects. In her astute analysis of the film, Caitlin McGrath has linked the film's traveling shots to previously established techniques from the cinema of attractions, comparing the film's famous trolley shot to Billy Bitzer's subway film from 1904.[72] While Murnau is using his camera to tell a story, the movement of the camera has lost none of its power to astonish, offering the spectator the opportunity to experience the thrilling sensation of movement itself.[73]

This example brings us back to Gunning's important point that the cinema of narrative integration does not simply replace the cinema of attractions; rather, narrative cinema sublates the energy of the attraction.[74] To sublate is to assimilate one element into something larger. The extraordinary dynamism of early cinema camerawork had been harnessed, put in the service of a systematic approach to storytelling. Though the results were sometimes formulaic, losing some of the attraction's anarchic energy, the most inventive filmmakers could still surprise us with fresh ideas about what the camera could do, fusing the attraction and the narrative together.

Silent Cinematography and Cinematographic History

The conversion to sound changed cinematographic technology in many ways. Paul Read summarizes these changes efficiently: "The silent, full frame, somewhat imprecise 20–24 frames per second projection of tinted and toned film was replaced by a 24fps 'Academy' (or near Academy) format, monochrome film, with synchronized sound."[75] Cinematographers relinquished control of what were now mechanically controlled cameras, initially to a team of operators working with multiple cameras, but soon to a single operator using one camera for most scenes. As Barry Salt notes, laboratory processes also were standardized around this time, with specific studios adopting norms to which cinematographers were expected to adhere.[76] Chris Cagle discusses these changes in more detail in the next chapter.

Even before these significant technological changes, the silent period had established norms that would impact Hollywood cinematography for decades. Most notably, the three-point lighting system established in the 1910s and adopted

almost universally in Hollywood in the 1920s would continue to be the default norm for lighting actors throughout the studio period and beyond. The significance of such long-lasting norms is clear, but we must be careful about framing the history teleologically, since the classical style was by no means the end point of all or even most of the developments discussed in this chapter. In addition to laying the groundwork for the classical Hollywood style, cinematographers explored a range of options that were foreclosed by studio-era conventions, as well as several techniques that would resurface in unexpected ways over the years. For instance, the "phantom voyages" of the cinema of attractions, offering spectators the thrilling impression of moving through space, would return in the sometimes vertiginous illusions of Cinerama and, later, IMAX.[77] Sometimes, old techniques returned as a form of tribute. The great 1970s cinematographer Nestor Almendros valorized natural lighting as an ideal, describing his work on *Days of Heaven* (Terrence Malick, 1978) as "an homage to the creators of the silent films, whom I admire for their blessed simplicity and their lack of refinement."[78] In this film, the soft, subtle lighting on the figures can be remarkably similar to the diffuse daylight style of the early silent years. Here, Almendros is rejecting the more polished style of classical Hollywood in favor of an abandoned but still rewarding alternative.

Looking beyond specific technologies and techniques, the silent period also established institutional patterns that would continue to impact the profession of cinematography, with the cinematographer placed, sometimes uneasily, between the ideals of the ASC and the demands of the studios.[79] Most generally, we can see the silent period as formative for the history of cinematography as a whole because tensions among the competing ideals of narrative integration, industrialization, and aestheticization remain relevant even today. In this chapter, I have treated these three factors as a linked trio because no single factor can be reduced to another. The cinematographer's professional identity as an artist might hurt the narrative (by encouraging the elaboration of eye-catching imagery) or help it (by stressing the thoughtful control of composition and mood); the mandate to tell stories might impair industrial efficiency (since every story requires different emphases and emotions) or improve it (since stories can be shot according to predictable conventions). Even the ideals of industrialization and aestheticization, which would appear to be irremediably at odds, could be resolved in some cases, as the most successful artistic techniques (such as a striking lighting effect or an ingenious camera movement) could be routinized and made available to all practitioners. In conclusion, the cinema of the silent era continues to shape the ever-changing history of Hollywood cinematography, both in terms of the tensions and contradictions that produced that history, and in terms of the silent-era visual styles that cinematographers continue to embrace, discard, and rediscover.

2

CLASSICAL HOLLYWOOD, 1928–1946 Chris Cagle

On the occasion of a tenth anniversary screening of a 1912 Mary Pickford vehicle that took place at an American Society for Cinematographers (ASC) meeting in 1922, Victor Milner reflected on the rapid development of the profession in the pages of *American Cinematographer*:

> Those at the meeting who viewed the picture realized that, if judged by the standards of 1912, it was nothing short of a master effort for that period. . . . Tony Gaudio had certainly employed everything known to the cinematographer at that time. But the difference between the 1912 effort and the pictures of today stressed most forcibly the advancement which has been made in films in the past 10 years.
>
> If so much progress has been made in the past decade, what, with the art as young as it is, are we to expect in 1932? Will the feature of today seem in 1932 as the 1912 picture does at present?[1]

It turns out that Milner was able to answer his own question. In the December 1932 issue of the trade periodical, he addressed the changes of the previous decade, particularly with the arrival of talking pictures, and speculated about what the next ten years might bring.

I am confident that cinematography will make great strides in the next decade as it has in the one just passed. While we will probably not encounter any change so revolutionary as the advent of sound, we can confidently look forward to continued improvement in the technique of cinematography—in the materials and apparatus used by the cinematographers.[2]

Milner at both points was prescient about the changes to come. Whereas in 1922 he imagined that incandescent lights would transform the lighting process, in 1932 he foresaw faster lenses, faster film stocks, and "natural color cinematography." Perhaps his predictions were merely extrapolations from ongoing developments; in any case, these developments never liberated the cinematographer to be the ideal chronicler that Milner had envisioned. Nonetheless, his articles in *American Cinematographer* point to both the continuity and the evolution of cinematography in the first half of the twentieth century.

Beyond providing predictions, Milner's articles point to the shifting stakes for cinematography's development. Patrick Keating has demonstrated in the previous chapter how during the decade from 1912 to 1922 cinematographers professionalized their art and standardized their technical processes. During the decade from 1922 to 1932 cinematographers refined a visual storytelling language and subsequently weathered the conversion to sync-sound cinema. In contrast, from 1932 to 1942 there were many smaller, incremental changes to the art and profession of cinematographer. In fact, much of the expressive language and professional practice of late silent cinematography endured into the 1930s and 1940s. What was distinctive about the classical years was the continued innovation in visual language that accompanied a relatively stable approach to storytelling. These did not add up to a revolution, but they did dramatically change the aesthetics of cinema from the early talkies to the immediate postwar years.

Much of the historiography of the classical era has stressed the stability of the studio system, both institutionally and aesthetically. Cinematography is no exception, since the practice developed under the auspices of an oligopolistic system. However, overemphasizing the standardization of the "classical Hollywood system" can cause historians to undervalue important stylistic developments. Cinematography in the years of classical sound cinema was both incremental and dynamic in its pace and scope of change. On the one hand, cinematographers fine-tuned stable professional and aesthetic practices that held sway. Even technological additions like sound and color prompted the adaptation of prior norms. On the other hand, the visual style of Hollywood films changed dramatically during the period. Some changes came from sound cinema, which imposed its own demands and adjustments, while other changes came from industry-wide changes in technology and aesthetic discourse. Ultimately, many changes stem from what John Caldwell has termed a "production culture," a concept that refers to the localized, shared sensibility of industry professionals—less monolithic

than "industry" and less institutionally defined than "trade." As Caldwell describes his mission, "Studying what might be termed the 'indigenous' interpretive frameworks of local production cultures provides specific insights about how individual filmmakers make aesthetic decisions, put theoretical ideas into practice, and make critical distinctions in their job tasks and work worlds."[3] A production-culture approach means understanding the dividing line between the "craft" and "art" of cinematography as a more complex interplay not reducible to professional instrumentality or an ideology of progress.[4]

A defining paradox of the classical period was that stylistic innovation emerged in the context of stable norms and the industrial dynamics of mature oligopoly. Moving from the general to the specific, the cinematography of this period displays three levels of stylistic variation: industry-wide experimentation, studio-based stylistic identity, and personal style within the context of the studio system. Taking all three levels into account helps us better understand the interrelation between formal and industrial "systems" and particular stylistic developments.

Crisis and Stability in the Profession

> On the one hand [cinema] has reached a state of great mechanical perfection, but on the other hand, its artistic growth has been arrested in the past year; and on every side we see irrefutable evidence that the art of the camera, upon which all screen art is based, is in danger of being overlooked and becoming stagnant and buried beneath a great maze of ohms, watts, amps, and thoughtlessness.
>
> —Bert Glennon[5]

In his study on the emergence of talking pictures, Donald Crafton writes, "It is difficult to think of a more profound discrepancy between popular and academic discourse on a subject than that which currently exists with regard to movie sound."[6] The change to sound cinema, Crafton demonstrates, was neither a sudden event nor a complete rupture from the past. Whatever the ultimate continuity, however, the introduction of sound had a considerable subjective impact. Those inside the film industry and those observing from outside saw sync-sound production to involve a drastic break from the practices of silent cinema. In reflecting on this period, cinematographer Leon Shamroy stated that "in those early days, of course, no matter what the historians say, almost everything in the dialogue sections was just photographed play."[7] One observer complained in *American Cinematographer* in 1929 that "every blooming sound expert" was "convinced that the only way to make satisfactory sound pictures is to sacrifice every other feature of value in Filmland to the proper recording of sound."[8] In

response, a sound engineer wrote a rejoinder titled "Let Us Have Peace," asserting the need for engineer-cinematographer cooperation and also acknowledging the change in filmmaking.[9] Because of their professional ethos, Hollywood's cinematographers soon would achieve a compromise with the demands of sound recording and engineering, but talking cinema posed real practical problems and challenges to their aesthetic autonomy.

The challenges of early sound cinema were multiple. Most famously, camera noise required booths or blimps, which impeded camera mobility and flexibility in lighting setups. Prestige direction during the late silent period had favored expressive and often extravagant camera movement; in Bert Glennon's *The Last Command* (Josef von Sternberg, 1928), for instance, the last scene includes subtle reframings, high- and low-angle shooting, and a thematically significant backward tracking shot at the film's end. In 1929, *American Cinematographer* editor William Stull noted that the "ice box" problem hindered the techniques to which cinematographers were accustomed:

> The size of the booth completely eliminates any possible mobility, as well as restricting the placement for angle-shots. Also the glass through which the scenes are photographed acts as a diffuser, and gives "talkie" photography its objectionable "mushy" quality. . . . Practically every technical staff in Hollywood has attacked the problem of doing away with the booth. The actual devices resulting from this work are different in each studio, but they are all recognizable as springing from the same urge, and toward a common goal. In every case the same principal aims have been in the designers' minds:
> 1. To do away with the booth.
> 2. To restore the camera's mobility.
> 3. To eliminate the glass window.[10]

Booths did not negate all expressive possibilities, but they did curtail certain dramatic techniques and require cinematographers to relinquish some control over lighting effects. David Bordwell notes that sound recording needs dictated the temporary move to multiple-camera shooting, which presented lighting and compositional challenges for cinematographers. Whereas one-camera shooting could optimize the lighting setup for each angle to model the actors and underscore the narrative, multiple-camera shooting required a more general setup that would work from multiple angles. Moreover, multiple-camera shooting constrained directors and cinematographers from using closer shot distances, wider lenses, and moving camera effects. A handful of films in the early sound, such as the prestige productions *Applause* (Rouben Mamoulian, 1929, d.p. George Folsey) and *All Quiet on the Western Front* (Lewis Milestone, 1930, d.p. Arthur Edeson), accomplished some virtuoso tracking shots and offered rich tonal ranges, yet had

to sacrifice direct, synchronous sound recording to achieve them.[11] This tendency even led to a backlash among cinematographers, who felt directors were overusing the tracking shot.[12]

One good example of transitional talking-picture cinematography is *The Letter* (Jean de Limur, 1929, d.p. George Folsey), a Paramount theatrical adaptation that synthesized late-silent motion picture style and talking-picture aesthetics. The opening scene introduces the city of Singapore in three long shots, each of which uses mid-to-low key lighting and strong high-angle spotlights with arc lights. The effect is an atmospheric composition in which actors walk in and out of illumination. These are followed by two extravagant crane-tracks toward the plantation house, also shot silent. However, once the interior scenes begin, the tonal approach is much more high-key. For some shots, the lights model the actors, though relying on an exaggerated kicker—a backlight that illuminates the edge of an actor's face. For others, the lights even out their subjects into the middle range, as in figure 2.1. This alternation continues throughout the film between parts shot silent and those shot with direct sound. The talking portions are not without some attention to foreground-background differentiation, but the alternation suggests two important tendencies: first, that films had a more hybrid aesthetic in their visual approach; and second, that dialogue scenes tended toward a minimally modeled high-key style.

Many historical accounts of this transitional period stress the adaptation of professional norms, as opposed to revolution. Bordwell argues that the "detour" of multiple-camera shooting in fact maintained analytical editing and basic

FIGURE 2.1: Full-set lighting interferes with careful modeling in *The Letter* (1929).

continuity rules. Studio practitioners, cinematographers especially, adjusted to the talking cinema through aesthetic adaptations that eventually stabilized into new norms. The trade discussions of the late 1920s and early 1930s focused disproportionately on the aesthetic challenges of sound cinema and potential technological solutions. Bordwell notes the "small-scale" technological innovations, often developed in-house at various studios or by smaller firms working symbiotically with the studios.[13] For instance, the bigger studios each developed their own silent-operating crane-dolly equipment; Universal used a bigger crane, MGM featured a "Rotambulator" with a lower, heavier base, and Fox adopted the "Velocilator" for its lighter design.[14] Cinematographers were key inventors, as when Paramount's Virgil Miller developed his own blimps, nicknamed "baby booths"; even basic equipment like tripods needed to be adapted to the additional weight.[15] Beyond piecemeal innovations, studios and cottage-industry firms accommodated sound cinema with two major developments: new lighting sources and the silent-operating cameras. In fact, Bordwell claims the "Mazda tests" of incandescent lighting in 1928 led to the central role for service firms in technological development in the studio period.[16] Incandescent lighting challenged the silent-era reliance on carbon-arc lighting because of cost-saving capability, production efficiency, and compatibility with sound recording.[17] In turn, Mole-Richardson introduced arc lights that would operate noiselessly.[18] To solve the problem of camera noise, studios worked in-house for blimping solutions; by the end of 1933, Mitchell Camera Company and Bell & Howell had developed silent cameras, though their cost still hindered complete adoption.[19] The result of these developments meant a partial return to stylistic business as usual, but in Bordwell's model the return to single-camera shooting with a mobile camera involved new stylistic conventions incorporating some practices of multiple-camera shooting, such as the prevalence of a master shot.

This adaptation meant that two basic continuities linked the 1920s to the rest of the classical period. First was the culture of cinematography: its trade institutions, professional identity, apprenticeship system, and day-to-day practices. Even if cinematographers and cameramen had to defer to sound engineers on key matters, they still embodied, and furthered, the professional identities they had forged in the 1920s.[20] One key change was in the cinematographer's promotion to a managerial role, another consequence of multiple-camera shooting.[21] As director Ernst Lubitsch reflected on his experience with Milner on *The Love Parade*: "Just the same, this change in the camerawork of the talking films has done one good thing. It has freed the First Cinematographer from the mechanical routine of running his camera. That is good. Anyone can run a camera, but it takes a real artist to arrange the lighting so as to bring out the full beauty of the set and actors, and match the emotional key of the scene."[22] Lubitsch's comments suggest the paradoxical situation in which the managerial role for cinematographers and a team organization for cameramen aided the artistic prestige of the profession.

Second, along with professional practice, Hollywood cinematographers continued aesthetic norms from the 1920s into the 1930s and 1940s. Patrick Keating argues that figure lighting, generic lighting, effects lighting, and composition were key types of classical cinematographic convention.[23] Figure lighting comprised a series of conventions for lighting actors, primarily to suggest three-dimensionality, to differentiate stars, and to provide glamour. To this end, cinematographers employed some variant of three-point lighting, and adjusted light direction, contrast, diffusion, and focus to achieve the desired portraiture. Genre lighting adapted tonality and contrast to match the subject matter, even on a scene-by-scene basis. As Keating argues, generic and scenic motivation accounts for much of what normally might be seen as an exception to Hollywood norms. "Effects lighting" was a term in the trade discourse; most narrowly, it referred to lighting motivated by specific sources on screen (e.g., a fireplace) but encompassed more broadly a range of atmospheric and dramatic lighting effects more localized than genre lighting. Finally, compositional lighting differentiated foreground and background and directed spectators' attention to significant narrative elements in the frame. Cinematographers balanced these goals, with an eye for functional storytelling and aesthetic harmony.[24] For all the changes from the silent era, this basic sensibility survived unabated through the classical years.

For several reasons, the year 1935 marks the beginning of a long decade of industrial stability. The Twentieth Century–Fox merger was the final development in the revised oligopolistic arrangement that would last the remainder of the studio years. Joseph Breen's stewardship of the Hays Code meant greater self-censorship by the MPPDA and a consequent reprieve from major national government intervention into film production. By mid-decade, the industry had adjusted to the new double-feature system, and attendance figures rose from their early Depression lows.[25] The post-1934 stabilization of the film industry set the conditions for a mature classical system. If the transitional sound years demonstrated cinematographers' ability to adapt to crisis and technological change, the post-1934 years showed cinematographers innovating from a more solid position.

Technology and Stylistic Evolution

[A cameraman] first . . . had to be a technician.
 —*Arthur C. Miller*[26]

The stability of the broadest aesthetic norms does not mean that cinematographic style remained constant over the talking-picture classical years. Even the trade-press discussion of the late 1930s and early 1940s focused increasingly on aesthetic reflection and goal setting, without ignoring technical matters.[27] Technological

developments emerged from cinematographers' aesthetic goals and in turn pushed cinematographers in new directions.

After 1935, camera and production technology had more or less overcome the most immediate practical obstacles of sync-sound shooting. New camera equipment and lights had enabled cinematographers to gain back much of their expressive vocabulary. As an indication, the yearly review of technological progress in a 1936 issue of *American Cinematographer* notes no revolutionary changes but instead changes "of more lasting value: detail improvements in materials, equipment and method which the industry can assimilate in its stride. It is especially significant that during 1936 virtually every studio began in some fashion the long-deferred task of replacing obsolescent equipment, much of which had been in service since the coming of sound nearly a decade ago."[28] The mature classical years would not be a period of revolutionary change, yet the small technical innovations had an important impact. The "detail improvements" changed the look of Hollywood films, sometimes considerably. In key areas—image tonality, focus preferences, camera movement, foreground-background relationship, and (where applicable) color—technological innovation and aesthetic fashion went hand in hand.

One of the most immediate differences between films shot in the 1930s and those shot in the 1940s is the shift from a soft to a sharper visual style. *Bird of Paradise* (King Vidor, 1932, d.p. Lucien Andriot, Edward Cronjager, and Clyde De Vinna) is perhaps the apotheosis of romanticized diffusion, but *A Farewell to Arms* (Frank Borzage, 1932, d.p. Charles Lang) makes extensive use of diffusion and soft focus within a genre not coded as exoticist: the shots in the opening scenes of Lieutenant Henry's (Gary Cooper) arrival mostly use diffusion for what normally would not be classified as the "romantic" part of the narrative. Even a lower-budget example like *The Guilty Generation* (Rowland Lee, 1931, d.p. Byron Haskin) uses a watery diffusion for transition shots. The shift away from this soft style was comprised of various changes to film stock, lighting and diffusion practices, and focus capabilities. Barry Salt has charted the technological changes, noting the changing sensitivity of various stocks according to the ASA scale. In this scale, doubling the number indicates that a stock is twice as sensitive to light. A slow negative stock equivalent to 20 ASA (whether made by Kodak, Agfa, or competitors) was the standard in 1928; by the mid-1930s Kodak had introduced a Super X negative equivalent to 40 ASA, and by the late 1930s Plus X and Super XX were capable of 80 and 160 ASA. As Salt notes, Plus X gained popularity, more for the possibility of reducing drastically the amount of light required for sets than for the ability to stop down the aperture to increase depth of field.[29] The faster stocks brought a sharper image, often with more contrast. In addition, Kodak introduced anti-halation stock, which reduced the amount of scattered light around brightly illuminated parts of the image.[30] The visual effect can be gauged in the difference between a film like *The Most Dangerous Game* (Irving Pichel

and Ernest B. Schoedsack, 1932, d.p. Henry W. Gerrard) and a later example like *The Spiral Staircase* (Robert Siodmak, 1945, d.p. Nicholas Musuraca). Both are RKO films in a low-key gothic vein, but the contrast and definition in the latter, with strong ink blacks, is particularly stark in comparison to *The Most Dangerous Game*, in which the blacks take on a charcoal hue. Some of the difference owed to lighting practices, but it also reflected a base change in the film stock.

The soft look did not disappear quickly. From the early 1930s to the early 1940s, cinematographers gradually shifted the look to a harder style. The introduction of faster film stock initially was mitigated by diffusion to soften the image. To use the example of two MGM features with the same director (George Cukor) and director of photography (William Daniels), *Romeo and Juliet* (1936) gained definition over *Dinner at Eight* (1933) and was noticeably less soft. The close-ups in *Dinner at Eight* are highly diffused with the backgrounds extremely out of focus, as in figure 2.2. *Romeo and Juliet* still uses shallow focus, as in compositions with Juliet in the foreground, and diffusion on glamour close-ups of Norma Shearer and Leslie Howard. However, only certain shots tend toward a soft style comparable to *Dinner at Eight*. Other shots are crisp in their definition. For the most part, the exterior scenes reveal a hybrid aesthetic—half defined, half diffused—that characterizes the prestige style of the mid-1930s, as in figure 2.3.

Very likely, larger cultural shifts drove the gradual move away from the soft style. In his account of the rise of realist cinematography, Keating cites the shifts in straight photography, New Deal documentary photography, and photojournalism. Within a decade, the painterly approach of "art for art sake" photography

FIGURE 2.2: The soft style: heavy diffusion, shallow focus, and a "halo" effect in *Dinner at Eight* (1933).

FIGURE 2.3: Sharper definition in *Romeo and Juliet* (1936), showing MGM's late 1930s high-key look.

gave way to a more direct visual style.[31] John Raeburn, a historian of photography, makes a similar claim, noting that in 1930s America mass-market magazines introduced European modernist photography to a broader audience and broadened photography's canon formation.[32] These changes were part of what Lea Jacobs has argued is a turn away from sentiment in American popular culture.[33] Even if the shift she describes occurred a decade before the move away from the soft style, her history, combined with Raeburn's account, suggests how developments specific to photography and the popular press could tap into preexisting cultures of "sophistication" and "modernity." Indeed, the visual style of 1930s Hollywood is one key component of what Miriam Hansen diagnoses as a vernacular modernism underlying classical Hollywood.[34]

Eventually cinematographers used the technological capability of sensitive film stocks and faster lenses to achieve greater depth of field, in a process now well documented. "Cinematography in the 1930s," David Bordwell notes, "became a give-and-take between technical agencies and the cinematographers. . . . In short, most cinematographers sought to maintain a balance between technological novelty and the 'artistic' demand for soft images."[35] Bordwell, Salt, and others have traced instances of experiments in the 1930s to use deep focus, whether through stopping down the lens aperture or using a lens mount for a split diopter; Bordwell argues that the experiments encouraged directors to stage more in depth, in turn leading to cinematographers' increased eagerness to employ deep focus.[36] Gregg Toland's famous films of the late 1930s and early 1940s pushed the

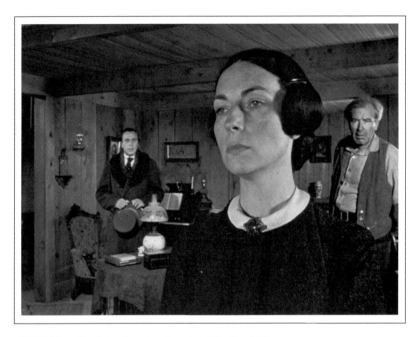

FIGURE 2.4: Gregg Toland's deep-focus cinematography in *Citizen Kane* (1941).

technical and expressive possibilities of deep focus: *Dead End* (William Wyler, 1937), *The Grapes of Wrath* (John Ford, 1940), *The Long Voyage Home* (Ford, 1940), *Citizen Kane* (Orson Welles, 1941), and *The Little Foxes* (Wyler, 1941). Cinematographers and commentators in the trade press met these works with a combination of admiration and hesitation. Charles Clarke, for instance, unfavorably contrasted the excessive use of deep focus in *Citizen Kane*, shown in figure 2.4, with the more restrained use of deep focus in *How Green Was My Valley* (Ford, 1941, d.p. Arthur C. Miller).[37]

By the mid-1940s, deep focus became a standard and increasingly default option for staging and photography. Even a genre film like *Lured* (Douglas Sirk, 1947, d.p. William H. Daniels) would make extensive use of deep focus and a radical staging in depth, as in one ballroom-scene shot which frames the detective in the foreground and the lead character Sandra (Lucille Ball) making her entrance in the deep background.

The other major innovation in technology was in color, which unsurprisingly brought the most drastic changes to cinematographic practices. Before the development of three-color Technicolor process, Hollywood had used color in various ways, both by tinting and toning black-and-white stock and by experimenting with two-color and additive film processes. As important as earlier uses were, three-strip Technicolor offered a significant and stable color alternative to black-and-white feature filmmaking. Cost would constrain the extent of its adoption throughout the 1930s and 1940s, but the productions shot in Technicolor were a

significant part of the studios' output, particularly the high-profile spectacle films. Technicolor posed some technical challenges—greater lighting requirements, difficulties in image definition for wide-angle shots, and tighter coordination with set designers—but it also opened aesthetic possibilities. Cinematographers rebelled against the "lazy" use of Technicolor based only on the novelty of color, instead championing a more realist or more expressive approach.[38]

Scott Higgins's account depicts a process of technological development similar to that of sound and deep focus: novelty, experimentation, adaptation, and finally new hegemony. The short *La Cucaracha* (Lloyd Corrigan, 1934, d.p. Ray Rennahan) and the early color feature *Becky Sharp* (Rouben Mamoulian, 1935, d.p. Ray Rennahan) experimented with an expressive range of possibilities, often using lighting to foreground vivid, saturated colors. *The Adventures of Robin Hood* (Michael Curtiz and William Keighley, 1938, d.p. Tony Gaudio and Sol Polito) modeled the use of chromatic themes to limit the color palette for narrative emphasis, while a muted color palette in *A Star Is Born* (William Wellman, 1937, d.p. Howard Greene) and other dramas proved to cinematographers that Technicolor could adapt to a mature restrained style.[39] By the 1940s, more and more prestigious cinematographers were assigned to Technicolor projects; Charles Rosher in particular developed a nuanced, jewel-like approach to Technicolor and, in films like *The Yearling* (Clarence Brown, 1946), reconciled opposing approaches—hot-cold contrast versus a monochrome theme, and saturated versus neutral palettes. *The Yearling*'s nighttime interior shots in particular show the duochromatic juxtaposition of bright yellow-orange and muted blue light, as in color plate 2.

Alongside changes in film stock, companies aligned with the industry introduced incremental improvements in lighting technology. Incandescent lights had gained dominance in the early sound years because their lack of noise made them a better choice of sound stage recording. They remained dominant because of the lower energy costs, and their use also gained favor among cinematographers in the 1930s and 1940s because of greater capability and new developments in spot-lighting. At the same time, companies developed carbon-arc lights suitable for soundstage shooting, and over the 1930s arc lights made up some of their lost ground, remaining an option for situations that required stronger or more intense light. Furthermore, Technicolor needed much more illumination than black-and-white photography, and the illumination needs and color temperature requirements of Technicolor meant that cinematographers preferred arc floodlights.

Along with the technological basis, lighting practices shifted. Primarily, studios and cinematographers aimed to reduce the amount of illumination on the set, both for cost control and actor comfort. One observer commented in 1935, "Today's trend among Hollywood's outstanding exponents of cinematographic lighting is toward the use of fewer light-sources and more actual lighting effects."[40] Both trends continued through the decade. Spotlights rather than flood illumination took on a greater role in lighting setups than in the first part of the 1930s.[41]

The starkest impact of these practices was in the realm of glamour lighting. Some, like Lee Garmes, James Wong Howe, and Leon Shamroy, sought to achieve glamour lighting through other means. For them, sparse or low-key lighting setups would double for figure lighting to flatter the star. More heterodox were attempts to resist glamour lighting altogether. Prestige cinematography could on occasion keep key actors in relative darkness; in Ray June's work on *Arrowsmith* (John Ford, 1931), the climactic death-bed scene has silhouette lighting with just a trace of a backlight to outline Ronald Colman's face. A deeper aesthetic revolt could be detected in the pages of *American Cinematographer* by the mid-1930s, as in this profile of Nicholas Musuraca:

A person does not go through life nor through even a series of events with his face constantly bathed in light. There are times, in ordinary course, when that person's face may be entirely in shadow. If so in Nature, why not, queries Musuraca, on the screen?

An interesting instance of this took place a few productions back. He took an entire scene with his star's face black. He established the star entering a room illuminated presumably only by scattered beams from a street-lamp penetrating the window. . . .

But Musuraca held his face quite dark, the expressions indefinable. For the simple reason, he contended, that a person's face need not necessarily be highlighted every time he uses a telephone. . . .

The star was not particularly pleased that his carefully put on expressions were lost in shadow, nor did the studio imports enthuse.[42]

FIGURE 2.5: Leon Shamroy's minimal lighting obscures the figure in *Lillian Russell* (1940).

In practice it would be the 1940s before prestige cinematography was allowed more latitude to resist glamour cinematography. *The Magnificent Ambersons* (Orson Welles, 1942, d.p. Stanley Cortez) is notably extreme in obscuring actors' faces and bodies, but *Lillian Russell* (figure 2.5; Irving Cummings, 1940, d.p. Leon Shamroy) shows a similar sensibility suited for prestige-drama production values, whereas *Gilda* (Charles Vidor, 1946, d.p. Rudolph Maté) selectively adapts the technique to genre-film shooting.

At the other end of the spectrum, cinematographers grew increasingly willing to light female stars with flat, slightly unflattering light. Joseph LaShelle's lighting of Gene Tierney in *Laura* (Otto Preminger, 1944) did not depart entirely from glamour traditions but varied considerably from the kicker-heavy practice of the 1930s. This practice was even more notable in male-oriented genres like the war film; Patrick Keating points out the example of *Sahara* (Zoltan Korda, 1943, d.p. Rudolph Maté), with its very sharp focus and lack of three-point lighting.[43]

In all, many of the changes in the latter half of the 1930s and first half of the 1940s combined to effect a move toward a more realist style. The canonical account stresses the influence of documentary photography and film on Hollywood, notably in examples like *The Grapes of Wrath* and *Air Force* (Howard Hawks, 1943, d.p. James Wong Howe).[44] Undoubtedly, this account captures both the changes to the field of photography as well as the self-conscious articulations by cinematographers of the impact of documentary.[45] Beyond the pseudo-documentary approaches, a realist style proliferated more broadly in the early 1940s, first in dramas and eventually in other genres. *American Cinematographer* praised *The Human Comedy* (Clarence Brown, 1943, d.p. Harry Stradling) for "the most sincere and realistic presentation" of its subject matter, a judgment undoubtedly helped by the film's harder focus and mid-key lighting.[46] Significantly, MGM was one of the studios least known for its realism, yet as an indication of the reach of the realist style, the studio produced dramas like *The Valley of Decision* (Tay Garnett, 1945, d.p. Joseph Ruttenberg) that were in the same vein. Genre films of the latter part of the 1940s—the romantic comedy *The Bachelor and the Bobby Soxer* (Irving Reis, 1947, d.p. Nicholas Musuraca) is a good example—adopted much of the harder-edged, sharp focus look. "Realist" does not adequately describe all the films of the 1940s, certainly, nor all of the visual trends of the decade, but many of the large-scale shifts in cinematographic style came under the name of realism.

House Style

I'm not sorry I stayed at M-G-M for all those years. Everybody has a home and mine was M-G-M.

—Joseph Ruttenberg[47]

Over time, the industry's stylistic preferences evolved, but at any given moment studios showed differing approaches and preferences. Although the concept has rarely been interrogated, critics have used "house style" to refer to these studio-based stylistic signatures. For popular and academic historians alike, "house style" means a broad pattern by which generic material finds a matching tone: MGM means star-driven melodrama, Warner Bros. means gritty realist problem films, and Universal means atmospheric horror films. Most notably, Thomas Schatz's books identify the genre-tone nexus as "house style," and his account of Darryl F. Zanuck's role in Warner Bros. in the early 1930s reveals his assumptions regarding the term.

> He [Zanuck] soon whipped the studio into shape and in the process he fashioned the most distinctive house style in Hollywood. That style—a model of narrative and technical economy—was ideally suited to Harry's fiscal policies. Warners shunned the high-gloss, well-lit world of MGM and Paramount, opting instead for a bleaker, darker world view. . . . As with any studio, the house style at Warners was keyed to its star-genre formulations.[48]

Schatz's conception does not preclude a consideration of cinematic style, since presumably stylistic choices follow from the genre-star-narrative-tone nexus, yet his account privileges nonformal elements of "house style," as when he notes that RKO "never really did develop a consistent house style"—by which he possibly means that it never branded itself by star-genre combinations.[49] RKO films, in fact, had a remarkably consistent visual look, certainly by the late 1930s.

These genre-based accounts of house style are useful, since studios did specialize in subject matter and matched generic material with a consistent tone. The generalizations, however, are too broad to identify various studios with recognizable cinematographic styles. What exactly defined MGM's high-gloss look? How do we distinguish it from other studios' high-gloss productions? The genre-tone definition of house style should be amended to address more specific elements of "style." These include cinematographic elements, but also potentially production design, costuming, and any craft of the visual field. (House style is rarely invoked for sound design, but there would be no a priori reason not to do so.) Alternatively, one might conceive of house style as a kind of auteur reading based not on director but on studio. Jerome Christensen has argued that a corporate authorship rather than an individual, directorial authorship organized classical Hollywood's product. He puts his case succinctly by noting that "it is as important for a student of Hollywood to know that *The Big Sleep* (1946) was a Warner Bros. feature as it was to know that Howard Hawks directed the picture."[50] Christensen distinguishes corporate authorship from house style, although the two are related.[51] Some stylistic traits carry across

the industry or at least vary without a strong alignment with one studio or another. Others show variation within a given studio, for generic or expressive purposes. House style as a concept identifies the patterns that appear in a studio's output—across genre, director, and cinematographer—and distinguish it from other studios. These patterns need not be absolute since, for example, not every MGM film will be shot in the same manner. For this reason, house style could productively be seen as a "cluster concept," a flexible collection of stylistic elements, not all of which would be applicable for a given film, but which would nonetheless help distinguish different stylistic signatures.[52] *Pace* Schatz and the popular histories, house style can encompass visual expression not explicitly tied to a studio's branding.

House style by this conception could be an ongoing research agenda for film historians, since the studio system saw multiple companies develop quasi-autonomously, each studio with its own evolution. Cinematographers and other artistic personnel tended to work under contract to a given studio, and the relative lack of movement fostered studio-specific cultures. The companies themselves set parameters that affected house style: cameras, laboratory processes, special effects equipment, and producer directives. Whereas other periods or national cinemas could have an equivalent of house style, the Hollywood studio system developed it par excellence.

House style has a technological basis. While some equipment was standardized across the film industry, each studio developed its own equipment and processes. These studio-specific technical standards served as a baseline; despite individual artists' approaches, there could be discernable similarities in the overall look of the film. Barry Salt has pointed out two key areas of distinction, film processing and cameras. Salt notes that MGM overexposed and underprocessed its negatives, resulting in a pearly-gray sheen.[53] Twentieth Century–Fox's starker look owed to the camera developed in-house and in particular to the nonglare lens coating, which enabled shooting with smaller apertures and hence greater depth of field.[54] The resulting look is noticeable across genre, including gothic horror films (John Brahm, *Hangover Square*, 1945, d.p. Joseph LaShelle), biopics (*Brigham Young*, Henry Hathaway, 1940, d.p. Arthur C. Miller), Alice Faye musicals (*Lillian Russell*), or sentimental melodramas like *Keys of the Kingdom* (John Stahl, 1944, d.p. Arthur C. Miller). In these films, focus is noticeably sharp and contrast strong, even for relatively high key shots. Black tones are consistently darker than in competing studios' films of the time, and the shooting tends toward greater depth of field. Indeed, the technological stylistic baselines reveal the limits of treating house style as synonymous with studios' genre specialization.

Technological decisions were not by happenstance. MGM's pearly look matched its overall aesthetic sensibility. Therefore, to speak of house style is to propose a production culture wherein cinematographers, process artists,

engineers, and laboratory specialists shared comparable or converging aesthetic goals. For instance, Scott Eyman asked James Wong Howe specifically how house style constrained his choices. Howe responded:

> I didn't find that so much at Warner Bros.; I found it at M-G-M. You had to please the laboratory superintendent and you had to please the Art Director, who was Cedric Gibbons. We had to light the sets up more, give more high-key so the lab would get a stronger negative. When I was signed at Warners, the picture that Mr. [Jack] Warner saw of mine was *Algiers* [John Cromwell, 1938], and that had a low-key kind of feeling and he liked that type of photography. It probably suited the studio's policy, therefore, I was left alone.[55]

Studios could differ in their production cultures and the locus of decision making. It can be difficult to provide a close historical picture of such a production culture, but one can read stylistic consistency across a studio's output and in distinction from other studios. To the extent that the visual consistency is not attributable to either the technological base or the individual cinematographer's stylistic signature, then some coordination seems very likely. This coordination may be formal or informal, purposive or unconscious, and hierarchical or communitarian; without a close case study, house style analysis may have to proceed with effects rather than causes.

Three examples are particularly worthy case studies for the role of cinematography in fostering a distinct house style: MGM in the middle 1930s, Warner Bros. in the early 1940s, and Twentieth Century–Fox in the middle 1940s. These moments are instructive because they are not necessarily associated with a famous genre. Each was developed by some of the studio's more prestigious and influential directors of photography but was practiced by a range of contract cinematographers. Some companies may have had weaker house styles (Paramount in the late 1940s, arguably) and some may have had a more famous and cohesive production unit style (RKO's Val Lewton unit of the early 1940s), but the examples under consideration put forth the case for house style that is consistent but not self-obvious.

The wealthiest studio, MGM, focused on quality, even in its cheaper productions, but its house style paradoxically depicts luxury without being lush. Since the studio prided itself on its star stable, of all the studios it was the one particularly inclined to an emphasis on glamour lighting. *Wife vs. Secretary* (Clarence Brown, 1936, d.p. Ray June) shows the typical range of the studio's glamour approaches: invoking modernist fashion photography in earlier bedroom scenes (shooting in profile, heavy rear lighting) and relying on a default mid-gray full illumination for daytime close-ups as in the final confrontation of the couple. *Wife vs. Secretary* also exhibits the other defining characteristic of MGM style: its gray high-key style, with medium diffusion. The tonal quality and the glamour lighting are

also displayed in *Romeo and Juliet* (figure 2.3), and the style would continue into the 1940s. *When Ladies Meet* (Robert Z. Leonard, 1941, d.p. Robert Planck) has slightly deeper dark hues but ultimately the same tendency toward bright, high-key lighting and glamour. Even the realist-inflected action drama *The Crowd Roars* (Richard Thorpe, 1938, d.p. John Seitz) uses a low-key and pictorial approach for certain scenes before returning to the washed-gray high-key look. MGM sometimes used sets with minimalist detail, whether Modernist or more traditional in architectural idiom; combined with the high-key style, the visual field would seem washed out, so cinematographers used simple architectural background lighting. *The Great Ziegfeld* (Robert Z. Leonard, 1936, d.p. Oliver Marsh) is exemplary in combining these: one typical shot in which Ziegfeld reads the paper shows heavy illumination, slightly diffused on William Powell, while Louise Rainer is distinguished from a basic set by a trapezoid of background light.

Although film historians often treat Warner Bros. as the opposite (cheap, gritty) of MGM, it is worth pursuing connections between the crime and action films and the prestige dramas. Warners' cinematographers like Sol Polito, Ernest Haller, and Arthur Edeson developed a visual house style of the early 1940s based on crisp, high-contrast cinematography alternating with glamour-photography lighting adapted to the realist style. *Now, Voyager* (Irving Rapper, 1942, d.p. Sol Polito) shows the distinctive approach to glamour, at times combining a strong kicker light, an over-illuminating spotlight on the figure, and lens diffusion, while at other times using a "realist" front-lighting or underlighting on Bette Davis, as in figure 2.6. *Casablanca* (Michael Curtiz, 1943, d.p. Arthur Edeson)

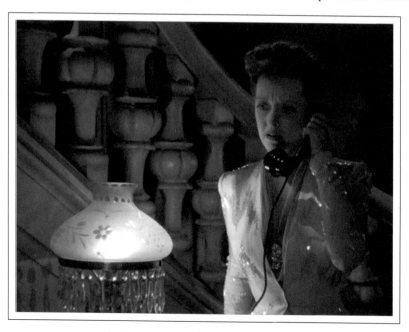

FIGURE 2.6: The Warners' style: realism, glamour, and practical light sources in *Now, Voyager* (1942).

takes a similar approach, with a balance of "realist" mid-grayscale and overexposed reflective surfaces. Other films like *Mildred Pierce* (Michael Curtiz, 1945, d.p. Ernest Haller) continued some variation of this. *Mildred Pierce* demonstrates another Warners pattern of using rear flood-lighting without a corresponding front key light, producing the silhouette effects in the opening and closing of the film; this practice is visible extensively in more action-oriented films from the studio, like *Castle on the Hudson* (Anatole Litvak, 1940, d.p. Arthur Edeson). The Warners style also features the expressive use of practicals—that is, lamps that are visible onscreen as part of the set. Finally, a Warners cinematographer might employ a cucoloris (a piece of grip equipment, typically a flat object with holes in it, placed in front of a lamp) to create intricate shadow patterns on background walls, even without effects-lighting motivation. The *Mildred Pierce*–like film *The Unfaithful* (Vincent Sherman, 1947, d.p. Ernest Haller) is a textbook example of this developed Warners style, but even a downbeat realist film like *In This Our Life* (John Huston, 1942, d.p. Ernest Haller) employs most of the stylistic tropes of the studio style.

Warners tried to upgrade its production values by combining the romanticized glamour of Paramount or MGM with its prior bare-bones realist style, but Twentieth Century–Fox staked out a niche for a prestige realist style. As suggested above, Fox's camera, shooting, and laboratory processing all favored a faster look and increased depth of field. Arthur Miller's work is particularly notable for crisp image definition, finely gradated grayscale, and a balanced use of sunlight or other heavy key lights; films like *Manhunt* (Fritz Lang, 1941), *The Song of Bernadette* (Henry King, 1943), *Keys of the Kingdom*, and *The Razor's Edge* (Edmund Golding, 1946) all show variations on these aesthetic priorities. Other Fox cinematographers shared elements of this style. Even though Joseph LaShelle and Leon Shamroy used a more romanticist, less realist style in *Laura* and *A Tree Grows in Brooklyn* (Elia Kazan, 1945), respectively, the contrast and image definition are comparable to other Fox films. LaShelle's work in *Foxes of Harrow* (John Stahl, 1947) and Shamroy's in *Daisy Kenyon* (Otto Preminger, 1947) are even starker, with more medium-low-key illumination and more resistance to kicker light (and even fill). The Fox 1940s look in particular used arc lights for a more powerful light, but rather than flood the set their cinematographers would often light more selectively: the slave auction scene in *Foxes of Harrow* is an excellent example of this practice. Meanwhile, it is debatable how much influence the semi-documentary films had on the rest of the studio's photography, but the cycle, starting with *House on 92nd Street* (Henry Hathaway, 1945, d.p. Norbert Brodine), comprised a significant portion of the studio's output in the postwar years. (Lisa Dombrowski explores in the next chapter this semi-documentary realism and its influence on postwar realist style and location shooting.) Whereas other studios such as Columbia ultimately adopted the semi-documentary style for crime thrillers and procedurals, for Fox it was one constitutive element of an overall realist sensibility.

Even the normally staid Charles Clarke mimicked it in the family-oriented *Miracle on 34th Street* (George Seaton, 1947), which starts off with handheld grainy footage and features harshly lit location interiors of Macy's and other New York City settings. Whatever the source of these decisions, they corresponded broadly to Darryl F. Zanuck's aesthetic vision for the studio—his sense that entertainment, showmanship, and artistic quality were not mutually exclusive.

Personal Style and the Cinematographic Auteur

> *Even though fettered by economic restrictions imposed upon him by the public taste, the creative cinematographer continues to experiment.*
> —Leon Shamroy[56]

Against the backdrop of Hollywood's long-term stylistic evolution and each particular studio's stylistic differentiation, individual cinematographers make personal artistic choices within the constraints of both practical considerations and storytelling conventions. Barry Salt argues that individual styles are particularly difficult to discern: "Despite being able to recognize the difference in some cases between the work of two cameramen when presented side by side, I would never claim to be able to guess the name of a cameraman who had lit a film I did not know, if shown it 'blind.'"[57] This claim may be falsifiably true, but as Salt himself suggests, lighting practices and other aesthetic strategies varied by cinematographers. "I can see little obvious connection," he writes, "between the strong chiaroscuro appearance of the lighting in *The Murders in the Rue Morgue* and the rather pedestrian mid-key look of *Back Street*, both photographed by Karl Freund for Universal in 1932. However, when Freund's work is juxtaposed with that of William Daniels on *Camille* (1937), a difference is recognizable."[58] Like house style, individual style may rest less on a strict coherence of approach than on a distinction from other cinematographers' work.

For this reason, certain cinematographers became known in the field not only for their accomplishments but also for their ability to encapsulate expressive possibilities of the medium. For instance, Charles Lang's work on *A Farewell to Arms* won the Academy Award for Cinematography for 1932 largely on the basis of his ability to encapsulate the trend in the early 1930s toward romanticized pictorialism and to do so with a minimum sacrifice of the storytelling needs. *American Cinematographer*'s review praised both its "absolute naturalness" and "intelligent pictorialism," while valuing lighting setups "intriguing in themselves."[59] The individual cinematographer-auteur then often combined a distinct aesthetic sensibility that married to more baseline norms and conventions. Four examples help illustrate the range of individual style: James Wong Howe, George Barnes, Rudolph Maté, and Leon Shamroy. The truism about classical cinematography is

that it is a highly conformist style, and each of these cinematographers pursued difference from within the shared functions that Patrick Keating has identified as basic to classicism: storytelling, glamour, realism, and pictorialism. All the same, each style was expressively distinct.

Along with Gregg Toland, James Wong Howe was the most famous of the classical cinematographers. Not only was he the subject of the occasional popular press profile,[60] he is the only cinematographer who is the subject of a dedicated historical monograph, Todd Rainsberger's book-length study of Howe's style. Drawing upon both Howe's interviews and an analysis of his work, Rainsberger identifies the overarching realist sensibility of the Howe style.[61] This realism consisted of a few tenets: an insistence on motivated lighting sources, an attempt to transform stage sets into something more verisimilar, and a deemphasis of some glamour conventions—this, despite Howe's initial success in shooting Mary Miles Minter during the silent years.[62] The realist Howe is on display most clearly in *Air Force*. This film mixes documentary footage into the fictional framework and models other aesthetic choices (16mm handheld in the interior plane shots, frontal lighting, single-source lighting) on documentary filmmaking.[63] Beyond the pseudodocumentary moments, the film relies on mono-directional lighting setups, particularly in the underlit nighttime tarmac scenes. In these, Howe not only motivates the light source, but also varies the intensity by direction. While his approach applies to high-key scenes as well, his realist tendencies are most striking in the low-key cinematography, as in the climactic nighttime battle scene of *Objective Burma!* (Raoul Walsh, 1945) in which single-source front-, side-, and backlight provide little visual information about the combatants.

All the same, Howe still managed to subjugate realist effects to the emotional needs of the story and the unobtrusive presentation of the diegesis. As Rainsberger observes, Howe "alternated between documentary realism and a heightened realism suitable for melodramas."[64] Among Howe's early 1940s work at Warner Bros., *Kings Row* (Sam Wood, 1942) represents perhaps the fullest subjugation of the realist impulses to the generic storytelling aims of the melodramatic script. In *American Cinematographer*'s eyes, Howe's work on *Kings Row* "accentuates realism" while serving largely functional aims of storytelling.[65] Some of the cinematography is similar to the semi-documentary *Air Force* or to Howe's lower-key action genre films like *Out of the Fog* (Anatole Litvak, 1941), but *Kings Row* is surprisingly high-key in look, often with a nearly washed out grayscale relying on natural light and extensive fill. For *Kings Row*, Howe collaborated with production designer William Cameron Menzies in an unusual arrangement in which Menzies provided drawings and determined camera positions; Howe even credited Menzies with the overall look of the film.[66] Even considering Menzies's design oversight, though, *Kings Row* (figure 2.7) matches Howe's aesthetic preoccupations of the early 1940s with the production values expected of a Warner Bros. prestige drama. The film combines moderate lamp diffusion with faster

FIGURE 2.7: In *Kings Row* (1942), a flat, "realist" approach to high-key lighting.

film stock and relatively little lens diffusion. Deep focus becomes a recurring formal device, though it is used in decidedly understated fashion. The directional lighting is a guiding principle—though not strict, it provides unexpected shadows or flat frontal illumination. When *American Cinematographer* praised the film's ability to achieve both realism and storytelling impact, the review signaled Howe's ability to align motivated directional lighting and genre lighting, as in instances of gothic lighting within an interior scene. As a case study, the film reveals how "realism" was not merely flat mimicry of documentary.

In contrast to the realism of Howe, George Barnes developed a romanticist, lush style. Sometimes this could take the form of pictorialism (striving for painterly effects), but just as often it was simply the approach to a balanced tonal range that gave a well-rounded sensibility to his work. His most famous exploration of a romanticist style is in *Rebecca* (Alfred Hitchcock, 1940), which features overexposure in the bedroom scenes to give a dreamlike quality to the action. As with many cinematographers, the independent and prestige productions gave Barnes freer rein to work in an individual style, but even his more routine assignments for RKO show a distinct approach to lighting. *Once Upon a Honeymoon* (Leo McCarey, 1942), for instance, achieves a strong contrast in black and white with fine grain, grayscale gradation, and slight diffusion. This tonal approach combines qualities associated with the emerging realist style with certain aspects of the early 1930s soft style. The Twentieth Century–Fox prestige production *Jane Eyre* (1944) is the apotheosis of the Barnes style and a good case for the

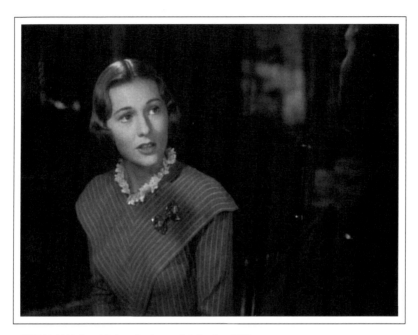

FIGURE 2.8: Ink blacks and finely rendered grayscale in *Jane Eyre* (1944).

cinematographer-as-auteur, since Barnes's aesthetic is decidedly a greater guiding force for the look of the film than Robert Stevenson's direction. The opening shot of the film, in which servants carry a sole candle in the dark, shows the unusual combination of contrast with lushness. The glamour photography uses especially fine tonal variegation, as in figure 2.8. As a gothic narrative, the film plays heavily on the sense of atmosphere, and Barnes's work reveals that atmospheric cinematography did not need to rely heavily on the pictorialism that was the default choice of Hollywood filmmakers.

Rudolph Maté, meanwhile, was better known for his adaptation and importation of a "European" modernist sensibility. Modernism could entail several qualities. In his most striking examples, like the interrogation scene in *Foreign Correspondent* (Alfred Hitchcock, 1940), angular compositions, direct light into the camera, high contrast, and expressionist directional lighting all show a rebellion against the Hollywood norms of aesthetic restraint. Of course, such rule bending could function within parameters of genre and effects lighting, but given these conventions Maté stood out as an unusually "arty" and rule-bending cinematographer, and the trade-press coverage emphasized both his knowledge of art history and his experience in 1920s Europe, particularly in works like *The Passion of Joan of Arc* (Carl-Theodor Dreyer, 1928).[67] This modernism is perhaps strongest in *Sahara*, which visually abstracts the desert imagery in a manner comparable to European and American avant-garde films. Maté could adapt to more conventional filmmaking like *My Favorite Wife* (Garson Kanin, 1940), and

many of his films break rules selectively and creatively by combining modernist touches with conventional cinematography.

Leon Shamroy became known for his self-professed minimalist lighting, particularly during his long career at Twentieth Century–Fox. He sums up his approach: "Zanuck gave me complete freedom at 20th. Here I developed my technique of using the absolute minimum of lights on a set. . . . To light economically is a rarity in this business: most cameramen put a light in front, others at the side fix up backlighting here and there; I don't."[68] In practice, lighting economy was not absolute (Shamroy did in fact use complicated lighting setups), but his approach involved a number of separate strategies. Most immediately, his films rely heavily on spotlights, either to achieve glamour lighting or to achieve the full lighting for the shot. The practice is most evident in low-key films like *Lillian Russell*, and both that film's bedroom scenes and the final production number are particularly striking for their use of spotlights (see figure 2.5). Even Shamroy's Technicolor films throw pools of spotlight on the actor, as during a tableside scene in *Black Swan* (Henry King, 1942), in which Tyrone Power's character leans back out of the light. More expressively, too, the color films often use color spotlights, sometimes with contrasting orange-green tones. *Leave Her to Heaven* (John Stahl, 1945) lights its interiors with contrasting and crisscrossed spotlights, and in general the film's interior scenes have surprisingly low illumination, as in color plate 3. Shamroy's work has a strong preference for lighting figures from above, even without the traditional genre/effects-lighting cues for such treatment. As if to compensate for the single-source minimalism, Shamroy sometimes lights the main figures with extra illumination, so that slight overexposure rather than heavy diffusion provides glamour lighting.

For more ambitious scenes, Shamroy often choreographed complex crowd compositions with many lights for individual persons rather than relying on a general illumination for the crowd. He recounts his experiences filming *Wilson* (Henry King, 1944): "We did one scene in the Shrine Ballroom, and I went down and hid lights behind the flags, and did a complete floor map so as to work out how we could move the arcs around. I had a hundred men moving the arcs around, and each man had to be handpicked. . . . It's the most startling shot I've ever done, the most startling shot I've ever seen on the screen. Five thousand people in a blaze of light."[69] This is perhaps the trademark Shamroy shot: the multiple-focus composition with individuated multiple setups. One scene set in a diner in *You Only Live Once* (Fritz Lang, 1937) is a simpler example of this kind of lighting setup.

Throughout the 1930s and 1940s, cinematography as a profession grew more self-consciously aware of its own history and legacy as an art form. *American Cinematographer*'s regular profiles in its "Aces of the Camera" series helped present and codify this historical self-image for its members. These profiles combined biography, interviews, and stylistic analysis of individual cinematographers. The

field of cinematography had an uneasy relation to individual style. The ASC and its members were understandably keen to point out the vital contributions of the cinematographer, yet their professional practice valued an unassuming style without too much individual flair. Arthur Miller summarized the storytelling goals of much classical cinematography: "My opinion of a well-photographed film is one where you look at it, and come out, and forget that you've looked at a moving picture. You forget that you've seen any photography."[70] Miller himself had a developed and unique style, but his words point out the impediment for the burgeoning notion of the cinematographer-auteur.

James Wong Howe and Leon Shamroy show how individual style both conformed to studio house style and departed from it. As *American Cinematographer*'s critic, Herb Lightman, describes the films, Shamroy's "compositions have a *modern* feeling, a strong sense of line and movement which directors find valuable in presenting action from the most forceful angle. His use of color is bold without being jarring. It is Shamroy's fine balance of art with box-office that makes his photography so widely appreciated in Hollywood."[71] On one hand this is another variation of the pattern visible in the reception of Howe's films: heterodoxy could be accepted or even praised within limits, as long as there was some ultimate accommodation with orthodox cinematographic practices. On the other hand, Shamroy's heterodoxy was a particularly formalist one. Whereas Howe could justify his lighting and composition on the grounds of narrative motivation and verisimilitude, Shamroy's took on purely expressive qualities.

Craft and the Canon

The classical Hollywood cinematographers have left a complicated legacy. Generally ignored by film studies and cinephiles, cinematographers only get their occasional due for the visual look of movies. For instance, only one English-language monograph, Rainsberger's, has been written on a classical Hollywood cinematographer, compared to countless director studies.[72] At the same time, the historical importance and economic dominance of Hollywood has meant that film historians have given the American studio system considerable attention. The effect of this situation is to reinforce the idea of the classical cinematographer as craftsperson. The distinction between "craft" and "art" might not hold up to close scrutiny, but the justification for considering studio cinematography a craft seems understandable. Classical cinematographers did not always consider themselves artists or at least not primarily so; the habitus of their field has been that of the journeyman professional. They worked within the tight control and constraints of a strong studio system. Various aesthetic dimensions of realism, pictorialism, and modernism generally were subsumed within the entertainment commodity-oriented demands of narrative clarity and star glamour.

The documentary film *Visions of Light* (Arnold Glassman, Todd McCarthy, Stuart Samuels, 1992, d.p. Nancy Schreiber), which remains one of the main popularizers of the art of cinematography, has also forwarded the classicism-as-craft thesis. Divided into chronological sections, the documentary pedagogically lays out the aesthetic dimensions of cinematography while giving a chronological history of American cinematography's development. One-third of the way through the film, post-classical cinematographer Stephen Burum says in voiceover, "Every one of the old-time D.P.s—like Charlie Clarke and Leon Shamroy, Arthur Miller and James Wong Howe—the people I met and knew, they really thought of it as a job, and thought of it as a craft. And when you'd talk with them about any kind of art kind of thing, they would never kind of admit to it being art." At this point in the documentary structure, the focus shifts from the studio era to a celebration of modernist cinematography in European art cinema and the Hollywood Renaissance. Explicitly or implicitly, the narrative reifies the distinction between classical cinema/craft and contemporary cinema/art.

Film theory and cultural studies alike have taken up the problem of taste formations—of ways in which meaning or value judgment become narrow, socially reinforced patterns of reception. Rosalind Galt has taken up the category of the "pretty" and argued that critics and theorists systematically discount and misunderstand certain aestheticized images.[73] She primarily addresses "excessive" kinds of representation (Derek Jarman and Ulrike Ottinger films, or popular art films), but a comparable dynamic treats classical Hollywood cinematography with the logic of "pretty, but. . . ." Despite the canonical nature of a significant portion of Hollywood's studio era, the canon still privileges the exceptional over the typical, or the stylistically excessive over the balanced. Classical cinematography's gradual evolution over a couple of decades seems less revolutionary than the modernist-inspired cinematography that would follow. In fact, it cannot adequately be understood in terms of the modernist and postclassical turns in cinematography that were to follow. To take the examples above, James Wong Howe's and Leon Shamroy's work—some of the most distinctive and heterodox cinematography to emerge from the heart of the studio system—foreshadows future directions in post-classical and art-cinema cinematography, yet only in the most limited sense could anything that follows be described as in the Howe or Shamroy style. Well-meaning accounts like *Visions of Light* invoke a teleological understanding, but the complexity of cinematographic style in the 1930s and 1940s should commend the virtue of taking the classical years on their own terms.

3

POSTWAR HOLLYWOOD, 1947-1967 Lisa Dombrowski

The two decades following World War II marked a period of dramatic change in the organization of American film production and the look of the movies themselves. As Thomas Schatz has explained, after the economic boom years of the war, 1947 initiated a sharp financial decline for the motion picture industry. Attendance and box office receipts dropped as young families moving to the suburbs spent their money on a wide array of consumer goods and leisure activities, including television. Meanwhile, surging production and operating costs eroded profit margins for the studios and exhibitors. As a result of the Supreme Court's Paramount Anti-Trust Decision of 1948, the major studios divested their theater holdings and accelerated cutbacks in production.[1] With rising costs and fewer films in the pipeline, the studios slashed their overhead, selling or renting land and soundstages and laying off talent and staff under contract. By the mid-1950s, independent companies who relied on the majors primarily for financing and distribution produced an increasing percentage of Hollywood's films. Previously, an individual producer under contract at a studio had a commitment to make a set number of films a year utilizing the studio's money, soundstages, equipment, talent, and craftspeople. Now, a producing company contracted for one film at a time, leasing or purchasing facilities and equipment from any studio or supplier, and configuring cast and crew from any workers available.[2] Occurring gradually

and at different rates from studio to studio, this shift in the mode of production signaled the end of Hollywood's studio system.

Economic pressures and industrial change had a direct impact on photographic practices, as producers exploited existing and emerging technologies in an effort to differentiate their product and entice audiences back into movie theaters. "Realism" and "participation" were the ideals of the day. In the late 1940s, filmmakers' varied attempts to increase a sense of realism were assisted by faster film stocks, portable lights, and more mobile cameras that enabled shooting to move out of the studios and onto the streets. By the early 1950s, advances in color, stereoscopy, and widescreen technologies offered new tools to emphasize the spectacular nature of the movies and seemingly involve the viewer as a participant in the action.

Despite changes in technology and formats, veteran cinematographers continued to highlight how their technical and aesthetic choices invisibly supported the fundamental functions of classicism: clarifying mood and narrative, providing a sense of realism, crafting pictorial images, and highlighting the glamour of the stars. In practice, however, an increasing number of postwar filmmakers displayed a new willingness to test the limits of the institutionally established ideals of classical storytelling. Paired with an encouraging director and an appropriate script, cinematographers pushed the classical envelope and experimented with convention. Independent production further encouraged individual craftsmen to adopt more visible aesthetic choices and to disintegrate the "house styles" of the major studios. While some old studio hands displayed their flexibility by trying out new tricks, other veterans retired; meanwhile, a new generation of cinematographers trained outside of the major studios and influenced by documentary and European cinema emerged to reimagine the look of Hollywood pictures. By 1968, the list of nominees for Best Cinematography included innovative films like *The Graduate* (Mike Nichols, 1967, d.p. Robert Surtees), *In Cold Blood* (Richard Brooks, 1967, d.p. Conrad Hall), and eventual winner *Bonnie and Clyde* (Arthur Penn, 1967, d.p. Burnett Guffey). America had awakened to what *Time* magazine called "the shock of freedom in films."[3]

Postwar Realism and the Rise of Location Shooting

In his 1949 book on motion picture photography, *Painting with Light,* John Alton described the influence of World War II on the look of Hollywood films:

> In interiors as well as exteriors, Hollywood was addicted to the candied (not candid) type of chocolate-coated sweet unreal photography. Then came the war. The enemy was real and could not be present at production meetings. There were no rehearsals on battlefields or during

naval or air battles. There was only one take of each scene. There were no boosters, no sun reflectors, no butterflies, and no diffusors. The pictures were starkly real. Explosions rocked the cameras, but they also rocked the world, and with it rocked Hollywood out of its old-fashioned ideas about photography. The year 1947 brought a new photographic technique. *Boomerang* [Elia Kazan, d.p. Norbert Brodine] and *T-Men* [Anthony Mann, d.p. Alton], photographed on original locations, prove that realistic photography is popular and is accepted by the great majority. Let us have more realism.[4]

As Alton suggests, wartime newsreels and documentary films containing raw combat footage introduced American audiences to cinematography that was both galvanizing in its immediacy and palpable in its imperfections. Realism in movies no longer meant simply lifelike—as carefully constructed on a Hollywood sound stage—but life itself, in all of its warped beauty. Yet Alton's before-and-after-the-war description oversimplifies matters, as realism had long been one of the primary functions of classical Hollywood cinematography and for decades had been prominent in still photography as well, as in the sharp, deep-focus images of photographers such as Edward Weston and Paul Strand; in the pictures of Depression-era rural poverty captured by documentary photographers such as Lewis Hine and those employed by the Farm Security Administration; and in the "you are there" images in *Life* magazine's photo essays.[5] Rather than introducing realism to Hollywood, faster film stocks, portable lights, and postwar location shooting expanded the photographic tools available to cinematographers pursuing a realistic look, enabling them to create images that contained established markers of authenticity. While certain stylistic choices—such as black-and-white film stock, location shooting, and low-key lighting—were most frequently associated with realism, cinematographers produced a realistic "mood" through a range of techniques across different types of films.

Even before the war in the 1930s and early 1940s, some cinematographers turned away from the dominant "soft style" of the late silent era and sought to craft a "realistic" look through sharper images and greater depth of field. While Gregg Toland's extravagant deep-focus cinematography in *Citizen Kane* (Orson Welles, 1941) generated much attention, most cinematographers in the 1940s used deep-focus selectively for stories that lent themselves to the "harshness" of realism, such as those in the war, crime, and action genres.[6] David Bordwell notes that by the late 1940s and into the 1950s, deep focus was a standard shooting option within the classical system due to emerging practices and technology. Shorter focal-length lenses were more popular, and by 1950 the 35mm lens had supplanted the 50mm as the customary lens. The arrival of the Garrutso modified lens at the end of the 1940s allowed increased depth of field without necessitating increased amounts of light. Additionally, cinematographers took advantage of

faster and finer-grained film stock to stop down the aperture for greater depth.[7] Combined with other stylistic choices, deep-focus cinematography became a hallmark of realism.

Immediately following the war, the "semi-documentary" production cycle referenced above by Alton accelerated Hollywood's interest in realism. Set in motion at Twentieth Century–Fox by producer Louis de Rochemont, a veteran of the *March of Times* newsreels, the trend originated with *The House on 92nd Street* (1945, d.p. Norbert Brodine) and *13 Rue Madeleine* (1947, d.p. Brodine), two Henry Hathaway–directed investigative dramas featuring location shooting. The pictures established the initial model for the cycle: a scripted story based on real espionage or crime-related events, an objective voiceover narration, selective use of non-actors in secondary and extra roles, little to no musical score, and, most importantly, at least partial shooting on actual locations. The vivid texture created by a real story shot in real locations provided the films with an aura of newsreel authenticity, distinguishing them in the marketplace and generating considerable publicity. Including *Boomerang!* (1947), *T-Men* (1947), and *Call Northside 777* (Hathaway, 1948, d.p. Joe MacDonald), the cycle reached its apex with *The Naked City* (1948).

The story of a murder investigation, *The Naked City*, directed by Jules Dassin and lensed by William Daniels, utilized ten weeks of second-unit and principal photography in New York City. Daniels crafted hidden-camera shots to capture street scenes, a visceral take of the detectives ascending an exposed elevator above Park Avenue, and graphic compositions of the Williamsburg Bridge for

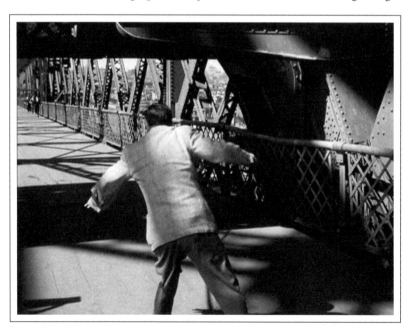

FIGURE 3.1: The entrapment of the killer on New York's Williamsburg Bridge in *The Naked City* (1948).

the climactic chase (see figure 3.1). Yet despite the challenges of location shoot-
ing, Daniels stressed his dedication to maintaining the quality of his craft: "We
were after—well, let's call it *realism*. I dislike the term 'documentary' because the
word has come to mean badly shot 16mm footage."[8] For Daniels, realism meant
shooting the actors on location without makeup using a simplified but nonethe-
less classical lighting style, not the heavy application of low-key "mood" lighting
associated with other forms of realism.

The distinction Daniels made between documentary and realism was widely
repeated in the rhetoric of cinematographers in the late 1940s and 1950s. In a
January 1947 *American Cinematographer* treatise on the development of cine-
matographic art, Joseph V. Noble traced the origin of documentary filmmaking
to Robert Flaherty's *Nanook of the North* (1922), government-produced films such
as *The River* (Pare Lorentz, 1938), newsreels, and wartime fusions of journalism,
education, and propaganda. Noble argued that documentary films appeal to logic
and must be believable to succeed; realism is thus "stressed in camera angles,
lighting, natural settings, and the absence of make-up."[9] Noble's neutral account
of documentary linked its visual characteristics to the semi-documentary film
cycle, yet de Rochemont and Hathaway, creators of *The House on 92nd Street*
and *13 Rue Madeleine*, preferred to describe the films' look as "newsdrama cin-
ematography," blending "the best elements of studio and newsreel technique."[10]
Spinning the camerawork as a combination of studio and newsreel "looks" rein-
forced the cinematographer's role as both artist and technician: artist, as he does
not simply record reality but dramatically interprets it; technician, as he adheres
to professional conventions that ensure a high level of quality. The semi-doc-
umentary films might contain elements of documentary style—documentary
"mood" effects—but in the eyes of Hollywood their polish and gloss separated
them from nonfiction filmmaking.

Norbert Brodine, who photographed both *The House on 92nd Street* and *13
Rue Madeleine*, also noted another way in which his camerawork differed from
that of some pictures described as realistic—namely, it wasn't "exaggerated"
or "weird":

> Those of us in the industry, along with theatergoers in the large key cit-
> ies, recognize and appreciate the artistry of low-key, cross-lighting, and
> the more extreme mood effects. However, in making pictures, we must
> think of the people in the smaller towns who make up the majority of
> our audiences. The butcher, the baker, and the candle-stick-maker who
> pay their 35 cents to go to the movies on Saturday night are anxious to
> watch certain stars and to be able to see their faces. I personally believe
> in avoiding effects that are too dark and extreme, and might prevent the
> audience from seeing the faces of their favorites.[11]

Brodine emphasized the importance of balancing realism with glamour, of lighting to distinguish planes and favorably model actors' faces in a subtle fashion that is not overtly "arty." As the semi-documentary cycle continued, however, cinematographers began to mix the visual markers of newsreel authenticity with different stylistic choices that also connoted realism, many of which deemphasized glamour. In particular, cinematographers shooting on location increasingly interpreted reality in a more naturalistic or even expressive fashion.

In a fall 1948 interview in *Pageant*, James Wong Howe heralded the decline of glamour and the rise of naturalism: "Hollywood photography used to be pretty and slick all the time. There wasn't enough realism and naturalness. Every hair had to be in place. The makeup had to be just right. Well, times are changing, and movie audiences want to see people and things on the screen that are more natural."[12] Naturalism in Hollywood was defined as much by what does not appear on screen—slickness, gloss, glamour, precision, perfection—as by what does: the ordinary and the everyday; the worn, the chipped, the stained; the dark visions of poverty, prejudice, violence, and vice. With the backing of director Daniel Mann and star Anna Magnani, Howe applied a starkly naturalistic approach to the black-and-white cinematography of *The Rose Tattoo* (1955), the adaptation of a Tennessee Williams play about a working-class Italian American widow's intense grief and ultimate reawakening to love. For the bulk of the film, Magnani haunts her shadow-filled, run-down house with unkempt clothes, greasy, disheveled hair, and no makeup. Howe's low-key sidelighting casts unflattering shadows across her face and emphasizes her wrinkles and sagging chin in a manner designed to illustrate the all-consuming nature of her sorrow, as in figure 3.2. As the widow warms to the attractions of a suitor, she begins to tidy up; only after she accepts the overtures of her new love do her clothes, hair, makeup, and lighting conform to classical feminine glamour norms. Although Howe's deliberately flat and unsightly lighting seemingly ignores the photographic goals of pictorial beauty and glamour, it strongly advances the story and provides an appropriately gritty, naturalistic mood. Howe's peers clearly approved, rewarding his daring efforts with the Academy Award for best black-and-white cinematography.

In selected black-and-white social dramas as well as the more commonly low-key masculine genres of crime, war, and horror, a naturalistic approach to realism consistently took precedence over glamour in the late 1940s and 1950s. *American Cinematographer* described Harry Stradling's lighting on *A Streetcar Named Desire* (Elia Kazan, 1951) as "an honest style of low-key that chucked glamour out the window and dragged in reality by the hair of the head." Stradling indicated he lit the set to suggest realistic light sources rather than to provide consistent illumination throughout the scene: "It was wonderful to be able to light a picture without having to worry about the fact that the star's face would be in shadow during part of the scene. When a light burned out, we'd often leave it out, because the effect was more honest and dramatic that way."[13] Robert

FIGURE 3.2: Unglamorous shadows across Anna Magnani's face in *The Rose Tattoo* (1955).

Surtees photographed *Act of Violence* (Fred Zinnemann, 1948) on location using a 28mm lens, no diffusion, and no makeup: "The primary thought in lighting the sets was to light for the mood of the action, no matter whether it flattered or detracted from the actor's appearance."[14] Even Hal Rosson, a cinematographer known for his glamour lighting, abstained from utilizing light designed to flatter the actors in *The Asphalt Jungle* (John Huston, 1950)—with the notable exception of Marilyn Monroe. Instead, he lit the locations to simulate natural light sources, let the shadows fall where they may, and allowed the actors to move in and out of the dark even if silhouetted against the background. *American Cinematographer* noted that Rosson's approach "took into consideration the fact that the under-world has a peculiar glamour all its own—a harsh, sinister, ominous quality that warns of danger lurking in every shadow."[15] Rather than lighting to emphasize the beauty of actors, some cinematographers generated glamour by prioritizing mood—in particular, the mood of the criminal milieu. It is in pictures such as *The Asphalt Jungle*, later described as film noir, that traits associated with various forms of realism—deep focus, location shooting, diluted glamour, low-key lighting—converge for particularly expressive effects.

The postwar adoption of latensification, faster film stocks, and portable lights and cameras enabled cinematographers to achieve the aesthetic goal of realism while also maximizing efficiency. Latensification is a process in which negative stock that has been deliberately or necessarily underexposed during production is reexposed to a weak light prior to development in order to produce an image of acceptable quality. Paramount and Du Pont introduced the process in 1947 in order to save on lighting costs, and within a few years the practice spread throughout the studios. Cinematographers utilized latensification for varying purposes: John Seitz submitted negative from *Sunset Blvd.* (Billy Wilder, 1950) to

the process so he could reduce the aperture for increased depth in low-key light; Charles Clarke rescued footage shot in adverse light conditions while on location in Germany for *The Big Lift* (George Seaton, 1950); and Hal Rosson employed latensification widely on *The Asphalt Jungle* in order to shoot exterior night scenes with less illumination than normally required.[16]

Cinematographers gained an additional advantage in 1954 when Eastman released Tri-X black-and-white negative stock, surpassing the speed of its Super XX while reducing the granularity.[17] The faster speed (increased sensitivity) of the stock provided the flexibility to shoot with less illumination, thereby simplifying lighting setups, speeding production, and reducing costs. When director Richard Brooks wanted to stage the classroom scenes in *Blackboard Jungle* (1955) such that every row of seated students remained simultaneously in focus, cinematographer Russell Harlan used Tri-X almost entirely; the stock enabled Harlan to achieve maximum depth of field by closing the aperture to f/5.6 and using a 30mm wide-angle lens, while still using a relatively modest amount of illumination. Tri-X also allowed the film's night scenes to be shot on location using available light.[18] Years before John Alcott experimented with candlelight while shooting *Barry Lyndon* (1975), Stanley Cortez photographed one shot of *Black Tuesday* (Hugo Fregonese, 1954) using Tri-X and—rather impressively—only a single candle as illumination.[19] Eastman continued to release ever-faster negative stocks over the next decade, with the color 5250 debuting in 1959 and the black-and-white 4X in 1964, further increasing production efficiency.

"Simplification" became the dominant trend in Hollywood lighting by the late 1940s due to the increase in location shooting, the proliferation of portable lighting, and the influence of cinematographers such as James Wong Howe, Russell Metty, and Woody Bredell. In a January 1949 article on changing trends, Herb A. Lightman noted the majority of cinematographers were gradually adopting "simpler lighting setups, fewer lighting units, and lighting that has greater depth and dimension." The industry, he continued, is "permitting dramatic lighting to come into its own."[20] Portable light units proved key to the simplification trend, as they saved productions from having to haul heavy-duty studio lamps and generators to remote sites, encouraging simpler lighting setups as a norm throughout the industry. The 1940s saw the introduction of photoflood bulbs with interior reflective surfaces, which produce more light per watt than others of the same rating. Often designed to be screwed into household sockets and run off regular power sources, photofloods became popular for lighting location interiors after their use by William Daniels for *The Naked City*.[21] In 1949, Colortran introduced "suitcase" lighting units that contained a range of lamps, stands, and a voltage-boosting transformer; although smaller and lighter, a 1-kilowatt Colortran lamp could produce roughly the same amount of light as a typical 2-kilowatt film lamp.[22] Throughout the 1950s, Colortran and other manufacturers expanded the range of lightweight, energy-efficient lighting units, providing

a complete system of high-quality lighting for location shooting.[23] When Walter Strenge shot the James Mason thriller *Cry Terror* (Andrew Stone, 1958) on location for MGM, he brought sixteen Garnelite and Colortran units, four baby Spots, and two Juniors; with the exception of a scene shot in the New York subway that required a generator, all the power was run off local power sources.[24]

Lightweight cameras and new camera supports also provided cinematographers with increased flexibility when shooting. In 1949 Éclair introduced to the United States the Camerette, a lightweight (14 pounds with a 400-foot magazine) 35mm camera with an adjustable reflex shutter—that is, a shutter allowing the operator to look through the lens during shooting, thereby allowing accurate framing and focusing. The Camerette could rest on the shoulder of the operator; early adopters included Orson Welles.[25] In 1960, Mitchell unveiled its own new reflex camera, the R-35. Though more substantial than the Camerette, the R-35 was lighter and more compact than the workhorse Mitchell cameras then dominant at the studios, and it could be handheld or used for shooting in tight spaces.[26] The debut of the crab dolly in the late 1940s, with wheels that could be shifted as a group to the desired angle, facilitated elaborate camera movement, enabling forward and backward trajectories as well as abrupt angular turns. The year 1950 saw the addition of a crab dolly with a hydraulic rise, while by 1966 Colortran had released a crab dolly small enough to fit through a standard doorway, particularly appealing for location shooting.[27] Tripod heads with built-in hydraulic fluid appeared in 1960; as the fluid dampened movement during pans and tilts, cinematographers could now capture following shots with long focal-length lenses without the effects of friction—a particular necessity for the continuous pan-and-zoom strategy later adopted by directors such as Robert Altman.[28] Moving camera shots taken from helicopters additionally extended the visual choices available to postwar cinematographers; early examples include the openings of *They Live by Night* (1948) and *Johnny Belinda* (1948).[29] By the mid-1960s, increasing usage of helicopter shots prompted the creation of camera mounts and lenses designed to reduce the effects of the aircraft's vibration on the image.[30]

Many—if not most—of the technological changes described above were directly inspired by the increasing number of postwar films shot at least partially on location. The primary motive for location shooting was economic: labor costs were lower outside of California, and the tight working conditions within most location interiors limited the size of crews. The previously mentioned *Cry Terror* (1958) was shot entirely on location in Los Angeles and New York with a camera crew of five, three electricians, and only two grips.[31] In addition to budget savings, the shift to location shooting offered productions a distinct aesthetic advantage, namely, the ability to situate a story amid the unique look and feel of an actual locale or a famous landmark. The texture and specificity—the sense of realism—provided by location shooting thus added production value to even lower-budgeted pictures while offering opportunities to exploit the pictorial

FIGURE 3.3: The pictorialism of the Texas panhandle in *Hud* (1963).

possibilities of actual lived-in environments. Even a location as seemingly empty of visual stimulation as the flat, desolate Texas panhandle could prove a boon, as James Wong Howe explained regarding *Hud* (Martin Ritt, 1963): "We took advantage of the barren land and made it pictorial. For example, for one important scene we elevated the camera crane so that when Hud pulled away in his car and moved down the long, receding ribbon of road, we were shooting down at a very low horizon line, which accentuated the feeling of space and the vast land area. This became a motif and a symbol of the man's character."[32] Shooting on location energized cinematographers divorced from their usual soundstages and lighting rigs, sparking creative problem-solving and contributing to a heightened sense of realism, as in figure 3.3.

Hollywood-financed films were photographed on location not only in the United States but also abroad. As a practical matter, shooting overseas multiplied day-to-day challenges, requiring the cinematographer to supervise a local camera crew trained in different production practices than those used in Hollywood (and speaking a different native language). While the review of *Gigi* (Vincente Minnelli, 1958) in the *Hollywood Reporter* highlighted the pictorial value of shooting in authentic Parisian locations, applauding Joseph Ruttenberg's photography for achieving "a Toulouse-Lautrec mood, especially in the shots actually taken in Maxim's famous restaurant," Ruttenberg himself bemoaned the trials created by variations in work conditions and labor responsibilities in France: "It would be a splendid thing for both Hollywood and foreign studios if there could be more interchange of industry ideas, so that production operations could be universally standardized."[33] Yet differences in work practices could also be liberating. Like Ruttenberg, William Mellor discovered when shooting *Love in the Afternoon* (Billy Wilder, 1957) in France that European cinematographers direct and adjust every light placement on the set, rather than relying on the gaffer to "rough in" the basic lamps and then add whatever else is requested. Mellor

FIGURE 3.4: Mystery lighting accompanies romance in *Love in the Afternoon* (1957).

responded by designing a highly unconventional, frequently low-key lighting scheme for the Audrey Hepburn–Gary Cooper romantic comedy (see figure 3.4), utilizing shadows and silhouettes to such an extent that *American Cinematographer* deemed the picture "one of the most controversial productions of the year."[34] Here Mellor exploited a side effect to working outside of the studio with a non-American crew—freedom from Hollywood conventions and union protocols, thereby enabling him to challenge generic norms.

As in the United States, shooting on location overseas allowed productions to take advantage of spectacular landscapes and historic landmarks while also enjoying reduced labor costs. Further incentives included tax advantages, expanded appeals to overseas audiences, participation in European subsidy programs, and the ability to pay for foreign crews and materials with revenues frozen by postwar trade agreements. At the height of "runaway production" in the early 1960s, approximately 55 percent of films released by American studios were shot abroad.[35] The ideal of realism championed by John Alton and James Wong Howe at the end of the 1940s—gritty, naturalistic, "starkly real"—appeared by the mid-1950s in a new, quite different form, as a ticket to see the world—and, through color and widescreen, to participate in its spectacle.

Spectacle

In response to declining attendance, Hollywood doubled down on spectacle in the postwar era, embracing technological innovations to increase production

values and spark audiences' interest. Even prior to the war, studios researched wide film gauges (that is, wider than 35mm) while also increasing their color picture output.[36] The arrival of Eastman monopack color stock in 1950 provided quality color reproduction at an affordable price, prompting major studios to invest in color photography as a principal means of distinguishing film from television. The initial massive success of Cinerama, a multiple projector wide-screen system, renewed investment in visual formats that immersed the viewer in the image and sold themselves as a participatory experience. Although inconvenience and poor-quality projection hobbled the stereoscopic motion picture craze of 1952–1953, a range of widescreen systems utilizing anamorphic lenses, wide-gauge stock, or simply a masked image radically inflated the size and aspect ratio of projected films and provided an ideal complement to epic storytelling. By the end of the 1950s cinematographers integrated widescreen into longstanding professional practices, and the wider aspect ratios of 2.35:1 and 1.85:1 replaced 1.37:1 as the new industry norms.

From the 1930s into the early 1950s, color filmmaking meant Technicolor, a three-strip process that produced vibrant color saturation but required a cumbersome camera and exponentially more light than black-and-white. Color enhanced spectacle, and the choice to utilize color was determined almost strictly by genre: musicals, historical epics, and adventure films in faraway locations were most likely to merit the process. Nevertheless, classical conventions dictated that spectacle must not overpower storytelling. Regardless of the hue of the scenery, sets, and costumes, actors' faces remained of primary importance in color films, and capturing appropriate skin tones was a Technicolor cinematographer's top job. Most used bright color selectively to accent a plot point, establish a mood, or craft a pictorial image during a moment of heightened drama.[37] Leon Shamroy, who won three Academy Awards for his Technicolor work, explained the classical approach to color: "Visual emphasis within the scene depends upon how selectively color is used to point up the action. For this reason, an important area or costume should be given enough color to attract the eye, while everything else in the scene is restrained. Since the audience can not pay attention to two centers of interest at the same time, it is not good cinema to have two units of brilliant color fighting for attention; one or the other must dominate."[38] In the classical system, color ideally complemented drama—and was deemphasized if appropriate—rather than being competitive, extravagant, or jarring. That said, individual cinematographers did activate Technicolor's potential for overt spectacle during strategic moments—including Shamroy, who prioritized bold pictorialism in sequences of *The Black Swan* (Henry King, 1942) and *Leave Her to Heaven* (John Stahl, 1945).[39]

In 1950 Eastman announced the production of a new, one-strip color negative that could be used in any camera and printed by conventional means; by 1954, after the major studios discovered Technicolor did not provide enough resolution

for widescreen images, the Eastman color process supplanted three-strip Technicolor.[40] The ease, efficiency, and economy of Eastman color encouraged studios to pair it with widescreen productions shot on location, particularly overseas, heightening the spectacle and glamour of stars, landscapes, and action. Color film production spiked, rising from approximately 15 percent of Hollywood's releases in 1950 to nearly 50 percent in 1955; after a slowdown in the mid-1950s due to cost-cutting and concerns over sales of color films to black-and-white television, color production picked up by 1959 and accelerated throughout the 1960s.[41]

The color philosophy of most cinematographers did not significantly change after the initial transition from Technicolor to Eastman color negative. Restrained, selective use of color and softer, flatter high-key light with little backlight remained conventional; the Society of Motion Picture and Television Engineers recommended low-contrast lighting for color through 1957.[42] High-contrast exceptions tended to be motivated by the particular mood required for a given genre or scene. In *Bigger Than Life* (Nicholas Ray, 1956), for example, once the protagonist's drug-induced illness shifts the narrative into horror territory, cameraman Joe MacDonald fills the character's house with pools of darkness and positions unnaturally low-angle lights to cast oversized, sharp, dense shadows behind him and his family, as in color plate 4. Harry Stradling also patterned low- and high-key scenes in *My Fair Lady* (George Cukor, 1964) to underline the dramatic journey of the protagonist. When Audrey Hepburn's Eliza is first introduced selling violets in Covent Garden at night, low-key light deglamorizes the dirt-covered star. Once Eliza enters the world of Henry Higgins and the upper crust, on the other hand, high-key predominates. Stradling's handling of the Ascot race scene is particularly impressive due to its lack of color: dozens of well-heeled couples impassively watch the race, the men dressed strictly in Ascot gray, the women in white with black and gray trimmings, all standing against a black-and-white pavilion and washed-out grass and sky. In order to create separation and detail with so much white-on-white, Stradling placed lighting units behind the muslin backdrops of the set, building up the illumination to balance the lighting from the front. The result earned him an Academy Award for Best Color Cinematography and prompted *American Cinematographer* to deem the film "the most beautifully photographed motion picture ever produced."[43]

Hollywood's search for enhanced spectacle in the 1950s also led to the proliferation of widescreen and 3-D processes, all sold to the public with the promise of increased involvement in the filmic action. For John Belton, the decade inaugurates a new era of film spectatorship rooted in the idea of enhanced "audience participation." Rather than accepting the uniformity and smaller scale of Academy-ratio movies, moviegoers could now choose to experience cinema through various processes designed to engross them perceptually in the pictures—via extremely curved screens, stereophonic sound, and three-dimensional images.[44] An advertisement for *This Is Cinerama* (Merian Cooper, 1952, d.p. Harry Squire)

illustrates the sorts of exaggerated participatory claims made by industry marketing regarding the new screen processes: "Everything that happens on the curved Cinerama screen is happening to you. And without moving from your seat, you share, personally, in the most remarkable new kind of emotional experience ever brought to the theater."[45] While Cinerama and 3-D were designed to produce visceral thrills in a manner that harkened back to the early "cinema of attractions," CinemaScope and other widescreen systems aimed to integrate spectacle with narrative—a formula that proved more engaging in the long run.

Cinerama and stereoscopic motion pictures were the first attempts to immerse the 1950s viewer in the spectacle of cinema; both debuted strongly in 1952 with box office hits, but subsequently proved cumbersome and uncompetitive in the marketplace. Cinerama featured three 35mm cameras side by side that recorded a panoramic view; three synced projectors then screened the images, slightly overlapping, on a curved screen at 26 frames per second for a combined aspect ratio of 2.59:1. With a screen often extending 75 feet in width and wrapping around the spectator's peripheral vision, Cinerama engulfed the spectator in a powerful fashion. *Time* magazine described it as a "'three-dimensional' sensation to eyes & ears" despite its lack of stereoscopy.[46] Although Cinerama's early output consisted exclusively of travelogues, it released two fiction features, *The Wonderful World of the Brothers Grimm* (Henry Levin, 1962, d.p. Paul Vogel) and *How the West Was Won* (John Ford, Henry Hathaway, and George Marshall, 1962). William Daniels, one of the cameramen on the latter, described the challenge of staging a narrative scene for projection on such a sharply curved screen: "An actor on the right or left [of the frame] cannot look directly at an actor at the center; if he does, he will look, on the [curved] screen, as if he is looking out front [into the auditorium]."[47] The difficulty of staging and cutting for the strongly curved screen, the distraction of the twin "seams" joining the three projected images, and the tremendous expense involved in converting theaters to Cinerama limited the utility of the process for narrative filmmaking.

Although experiments with stereoscopic motion pictures began in the late 1880s, 3-D did not capture Hollywood's imagination until the independently produced *Bwana Devil* (Arch Oboler, 1952) became a multimillion-dollar hit. Stereoscopy provides the illusion of depth by presenting each eye with a separate and slightly different view of the original picture; the brain combines the two, forming a single three-dimensional image. Joseph Biroc, the cameraman on *Bwana Devil*, utilizes wide-angle close-ups, shots composed with diagonal movement in deep focus and deep space, and even a spear pitched toward the camera to highlight the depth of the image. Nevertheless, the lack of technical knowledge about stereoscopy within the photographic field was on display, and the picture's photography received a drubbing.[48] The major and minor studios quickly went to work to build or acquire their own 3-D cameras, run tests, and put stereoscopic films into production, while the Academy's Research Council accelerated its own

work on stereoscopy and offered lectures for cinematographers.[49] As was their habit, studio technicians sought to integrate stereoscopy into preexisting production practices and aesthetic norms. In March 1953, the president of the American Society of Cinematographers, Charles G. Clarke, published technical recommendations for shooting in 3-D, cautioning his peers to avoid very wide angle lenses or objects close to the foreground, as "it will take some time before audiences will accept persons or objects standing out in front of the screen . . . or out over the audience."[50] As with color, cinematographers sought to balance 3-D's potential for spectacle with classical demands for restraint and verisimilitude. When it became clear by the end of 1953 that the public appetite for 3-D had waned, the editors of *American Cinematographer* blamed the troublesome glasses and poor projection: "With very few exceptions, the 3-D releases . . . from major studios were technically perfect photographically."[51]

Where Cinerama and stereoscopy proved too expensive, cumbersome, and ill suited for widespread use, the anamorphic widescreen system CinemaScope offered the studios a more easily obtainable route to a spectacular image. Anamorphic lenses squeeze a wide image onto a regular 35mm strip of film during production, distorting the picture so it appears stretched out vertically; then another lens unsqueezes the image during projection, producing the wider aspect ratio. Twentieth Century–Fox president Spyros Skouras learned of Henri Chrétien's anamorphic system in December 1952 and decided to adopt it as a remedy for the studio's declining revenues. The ease of use and relative economy of the system was a plus: anamorphic lenses could be attached to existing cameras and projectors and required no changes in film stock or in production and exhibition practices. Fox's head of production, Darryl F. Zanuck, focused the studio's slate on spectacle, announcing that all upcoming films would be in color Cinema-Scope, highlighting size, action, and location.[52] CinemaScope debuted with the biblical epic *The Robe* (Henry Koster, d.p. Leon Shamroy) in September 1953; the critically acclaimed picture captured the box office as well, becoming the year's top grossing film. Fox worked with Bausch & Lomb to improve Chrétien's lenses and licensed the format widely.

CinemaScope posed a number of technical and compositional challenges for cinematographers. First, the nature of the anamorphic lenses increased distortion and reduced definition and depth of field. A 50mm lens with the anamorphic attachment produced a width similar to that obtained from a 30mm lens but provided a shallower depth of field. While the shorter 35mm anamorphic lens increased depth of field, it also created distortion; not until the adoption of Panavision lenses of shorter focal lengths in 1959 were filmmakers able to increase depth of field without risking warped horizon lines and bloated faces.[53] The shallow depth of field of the CinemaScope lenses also made deep focus challenging, particularly with large foreground planes. To increase depth of field, cinematographers distanced the foreground plane from the camera, or

utilized sunlight in exteriors.[54] Film speed became an ally; the faster the speed, the less light necessary to generate significant depth. The faster speeds of black-and-white negative thus offered greater opportunities for deep-space, deep-focus filming when shooting in Scope. Finally, the proportions of the CinemaScope frame—initially 2.55, then 2.35 times as wide as high—tested cinematographers' abilities to activate the extra width of the frame in a dynamic fashion, a problem particularly acute with close-ups.

While CinemaScope was a boon to directors who preferred a long-take style, most cinematographers were not fans of Scope's technical limitations or its extreme horizontality. Lee Garmes declared, "I found working with CinemaScope a horror."[55] Walter Lassally argued, "From a production point of view, the new shape scores only if the entire future output of the industry is to be concentrated on spectacle, landscapes, and long shots."[56] In 1955 Twentieth Century–Fox cameraman Charles G. Clarke contributed a journal article designed to address the reluctance of cinematographers to embrace the new technology. According to Clarke, Scope would reduce the need for camera movement, require fewer shots, and encourage greater lateral staging with the actors.[57] In practice, cinematographers and directors adapted preexisting classical norms within the limitations set by the CinemaScope technology. Rather than merely adopting theatrical staging and spreading characters across the frame at a distance from the camera, most filmmakers after 1955 integrated analytical editing and close-ups with some form of depth staging, thereby highlighting character emotions while emphasizing their position in the environment. During tighter shots, cinematographers sought to fill empty spaces next to actors' heads with shadows, action, or a suitable background; alternately, they framed the close-up over the shoulder of another actor. The greater depth of field available to black-and-white films enabled more use of focused axial depth staging, as in figure 3.5, from *The Hustler* (Robert Rossen, 1961, d.p. Eugene Shuftan). Nevertheless, color films also utilized axial depth, either with a more distanced foreground or with out-of-focus mid- and backgrounds.

FIGURE 3.5: Lateral and axial depth staging in *The Hustler* (1961).

The enthusiastic responses of audiences to Cinerama and CinemaScope sparked the development of widescreen systems utilizing a film gauge larger than the normal 35mm. After the debut of many wide gauge processes, 70mm emerged as the standard. Todd-AO was the first successful 70mm system, featuring an aspect ratio of 2:1 and a frame rate of 30 frames per second. The wider gauge and faster frame rate produced crisp definition in the image, sometimes to the detriment of the actors. "One thing we learned early," said Robert Surtees, cameraman on the debut Todd-AO film *Oklahoma!* (Fred Zinnemann, 1955), "is that Todd-AO is not kind to the aging. Middle-aged or elderly players really look their age when photographed in color with Todd-AO, even with the benefit of the most expert makeup."[58] As when photographing in CinemaScope, cinematographers using wide-gauge systems utilized light, depth of field, actor movement, and compositional elements to highlight important action within the wide frame. While the technologies and proportions of various widescreen systems altered photographic practices, the widescreen revolution did not necessitate a complete overhaul of Hollywood norms. Rather, the conversion illustrated how even new technologies designed to highlight spectacle could be harnessed to the power of classical storytelling. Nevertheless, support for classical ideals was not unanimous among Hollywood filmmakers. As the studio system declined and individual workers were less bound by hierarchical oversight, directors and cinematographers increasingly pushed the boundaries of what was considered acceptable Hollywood style.

Pushing the Envelope

A range of factors encouraged a more expansive and varied approach to classical style in the postwar era. New technologies, bold directors, and the personal aesthetics of creative cinematographers altered production practices and stylistic choices. Shooting on location exposed filmmakers to unpredictable working conditions, as well as different professional practices when overseas, undermining the applicability of convention. Additionally, as independent production steadily overtook the studio system in the late 1950s and into the 1960s, the shift in the mode of production made every cinematographer a freelance technician rather than a member of a camera department, no longer subject to a studio's house style or professional oversight. Free agency encouraged cinematographers to approach every film as a potential calling card; now there was an incentive for work to be noticeable rather than subtle or invisible. While some filmmakers developed a signature "look," others stressed their adaptability.

Perhaps the most singular cinematographic experiment of the late 1940s was Alfred Hitchcock's *Rope* (1948). With only ten extremely long takes in its entire 75-minute run, the picture explores how camera movement and changing

compositions can function as alternatives to classical scene dissection and editing. During preproduction, Hitchcock staged the action on a model of the set while cinematographer Joe Valentine diagrammed the camera movements on a blackboard. The crew rehearsed for two weeks. When it came time to shoot, the 685-pound Technicolor camera was mounted on the newly developed crab dolly and continuously followed the action. To allow for maximum flexibility of camera movement, technicians hung all lighting units from above and shifted furniture, props, and the walls of the set for each camera position. The positions were marked with a numbered circle; during individual takes, a camera technician used a pointer and hand cues to direct the grips to move the dolly from one numbered circle to the next. Even more challenging for Valentine than choreographing the camera moves was eliminating the shadows of the moving camera and the microphone booms (upward of ten in operation per take). While the crew's work was virtuosic, Hitchcock insisted it served the suspense of the story: "If the audience is aware that the camera is performing miracles the end itself will be defeated."[59]

Orson Welles was far less concerned than Hitchcock with eliding camera technique, often embracing highly visible cinematography, as in *Citizen Kane*. Welles's maverick nature aroused both consternation and excitement in the industry, as noted by *American Cinematographer*: "His originality is based on the premise that anything worth showing to an audience is worth showing dramatically. If he sometimes goes a bit overboard with the result that the creaking of the machinery can be heard, he is still to be complimented for endeavoring to inject a fresh perspective into the presentation of cinematic ideas."[60] Welles's interest in bold and visceral images encouraged his cinematographers to craft more overtly expressive shots. For *The Lady from Shanghai* (1948, but photographed earlier), Charles Lawton photographed extreme close-ups with canted angles and a wide-angle lens to distort faces in a grotesque manner and slid down a fun-house slide for a kinetic hand-held shot of Welles, following behind. In the climactic hall of mirrors shootout, regular, warped, and two-way mirrors create serial reflections under high-contrast lighting, while superimpositions and matte shots further abstract the characters in space and time. Equally self-conscious effects are produced in the unnerving scene set in San Francisco's Aquarium, when Welles and Rita Hayworth converse in silhouette in front of a rear projection shot of slithering sea creatures whose appearances are timed to eerily punctuate the couple's dialogue.

Where Hitchcock and Welles prompted their cameramen to experiment with production practices and expand stylistic norms, cinematographer John Alton brought his own distinct brand of mannerism to films with a wide range of directors. Alton's particular interest lay in light and shadow. In *Painting with Light* he discusses the conventions of "mystery lighting" and "criminal lighting": "Where there is light, there is hope," and "In the dark there is mystery."[61] Alton's aesthetic

made him particularly well suited for crime stories and thrillers, to which he contributed an extreme form of generically conventional high-contrast, low-key lighting in pictures directed by Anthony Mann (*T-Men*; *Raw Deal*, 1948; *Border Incident*, 1949; *Reign of Terror*, 1949), Crane Wilbur (*Canon City*, 1948), Alfred Werker (*He Walked By Night*, 1948), and John Sturges (*Mystery Street*, 1950), among others.

Alton's photography in the opening and closing scenes of Joseph H. Lewis's *The Big Combo* (1955) characterizes for many what defines film noir. Following the credits, the picture begins with an anonymous woman running through the corridors of an auditorium hosting a boxing match. Chased through pools of light and dark by two unknown men, the woman runs first toward the camera, then away from it, then across the screen from right to left, as in figure 3.6. The low camera height and distanced framing collude to entrap her amid the receding floor, walls, and ceiling, while the high-contrast lighting injects suspense into the pattern of reveal and conceal—will the woman escape to safety, or will she be caught and experience a ghastly fate? The lighting and compositions function to create a very specific mood: a repetitive, abstract illustration of terror and vulnerability. At the end of the picture, the protagonist (Leonard, played by Cornel Wilde) and the blonde from the opening scene (Susan, played by Jean Wallace) catch the antagonist in a fog-filled airport hangar. After Susan quite literally traps the bad guy with a spotlight and the police take him away, the final shot presents Leonard and Susan in silhouette in a distanced, dorsal framing, walking numbly away from the camera. Heading toward a wall of fog, a single, high spotlight the

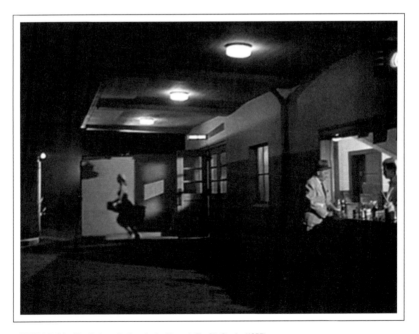

FIGURE 3.6: John Alton's deep shadows in the film noir *The Big Combo* (1955).

only apparent illumination, the two could be any man and any woman facing the unknown. Todd McCarthy describes the shot as "one of the quintessentially anti-sentimental noir statements about the place of humanity in the existential void."[62] In both sequences, Alton sacrifices detail—and, in the latter, depth cues—in order to produce abstracted, expressive illustrations of specific feelings and ideas. "Other cameramen illuminated for exposure," Alton explained. "They'd put a lot of light in it so the audience could see everything. I used light for mood."[63]

While some critics long considered the low-key lighting that marks the above shots an essential, nonclassical element of film noir, revisionist historians including Barry Salt, Frank Krutnik, Marc Vernet, Thomas Elsaesser, and Steve Neale argue the opposite, describing the stylistic characteristics of films commonly placed in the film noir canon as both supremely varied and typically well within existing conventions—the latter acknowledged by Alton himself in his discussion of "mystery lighting" and "criminal lighting," examples of which can be found in American films dating back to the 1910s.[64] In *Hollywood Lighting from the Silent Era to Film Noir*, Patrick Keating advances the revisionist account, examining the expressivity of generically motivated film noir lighting in relation to other cinematographic ideals, including the enhancement of depth cues, narrative clarity, and glamour. He finds a range of approaches to visual convention in noir films, from William Daniels's classically balanced *The Naked City* to John F. Seitz's precisely modulated expressivity in *Double Indemnity* (Billy Wilder, 1944) to shots in which storytelling goals trump gendered figure-lighting conventions in *Ministry of Fear* (Fritz Lang, 1944, d.p. Henry Sharp). What distinguishes Alton from the cinematographers of these films, Keating argues, is how his experimentation with expressive visual choices prioritizes mood over other photographic functions, steering the pictures he worked on away from the story-motivated nuance and balance that characterize classical style.[65]

John Alton's reputation for lighting simply, working quickly, and producing original results endeared him to directors but less so to other cinematographers and technicians. Walter Strohm, the production department head at MGM where Alton was under contract in the 1950s, theorized Alton's mixed reputation: "I know why they didn't like him, and that was the thing that we liked about him the most: He had none of this old studio technique. Some cameramen used the same lighting techniques every time to light a set, because the more units they had up there to light with, the more electricians it gave jobs to. Alton didn't give a damn about any of that. He was interested in getting an effect, and he could get an effect like *that*."[66] The friction between Alton and other MGM workers illustrates the power—and utility—of conventional practice. While some directors—with their producer's support (or, in the case of many B-movies, indifference)—enabled their crew members to push classical boundaries in search of greater expressivity, cinematographers' best practices were generally reinforced by labor hierarchies, union rules, and professional organizations.

The response of Daniel L. Fapp's peers to his cinematography for *West Side Story* (Robert Wise and Jerome Robbins, 1961) demonstrates that the standards of acceptable photographic practices had expanded considerably by the early 1960s. In his profile of the film's photography in *American Cinematographer*, Herb A. Lightman notes how former Paramount cameraman Fapp had to balance two theoretically opposing sets of generic conventions when shooting the film. On the one hand, the story is a contemporary tragedy set against the backdrop of racial prejudice and juvenile delinquency. On the other hand, the film's status as a musical expanded its realist palette, allowing an authentic story of potentially serious import to be visually presented in a manner that highlighted artifice. Yet though musicals had always featured extensive stylization, Fapp's consistently bold deployment of light, color, and optical effects bypassed preexisting generic norms, pushing mannered visual choices firmly into the mainstream.

Fapp credits director Robert Wise with encouraging him "to experiment with off-beat ways of using the camera to tell the story more effectively."[67] Fapp's approach announces itself in a wordless prologue musical sequence introducing the two rival gangs, the Jets and the Sharks: the head Shark, wearing a bright red jacket, pops up against a brightly colored red brick wall. Red, long considered the color most in need of restraint—to be used selectively as an accent if at all—is dominant in the frame, a visual marker of the Sharks and their territory. Color is motivated by the story, but it is no longer tamped down as earlier classical norms dictated; instead, it explodes off the wide Panavision-70 screen. Broad, dense planes of color form the backdrop of scene after scene, painted on the exterior and interior walls of the sets and even on the ceilings and floors. Not only are bold colors deployed in the background, but also via the costumes. The blues and yellows of the Jets and their women mix with the lush reds and purples of the Sharks and theirs in a physical riot of color during the mambo gym dance, offering so many competing areas of interest that Maria, the heroine, is visually differentiated only by the lack of color in her white dress. Fapp even layers multiple colored lights onto actors' faces, abandoning the classical goal of maintaining realistic skin tones. After Tony and Maria meet and fall in love, Tony leaves the dance in a daze and walks toward the camera in his Jet-yellow jacket, framed from the waist up. Singing "I just met a girl named Maria . . . ," he floats down the hall and through exterior streets, his dreamlike romantic feeling expressed through layered rear projection and yellow, magenta, and orange gels on the key light, the candy-colored light even overlapping on his face and shirt in a manner pictorial but neither realistic nor glamorous, as seen in color plate 5. A decade earlier, Lightman may well have criticized Fapp's highly expressive color and light choices for revealing the "creaking of the machinery," even if the motivation of the story justified overt mood effects. In 1961, however, Lightman enthusiastically describes *West Side Story* as "an extraordinary blend of gutsy realism and stylization amounting almost to fantasy, but so skillfully are the two

genres integrated that the mechanics are never obtrusive or out of key with the story. When fantasy prevails, it is motivated by the wishful daydreams of the hostile adolescent gang warriors themselves."[68] Fapp's fellow cinematographers concurred, awarding his work on the film the Academy Award for Best Color Cinematography. Within a few years, however, the arresting displays of vivid color seen in *West Side Story* began to decline. Once color television broadcasting accelerated in 1965–1966 and more news and topical programming appeared in color, color in cinema became less associated with spectacle and more with realism, leading to the adoption of muted color palettes.

The gradual expansion of the use of zoom lenses in feature film cinematography provides a different illustration of changing norms, one in which professional rhetoric is slow to catch up with actual production practice. By the mid-1950s, Zoomar and Pan-Cinor lenses had improved on the focusing abilities and range of focal lengths of earlier zoom lenses and were used widely in the television industry for everything from sports, parades, political conventions, and live news to scripted entertainment and dramatic series.[69] Feature films began to include zoom shots more frequently as the lenses were released for 35mm cameras, appearing in such films as *Apache* (Robert Aldrich, 1954, d.p. Ernest Laszlo) and *Odds Against Tomorrow* (Robert Wise, 1959, d.p. Joseph Brun).[70] Developments in motorization, remote control, and the 1963 introduction of Angénieux's 10:1 zoom lens increased the ease of zoom shots, while the tight interiors and uneven surfaces often encountered during location shooting made the flexibility of the zoom more appealing.[71] The zoom lens's efficiency, flexibility, and effects sparked a gradual increase in its use and functional applications from the mid-1950s to the mid-1960s in Hollywood, even as cinematographers debated its appropriateness within the pages of their trade journal. One exchange in 1965 between Richard Moore, a cameraman and founder of Panavision, and Hal Mohr, ASC president from 1963 to 1965, illustrates the mix of opinions among cinematographers regarding the zoom's stylistic effects and practicality. Moore celebrates the possibilities provided by the zoom and argues that "when used with discretion, a zoom shot can produce sensational effects" unable to be achieved through other means; additionally, zooms "can be left on the camera permanently and used as a lens with an infinite number of fixed focal lengths. The advantages of doing this are immediately apparent in terms of time and motion."[72] Mohr, on the other hand, claims, "I don't think that the zoom's inherent dangers can be dismissed with a simple 'So what?'"—highlighting how the zoom's flattening of planes and extreme shifts in focal length can disrupt the viewer's immersion in the narrative and potentially undermine the quality of the picture.[73] Regardless of the caution expressed by many studio veterans in the pages of *American Cinematographer*— especially regarding the use of zooms as a substitute for tracking in and out—the actual use of zooms in both film and television increased significantly by the late 1960s, including as an alternative to camera movement.[74]

By the end of 1965, economic, professional, and aesthetic developments pointed toward emerging change in Hollywood and its pictures. The spectacular blockbusters the studios relied on in the postwar era no longer brought in audiences but kept them away. Sales of film rights to television considered essential to financing big-budget pictures dried up. Meanwhile, an older generation of producers, directors, and cinematographers who began their careers in the silent era retired. A new generation of artists and craftspeople trained not in Hollywood studios but in New York or overseas, often in television or in documentaries, entered feature filmmaking. Suspicious of glossy artifice passing as realism and influenced by the playful visual styles of the European New Wave, the immediacy of Direct Cinema documentaries, and the rough vigor of New York independent filmmaking, a younger generation of cinematographers incorporated previously questionable visual choices into their professional practice, including zooms, unstable hand-held camerawork, unglamorous lighting, lens flare, and deliberate overexposure. If properly motivated, these "imperfections" now functioned realistically as signs of authenticity.

Who's Afraid of Virginia Woolf? (1966) and *Bonnie and Clyde* (1967) set the template for what was to come. The former featured a novice director (Mike Nichols), a young cameraman experienced in documentary (Haskell Wexler), stars willing to be deglamorized (Elizabeth Taylor and Richard Burton), and a script filled with psychological and physical violence. Wexler's largely hand-held cinematography incorporates traits historically associated with realism, such as black-and-white film stock; deep-focus, deep-space staging; and source-specific low-key lighting that allows actors to move in and out of pools of light. In scenes of physical activity and/or heightened viciousness, Wexler's choices emphasize the spontaneity and imperfections of the actors, redefining realism as "naturalism-plus"—sweaty, vulgar, and grotesque. From the kinetic, hand-held pans following a disheveled Elizabeth Taylor in extreme-close-up, to the series of quick zooms marking characters' surprised reaction to Burton with a gun, to the rough focus during multiple rapid hand-held shots, to the at-times awkward compositions and near-light flares during the dance number, the film's photography serves the story in a fashion that decouples realism from glamour and pairs it instead with authenticity. *American Cinematographer* lauded Wexler's work as "gutsy, graphic, audaciously bold, richly inventive, fluid."[75] His peers awarded him the last Academy Award offered in the black-and-white cinematography category.

Young directors desiring a less refined approach challenged even veteran cinematographers to adjust conventional practices. When Burnett Guffey arrived on location in Texas to shoot *Bonnie and Clyde*, he brought with him more than forty years of experience in the industry, four Oscar nominations for Best Black-and-White Cinematography, one win (for *From Here to Eternity*, Fred Zinnemann, 1953), and a sterling reputation as a leader within the ASC. But director Arthur

Penn, despite having only four feature credits to his name, consistently pushed Guffey out of his comfort zone. Seeking a mood authentic to the Depression era yet also modern in sensibility, Penn demanded minimal source lighting and prized spontaneity more than legibility and continuity. Guffey pushed back, fearing slip-shod results. "He hated flash, or lens flare, or bumps. Having the light change in a shot was, to him, a taboo," claims production designer Dean Tavoularis.[76] Yet despite consistent battles with Penn that ultimately led to Guffey temporarily quitting the shoot, Guffey delivered his director's vision. When Penn requested a soft, hazy feel for the scene in which Bonnie reunites with her mother and extended family, Guffey used a window screen to filter the light (see color plate 6).[77] The resulting diffusion and washed-out color palette provide the scene with a dreamlike quality, emphasizing the fleeting, melancholy nature of the family reunion. The distinct look of the scene marks a visual turning point in the film, as both the police and darkness soon overtake the Barrow gang. Guffey lights these nighttime scenes with limited sources, relying heavily on car head-lamps to function simultaneously as key lights and backlights. With much of the frame shrouded in darkness, sound and movement come to the fore, heightening the chaos and confusion of the action.

Guffey feared *Bonnie and Clyde* would appear underlit and amateurish; the following April he won his second Academy Award for the film. Change was afoot. Convention was giving way to experimentation. In the coming decade, the look of the Auteur Renaissance took hold.

4

THE AUTEUR RENAISSANCE, 1968–1980 Bradley Schauer

The labels commonly employed by critics and historians when discussing American cinema from approximately 1968 to 1980, such as "New Hollywood," "The New American Cinema," and "The Hollywood Renaissance," reinforce a sense of the era as one of rupture, innovation, and differentiation from prior tradition. Here, the "Old Hollywood" is the classical studio system, characterized industrially by oligopolistic vertical integration, and formally by a self-effacing style whose chief function was to convey story material effectively. This iteration of Hollywood was gradually dismantled and refashioned over the course of the 1950s and 1960s—indeed, critics had declared the "end of Hollywood" as early as 1961.[1] Yet it was not until the film industry faced economic collapse in the late 1960s that it was spurred to depart from classical norms in a widespread manner.

Understanding that the recession of 1969–1971 was due in part to poor investments in expensive, old-fashioned blockbusters like *Doctor Dolittle* (Richard Fleischer, 1967, d.p. Robert Surtees), the major studios responded by slashing budgets and curtailing the number of films released. The reduced risk represented by lower budgets allowed for increased formal experimentation, as the studios began to target younger (thirty and under) moviegoers with edgier product that borrowed from European art cinema and exploited loosened censorship

regulations. In 1967 *Time* declared that films like *Bonnie and Clyde* (Arthur Penn, 1967, d.p. Burnett Guffey) were the first examples of a "New Cinema": "They are not what U.S. movies used to be like. They enjoy a heady new freedom from formula, convention, and censorship."[2] Crucially for the studios, these inexpensive youth films had much greater profit potential than overblown musicals or family films like *Chitty Chitty Bang Bang* (Ken Hughes, 1968, d.p. Christopher Challis); to take an extreme example, in 1969 the biker film *Easy Rider* (Dennis Hopper, 1969, d.p. László Kovács) returned over $7 million in rentals but cost only about a half million dollars.[3]

American cultural liberalization, economic crisis in the film industry, and changes in the industry's conception of its audience all contributed to the rise of the "Auteur Renaissance." But the most direct agents of change in the late 1960s were the "Movie Brats" themselves. Directors like Martin Scorsese and Francis Ford Coppola were born in the late 1930s or 1940s and typically were educated at one of the new degree-granting film production programs at UCLA, USC, or NYU. The foreign art cinema they studied in school, and the auteur theory surrounding it, profoundly affected their aesthetic projects and career aspirations. By the time these brash young filmmakers reached Hollywood, the struggling industry was receptive to their auteur-oriented revisionism.

Alongside this new generation of directors worked a cohort of cinematographers, equally eager to experiment with visual style and new technologies. They were a heterogeneous group in terms of age and training: some, like William Fraker (b. 1923) and Conrad Hall (b. 1926), were film school graduates whose careers began in 1950s television. Others, like Owen Roizman (b. 1936) and Gordon Willis (b. 1931), were New York–based and worked in commercials before transitioning to features. Two of the most esteemed cinematographers of the period, Kovács (b. 1933) and Vilmos Zsigmond (b. 1930), were Budapest film school graduates who had documented the 1956 Hungarian Revolution before fleeing to the States. Finally, a number of older cameramen who made their names in the studio system were amenable to departing from those norms in collaboration with a younger director—for instance, Robert Surtees (b. 1908).

Despite their disparate backgrounds, these cinematographers were alike in their willingness to diverge from the classical studio style in two significant ways. First, they developed a new naturalistic aesthetic, grounded in diffuse and grainy techniques. This new look was not just another way to counter the artificiality of studio-bound filmmaking; its visual softness also broke with previous norms of realism in Hollywood. Second, pushing the envelope in ways that would have been considered excessive even in the postwar period, the cinematography of the Auteur Renaissance foregrounded the presence of the filmmaker, experimenting with bold new techniques like the handheld camera and the split screen.

Naturalism, Nostalgia, and Hollywood's New Look

Writing for *American Cinematographer* in 1978, director of photography Bill Butler took pains to defend the sharp images and saturated colors of his new project, the musical *Grease* (Randal Kleiser, 1978): "It's dangerous to go for a crisp, old-fashioned look when photographing films today. . . . The 'Kodachrome' look, or the old 'Technicolor look' has been out of vogue for some time."[4] In today's high-definition era, it may seem incomprehensible that the creative decision to aim for sharpness of detail and deep saturation could ever be considered "dangerous." Yet Butler's comments accurately reflect the extent to which that style, associated with the films of the late studio era, had become increasingly unfashionable over the course of the 1960s and 1970s, replaced by a dominant aesthetic of lower resolution images—either grainier, more diffuse, or both. This soft new look was accompanied by desaturated colors, as well as softer, indirect, relatively dim lighting that communicated a sense that the film had been photographed in natural, "available" light.

The perfect exposure, sharp focus, and vibrant color of the classical style revived in *Grease* were rejected by many cinematographers of the period as a gaudy exaggeration of real world colors and perception. As cinematographer Conrad Hall explains in regard to his work on *Butch Cassidy and the Sundance Kid* (George Roy Hill, 1969) and *Tell Them Willie Boy Is Here* (Abraham Polonsky, 1969): "I didn't like pure green or those vivid kinds of colors. I didn't see light that way and there's always atmosphere between color and me in the form of haze, smog, fog, dust. There's a muting of color that goes on in life. . . . I felt film was too sharp; I didn't see life that sharp and I don't like it that sharp, actually. So I always destroy sharpness."[5] Similarly, French New Wave veteran Nestor Almendros appealed to realism to explain his rejection of hard shadows and halo-producing backlights. According to his gaffer on *Goin' South* (Jack Nicholson, 1978), Almendros argued that these techniques epitomized "old-fashioned sophisticated studio lighting, and not the way light appears in reality."[6] Though the most formulaic studio pictures retained the conventional sharpness throughout the decade, the new naturalism was linked to a significant trend in Hollywood narrative, favoring grittier realism over glossy escapism.

Some aspects of the new style were logical extensions of a more gradual movement toward stylistic realism in Hollywood that extends at least as far back as the late 1940s. As detailed in the previous chapter, semi-documentary thrillers like *The Naked City* (Jules Dassin, 1948, d.p. William H. Daniels) and exotic "runaway productions" like *Hatari!* (Howard Hawks, 1962, d.p. Russell Harlan) generated a realistic atmosphere through location shooting. Yet these films still retained aspects of the traditional studio look that later films would avoid, from the intricate, expressionistic lighting of the 1940s films to the lush Technicolor cinematography of the 1960s epics. The most immediate influence on the films of the Auteur Renaissance

was European art cinema, particularly Italian Neorealism, the French New Wave, and British Kitchen Sink Cinema. Films like *La Terra Trema* (Luchino Visconti, 1948, d.p. G. R. Aldo), *Breathless* (Jean-Luc Godard, 1960, d.p. Raoul Coutard), and *Look Back in Anger* (Tony Richardson, 1959, d.p. Oswald Morris) were characterized by their location shooting and use of available light, producing a deliberate visual contrast to the controlled studio environment and artificial lighting typical of the commercial film of the period. Not only did the style of these art films exude a sense of authenticity, but the location shoots were also thought to aid the actors in delivering more naturalistic performances. This aesthetic was reinforced by a new trend in documentary filmmaking that replaced the rigid structure and didacticism of traditional documentary with a more candid, observational approach, as in *Primary* (Robert Drew, 1960, d.p. Richard Leacock and Albert Maysles).

The documentary style reached popular fiction filmmaking with films like Richard Lester's *A Hard Day's Night* (1964, d.p. Gilbert Taylor), juxtaposing a kitchen-sink look with anarchic, madcap humor. In America, the independent films of John Cassavetes, such as *Shadows* (1959, d.p. Erich Kollmar) and *Faces* (1968, d.p. Al Ruban), applied the *vérité* aesthetic to intense, semi-improvised melodramas. While their grainy, high contrast 16mm stock succeeded in communicating a documentary-type authenticity, they did not meet Hollywood studio production standards. Technological innovation was necessary before the naturalistic look of the New Waves and direct cinema could be translated to mainstream fiction filmmaking.

The initial and most important technological development that facilitated the increase in interior location shooting in Hollywood was the release of the 35mm 5254 color film stock by Kodak in 1968. Though high-speed black-and-white stocks had been available for decades, this new color stock (twice as fast as the stock it replaced) represented a sea change in terms of a cinematographer's ability to shoot color 35mm film in low-light environments.[7] With 5254, shooting indoors with available light—such as tungsten light from lamps or daylight through windows—became a legitimate possibility. This potential was enhanced in the early to mid-1970s by the development of fast prime lenses—that is, lenses that allow the cinematographer to open the aperture wider than usual, allowing in more light. Previously, a lens that opened to a T-stop of 2.0 was considered fast. By contrast, the Canon K-35 lenses and the Panavision and Zeiss "Super Speed"/"Ultra Speed" lenses featured T-stops that could open to T/1.5 or T/1.3, the smaller number indicating a larger opening in proportion to the focal length of the lens. In 1973 Stanley Kubrick notoriously used a modified ultra-fast T/0.7 Zeiss still-camera lens, originally made for NASA, to shoot *Barry Lyndon* (1975, d.p. John Alcott), including interiors that were lit entirely by candlelight with a reflector on the ceiling.[8]

Although the faster stock and lenses enabled cinematographers to shoot in low-light environments, most "available light" interior scenes were achieved by

mixing natural and artificial light. As Owen Roizman remarks about a scene in *The Exorcist* (William Friedkin, 1973) set in the Georgetown University chapel: "It required extensive lighting to give it an 'available light' look."[9] Ironically, the painstaking construction of the *appearance* of available light could actually result in a more realistic look than the comparatively simpler use of natural light alone. Roizman notes that natural light shifts in color and intensity throughout the day, which can lead to continuity errors if the cinematographer does not continuously correct for the discrepancy.[10] For some cinematographers, the obsession with using natural light was an empty exercise in virtuosity, since the end visual result was arguably equivalent. For Gordon Willis, "It is make believe. It is a business about re-creating reality. . . . You get reality the other way, which is to reconstruct it."[11] Even Kubrick relied on a mixture of natural and artificial lights in most scenes in *Barry Lyndon*.[12]

A number of new lamps were developed during the period to assist cinematographers in achieving the available light look. Due to the popularity of location shooting, it was crucial that these new lamps be lightweight and require as little power as possible. While shooting *The Molly Maguires* (Martin Ritt, 1970) in 1969, legendary classical Hollywood cinematographer James Wong Howe sought a portable alternative to the "Brute" carbon arc lights that had been standard on Hollywood sets for decades. He opted instead for "Mini-Brutes," a cluster of quartz-iodine (halogen) lights that were smaller and less intense but sufficient for the film's needs.[13] For exterior lighting, the Xenon arc "Sunbrute" light, introduced in 1970, replicated the color temperature of sunlight and provided nearly the equivalent foot-candles of a Brute.[14] But the HMI metal halide lights, introduced in 1974, proved the most popular daylight-balanced light.[15] While the HMI lights were prone to flicker due to voltage frequency fluctuation, they were small and powerful enough to make up for any deficiencies.[16] Additionally, as the 1970s progressed, cinematographers grew more comfortable with filming fluorescent lights, whose green pallor contrasted sharply with the warm orange hue of tungsten bulbs. They opted either for "White Warm Deluxe" fluorescents whose color temperatures approximated tungsten,[17] or, as in *Taxi Driver* (Martin Scorsese, 1976, d.p. Michael Chapman), they simply let the mismatched colors stand as a nod toward realism (see color plate 7).[18]

When new lighting equipment, faster stocks, and faster lenses failed to achieve the desired exposure in certain low-light settings, cinematographers resorted to processing techniques. "Pushing" or "forcing" the film stock was extremely common in Hollywood film of the seventies. The technique involved overdeveloping the film by leaving it in the processing chemical bath for longer than usual. This served to brighten the film, correcting for underexposure at the shooting stage. In other words, if a proper exposure could not be achieved on-set in a low-light location, the stock could be pushed one stop or further in the lab. When shooting *The Candidate* (Michael Ritchie, 1972), cinematographer Victor J. Kemper

was confronted by a number of low-light locations. In one instance of shooting in a motel room, the location was too small to accommodate artificial lights. In another scene, a political rally, lighting the large indoor arena would have been impractical. Kemper solved the problem by pushing the 5254 stock one stop, effectively making the stock twice as sensitive.[19] Pushing could be valuable in the studio as well—all the interior scenes of *The Exorcist* (1973) were pushed one stop, because the sets (such as the bedroom set where the exorcism occurs) were too small to accommodate an adequate amount of lighting equipment.[20]

Pushing not only brightened the exposure, it created a grainier, lower reso-lution image, with added contrast, slight desaturation, and loss of detail in the shadows and highlights. This was such an appealing look in the decade that many cinematographers deliberately underexposed and pushed one stop, even if there was sufficient location light for a proper exposure. The graininess distanced the film from the classical aesthetic, recalling the available-light 16mm aesthetic of the French New Wave and direct cinema. As Mario Tosi explains, "For interiors I always push one stop anyway, even if I have enough lights. . . . You have to work on [the negative] to tone down the perfect color, perfect saturation, perfect sharpness. We don't want it perfect; we want it moody."[21] Alternatively, cine-matographers would occasionally "pull" the film—that is, overexpose and then underdevelop it in the lab. Here, Conrad Hall's work on *Tell Them Willie Boy Is Here* and *Butch Cassidy and the Sundance Kid* is exemplary. Hall overexposed desert exteriors by two stops to create a washed-out look and avoided the use of fill lights.[22]

The popularity of pushing in the 1970s highlights an ironic disparity between technology and practice. As Kodak continued to develop film stock with greater saturation levels and finer grains (and thus a sharper image), many cinematog-raphers were taking great pains to degrade their image to reduce those qualities. When shooting *Close Encounters of the Third Kind* (Steven Spielberg, 1977) in 1976, Vilmos Zsigmond gleefully reported that the new 5247 could be "easily" pushed one stop, if not more—although he bemoaned the fact that the stock looked "too good. It renders everything too real."[23]

Zsigmond's comment suggests that, despite the prominence of the "vérité look" in Hollywood, cinematographers were often motivated by factors besides realism. Many films of the period exhibit a different impulse—the evocation of nostalgia, or a sense of times past. Rather than the immediacy of a documen-tary-style film like *The French Connection* (William Friedkin, 1971, d.p. Owen Roizman), these films ask the viewer to engage with the narrative in a more retrospective, stylized manner. Perhaps the most famous example is Gordon Willis's work on *The Godfather* (Francis Ford Coppola, 1972). Nicknamed "the Prince of Darkness," Willis used low-key, overhead lighting for many of the film's interiors and underexposed the entire film by 1.5 stops. He then instructed the lab to push the film one stop, which leaves the final images underexposed by a

half stop. The final look is striking: grainy and full of pervasive, deep shadows, including pooled shadows obscuring Marlon Brando's eyes. Willis wanted the film to "be hanging on the edge from the standpoint of what you see and what you don't see."[24] For him, the dim lighting and underexposure represented the "evil" of the Corleones' crime business (especially in the film's opening scenes, when Don Corleone's dark office is contrasted with the bright exteriors of his daughter's wedding reception [color plate 8]).[25] But Willis also "wanted a retrospective, 1940s kind of feel" to the film, which takes place from 1945 to 1955.[26] This approach was enhanced by the use of color filters, such as a chocolate filter for scenes shot in Sicily, or a yellow filter used for the flashback sequences in *The Godfather Part II* (Coppola, 1974).[27] The films' cinematography elicits a sense of moody stylization more than documentary realism. "I wanted to achieve a sense of photogravure," Willis says.[28]

The nostalgic look of Robert Altman's *McCabe and Mrs. Miller* (1971, d.p. Zsigmond), a western set in the Pacific Northwest at the turn of the century, is similarly motivated. To achieve the director's desire for a film resembling "antique photographs and faded-out pictures," Zsigmond offered to "flash" or "fog" the negative.[29] The technique, which had been used previously by cinematographer Freddie Young in *The Deadly Affair* (Sidney Lumet, 1966), entails exposing the film to a small amount of light before processing, either before or after shooting. Flashing reduces contrast and desaturates the image, creating milky blacks and soft, muted colors. As Zsigmond notes, "It's really like adding fill light," in that it brightens the shadows, revealing more detail, without having to use artificial fill lights or bounce cards.[30] Zsigmond post-flashed *McCabe*, controlling the level of flashing according to the narrative demands of each scene. The combination of flashing and pushing would create a very grainy, murky image, which was precisely what Zsigmond and Altman desired. As the effect of flashing is so pronounced, the technique never became as prevalent in the 1970s as the subtler alternative, pushing. However, Zsigmond continued to employ flashing on several of his subsequent films. Certain period films also used the technique: for instance, Haskell Wexler flashed the Woody Guthrie biopic *Bound for Glory* (Hal Ashby, 1976) to achieve a washed-out look that matched the Dust Bowl setting.

The unique visual style of *McCabe and Mrs. Miller* was also partly the result of diffusion, another common technique in this period. Heavy diffusion is especially prevalent in films that occur in the past; it serves as the literal visualization of the cliché "haze of memory." The effect is achieved most often through the use of lens filtration such as fog filters. Originally created to simulate the effect of fog, these filters reduce contrast and sharpness, while tending to flare light sources. On *McCabe*, Zsigmond used a heavy #3 fog filter to create a blurred, "flarey" quality, as in color plate 9.[31]

A number of other more traditional diffusion techniques were used to achieve a look synonymous with nostalgia or the representation of the past. Conrad Hall

shot *The Day of the Locust* (John Schlesinger, 1975) with nets, silks, and gauzes on the lens in order to create an ironic, glamorous look for his tale of Hollywood lowlifes and losers in the late 1930s.[32] Films like *Fiddler on the Roof* (Norman Jewison, 1971, d.p. Oswald Morris) and *Bound for Glory* achieved an "old" look by shooting through brown hosiery.[33] As *Fiddler* director Norman Jewison explains, "Modern life is perceived sharply, but the moment you move into a period it becomes, somehow, faded and a bit hazy. Your references to it are through old photographs and books and things."[34] When shooting another revisionist western, *Heaven's Gate* (Michael Cimino, 1980), Zsigmond used on-set smoke as well as flashing to achieve a period ochre look. Here, verisimilitude was used to justify the effect: "In the old photographs of those days the interiors were always hazy and smoky, because those old wood stoves gave off a lot of smoke."[35] Yet Zsigmond and director Michael Cimino were still looking to achieve a "romantic, nostalgic mood" via a desaturated, sepia-toned image, as both the negative and the release prints of *Heaven's Gate* were flashed.[36]

Perhaps the most ardent proponent of diffusion during the decade was William Fraker, an unapologetic escapist. In 1978 he commented: "I face realism every day, and I'm tired of it. I want to escape, I want adventure. . . . I don't want sharpness. I hate the reality of reality. I put everything I can in front of the lens to soften those lines."[37] The suspense film *A Reflection of Fear* (1973), directed by Fraker and shot by Kovács, relies on heavy diffusion to create a moody atmosphere of sinister fantasy. The film explores a series of murders in an old mansion where an emotionally disturbed girl (Sondra Locke) remains sheltered from the outside world. Here, the soft images and flared lights of the mansion represent the girl's delusional psychological state—even the low-key, nightmarish bedroom scenes where the girl is tormented by hallucinations are highly diffuse (see figure 4.1). While the offbeat *Reflection of Fear* was a box office flop, Fraker's soft

FIGURE 4.1: William Fraker's trademark heavy diffusion in *A Reflection of Fear* (1973).

style would be much more successful with films like the fantasy-comedy *Heaven Can Wait* (Warren Beatty and Buck Henry, 1978), for which the cinematographer received an Oscar nomination.

By the mid-1970s, diffuse and grainy images were beginning to fall out of fashion. Owen Roizman, heretofore known for pushing all of his films, began to avoid the practice beginning with 1975's *Three Days of the Condor* at the request of director Sydney Pollack, who found pushed film to be too "dingy."[38] When filming *Chinatown* (1974), Roman Polanski insisted on shooting the film (set in the 1930s) without diffusion of any kind, even when shooting close-ups of Faye Dunaway, a decision that strips the period film of any sense of warm nostalgia.[39] Even a film like *Barry Lyndon*, which has a soft look, avoided diffusion filters in favor of using soft lights and low-contrast filters, which have a subtler softening effect. In the words of John Alcott: "An awful lot of diffusion was being used in cinematography at the time. So we tended not to diffuse."[40] Aside from being overused, diffusion was seen by some as inelegant or amateurish. In 1972, Robert Surtees, who had just shot the quintessential diffuse nostalgia piece *Summer of '42* (Robert Mulligan, 1971), declared that he would avoid fog filters in the future: "Some people use them as a crutch. After all, it's harder to light a set right than to put on a fog filter to gloss over lousy lighting."[41]

Two influential cinematographers who rejected the diffuse look were László Kovács and Nestor Almendros. While Kovács had used diffusion on *Reflection of Fear* and other films, by the late 1970s he was speaking out against diffusion. Discussing *The Runner Stumbles* (Stanley Kramer, 1979), set in the early twentieth century, Kovács remarked, "I gave a lot of thought to selecting a proper 'period' visual style, without falling back on something as obvious as diffusion. . . . I like the crisp, sharp image in focus on the screen. If you want a feeling of softness, it should be created with the lighting, instead of escaping into a piece of glass."[42] Almendros was perhaps the cinematographer best known for his emphasis on a "natural" style. In an interview with the *Los Angeles Times* about his work on Terrence Malick's *Days of Heaven* (1978), Almendros argued that film art had reached a "dead end" with artificial light, and expressed a desire to get back to the early days of silent film, when "the studios had no ceilings."[43] To that end, several scenes in *Days of Heaven* were shot with available light only, as in color plate 10, and often with no diffusion or filters of any kind.[44]

Also crucial to the decline in the "degraded" look were certain changes in film content, particularly the emergence of the special effects–driven blockbuster. As a global visual strategy, pushing was not viable for films that featured special effects, as scenes with composite shots would out of necessity be second- or third-generation, and could not handle additional image degradation from pushing.[45] Diffusion was avoided, as shots that incorporated miniatures or matte paintings needed to be as crisp as possible to be convincing.[46] To maximize definition, many effects were shot on 65mm stock.

As previous chapters in this volume have discussed, stylistic realism has been defined in a variety of ways throughout the history of Hollywood. For instance, Dombrowksi argues that in the postwar period it was associated with deep focus, location shooting, and a partial rejection of glamour. The 1968–1980 period remains anomalous in Hollywood history in terms of defining realism through the soft image, a look that was previously associated with glamour and aesthetics, as Keating indicates in his chapter. Perhaps because it was so distinctive, the grainy, desaturated, natural-light look remains associated with 1970s filmmaking. In 2010, when cinematographer Harris Savides described the "70s look" of some of his films, including *Margot at the Wedding* (2007) and *Milk* (2008), he referred to "a lack of resolution." He continues: "They're not as defined as this, let's just call it the HD look that we experience now. And in some indirect way, it evokes a feeling."[47]

Vérité and Fiction

The influence of documentary style on the period is evident not only in the grainy, available-light look of many films, but also their use of handheld cinematography, zoom lenses, and shallow focus, which help to construct an aesthetic of spontaneity. Originating out of necessity in World War II combat photography, vérité camera style was refined by direct cinema practitioners before entering Hollywood via European art films of the 1960s. Particularly influential was Claude Lelouch's low-budget, documentary-style *A Man and a Woman* (1966, d.p. Claude Lelouch), which won two Academy Awards and was a box office hit in America. Two years later, Haskell Wexler directed and shot *Medium Cool* (1969), perhaps the most fully realized example of the vérité aesthetic to be released by a major Hollywood studio. The film relates the story of a TV cameraman who achieves political awareness and falls in love with an impoverished single mother while researching black militant movements. Its climax famously blurs the boundaries between fiction and documentary filmmaking when the camera follows actress Verna Bloom as she makes her way through a group of real protesters during the unrest surrounding the Democratic National Convention in Chicago. Wexler, who began his career in documentary film, shot *Medium Cool* with Eclair CM3 35mm cameras, which featured rear-loading magazines allowing for easy handheld use.[48] Several scenes are shot handheld, including love scenes, party scenes, roller derby footage, and the Chicago protest itself (figure 4.2).

As Paul Ramaeker has argued, later Hollywood films would use the handheld technique more selectively, as one choice in an array of stylistic options.[49] In action sequences or crowd scenes, the handheld camera is used as a kind of shorthand for immediacy and excitement, after which the film typically resumes a more conventional style. In *Vanishing Point* (Richard Sarafian, 1971, d.p. John A. Alonzo),

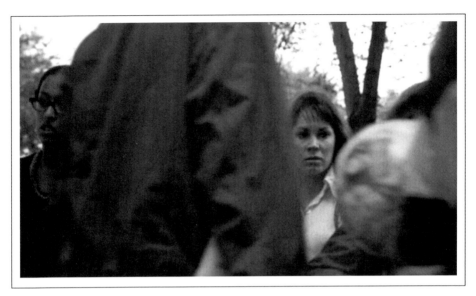

FIGURE 4.2: *Medium Cool* (1969) blurs the boundaries between fiction and documentary filmmaking.

handheld camerawork captures the frantic savagery of an assault on a radio station engineer by a group of racists, with POV shots representing the engineer's perspective as the thugs' fists rain down. The film's car chase sequences also incorporate handheld work, shot from a crew car driving alongside. However, conversation scenes outside the car (such as in the DJ booth or police station) are shot conventionally with a camera mounted on a dolly. Likewise, the crowd scenes in *Dog Day Afternoon* (Sidney Lumet, 1975, d.p. Victor J. Kemper) are shot handheld, while the more subdued, intimate scenes within the bank are not. This more judicious use of handheld cinematography allows filmmakers to exploit its advantages in particular contexts without committing the film to an aesthetic that might be considered distracting or excessive to audiences.

Another aspect of the vérité aesthetic is the zoom lens, often used in concert with handheld camerawork. Zooming lent a strong feeling of spontaneity, as though the events were being covered by documentary cameras. On a more practical note, the zoom acted as a fast, cheap substitute for dolly shots. Typical dolly shots, such as a slow dolly-in for emphasis, could now be executed with a simple turn of the zoom dial. The change in shot scale could become hyperbolic with the use of a zoom lens. Very quick "crash zooms" accent or heighten moments of high drama, as in *Images* (Altman, 1972, d.p. Zsigmond) when the protagonist is startled to see her mysterious doppelgänger on the side of the road. Zooms also allowed changes in shot scale that would be difficult or impossible with dollies. In *Butch Cassidy and the Sundance Kid*, the titular outlaws are fleeing through rocky terrain; as Sundance shouts "Damn it!" a quick zoom-out reveals that they have reached the end of a steep cliff. Executing the same shot with a dolly would

have been impossible—even if tracks could have been constructed that led away from the cliff, they would have been visible in the shot as it dollied out.

A number of directors used the zoom to explore new aesthetic horizons. Stanley Kubrick used the zoom frequently, most notably in *Barry Lyndon*, which is constructed around a series of shots (twenty-five in all) in which the camera slowly zooms out from a close-up to a wider, composed tableau.[50] Vincent LoBrutto sees the technique as a modernist metaphor for the close analysis of eighteenth-century paintings, upon which Kubrick based some of his compositions.[51] Robert Altman also became known for his innovative use of the "pan and zoom" aesthetic, well suited to a mode of production based to an exceptional degree on improvisation by the actors and camera operators.[52] By positioning multiple cameras at a distance, actors were never certain what was being filmed, or which focal length the camera operator was using. Altman found that once the actors became accustomed to this unusual arrangement, they grew less self-conscious as they performed.[53] For David Cook, Altman's use of the zoom renders the camera a technological avatar for the viewer's own perception; it "approximat[es] the mental processes of the viewer as he or she focused, panned, and refocused on significant details within a seemingly arbitrary visual field."[54] That said, Altman also uses the zoom expressively in ways that depart from the "pan and zoom" style, as with the slow zoom to an extreme close-up of Julie Christie's eye that concludes *McCabe and Mrs. Miller*.

Despite the practicality and aesthetic possibilities of the zoom lens, it was integrated into mainstream Hollywood style with no small degree of ambivalence. In the previous chapter, Dombrowski discussed how in the 1950s zooms were considered too noticeable by cinematographers who were still committed to the ideal of the "invisible" style. By the 1970s conspicuous stylization had become more fashionable, yet other drawbacks remained. For one, zoom lenses were slower and led to a slightly softer image than prime lenses (although the latter characteristic was considered a benefit by the many cinematographers who avoided sharp images).[55] More broadly, the efficiency that made the zoom such a useful tool was also its undoing in the eyes of many, who associated it with laziness or artistic indifference. Because a zoom simply enlarges the image while a dolly movement alters the camera's angle to the action, the zoom was considered a compromised or inelegant substitute. For longtime studio cinematographer Leon Shamroy, the zoom "will not take the place of a dolly, because the effects on perspective are quite different."[56] The zoom's ubiquity in television, seen as an inferior medium, was another issue. According to cinematographer Isidore Mankofsky, who worked in both media, "The tendency is for [the zoom] to be overused as a time compensator, especially under the tight time schedules that are the norm in filming for TV. But when one switches over to theatrical features where there is more time, there is no reason to depend heavily on the zoom."[57]

A final key characteristic of the vérité style is shallow focus, in which a long prime lens or an extended zoom lens creates a narrow depth of field, throwing one plane (typically the background) out of focus and directing the viewer's attention to the subject in sharp focus. Even films of the period that eschewed semi-documentary camerawork tended to use shallow focus, due to the popularity of the available light look. Extreme depth is impossible to achieve in low light settings, such as tight location interiors with little room for studio lamps. Cinematographers at the time were typically shooting "wide open," using the widest possible aperture setting to capture the available light; deep focus would have necessitated closing down the aperture significantly, leading to an illegible underexposed image. Beyond the technical limitations that necessitated the shallow-focus look, some cinematographers simply preferred it from a storytelling standpoint; Owen Roizman argues that deep focus distracts the audience from the actors in the foreground.[58]

David Bordwell has identified several stylistic strategies associated with long lenses and shallow focus. In addition to the "searching and revealing" approach used by Altman, filmmakers can create compositions around out-of-focus objects in the foreground, drawing our attention to the blurriness itself.[59] Zoom or telephoto lenses also can shoot directly through windows, using the glass to create a distorted, diffuse image, as in the western *Monte Walsh* (1970, d.p. David Walsh), directed by longtime cinematographer William Fraker.

It is not surprising that during this period of auteur experimentation that some filmmakers rejected the shallow look associated with low light and long lenses. Director Peter Bogdanovich in particular strove for extreme depth of field in a number of his films from the 1970s. An enthusiast of classical Hollywood, Bogdanovich conceived of the deep-focus cinematography of *The Last Picture Show* (1971) as homage to Gregg Toland's pioneering work on *Citizen Kane* (Orson Welles, 1941). According to cinematographer Robert Surtees, who got his start in Hollywood in the 1940s, the cameras were often stopped down to T/10 in order to achieve the desired depth.[60] Bogdanovich also banned zoom lenses from the set; even subtle reframings, easily achievable with a zoom, necessitated the laying of track for the dolly, which delayed the shoot by several days.[61] Bogdanovich's experiments in Wellesian deep focus continued in *Paper Moon* (1973, d.p. László Kovács) and *Daisy Miller* (1974, d.p. Alberto Spagnoli).

While Bogdanovich used traditional means to achieve deep focus, other directors relied on the split-field diopter, a kind of "bifocals" that allows one to keep portions of both the foreground and background in focus simultaneously by using "a partial lens placed in front of the ordinary lens."[62] On one side of the split, the foreground would be sharp and the background out of focus; the opposite would be true of the other side. Multiple split lenses could be used for especially complex compositions. The split-field diopter enabled filmmakers to create deep-focus compositions when using anamorphic lenses, which normally reduce depth of

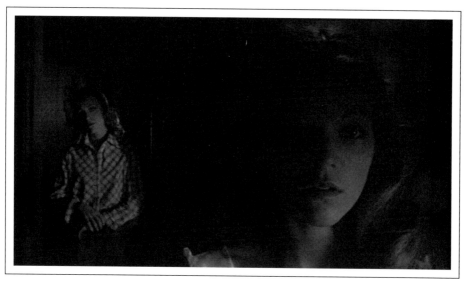

FIGURE 4.3: Self-conscious use of the split-field diopter in *The Fury* (1978).

field, or when shooting in low-light conditions, which require open apertures. In his comprehensive study of the split-field diopter, Paul Ramaeker notes numerous limitations of the device. The split between the two lenses is heavily blurred, requiring cinematographers to compose in such a way that the blur is disguised (by placing the split over a background shadow, for instance). Also, the compositing of two opposing lenses creates inconsistent depth cues within the image as a whole, thus demanding additional depth cues to reduce the disparity. While these efforts to conceal the diopter exemplify an impulse toward unobtrusiveness, Ramaeker argues that certain practitioners of the split-field diopter, particularly Brian De Palma, use the device in a highly self-conscious, hyperbolic manner in films like *The Fury* (1978, d.p. Richard Kline), as shown in figure 4.3.[63] In these instances, the split-field diopter is not a tool meant to reproduce classical depth compositions unobtrusively, but rather a flamboyant narrational technique. In its use of "fragmentary, multivalent images," Ramaeker compares it to the boldest compositional device of the late 1960s and 1970s, split-screen cinematography.[64]

Split-Screen Cinematography

In split-screen cinematography, two or more moving images are filmed and then combined in post-production, usually via optical printer, onto single frames for projection. Originating in the early silent period and continuing through the studio era, mainstream films employed the technique in a limited fashion, to depict both sides of a telephone conversation, or as a special effect that allowed one actor to play two roles within the same shot. Before the late 1960s, any more aggressive

use of split-screen was confined to avant-garde film practice, from the French Impressionists of the 1920s to the "expanded cinema" of the 1960s. However, beginning in 1966 several mainstream directors began to make split-screen an integral component of their films.

Hollywood's foray into split-screen can be traced to a few high-profile exhibitions at world's fairs in the mid-1960s. For the 1964 World's Fair in New York City, former avant-garde filmmaker Alexander Hammid teamed with Francis Thompson to produce *To Be Alive!*, a documentary celebrating multiculturalism that was projected across three screens at the fair's Johnson Wax Pavilion. At the same fair's IBM Pavilion, a Charles and Ray Eames–designed installation included a multi-screen film entitled *Think*, which explored the parallels between the computer and the human brain. Malte Hagener argues that the "environments and installations were designed to overwhelm and envelop the spectator in order to win them for some (political, ideological, or economic) goal."[65] An emphasis on visuality is appropriate to the particularities of the kinds of films that were featured at world's fairs, often corporation-sponsored documentaries that emphasized broad concepts and spectacle rather than traditional narrative.

After attending the 1964 fair, director John Frankenheimer was inspired to incorporate split-screen into his 1966 Formula One film *Grand Prix*.[66] When combined with 70mm projection, the use of split-screen lent the film's racing sequences a powerful, visceral intensity. Less than a year after the release of *Grand Prix*, a number of Hollywood practitioners such as directors Richard Fleischer and Norman Jewison attended the Expo 67 in Montreal, which boasted as many as ten multi-screen presentations.[67] The most directly influential of the films was Christopher Chapman's ode to Ontario, *A Place to Stand* (1967). Rather than utilizing multiple projectors and screens as in previous efforts, Chapman's "multi-dynamic image technique" required a single 70mm projector. The split-screen effect, involving as many as eleven simultaneous images, was achieved by using an optical printer; the 18-minute film required four months of lab work.[68] Chapman's one-projector method appealed to Hollywood, which had rejected multiple projection systems after the commercial failure of Cinerama in the early 1960s. Fleischer and Jewison were working on separate projects that lent themselves to the kind of simultaneous narration that split-screen allowed. Jewison's *The Thomas Crown Affair* (1968, d.p. Haskell Wexler) uses the technique to follow multiple characters during a bank heist, a genre effect later cited by Steven Soderbergh in the elaborate casino robbery in *Ocean's Eleven* (2001, d.p. Steven Soderbergh). Fleischer's *The Boston Strangler* could generate intensified suspense by simultaneously tracking the location of both the Strangler and his latest unwitting victim. Both films were at the vanguard of what *New York Times* film critic Vincent Canby termed the "neo-Expo 67" aesthetic.[69]

The most common use of split-screen during the 1970s is a simple dual-image split in which two Academy-ratio images are optically reduced to fit into the

elongated widescreen frame. This is the composition preferred by director Brian De Palma, the most ardent practitioner of split-screen in Hollywood. De Palma began using split-screen with *Dionysus in '69* (1970, d.p. Brian De Palma), a filmed document of a 1968 presentation by The Performance Group, a New York experimental theatrical troupe. De Palma shot the performance with two 16mm handheld cameras and printed the footage side by side for projection. He would continue using the dual-image split-screen in selected scenes from subsequent fiction films, including *Sisters* (1973, d.p. Gregory Sandor), *Carrie* (1976, d.p. Mario Tosi), and *Dressed to Kill* (1980, d.p. Ralf D. Bode).

Other films employ a multi-image split-screen, a more complex style allowing for interplay among the different sub-frames. For instance, *Charly* (Ralph Nelson, 1968, d.p. Arthur Ornitz) features a split-screen sequence in which the eponymous character dances at a psychedelic rave-up. The number of sub-frames and their arrangement change throughout the sequence, but each sub-frame contains footage from a different camera angle, depicting a different aspect of the party, such as a dancing girl or guitarist. Alternatively, a particular image may be repeated across the sub-frames. *The Thomas Crown Affair* contains an extended polo sequence featuring split-screen effects by graphic designer Pablo Ferro. As the sequence begins, the frame is packed with fifty-four sub-frames, each of them containing the identical footage of millionaire Thomas Crown (Steve McQueen) swinging his mallet (see figure 4.4). The shot quickly transitions to another variation of the multi-image split-screen—the mosaic effect—as the sub-frames combine to make a single image (in this case, Crown's galloping horse). The polo sequence of *The Thomas Crown Affair* exploits the potential of the multi-image split-screen to achieve incomparably dynamic compositions. Not only can each sub-frame contain a different image, but the filmmaker can edit rapidly within each sub-frame, or coordinate camera movements (including zooms) and screen

FIGURE 4.4: An elaborate split-screen effect in *The Thomas Crown Affair* (1968).

direction among the different sub-frames. The sub-frames themselves can also be animated to move within the larger frame.

The multi-image split-screen cinematography of the polo match in *The Thomas Crown Affair* is not constructed with spatial and temporal coherence in mind. Like *Grand Prix*, it is meant to convey a sense of physical intensity and breakneck excitement. This does not mean that narrative is utterly evacuated from the scene; it provides an example of Thomas Crown's athletic prowess and offers another glimpse of his privileged, thrill-seeking existence. But, in the words of the police detective in the film, "All right, so he plays polo. Now what?" Shifting from composition to narration, we can categorize the storytelling uses of split-screen according to the spatial and temporal relationships among the different sub-frames. The relationships can be some combination of synchronic (occurring at the same time), diachronic (occurring at different times), syntopic (occurring in the same place), and diatopic (occurring in different places). The 1973 slasher film *Wicked, Wicked* (Richard L. Bare, 1973, d.p. Frederick Gately), which consists almost entirely of split-screen footage, exemplifies three of the four permutations. In one scene, the right frame shows a woman checking into her hotel room, while the left frame shows the killer preparing his knives in another part of the hotel. Here, the split-screen is synchronic and diatopic. Another scene, synchronic and syntopic, acts as a simultaneous shot/reverse shot composition by showing both sides of a conversation. Finally, some particularly interesting scenes feature flashbacks from a character's past in one frame, with the character recalling the memory in the other frame. In *Wicked, Wicked*, these scenes are diachronic and diatopic, as the character is remembering his childhood in another place. But we could imagine a diachronic and syntopic scene in which a flashback from the same location is placed in one of the frames.

In spite of these creative opportunities, the technique's drawbacks were many. Split-screen required the shooting of additional footage, some of which the audience inevitably would not be viewing at any given moment. As an alternative to conventional continuity editing, the benefits were unclear. Is a split-screen shot of both sides of a conversation really preferable to an edited shot/reverse-shot structure, where the editor can direct the audience's attention and help determine the rhythms of the scene? Split-screen effects were also difficult or impossible to reproduce for 4:3 television screens, a crucial ancillary market. Perhaps because of these concerns, the trend had run its course by approximately 1973.

Still, split-screen cinematography has seen something of a resurgence since the late 1990s, as mainstream film style has grown even more stylized and digital technology has allowed for split-screen to be achieved much more easily. Notably, the technique is often used in films that recall the 1970s, such as *Boogie Nights* (Paul Thomas Anderson, 1997, d.p. Robert Elswit) and *Jackie Brown* (Quentin Tarantino, 1997, d.p. Guillermo Navarro), a testament to how split-screen has become linked with a particular moment in American film history.

The Auteur Renaissance and the Ideals of Classicism

The "vérité look" and split-screen technique exemplify a widespread trend toward greater self-consciousness in film style during this period. By the late 1960s, the new generation of Hollywood filmmakers and cinematographers, weaned on European art cinema, were interested in foregrounding their authorial presence in their films. Their bold rhetoric often emphasized the generation gap: "Everyone in Hollywood is 50 and creaking," complained twenty-five-year-old George Lucas in 1970. "The only thing they've got that we need is money."[70] The Movie Brats' defiant attitude toward the Hollywood establishment and their embrace of art cinema auteurism was a reflection of the sixties counterculture's revolutionary spirit and general suspicion of authority. But it was also a canny effort at industrial branding. Unlike the studio system, when directors were contracted personnel assigned to projects, each Hollywood Renaissance filmmaker had to differentiate himself in a crowded marketplace where the "package deal" reigned. A distinctive personal style (and, in many cases, an outsized personality) was the most effective way for one to carve a niche in the industry.

The same logic applied to cinematographers. As Vilmos Zsigmond argues, "I'm not going to get another picture if I shoot like other cameramen."[71] By assaulting the dominant stylistic paradigm, cinematographers could establish themselves as auteurs. A few top cameramen, such as Haskell Wexler, William Fraker, and Gordon Willis, were able to direct their own films. And for the first time in Hollywood history, directors of photography received significant attention in the mainstream press—for instance, profiles in *Newsweek* and the *Los Angeles Times*.[72]

The bold stylization of the Auteur Renaissance represented a threat to the transparent classical Hollywood style. As Richard Maltby notes, in typical classical Hollywood films, "spatial and temporal conventions work to efface themselves through their very familiarity, producing an apparently unimpeded access to the events of the plot and their meaning in the story."[73] By contrast, the unfamiliar conventions of the Auteur Renaissance do not efface themselves, instead standing out as directorial touches. As Robin Wood argued in 1975, "The [recent] stylistic changes in the American cinema imply a tacit recognition that the 'objective reality' of the technically invisible Hollywood cinema was always a pretense. . . . It was still possible to watch *Rio Bravo* [Howard Hawks, 1959, d.p. Russell Harlan] as if one were looking through a window at the world, [whereas] *The Long Goodbye* is 'a film by Robert Altman'—we cannot escape the director's omnipresent consciousness."[74] In the latter film, Vilmos Zsigmond's roving camera is constantly in motion whether or not the movement is motivated by the narrative. Zsigmond even admitted that "most cameramen will find it obtrusive and pretentious."[75] By untethering the camera movement from the demands of the script, Zsigmond foregrounds the camera's presence, and therefore the hand of the filmmaker.

FIGURE 4.5: Baroque, decentered composition in Gordon Willis's *Windows* (1980).

Camerawork of this period also frequently calls attention to the filmmaker's presence through the careful withholding and eventual revelation of crucial narrative information. Gordon Willis's work in the 1970s thrillers of Alan J. Pakula (*Klute* [1971], *The Parallax View* [1974], and *All the President's Men* [1976]) demonstrates the use of almost abstract compositions in which important characters are deemphasized. Willis's directorial debut, the voyeuristic thriller *Windows* (1980, d.p. Gordon Willis) is, to put it mildly, much less prestigious than Pakula's films, but its outstanding camerawork similarly challenges classical conventions. The film opens with a striking depth composition in a tunnel in which a conversation can be heard, but not seen. Gradually, the two characters emerge from the background in silhouette. The couple's discussion, concerning their divorce, is fairly dramatic, yet the audience has no access to their facial features. Rather than provide fundamental narrative information, the composition foregrounds the play of colorful neon lights. A few minutes later, the woman in the first scene is violently assaulted. When the police come to visit her, the camera again denies us access to her face, even though the police are speaking with her. The composition is baroque, positioning the two police officers at extreme ends of the widescreen frame and leaving nothing in the center but the woman's cat (see figure 4.5). The officers are in long shot, with one represented only by a shadow against the wall. The dramatic focus of the scene—the assault victim—is not seen at all. Preventing the viewer from seeing the victim's face may build tension, but it also foregrounds the camera's role in the act of narration.

The cinematography of the Auteur Renaissance also challenged classical norms through camera movements displaying a virtuosity that threatens to outweigh their narrative utility. New camera mounts like the Steadicam facilitated

experimentation with ostentatious movements. Introduced in 1976, the Steadicam allowed the operator to mount the camera onto a gyroscopically balanced body brace, absorbing the impact of the operator's movements and allowing the camera to record a steady motion without the jitter associated with typical handheld work. The operator checks the composition through a video viewfinder on the mount. A cinematographer could use the Steadicam to enhance his reputation as an auteur, as when Haskell Wexler employed the device to follow Woody Guthrie (David Carradine) through a migrant camp in the Steadicam's feature film debut in *Bound for Glory*.[76] The Louma Crane, introduced later in the decade, was similarly used to capture virtuoso shots. Unlike a traditional crane, the Louma is operated from a console that is separate from the boom upon which the camera is mounted.[77] This way, the crane can perform movements and reach angles that would be impossible to achieve if the operator were riding it. Shooting *1941* (1979), Steven Spielberg praised the Louma's ability to create complex, flashy movements: "I don't know of another camera that can shoot straight down and then make an arm drop to within inches of the ground and then suddenly tilt and be looking straight up again."[78] Mounts like the Steadicam and Louma Crane do more than expand a filmmaker's range of possibilities; they encourage a style that calls attention to itself through its dynamism and complexity.

Despite the increasing self-consciousness of film style in the period, by the mid-1980s critics and scholars were beginning to question the extent to which the classical model had truly been challenged. In 1985 Robert Ray wrote, "For a brief period, perhaps lasting only a few months, the New Wave style seemed to have radicalized the American Cinema and effected at last a genuine 'break' in Hollywood's paradigms. Close inspection, however, would have revealed that Hollywood's procedures remained intact. . . . The increasingly rapid dissemination of every cinematic innovation quickly co-opted the power of all but the most radical departures."[79] Indeed, the extent to which the overt stylistic techniques of the Auteur Renaissance were gradually tempered and assimilated into the mainstream suggests that the tenets of classicism were still strongly valued, even in a historical period of rupture. Dozens of contemporary interviews in *American Cinematographer*, a journal that represents the industry establishment, firmly support classical norms like self-effacement and the primacy of narrative. Owen Roizman's comments on the filming of *Network* (Sidney Lumet, 1976) are representative: "I don't think the camera should ever move unless something makes it move, an actor or a situation. . . . I don't think there was anything that would catch your attention so you would say 'Wow! What a great camera move that was!'"[80] Likewise, in 1974 John Alonzo argued, "The cinematography should never, never, in lighting or in composition or moves, distract."[81]

Some of these sentiments may be disingenuous, purely rhetorical, or simply hypocritical, as when Ralph Nelson, director of the split-screen film *Charly*, argues vehemently against overt stylization.[82] But the explanations of other filmmakers

demonstrate the elasticity of the classical model. Philip Lathrop rationalizes the flashy camera movements in the dance sequences of *They Shoot Horses, Don't They?* (Sydney Pollack, 1969) (including the use of helmet-mounted cameras) by way of narrative subjectivity.[83] Similarly, Alan J. Pakula argues that the virtuoso crane shot in the Library of Congress in *All the President's Men* is not mere "showing off," as it holds sizeable thematic relevance; the slips of paper that open the shot will eventually impact the entire nation, represented by the immensity of the library, seen in a bird's-eye view at the end of the scene.[84] These are shots that would seem "excessive" within the context of studio-era filmmaking, yet they fulfill a narrative function even as they impress us with their visual dynamism.

The tension between innovation and tradition is evident in several articles that adopted a more skeptical perspective on new developments in film style. In the late 1960s and early 1970s *American Cinematographer* published articles that criticized vérité documentary style, particularly the use of handheld cameras,[85] and in 1974 cinematographer Karl Malkames wrote an editorial discouraging cameramen from using the zoom and other "unnecessary camera exercises and gimmicks."[86] While it might seem counterintuitive that the American Society of Cinematographers would condemn showy stylistic devices that drew attention and notoriety to the cameraman, the classical norms of subtlety and unobtrusiveness still carried significant weight.

In terms of the vérité look, the rack focus was an especially maligned technique. Used out of necessity in documentary film to shift the focal plane between the foreground and background, the rack focus was popularized in fiction filmmaking by director Richard Rush. Rush and his cinematographer László Kovács first experimented with what Rush calls "critical focus" on the counterculture exploitation films *The Savage Seven* and *Psych-Out* (both 1968).[87] But Rush's campus drama *Getting Straight* (1970, also shot by Kovács) contains the most sustained use of rack focusing. Unlike *Medium Cool*, which revels in the loose spontaneity of documentary, the incessant pans, zooms, and rack focuses of *Getting Straight* are carefully composed and choreographed, even if the film still strives for a documentary feel. Kovács's use of selective focus leaves the viewer no choice but to pay attention to the dramatically pertinent subject. But whereas split-screen offered viewers too much liberty to select which information to attend to, pervasive use of the rack focus was understood as too heavy-handed. In the *New York Times*, critic Vincent Canby panned the film's style for "imposing arbitrary choices on the audience."[88]

As the decade progressed, stylized devices like the rack focus and the handheld camera were used more selectively. A year after the release of *The Long Goodbye*, Vilmos Zsigmond shot Steven Spielberg's *The Sugarland Express* (1974) with Panavision's new Panaflex handheld synch-sound camera. Unlike other handheld films like *The French Connection*, the filmmakers sought to efface their presence while using the handheld camera to immerse the audience in the

narrative.[89] In Zsigmond's words, "We would like the audience to feel that they're with us every single minute—inside of the car, outside of the car, everyplace—and we would really like not to be noticed at all."[90] *American Cinematographer* editor Herb A. Lightman notes that the camera in *Sugarland* "never calls attention to itself. There are no tricks for the sake of tricks. Even the zooms are so skillfully orchestrated that they are covered by the action and remain totally unobtrusive."[91] *The Sugarland Express* exemplifies how the vérité style, initially used in a very self-conscious manner, began to exhibit the influence of classical norms like transparency.

The fact that Vilmos Zsigmond could strive toward effacement in *The Sugarland Express* while achieving brazen overtness in *The Long Goodbye* just a year earlier exemplifies perhaps the most crucial quality of the Auteur Renaissance cinematographer: versatility. While a unique, personal visual style was desirable for a director of photography in the post-studio era, being too closely associated with a particular look could limit one's job prospects. Instead, one needed the necessary skills to adapt to any project, and to meet the demands of any director. The notion that a cameraman's style is determined by the nature of the individual film is a recurrent one in contemporary interviews. For instance, when discussing the production of *1941*, director of photography William Fraker argued that "the look of a picture . . . is inherent in the material. I can't tell what the picture is going to look like until we start shooting. . . . We 'discover' the look of a picture."[92]

This sense of aesthetic flexibility is partly responsible for the tremendous variety of stylistic approaches seen in Hollywood filmmaking from the late 1960s through the 1970s. Some cinematographers rejected the glossy, heightened look of the classical style in favor of a grittier naturalism, rooted in documentary practice and characterized by a grainier, desaturated image. Others explored the more stylized, pictorial aspects of the diffuse look, which could recall days gone by or suggest the haze of memory or fantasy. These unique visual styles, as well as experiments with camera movement and composition, challenged Hollywood norms by injecting the self-consciousness of auteur-driven art cinema. And if the cinematographers and directors of the period did not manage to utterly reinvent the American film industry, by departing from the unified transparency of classicism they created new norms for style and narration in mainstream filmmaking. As the remaining chapters in this volume indicate, both the industrial importance of the auteur and Hollywood's acceptance of overt stylization have remained essential components of the contemporary mode of production.

5

THE NEW HOLLYWOOD, 1981-1999 Paul Ramaeker

If American film in the 1970s began with an influx of young, art cinema–influenced filmmakers hired to cater to countercultural tastes by breaking the rules of Hollywood storytelling and style, by the beginning of the 1980s Hollywood had once more embraced big budgets, the star system, classical-era genre conventions, and mass appeal for its highest-profile products. Conglomeration gave studios financial stability, while feeding a corporate emphasis on economic, and therefore aesthetic, conservatism, avoiding the willfully challenging approach of the preceding period. Horizontal integration drove production strategies intended to exploit the audience appeal of studio properties, while new sources of financing for features, including revenue streams like cable, home video, and merchandising, provided the influx of money needed to make and market films that were as or more expensive than ever. While sales to pay cable outlets were the first of these to have an impact on production, distribution, and marketing strategies, home video proved the most valuable in the long run. In 1990, historian Tino Balio argued that as the grosses for home video rose, the market "eased the burden of financing: a hit Hollywood film can earn at least $10 million from cassette sales worldwide, while an average entry might garner from $4 to $5 million."[1] Quoted in *Time* in June 1981, MGM's Reid Rosenfelt would prove remarkably prescient with regard to the industry's direction to the

present day: "We're no longer in the movie business, we're in the entertainment software business."[2]

Shifts in financing changed not only where Hollywood made its money, but also what kinds of product it made that money on. While blockbusters have never wholly dominated studio release schedules, the industry's emphasis shifted to spectacular genre narratives following the success of Steven Spielberg's *Jaws* (1975, d.p. Bill Butler) and George Lucas's *Star Wars* (1977, d.p. Gilbert Taylor)— and after the failures of auteur films like *New York, New York* (Martin Scorsese, 1977, d.p. László Kovács) and *Heaven's Gate* (Michael Cimino, 1980, d.p. Vilmos Zsigmond). The higher production and distribution costs rose, the more important it was to make low-risk films that pleased as many subsets of viewers as possible. Ripe with opportunities for merchandising, the new films could be marketed easily across media to maximize the range of new revenue streams.

The shift from the art-genre cinema of the 1970s to the megapictures of the 1980s and beyond has led scholars of contemporary American cinema to posit a decisive break from the 1970s into the 1980s, from the "Auteur Renaissance" to the Reagan-era conservatism of the "New Hollywood." Cinematographers and their work became a critical part of this shift as they turned from the realism of 1970s prestige cinema to the hyperbolic pictorial exaggeration of the 1980s and afterward. With this, documentary and art cinema influences were set aside, directors and cinematographers instead turning to amplified revisions of classical-era precedents. Saturated color displaced desaturated; sharp, clean images displaced the tendency to graininess or diffusion in 1970s cinema; Steadicam largely replaced handheld camerawork; and high-contrast lighting replaced the low-contrast "natural" look.

In a period in which emphatic visual stylization was valued increasingly in Hollywood, cinematographers experimented with several image-making techniques, first using traditional film tools like lighting and camera movement, and eventually exploring the digital technologies that would have a seismic impact in the new millennium. These stylistic options were guided by a new set of aesthetic norms—norms grounded in hyperbolism, referentiality, and the overt, self-conscious cultivation of authorial "signatures." The "New Hollywood" period saw a virtually unprecedented breadth in the range of possibilities open to cinematographers, and the uses they made of them have continued to inform American cinema since.

Lighting

Some aspects of the visual realism found in the art-genre films of the 1970s remain present in Hollywood film through the present, most notably location filming. But where that realist style incorporated handheld camerawork,

diffusion, low-contrast lighting, shallow depth of field, and desaturated color, cinematography in American films of all production strata through the 1980s reverses all these terms. In this later period, virtuosity remained salient in *American Cinematographer*'s discussions of visual style, as it had in the Auteur Renaissance, but a virtuosity built from a very different set of techniques engaged in very different functions.

The films of Ridley Scott were particularly influential, with *Blade Runner* (1982) becoming a touchstone for many filmmakers. *Blade Runner*'s cinematographer Jordan Cronenweth cited Orson Welles's *Citizen Kane* (1941, d.p. Gregg Toland) as an inspiration for the film's style, noting the film's "high contrast, unusual camera angles, and the use of shafts of light."[3] This effect is particularly striking in the sequence where J.F. (William Sanderson) brings Pris (Daryl Hannah) to his apartment, featuring low-key back lighting and considerable depth of field in addition to the shafts of light, and shot in Los Angeles's Bradbury Building (figure 5.1). Most familiar from the classic film noir *D.O.A.* (Rudolph Maté, 1950, d.p. Ernest Laszlo), this choice of setting is one of the film's more conspicuous noir references. Consequently, Ridley Scott was able to depart from "rather bleak, pristine, austere, clean look"[4] of traditional science-fiction dystopias and explore a look that was at once more noir and more tailored to his own visual tastes.

Working with different cinematographers, Scott continued to explore the creative possibilities of low-key lighting as a form of pictorialism. On *Legend* (1985), Alex Thomson followed Ridley Scott's preference for the use of one particular device in his low-key lighting schema: "We had shafts of light that I sometimes had moving. Much of that was Ridley's idea, and it followed through from the thing he did in *Blade Runner* with searchlights that moved about for no reason at all except that they looked quite good."[5] On *Black Rain* (1989), Scott and cinematographer Jan De Bont aimed for backlighting, smoke, and practical light sources shot low-key, bringing a noir-ish flavor to his policier.

FIGURE 5.1: Chiaroscuro, backlighting, and decorative shafts of light in *Blade Runner* (1982).

In conjunction with chiaroscuro lighting, the films of both Ridley and his brother Tony Scott make extensive use of smoke in combination with very shallow focus, allowing regions of the image to go soft in ways that set off the sharpness of in-focus regions. This is most apparent in films like Tony's *The Hunger* (1983, d.p. Stephen Goldblatt), *Revenge* (1990, d.p. Jeffrey Kimball), and *The Last Boy Scout* (1991, d.p. Ward Russell); and Ridley's *Blade Runner, Legend*, and *Someone to Watch Over Me* (1987, d.p. Steven Poster). From the late 1980s into the 1990s, the Scott brothers' visual style proved hugely influential on filmmakers from James Cameron, John McTiernan, and Renny Harlin to Michael Bay. Cinematographer Dariusz Wolski once claimed, "David Fincher and I must have seen Ridley's film *Blade Runner* about 1,500 times."[6]

Low-key lighting typically was motivated by onscreen sources, yet also can be seen as an aspect of generic style, often linked to classical-era reference points. This points to what was a particularly prevalent stylistic model: 1940s film noir. Early examples include Peter Yates's *Eyewitness* (1981), photographed by the young Matthew Leonetti, and Wim Wenders's *Hammett* (1982), shot by the veterans Philip Lathrop and Joseph Biroc. Biroc later claimed, "Actually the way I photograph is the way they photographed 40, 50, 60, 80 years ago." The result, he said, was "a color film shot like a black and white film."[7]

Film noir even provided a generic and visual touchstone for thrillers that sought deliberately to differentiate themselves from that specific set of visual devices in lighting and other elements of mise-en-scène. Though John Alonzo's work on *Scarface* (Brian De Palma, 1983) differs substantially from noir cinematography, its precedent functioned as a reference point for his departures from it, as he strove to reverse that style's emphasis on chiaroscuro, high-contrast lighting.[8] On *Basic Instinct* (Paul Verhoeven, 1992), Jan De Bont aimed for a sort of *film blanc*, noir's shadows replaced by swathes of white décor. Aside from films specifically referring to or reacting against noir, though, we might speculate on the influence of noir as a model on a much more widespread trend toward high-contrast lighting.

Not only was high-contrast lighting a key feature of horror films in the period; increasingly, low-key lighting was also a feature of science fiction and fantasy, as the aforementioned examples of *Blade Runner* and *Legend* testify. However much the narrative of *ET: The Extra-Terrestrial* (Spielberg, 1982) shies away from any potential for horror or darkness, Allen Daviau experimented with similar lighting styles: "hard-edged, old-fashioned, visible source, tiny lights. We wanted the color clean, unfiltered, with good solid blacks."[9] Hard lighting was equally important to James Cameron's *The Terminator* (1984) and *Terminator 2: Judgment Day* (1991), where strong light avoiding warmth or beauty was critical to cinematographer Adam Greenberg's depiction of the Terminator(s).[10] But it must be noted here that science fiction and fantasy allow, indeed encourage, stylistic play freed from the demands of realism, such that lighting can be driven purely by visual or dramatic logic, explicitly eschewing verisimilitude.

If this degree of stylistic play is to be expected within the science-fiction genre, increasingly this period sees high-contrast lighting treated as a trans-generic norm, regularly appearing in *American Cinematographer* coverage of comedies. On *Delirious* (Tom Mankiewicz, 1991), a John Candy comedy vehicle about a soap opera writer who enters his own story world, Robert Stevens lit each scene for its dramatic content to differentiate it from a typical "over-lit comedy."[11] One of the more extreme examples of this trend was *The Cable Guy* (1996), a Jim Carrey comedy with a decidedly Hitchcockian edge, and shot by Robert Brink-mann for Ben Stiller very much as if it were a thriller, allowing the inclusion of handheld camerawork, split-field diopters, and what the filmmakers called "dra-matic" lighting.[12]

For many cinematographers, in fact, low-key, high-contrast lighting became a signature technique, to be utilized whenever possible. Like Gordon Willis before him, Frederick Elmes (best known for his work for David Lynch) became known as a kind of auteur of darkness, crafting a style that, as with Lynch's narratives, encouraged viewers to participate, to look closely and interpret the image.[13] In *Blue Velvet* (1986), for instance, Elmes uses shadowy low-key lighting to imbue seemingly safe, familiar places with a quality of foreboding and mystery in an art-cinematic variation on the film noir style (figure 5.2).

Elmes's work for Lynch points to the extent to which self-conscious varia-tions on film noir constituted a relatively low-cost form of visual stylization for independent filmmaking. Factoring that with the minimal budgetary demands of noir narratives, it follows that updated, even revisionist, "neo-noir" became one of the common genres in independent filmmaking in the 1980s and 1990s. While films from *House of Games* (David Mamet, 1987, d.p. Juan Ruiz Anchía) to the Wachowskis' *Bound* (1996, d.p. Bill Pope) borrowed directly from noir sty-listics, others set noir narratives against lighting and mise-en-scène decisively removed from that precedent, like the desert-set *After Dark, My Sweet* (James Foley, 1990, d.p. Mark Plummer) or the snowbound *Fargo* (Joel Coen, 1996, d.p.

FIGURE 5.2: Frederick Elmes's shadowy photography brings a sense of mystery and menace to *Blue Velvet* (1986).

Roger Deakins). Noir was a key influence on the narrative of *Suture* (1993), but directors Scott McGehee and David Siegel and cinematographer Greg Gardiner turned as much or more to the films of John Frankenheimer and Teshigahara Hiroshi, looking for an effect that explicitly would be the "opposite of film noir."[14] Whether as a direct influence or a grounds for departure, then, film noir provided a framework for filmmakers striving for striking visual effects across the budgetary spectrum.

Color

Closely related to high-contrast lighting was a shift in color, and here, too, we see a move away from 1970s norms. Techniques like pushing and flashing, as well as extremes of lens diffusion, seemed to fall almost completely out of the cinematographer's arsenal. Many of the examples here are extreme cases, perhaps, but American film production as a whole in this period sees a relatively high degree of color saturation compared to the desaturated look of the 1970s.

Perhaps the most vivid examples of the patterned use of color may be found in the work of Vittorio Storaro. Best known in the 1970s for his work with Bernardo Bertolucci on films like *The Conformist* (1970) and *Last Tango in Paris* (1972), by the end of the decade he had brought his motivic uses of highly saturated color to Hollywood for high-profile collaborations with Francis Ford Coppola on *Apocalypse Now* (1979) and *One from the Heart* (1982). In 1982, Storaro provided *American Cinematographer* with lengthy statements explaining the thematic uses of contrasting primary colors in *One from the Heart* (see color plate 11), along with a manifesto explaining the rationale behind the color scheme in Warren Beatty's *Reds* (1981).[15] Color saturation was often accompanied by a highly stylized use of color in mise-en-scène, including both production design and lighting. The carefully coordinated colors of *Dick Tracy* (Beatty, 1990) were critical to the creation of its fantasy-inflected, comic-strip world, dominated by a four-color scheme deriving from the four-color printing process of the strip's heyday, and where colored lights suffuse the set with no regard for practical motivation whatsoever. Though demanding and perhaps eccentric, Storaro proved an influential figure in the increasing surface stylization of American cinema in the 1980s and 1990s, in particular in the embrace of stylistic patterning as a guiding principle in cinematography.

In the comic-book mode, where Tim Burton's Batman films had a very limited palette—all blacks, grays, and blues, particularly in *Batman Returns* (1992, d.p. Stefan Czapsky)—Joel Schumacher's Batmans were a riot of saturated colors, which Schumacher framed in terms of the comic book origins: "Comic-book artists take daring license; they do all sorts of wild things, such as making an entire action sequence magenta. With that approach in mind, you can use a variety

of colors that you wouldn't ordinarily see; you can have purple street lights if you want."[16] The result was a hyper-real, vibrant color palette, both dramatic and overstated. For his part, Burton returned in *Mars Attacks!* (1996, d.p. Peter Suschitzky) to the saturated colors of *Pee-Wee's Big Adventure* (1985, d.p. Victor Kemper), *Beetlejuice* (1988, d.p. Thomas Ackerman), and *Edward Scissorhands* (1990, d.p. Stefan Czapsky), likewise partly due to the palette of the trading-card source material.[17]

As in *One from the Heart*, Las Vegas provided an opportunity for color stylization to any story set there, "realistic" or no, from the modestly budgeted *Leaving Las Vegas* (Mike Figgis, 1995, d.p. Declan Quinn), with its palette of salmon and gold, to the more lavish *Casino* (Martin Scorsese, 1995, d.p. Robert Richardson), which aims for a hallucinatory effect through the orchestration of camera movement, lighting, and saturated color, appropriate to convey something of the feel of lives lived inside gambling dens.

Ed Lachman described motivations for color in *Desperately Seeking Susan* (Susan Seidelman, 1985) in oppositional terms that echo Storaro and others who made symbolic use of color. Lachman aimed to create distinct divisions between the worlds of Rosanna Arquette's Roberta—"soft, bounced ambient light and colors more in the earth tones: beiges, grays, pinks—and they were *desaturated* colors"—and that of Madonna's Susan—"I tried to use primary colors that were saturated, and the light had a more chiaroscuro feeling—greater contrast between the light and dark."[18] Because controlling color in the sets and lighting was a highly economical means to impart a sense of stylization to a film as a whole, hyperbolic color became common in low-budget and independent films in this period, including those designed for art-house exhibition.

Partly inspired by Storaro, the self-conscious manipulation and systematic patterning of color became a tool in the creation of meaning. A specific kind of color-coding can be found in *Dead Presidents* (Albert and Allen Hughes, 1995, d.p. Lisa Rinzler), for instance in the use of green associated with drug use and overdosing. In *Se7en* (David Fincher, 1995, d.p. Darius Khondji), each sin is associated with different colors and atmospheres: dirty yellow for Gluttony, red for Lust, green for Sloth, and whites punctuated with red for both Pride and Greed (see color plate 12). Michael Ballhaus and Barry Levinson worked out in some detail a marriage of chronological and tonal progression in the color patterns of *Sleepers* (1996). "We wanted a different style for each act," the cinematographer explains.

> The first takes place in Hell's Kitchen, and we decided it should have a warm look because the kids are growing up there and they're safe. . . . For the second act, in the reform school, we went in the other direction. . . . It's a living hell. We wanted a cool, dark look—not friendly or warm. There's not one yellow or warm scene inside the school. . . . We wanted

the third act, which takes place 15 years later, to look more like real life, with neither the warmth of the first act nor the coldness of the second. The guys are grown up and now we see them in the real world.[19]

While the examples above center on the inclusion of certain colors for meaningful purposes, for others a patterned, often pictorial use of color entailed limiting the range of hues. Some cinematographers displayed a stylistic tendency that has become increasingly prevalent since the mid-1980s in studio films: a muted palette occasionally set off by a judicious splash of primary color, as in *9 1/2 Weeks* (Adrian Lyne, 1986, d.p. Peter Biziou).[20] Oftentimes, desaturation was motivated by period settings, as had been common in the 1970s, or indeed to reference the films of that decade. Ellen Kuras desaturated the colors by using suede filters on *Summer of Sam* (Spike Lee, 1999) to achieve a look reminiscent of 1970s American New York films. Flashing was used as well, partly because it produces not only a desaturated but also a hazy image to invoke the summer heat. (The film's distinctive color palette can be seen in color plate 13.)[21]

By the mid-1990s, competing bleach-bypass development processes were becoming popular precisely for the ways they could desaturate color yet maintain rich blacks. Deluxe developed the Color Contrast Enhancement (CCE) process. Conrad Hall (called a "master of desaturation") used this process on *Tequila Sunrise* (Robert Towne, 1988) to make shadow areas more legible, but it got more attention for its use in *Se7en* as a way to play with their film stock's contrast level in relation to the story action. As an article on Darius Khondji's work noted: "To that end, he began using a non-bleaching process in his color work, leading to further experimentation with a silver process that called for his stock to be run first through color baths and then re-souped as black-and-white, restoring silver to the negative and resulting in rich blacks while simultaneously desaturating colors."[22]

At the same time, the Technicolor ENR process was gaining ground as the more popular option. The best capsule explanation comes in coverage of *Michael Collins* (Neil Jordan, 1996), linked to desaturation in the service of capturing a period flavor:

> Three methods were used to help simulate the bluish pall which once hung over Dublin: smoke, cyan filters, and the ENR printing process, both individually and in combination. Technicolor's ENR process (pioneered by Vittorio Storaro, ASC, AIC), is a variation of the standard color positive developing process in which a small amount of silver is left in the film by way of skipping the final fix (bleach) bath and then running the negative through a black-and-white developer. . . .

Adds Menges, "The ENR process helped us to create a nearly monochrome image."[23]

The ENR process would go on to be used by Fincher and Savides on the former's follow-up to *Se7en*, *The Game* (1997), and by Fincher and Jeff Cronenweth on *Fight Club* (1999), as well as films as otherwise distinct as *Alien: Resurrection* (Jean-Pierre Jeunet, 1997, d.p. Khondji) and *Saving Private Ryan* (Spielberg, 1998, d.p. Janusz Kaminski). While experimentation with such laboratory techniques was pursued by many elite cinematographers in the 1990s, soon such experiments would be rendered obsolete by a new technology: the digital intermediate, as discussed in a later section.

Film Stocks

The move toward high-contrast lighting coincided with a general move toward image sharpness and depth relative to the shallow focus and diffusion prevalent in the 1970s, and consequently is one of a number of closely connected techniques in New Hollywood cinematography. This is not to suggest that diffusion uniformly fell out of favor, but rather to assert that using highly diffuse images tended to be reserved for very particular purposes.

Increasing film stock speed facilitated depth and low-key lighting. Kodak introduced several new film stocks over the period, and cinematographers vigorously debated their merits in the pages of *American Cinematographer*, some welcoming the faster speeds (that is, their increased sensitivity to light), others worrying about gains and losses in grain. Eventually, Kodak introduced an entirely new line in 1996 and 1997, the Vision color negative stocks. Though the pre-Vision stocks 5248 and 5293 continued to be used for day exteriors, Vision 5274 became a more common choice for interior filming, and Vision 5279 quickly became popular for its sensitivity in night exteriors on films like 1997's *Batman & Robin* (Schumacher, 1997, d.p. Stephen Goldblatt), and in night interiors on films like *Snake Eyes* (De Palma, 1998, d.p. Stephen Burum). The lack of grain proved to be of particular value for cinematographers in this period, though some found it too high contrast. Ed Lachman, speaking of his work on *The Limey* (Steven Soderbergh, 1999), argued, "A lot of people have been questioning the Vision stocks because they think they're too contrasty, but I think it's just how you use them. I generally light with big, soft sources, so I welcome the contrast, but I suppose it would be more unforgiving for someone who uses harder light."[24]

The preference for minimal-grain film stocks in the 1980s and afterward stands in contrast to the emphatic graininess of so much 1970s cinematography. Cinematographers in that decade had explored the visual potential of film grain, especially as an aspect of realism, and had worked to bring that grain out by underexposing and then "pushing" (overdeveloping) the negative. Others, meanwhile, had explored the potential of a high degree of image diffusion, not only through filtration but also such techniques as "flashing" the film, preexposing

1: A sequence in two-color Technicolor from *The Phantom of the Opera* (1925) emphasizes red and green.

3: A complicated spotlight-heavy setup in *Leave Her to Heaven* (1945).

4: Dense, exaggerated shadows produced by low-angle lighting in *Bigger Than Life* (1956).

5: Expressive, candy-colored lighting obscures skin tone in *West Side Story* (1961).

6: A washed-out color palette for a scene in *Bonnie and Clyde* (1967).

7: A mixture of color temperatures, including several green hues, in *Taxi Driver* (1976).

8: The underexposed, "pushed" look of *The Godfather* (1972).

9: The fog filter helps to create a hazy, flared look in *McCabe and Mrs. Miller* (1971).

11: Vittorio Storaro makes the most of color on Coppola's Las Vegas Strip in *One from the Heart* (1982).

12: A desaturated, noir composition accented with vivid reds in *Se7en* (1995).

13: The color palette favors desaturated colors in *Summer of Sam* (1999), evoking 1970s cinematography.

14: A digitally re-created Technicolor palette contributes to the period look of *The Aviator* (2004).

15: In *Contagion* (2011), some of Steven Soderbergh's low-resolution signatures: shooting with available light, tonal adjustment to the frame, and Hollywood stars in silhouette.

16: A low-light effect allowing the nighttime cityscape to be visible in the background in *Collateral* (2004).

it prior to photography to soften the black areas. The predominant trend in the New Hollywood, especially on studio films, was toward sharp, clean, grain-free images. Douglas Slocombe spoke of this as a stylistic goal of all the Indiana Jones films, particularly considering the practice of limited releases on 70mm for the biggest commercial pictures.[25] Later, director David Fincher consistently opted for a fine-grain look, with Alex Thomson overexposing and then printing down for rich blacks and very little grain on *Alien 3* (1992).[26]

Where grain was desired, though, it was pursued aggressively, and through a variety of often unconventional devices, as for instance in selecting alternatives to prevalent film stocks. On *Clockers* (1995), first-time cinematographer Malik Hassan Sayeed talked Spike Lee into going for an unusual Kodak reversal stock, 5239, which had never been produced in bulk. The reversal stock, originally designed to produce positive images without the negative stage, had a particularly raw grain structure, but also gave "intense, vivid colors."[27]

Sayeed's work on *Clockers* was inspired, in part, by the remarkable experiments of Robert Richardson. It's hard to think of another period in which a cinematographer whose work is as idiosyncratic, as flagrantly experimental, and as virtuosic to the point of being exhibitionistic as Richardson's could thrive. Though he later proved to be a perfect match for Scorsese, his work for Oliver Stone in particular established his credentials as a virtuoso. In *JFK* (1991), *Natural Born Killers* (1994), and *Nixon* (1995), a variety of film stocks and video formats were used in conscious juxtapositions as a means of creating meaning through contrasts in texture and emotional tone. As an *American Cinematographer* article on *Natural Born Killers* explained:

> In crafting the film's garish, eye-popping psychological mindscapes, Stone and cinematographer Robert Richardson, ASC, combined a wide variety of shooting formats (color and black & white 35mm, black & white 16mm, Super 8, Hi8 and Beta), with front- and rear-projection photography, bits of heavy-metal animation, stock footage and clips from other films, including several of Stone's previous projects.[28]

As this description indicates, cinematographic style in *Natural Born Killers* was driven by ambitions well above and beyond storytelling, at once commenting on a media-saturated society (the stylistic shifts intended to mimic channel-surfing in the film's tale of media celebrity killers), and creating a "radical," "hallucinogenic" style to mimic the central characters' subjective experience (see figure 5.3).[29] The aims that the filmmakers invoked for this were less those of the Hollywood paradigm and more those of modernist art movements, the shifting perspectives on the action created by this collage-like style forming the basis of comparisons to cubism and surrealism.[30] Stone and Richardson refined this aesthetic further on their next collaboration, *Nixon*, mixing conventional

FIGURE 5.3: Director Oliver Stone and cinematographer Robert Richardson mix film stocks and treatments for a hallucinogenic collage effect in *Natural Born Killers* (1994).

35mm footage with material shot using a variety of other cameras, including a "1970s-model Ikegami" and "antiquated, cumbersome tube cameras" from the 1950s.[31] Far from invisibility or illusionism, this was style that had to be noticed as such to achieve its intended effect.

Cameras and Lenses

Deep focus, like high-contrast lighting, was a technique that largely had fallen out of favor in the realist aesthetic of the art-genre period. Those who continued to use it (or to approximate it with split-field diopters, like Brian De Palma) largely did so for the sake of stylistic and dramatic emphasis verging on hyperbole. That deep focus began to be favored once again during the 1980s underlines the extent to which documentary-style realism had ceased to be quite so central for Hollywood cinematographers.

Wide-angle lenses, which facilitate deep-focus photography, became something of a signature for cinematographer-turned-director Barry Sonnenfeld. Shooting *Throw Momma from the Train* (1987) for Danny DeVito, Sonnenfeld stated, "The joke was that I would always call for a 21mm about a foot off the ground. It's a nutty way of shooting." In fact, for that film he claimed to have used a 21mm lens for "about one half of the shots."[32] This would remain a preference for Sonnenfeld when he turned to directing. As Don Peterman, Sonnenfeld's cinematographer on *Men in Black* (1997), put it, "He is very hands-off as far as the lighting, angles, or anything else is concerned, but he does like to pick the lenses,

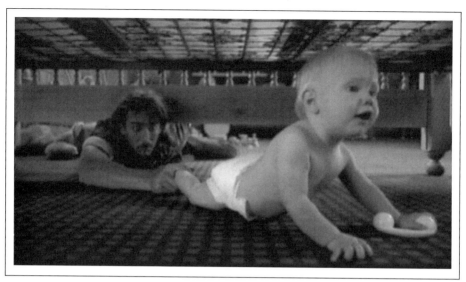

FIGURE 5.4: Wide-angle lenses, a signature of both the Coen brothers and cinematographer Barry Sonnenfeld, in *Raising Arizona* (1987).

and they're going to be wide lenses. Barry always used wide lenses on the movies he shot, such as *Raising Arizona* [Joel Coen, 1987] and *Blood Simple* [Coen, 1984]. He'll usually choose a 10mm, 14mm or 21mm, and he likes to shoot close-ups with a 27mm,"[33] the smaller numbers indicating a wider angle of view and an increase in depth of field. Figure 5.4, from *Raising Arizona*, shows the wide-angle lens producing a comic contrast in scale, exaggerating the size of the baby.

In some filming situations, wide-angle lenses had specific practical advantages: 17–24mm lenses were used for the cramped interiors of *Drugstore Cowboy* (Gus Van Sant, 1989, d.p. Robert Yeoman); 25–35mm lenses were used for the automobile interiors on *Night on Earth* (Jim Jarmusch, 1991, d.p. Elmes); 20 and 35mm lenses to film the astronauts in their capsule in *Apollo 13* (Ron Howard, 1995, d.p. Dean Cundey); and wide-angle lenses, verging on fish-eye, were used for the hidden cameras in Truman's car in *The Truman Show* (Peter Weir, 1998, d.p. Biziou).[34] But just as often, it was a choice determined by style for its own sake, or as a vehicle for authorship. Wide-angle lenses were a signature device for Brian De Palma, Martin Scorsese, Terry Gilliam, Tim Burton, and Jean-Pierre Jeunet. For the Coen brothers, as they commenced their long-running collaboration with Roger Deakins, wide-angle lenses were a bone of contention. They had begun their careers working with Sonnenfeld and shared his taste for short lenses, which Deakins resisted, preferring longer lenses. The result was compromise: 40mm instead of 25mm lenses on *Fargo* (1996).[35] Conversely, long telephoto lenses could be used as much for visual effect as for storytelling utility: for instance, Canon 600, 800, and 1000mm lenses on *Point Break* (Kathryn Bigelow, 1991, d.p. Peterman) to enhance the vastness of the waves and the ocean, as in figure 5.5.[36] Michael Bay's films nicely exemplify the extremes of lens length

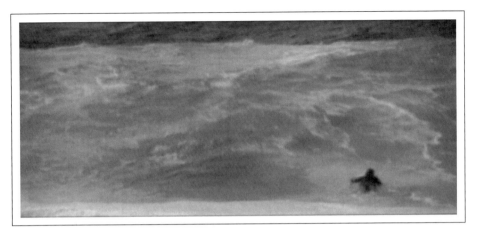

FIGURE 5.5: In *Point Break* (1991), long lenses enhance a sense of the vastness of the ocean.

that characterize the era in general, alternating between wide angle lenses used to exaggerate movement and long lenses used to compress space for dramatic and graphic effects.

Another factor must be accounted for in the breadth of cinematographers' lens choices in this period: a resurgence in the use of multiple-camera shooting, using two or more cameras running simultaneously to record a scene. Multiple-camera shooting was nothing new, of course; it had been used extensively in the early talkie period to compensate for limitations in sound editing, and had been a characteristic practice of Kurosawa Akira from the mid-1960s. But by the early 1990s, the ever-rising costs of filming big-budget action blockbusters had made it an attractive option for stunts, explosions, and similar scenes that were prohibitively expensive to restage for the camera. At the same time, the use of multiple cameras meant a profusion of shots, and thus of shot choices for the editing suite, while the rise of nonlinear editing made it easier to use a greater number of shots shaved to shorter lengths.

At times, coverage of productions using multiple-camera shooting reads like a kind of cinematographic arms race. *Backdraft* (Ron Howard, 1991, d.p. Mikael Salomon) used as many as nine cameras at once. The camera truck on *True Lies* (Cameron, 1994, d.p. Russell Carpenter) carried nearly a dozen cameras, while *First Knight* (Jerry Zucker, 1995, d.p. Adam Greenberg) only managed eight, and *Braveheart* (1995, d.p. John Toll) used a paltry four, three to film action during battle scenes and one to stay on director-star Mel Gibson in those scenes. On *Con Air* (1997), Simon West and David Tattersall used a full fifteen to film the plane crashing into the Sands hotel.[37] As the practice became more widespread, it often would be used for the aesthetic advantages of having extensive coverage. Spike Lee consistently used two cameras to film dialogue scenes, as in *Clockers*, to maximize performance (eliminating offscreen line-reading, speeding up production, facilitating dramatic continuity).[38]

Despite the importance of the home video market, the majority of blockbusters were shot in the 2.35:1 aspect ratio, and increasingly it was the format of choice across genres. As Lisa Dombrowski has explained, this ratio originally was associated with CinemaScope, the widescreen technology introduced by Twentieth Century–Fox in 1953. The format relied on "anamorphic" lenses to squeeze the image onto a regular piece of 35mm film. By the 1990s, however, many filmmakers began to appreciate the advantages of Super-35 over anamorphic lenses to film in that ratio. Simply put, Super-35 is a widescreen format shot with non-anamorphic spherical lenses, achieving a larger image frame by using part of the negative normally reserved for the optical sound track. Part of the image area (top and bottom) is then matted when theatrical prints are struck to achieve a wide frame comparable to anamorphic widescreen. That Super-35 utilizes more of the negative points to one of its principal advantages in a period when studios became more keenly aware of the importance of home video as a distribution platform, as it is essentially shot full-frame, such that the image does not need to be cropped for 4:3 presentation. While Super-35 had been in use in Hollywood since *Greystoke* in 1984, it wasn't until the early 1990s that it began to be taken up more widely. Its chief advantage was flexibility in lens choices, and specifically its ability to capture a greater depth of field than anamorphic lenses while using less light than necessary in anamorphic formats. The shallowness of anamorphic lenses had presented limitations throughout the history of widescreen cinema—for instance, it was one factor driving the use of the split-field diopter, noted in the previous chapter. The use of spherical lenses removed this barrier to depth of field. The option of using a greater variety of lenses drove the adoption of Super-35 on films like *The Age of Innocence* (Scorsese, 1993, d.p. Michael Ballhaus), *L.A. Confidential* (Curtis Hansen, 1997, d.p. Dante Spinotti), and *Fear and Loathing in Las Vegas* (Gilliam, 1998, d.p. Nicola Pecorini).

Still, some filmmakers grew dissatisfied with the format. Michael Bay, for instance, was persuaded to use Super-35 on *The Rock* (1996) after seeing what Fincher and Khondji achieved with the format on *Se7en*,[39] but returned to anamorphic for *Armageddon* (1998), reporting that *The Rock* appeared too grainy in theatrical projection. For Bay, shooting anamorphically meant less dependence on the lab, and therefore more control over the image.[40] Similarly, Terrence Malick and John Toll opted for anamorphic over Super-35 on *The Thin Red Line* (1998) to avoid a separate optical step at the stage of making answer prints, so that they could work with a greater knowledge of how the negative would translate to prints.[41] The ease and flexibility of Super-35 nonetheless meant that it remained a widely chosen option, and its use to create depth in moving shots speaks not only to a concern with achieving significant depth of field, but also Hollywood cinematography's increasing reliance on mobile camerawork.

Camera Mobility

Developments in camera mobility technique and practice were even more closely tied to self-conscious visual virtuosity. Handheld camerawork had become a common device in Hollywood films of the 1970s thanks to the influence of documentaries and the films of the French New Wave. But into the 1980s, other techniques, such as the Steadicam and the Louma Crane, offered a similar degree of mobility but without image instability; as the films themselves lost a narrative emphasis on realism, these other mobile camera technologies were preferred.

The Steadicam combined the practical attributes of hand-held cameras with the smoothness of dollies. In "Steadicam: An Operator's Perspective," published in two parts in *American Cinematographer* in April and May of 1983, Steadicam operator Ted Churchill provided an exhaustive discussion of the device's practical and stylistic advantages for filmmakers. While Churchill's discussion was enthusiastic to the point of evident bias, his description of the Steadicam's possibilities points toward prevailing attitudes to stylistic flourishes more generally, and particularly with regard to camera movement. At first, Churchill stresses the apparatus's practical advantages, noting that the Steadicam was often necessitated by "geographic necessity," in sets and locations, rather than its use in creating "flashy" shots.[42] Churchill's professional investment in the device and its use comes out more markedly in his discussion of the Steadicam as a stylistic choice. On the heels of his discussion of practical applicability, he allows that the Steadicam "does have one important non-technical function: it encourages innovation." This accounted for its use in television commercials to capture the attention of "a largely disinterested audience."[43] Regarding its use in narratives, he wrote, "There is little that can match a wide-angle Steadicam shot in pure kinetic energy. It makes for an eye-catching opening, is great for fast intercutting."[44] It could even replace the need for cutting: "actually charging into the ECU makes all the difference when it comes to exciting an audience as familiar with cutting as they are with breathing." At the same time, "Steadicam's ability to rapidly change perspectives, to make highly energetic moves, works wonderfully with quick cutting, creat[ing] enormous excitement for audiences."[45] However much Churchill's professional enthusiasm got the better of him here, he nonetheless isolated many of the uses to which the Steadicam had been put by 1983, and in particular its capacity and frequent use for kinetic, virtuosic movements.

As the period continued, Steadicam became an increasingly central component of the cinematographer's arsenal, and its operators key members of a production crew. Robert Richardson reported that 50 percent of the shots in *Born on the Fourth of July* (1989) were executed with a Steadicam,[46] and Matthew Leonetti reported using Steadicam for 50–60 percent of his shots for *Strange Days* (1995).[47] One celebrated example of the technique appeared in Scorsese's *Goodfellas* (1990, d.p. Michael Ballhaus): a lengthy, flashy Steadicam shot proceeding

from the street through the bowels of a supper club to the stage area. The device's use was not restricted to filmmakers as kinetic as Scorsese, Stone, or Bigelow, or even to films oriented toward action, like *The Rookie* (Clint Eastwood, 1990, d.p. Jack Green) or *Ronin* (John Frankenheimer, 1998, d.p. Robert Fraisse): continuous takes snaking around characters could be effective in the context of "naturalist" dramas like *Fried Green Tomatoes* (Jon Avnet, 1991, d.p. Geoffrey Simpson).[48] Still, some began to react against "overuse" of the Steadicam; Stephen Goldblatt disliked Steadicam because he was unable to exercise a sufficient degree of control over the image, as he would be unable to look through the viewfinder himself.[49]

While the Steadicam offered a flexible solution to camera movement in difficult production circumstances, a whole new set of systems offered remote-control mobility, eliminating even the physical restriction of hands-on camera operators. By the end of the 1980s, a computerized motion control system allowed for the easy replication of camera movements, useful for composite shots on effects-heavy films like *Back to the Future 2* (Robert Zemeckis, 1989, d.p. Cundey) and *Batman Returns*. The Louma Crane, utilized extensively on *To Live and Die in L.A.* (William Friedkin, 1985, d.p. Robby Müller), combined the functions of a remote-operating camera, a Steadicam, and a crane to effect its camera movements. In an *American Cinematographer* article, writer Ric Gentry enthused, "What makes the Louma altogether revolutionary is its ability to obtain perspectives that are impossible for an operator, behind the camera, to otherwise assume, and, moreover, to move forward and backward, up and down, and turn 360° in any direction with utmost fluency and speed."[50] The sheer variety of devices enabling types of camera movements, including the Pogocam (used on *Point Break* and *True Lies*, among others) and the Spacecam (used on *The Shawshank Redemption* [Frank Darabont, 1994, d.p. Deakins] and *Waterworld* [Kevin Reynolds, 1995, d.p. Dean Semler]), testifies to the value placed on cinematographic innovation in this arena.[51]

For cheaper productions, handheld camerawork remained an affordable alternative to the Steadicam. Discussing *The Terminator*, Adam Greenberg stated that "shooting hand-held gives an energy to a scene you can't get any other way"; while he and James Cameron had considered using Steadicam, "budgetary constraints precluded that."[52] It was not until the end of the 1990s that one began again to see handheld used more widely, not only to import kinetic energy, but as an aspect of a documentary-influenced realist aesthetic. Whereas Janusz Kaminski used a handheld camera on about 60 percent of *Schindler's List* (Spielberg, 1993), he estimated its use on *Saving Private Ryan* as 90 percent, so as to mimic World War II documentary footage, but in the most precisely calibrated, artificial manner: "For handheld work, we used Clairmont Camera's Image Shaker, which is an ingenious device. You can dial in the degree of vibration you want with vertical and horizontal settings, and mount it to a handheld camera, a crane, whatever."[53]

What motivations, or justifications, were offered for the abundance of camera movement in films of the 1980s and 1990s? In the action genre, camera movement equated to "energy"; a mobile camera could complement the movements of characters in the frame, but also impart kinetic impact to scenes with relatively little happening. The use of near-constant camera movement for pure kinetic effect can be seen in films like *Die Hard* (John McTiernan, 1988, d.p. De Bont), *Point Break*, and indeed most action films and thrillers from the late 1980s through the 1990s. Frantic characters in motion provided both opportunities for camera movement, and an alibi for it. Speaking of shooting *Patriot Games* (Philip Noyce, 1992), Donald McAlpine "notes that the thriller genre has evolved to a point where the audience expects to be dazzled by moving camerawork."[54] For Michael Bay, a constant level of motion became a signature. On *The Rock*, John Schwartzman said, "We shook the cameras a lot in action sequences, by banging on dollies or shaking iris rods. When we used car mounts, I told my grips, 'Keep the bolts loose, we want these cameras to shake.'"[55] Speaking of *Eraser* (1996, d.p. Greenberg), director Chuck Russell described his aim in terms that could describe norms of action filmmaking across this period and since: "Our overall approach to shooting this film was that if the shot itself didn't have some energy, we didn't want to do it."[56]

The lesson of these films—that camera movement in itself can impart energy—was taken up across genres, including period pictures. For Jane Campion's *The Portrait of a Lady* (1996), a society drama, Stuart Dryburgh told *American Cinematographer* that "the camera is in a state of constant motion throughout the film, as every shot was executed on a dolly." The rationale for this was partly about the story, but also about breaking with convention. Dryburgh explained, "Jane sees this as quite a modern story and therefore felt that it should be quite modern in its treatment. But we also kept the camera moving in order to maintain a sort of emotional restlessness and a sense of not being quite sure of what is going on."[57] That camera movement was itself seen as a way of contemporizing the film speaks to a use of style as part of a film's appeal to audiences. Speaking of a resolutely contemporary film, *Clockers*, Spike Lee perhaps indicates the economic importance of contemporary visual style more honestly than most: "I want vibrant energy, movement and life in my films," he explains. "Shooting any other way, for me, is too much like television. It costs $7.50 to see a movie today, plus extra for parking, popcorn and soda. If you don't give the audience something interesting to watch, they're going to stay right on that sofa at home, where they have 150 channels to choose from."[58]

Likewise, independent filmmakers found that striking camera movements, if they could be created inexpensively, could distinguish their films in the marketplace, and even garner mainstream and critical attention. Thus, creative solutions were the order of the day to achieve energetic motion shorn of the documentary feel of hand-held work. On *Blood Simple*, Sonnenfeld created camera movement

in one case by having members of the crew "[drag] me around on the floor hold-ing an Arri BL3 while lying down on a sound blanket." In other shots, he used Sam Raimi's "Shakicam," a two-inch-by-twelve-foot piece of lumber with a cam-era mounted on the middle carried by grips.[59] At the same time, though, other independents distinguished themselves from the increasing hyperactivity of stu-dio films by using comparatively little camera movement, a relative degree of stasis signifying a certain kind of small-scale character drama, and a subdued classicism emphasizing dialogue and performance. An example is the minimalist aesthetic of a filmmaker like Tom DiCillo. "Camera movement was used judi-ciously in *[Box of] Moonlight* [1996, d.p. Paul Ryan], usually as a psychological exclamation point for important moments in the story. 'Every single element of a film should serve what's going on in the film,' DiCillo declares. 'Not one frame should be purposeless, and the same goes for camera moves.'"[60] That independent cinema would become a home for this sort of unobtrusive craft, in contrast to Hollywood's increasing hyperbolism, indicates how much cinematographic style had changed in the studio system since the classical period.

Computers and Cinematography

Before concluding this survey of cinematographic techniques and practices, it must be noted that this period saw the first significant developments in digi-tal and computer-assisted cinematography, which would become increasingly important in the twenty-first century (and, as such, the focus of the next chap-ter). At the end of the 1980s, special effects for spectacles like the original *Batman* were still dominated by models and miniatures, blue- and greenscreen, and compositing. In the 1990s, though, the terrain began to shift, rapidly, in ways that would have a lasting impact on cinematographers and the range of possibil-ities open to them. Throughout the decade, *American Cinematographer* devoted increasing space to these issues, from computer-generated imagery to digital cin-ematography and color grading. For instance, in September 1992, an entire issue was devoted to electronic postproduction tools and "the changing art of the cin-ematographer," proclaiming that "cinematography now stands at the crossroads of film, video, and computer technologies."[61] From this point, various writers for *American Cinematographer*—both reporters and professionals—would regularly urge cinematographers to engage as fully as possible with digital production and post-production technologies.[62] Coverage of CGI as used in films as diverse as *Jurassic Park* (Spielberg, 1993, d.p. Cundey), *Forrest Gump* (Zemeckis, 1994, d.p. Don Burgess), and *The Age of Innocence* noted its inexorable rise, not only for creating spectacle but, in the latter two cases, giving an authentic feel to his-torical re-creation. Meanwhile, recurring features would update readers on new hardware and software.[63] The advantages of digital pre-visualization for films like

Judge Dredd (Danny Cannon, 1995, d.p. Adrian Biddle) and *Starship Troopers* (Verhoeven, 1997, d.p. Jost Vacano) would be highlighted,[64] as would developments in motion-control cameras that could facilitate compositing.[65] By 1998, the magazine could point to a definitive blurring of boundaries between film and video production and postproduction.[66]

In spite of a widely held fear that CGI and compositing would begin to erode the cinematographer's contribution to and control over the image, in at least one respect digital technology would have a profound impact on the cinematographers' art, increasing their direct control over the image. Digital color processing had developed by the late 1990s,[67] allowing the cinematographer to manipulate hue and saturation without the laboratory as an intermediary. As Christopher Lucas discusses in the following chapter, Roger Deakins was a high-profile early adopter of this technology.

Preceding the rise of high-end digital cameras in feature production in the coming millennium, in the 1990s "digital cinematography" was largely a matter of "virtual" cinematography, images mimicking motion picture shots but created by computer. On *Broken Arrow* (1996, d.p. Peter Levy), director John Woo required a degree of camera movement inside a B-3 bomber that would be impossible to achieve filming inside an actual plane. Instead, those shots were entirely digital: both the plane and the "camera" executing bravura moves in its interior were computer-generated. The best-known instance of virtual cinematography in this period was, of course, *The Matrix* (Andy and Larry Wachowski, 1999, d.p. Bill Pope), with its use of "bullet-time,"[68] initially achieved by surrounding the live actors with still cameras and digitally melding single frames into one fluid movement in which the speed of motion could be altered to achieve extreme effects (typically moving into and out of extreme slow motion). The same year's *Star Wars Episode I: The Phantom Menace*, too, featured virtual camerawork alongside compositing, and the use of digital sets to an unprecedented degree. George Lucas loudly proselytized for digital cinematography's cost-effectiveness and capacity for manipulation, particularly virtual camera mobility.[69] That film was the focus of an issue of *American Cinematographer* that took the opportunity to look ahead to Sony's "first prototype 24 fps, progressive-scan (1920 x 1080)" cameras, scheduled for delivery to Panavision later that year.[70] Such cameras would form the basis of digital cinematography in coming decades, central components of a profoundly altered filmmaking arsenal.

Hyperbolism, Referentiality, Authorship

The pictorialism of the New Hollywood period must be set within the context of the cinematographers' changing understanding of the craft itself, placing a fresh accent on stylistic exaggeration. David Bordwell has proposed that the period

continued a more general movement toward an "intensified continuity" system, a set of practices driven by a heightening of kinetic effect and an emphatic use of style for dramatic impact.[71] Across this period, one sees a steady trend toward rapid editing, increased camera movement, and greater variation in lens length, all of which impacted or derived from cinematographic practices. From this perspective, one can see many of the aforementioned cinematographic techniques as efforts to hold onto the spectator's attention in the midst of an increased emphasis on spectacle.

For instance, Douglas Slocombe spoke of the importance of composition in the *Indiana Jones* films, for two reasons. First, the sheer number of shots: "I would guess that the average film is told in something like 300–500 setups. But all three of the *Indiana Jones* films have to run to at least 1500 setups, probably close to 2000."[72] This meant that shots would be relatively shorter, and the action faster, but the films still had to work in the 70mm screenings then common on first release: "The bigger the screen, the more care one needs to take in really directing the eye to the right bit of the screen. Otherwise, people can get lost, especially when the action is very quick."[73] Such concerns for cinematographers in this period of stylistic amplification go well beyond the 70mm premieres, however: with such rapid editing, directing the eye would be critical for the film to retain coherence on any screen size. It is partly in light of such concerns that more and more cinematographers turned to the use of video assists on film cameras. A shot had to be quickly readable, and to play across distribution platforms, on TV as well as on the big screen. The increasing number of setups per film, the rapid cutting by which they would be combined, and the care to design images that could be read instantly undoubtedly encouraged directors and cinematographers to vary lens lengths as they parceled out story information in smaller chunks, if only to direct the viewer's eye with some precision.

While it is true that many of the techniques of "intensified continuity" had practical motivations, high-contrast lighting, extremes of focal length, saturated color, and highly mobile camerawork also demonstrate a tendency to stylistic artifice only partly motivated by narrative demands. In making this claim, I am not arguing for a post-classical cinema as such, a claim that tends to imply a more fundamental break with classical cinema than can be justified via formal analysis; however hyperbolic style could become in this period, it still functioned narratively first and foremost. But if Bordwell's "intensified continuity" describes contemporary Hollywood's zero-degree style, then how can filmmakers distinguish themselves? Through hyperbolic, self-declaiming stylization.[74] This was and remains a stylization functioning alongside but in excess of narration, a stylization justifiable as product differentiation, but also functioning as a vehicle for experimentation and authorship, viable precisely because compatible with neo-classical, genre-bound storytelling. Here, a distinction can be drawn between visual experimentation in Hollywood since the

1980s and the kind of genre revisionism and art-cinematic narration common in American prestige films of the 1970s. This position, then, is perhaps closer to the less radical post-classicism of Thomas Elsaesser in his essay on Coppola's *Dracula*: a palimpsest, a classical armature overwritten with stylistic excess; certainly, it suggests a change in relations between aesthetic and compositional norms.[75] Richard Maltby's idea of a Hollywood cinema dominated by "the commercial aesthetic," providing its audiences an "admixture of attractions," may be helpful here in reconciling classical narration with stylization performing other duties as well, suggesting, following Maltby, a Hollywood cinema driven by multiple and "overlapping" histories, and a constant dynamic of continuity and change.[76]

This tendency toward a self-declaiming style can be found in the work of cinematographers like William Fraker, Gordon Willis, and Vilmos Zsigmond in the 1970s, but in the next decade, as realism became a less pressing aesthetic goal, artifice and virtuosity took on more value in and of themselves. Stylistic hyperbole compatible with generic and narrational demands, yet manifesting a degree of visual artistry beyond them, became a favored path for aesthetic innovation. Moreover, this aesthetic can appear across the period, across genres, and across levels of production, from the makers of *Liquid Sky* (Slava Tsukerman, 1982, d.p. Yuri Neyman) creating "a vivid style despite the limitations of a small budget," incorporating both "blatant visual 'overkill'" and "subtler mood effects,"[77] to Simon West and David Tattersall devising a "highly specific visual schematic"[78] of steadily intensifying color and mobility in *Con Air*. Realism as an aesthetic goal survives in this environment, but virtuosity was a more common touchstone for aesthetic aims, and often for highly artificial, "theatrical" effects.

For most of this period, "realism" was rarely invoked outside of the qualifier that filmmakers were in pursuit of "heightened" reality; that is to say, realism was chiefly a concern in the context of fantasy and science fiction, genres that are inherently unrealistic. Here, the films of Spielberg provided a model for other filmmakers. On *E.T.*, Spielberg told *American Cinematographer*, "I wanted the movie to look very realistic"; consequently, "we decided to really let the closet be the magical hideaway but let every other room in the house be brutally dramatic and not suggest that we were making a picture about contemporary fantasy but, in fact, we were making a movie about contemporary suburbia and all the visual reality suburbia seems to invite."[79] A decade later, cinematographer Dean Cundey would face the additional challenge of creating a "realistic" depiction of humans interacting with CGI creatures in Spielberg's *Jurassic Park* (1993): "The audience has to believe the unbelievable," says Cundey. "You have to give them as much reality and recognizable truth as you can. They have to walk in the shoes of the characters. They have to feel the terror when the experiment goes wrong and a handful of people isolated on an island become prey for the dinosaurs."[80] These instances point to a very different conception of realism, one typically invoked in

the context of narratives with pronounced fantastic components; this illusionism stands in contrast, then, to the documentarism of the earlier art-genre pictures.

In other cases, visual stylization was explicitly seen as a way to depart from the strictures of realism. Discussing *One from the Heart*, Vittorio Storaro told *American Cinematographer* that "this is a totally unrealistic picture. We are expressing subliminally the emotions of the characters—expressing them in a more theatrical way."[81] For Stephen Burum, speaking of his work on the hyperbolic *The War of the Roses*, documentary realism was a fraud, a paradigm to be discarded:

> The moment we have a piece of film, the moment we put a lens on anything, we have distorted reality. The whole perception of realism in theatrical movies is a bunch of bunk, because actors are pretending to play the parts. What we have to do is to try to represent some kind of truth in a way that people will recognize it and will focus attention on the things we want to point out. . . . The whole idea of the cinema verite that the French started whipping on us in the 60s is a fallacious kind of philosophy, totally without any kind of philosophical truth.[82]

Hyperbolic stylization, free of an obligation to realism, was spoken of in terms that suggest not only filmmakers' increasing experimentation with pictorialist style, but also the extent to which it may have been perceived as a selling point for certain kinds of pictures. One of the clearest examples of cinematographic style performing a commercial function was in the first of the James Bond franchise with Pierce Brosnan in the lead, which, coming six years after the preceding entry (the longest gap in the series to that date), obliged producers Michael G. Wilson and Barbara Broccoli to adapt to contemporary action film norms. The goal was to "retain the good things about current Bond image and bring it up to the 90s in terms of visual style"; as cinematographer Phil Meheux put it, a new Bond must "beat" contemporary exemplars of the genre like *Die Hard* and *True Lies*.[83]

If the economic and aesthetic contexts of Hollywood cinema in the 1980s encouraged a high degree of play with the image, the specific qualities of this kind of artifice informed filmmakers' selection of aesthetic touchpoints, and their choices are informative with regard to the contrast between them and the documentary and *nouvelle vague* influences on the art-genre films. Many of the most notable trends in Hollywood film into the 1990s were related by practitioners to classical cinematic precedents, cherry-picked for the most bravura flourishes, and exaggerated still further in the revision.

Just as a self-conscious neoclassicism can be seen as a narrative tendency in megapictures like *Star Wars* and *Raiders of the Lost Ark* (Spielberg, 1981, d.p. Slocombe), so references to classical Hollywood visual techniques underlie much discussion of cinematographic strategies through the 1980s. Stated rationales for such classical references varied. In some cases, period settings motivated

allusions to films set in those periods. For *The Age of Innocence* (1993), set around the turn of the twentieth century, Martin Scorsese and Michael Ballhaus studied *The Magnificent Ambersons* (Orson Welles, 1942, d.p. Stanley Cortez), along with classic European films like *Lola Montès* (Max Ophuls, 1955, d.p. Christian Matras) and *The Leopard* (Luchino Visconti, 1963, d.p. Giuseppe Rotunno); Ballhaus believed that their visual play would make the films "a primer on how to invigorate historical material."[84] While the makers of *Billy Bathgate* (Robert Benton, 1991) stressed the authenticity of their film by contrast to 1930s gangster films, in discussing it they continually returned to such precedents, with Nestor Almendros avoiding the use of the 100mm lens because it was rarely used in 1930s Hollywood cinema.[85]

We have already seen cases in which classical Hollywood productions, particularly film noirs, were a strong influence on stylistic choices. However, important visual precedents for mainstream production varied far beyond film noir, and in many cases were characterized by yet more exaggerated stylization. In some cases, music video was an immediate aesthetic influence (though the comparison tends to be exaggerated). For *Flashdance*, Adrian Lyne and cinematographer Don Peterman screened some twenty music videos that "represented the stylized look Lyne wanted for the five big dance numbers in the film. The message was: 'Anything goes.'"[86] For cinematographer Dariusz Wolski, this would be a lifelong influence. According to one contemporary article, after coming to Los Angeles, "the cinematographer soon became allied with talented and ambitious young music video directors such as David Fincher, Russell Mulcahy, Alex Proyas and Julien Temple, all of whom exploited the no-rules aesthetic of the new medium."[87] Not only was music video an influence on motion picture cinematographers looking to stay current, but it also affected approaches to visual style and experimentation in its role as a training ground for young practitioners.[88]

In some cases, source material and genre categorization constituted a visual framework justifying seemingly any degree of stylistic exhibitionism. As we have seen, comic books provided much visual inspiration, a specific set of cross-media parameters in terms of color and aesthetic exaggeration. Along their own lines, fantasy, science fiction, and action all offered opportunities for stylized cinematography outside the confines of realism. On *Gremlins 2*, John Hora tried to create "stylized, crazy light" to fit the film's fantasy aesthetic; he spoke of experiencing freedom working on such a "cartoony" project.[89] But while such genres offered particular opportunities, being by their nature shorn of any narrative obligation to verisimilitude, hyperbolic style was a general transgeneric characteristic of the period, with numerous examples of filmmakers stressing the visual dimensions of their particular properties.

By the mid-1990s, though, a concern with achieving a realist look begins to creep back in. In contrast to the prevalence of realism in the 1970s, this becomes one option among many in an era of eclecticism in visual style. In some instances,

this could take the form of a relatively subdued visual style; Conrad Hall went for an "understated" "magic naturalism" on *Searching for Bobby Fischer* (Steven Zaillian, 1993) so as to avoid distracting from the story.[90] Documentary style was an influence on *JFK*, but with a collage-like effect that at no time allows spectators to forget its constructedness. Likewise, visual realism taken to particular extremes—of both roughness and violence—guided Steven Spielberg's approach to *Saving Private Ryan*, positioning it as an amplified version of what was by then a conventional approach to war film aesthetics (see figure 5.6). The use of what for him remains an extreme reliance on handheld camerawork was conditioned by referentiality, an association between handheld camerawork and the real circumstances of wartime photographers. The director explained:

> In the best sense, I think it's extraordinarily sloppy. But reality is sloppy—it's not the perfect dolly shot or crane move. We were attempting to put fear and chaos on film. If the lens got splattered with sand and blood, I didn't say, "Oh my God, the shot's ruined, we have to do it over again"—we just used it in the picture. Our camera was affected in the same way that a combat cameraman's would be when an explosion or bullet hit happened nearby.[91]

Realism had become a variant of a larger tendency to aesthetic referentiality.

More notable, in terms of the self-consciousness and referentiality of style in this period, is that as the 1990s wore on, so the 1970s themselves became an explicit touchstone by contrast with the more pictorial hyperbolism of 1980s crime pictures. Ed Lachman, talking about the "down and dirty" look of *The Limey*, attributed this to a reaction to the prevailing look of Hollywood films

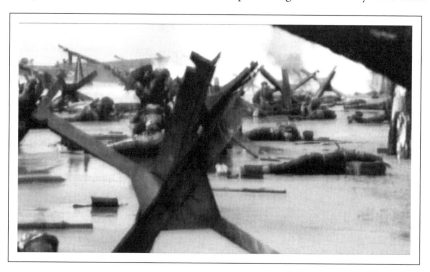

FIGURE 5.6: In *Saving Private Ryan* (1998), the cinematography of the Omaha Beach scene is noteworthy for giving the impression of having been shot by a war correspondent.

of the eighties and nineties: "The pendulum has been swinging away from the direction of creating cosmetically 'perfect' images. Film stocks are so grainless and wonderful, and lenses are so pristine and sharp, that I feel we need to go back a bit in the direction of feeling that something is 'real,' so that we're not manufacturing some homogenized abstraction of reality."[92]

On *Clockers*, Spike Lee listed *The French Connection* (William Friedkin, 1971, d.p. Owen Roizman) and *Bullitt* (Peter Yates, 1968, d.p. William Fraker) among his chief influences.[93] In adjusting the western narrative template of *Cop Land* (James Mangold, 1997) for its contemporary story of corrupt police, cinematographer Eric Edwards looked to Sidney Lumet's 1970s New York films *Serpico* (1973, d.p. Arthur Ornitz) and *Dog Day Afternoon* (1975, d.p. Victor Kemper).[94] But if a turn to 1970s stylistic precedents does constitute a swing of the pendulum away from the techniques of 1980s cinematography, it continues a basic principle: visual style as a mark of differentiation, performing duties well beyond conveying story information.

All these effects—hyperbolism, referentiality, patterning, even realism—could function as a vehicle for authorship in the absence of the opportunities for narrative innovations and genre revisionism of the 1970s. Some directors were more identifiable from the cinematographic qualities of their films than from any other element. Don Peterman reported being pleased to work with Kathryn Bigelow on *Point Break* because "the look of the film is very important to Kathryn. That's true of all her films. . . . Her work is generally very stylish. She storyboarded every action scene, and chose the style and color of every surfboard, every parachute, and all the wardrobe. She really knew what she wanted."[95] Darius Khondji, who worked with Fincher on *Se7en*, spoke of the challenges of working with a visually oriented director: "It's easy and very tough at the same time. He knows what he wants, but he also has the mind of a cinematographer; you have to bring him more than what he wanted. If you just do what he asks, it's not enough. . . . For me, David is like Ridley Scott when he did *Blade Runner* or *Alien*—there is a vision in him that is very strong."[96]

But this period also saw the continuation of one notable trend in craft discourse of the 1970s: the elevation of certain "star" cinematographers to quasi-auteur status. Though acknowledgment of the work of the cinematographer was hardly new in film journalism, there were several notable efforts to bring popular awareness to that work, in a variety of forms. Canonical figures from earlier eras published memoirs in these decades, while the University of California Press reprinted John Alton's *Painting with Light* in 1995. Kris Malkiewicz, author of *Cinematography*, a 1986 textbook for film students, also assembled *Film Lighting*, a guide to that subject largely taking the form of interview snippets with Conrad Hall, John A. Alonzo, Sven Nykvist, Caleb Deschanel, and many others. The highest profile project of this kind was *Visions of Light* (1992), a well-received documentary celebrating cinematographic art and its best-known practitioners,

and largely dependent on interviews with contemporary figures like Zsigmond, Willis, John Bailey, Allen Daviau, and others familiar from the pages of *American Cinematographer*. Perhaps the cinematographer most vocal about authorship was Vittorio Storaro. Besides being identified with a number of highly idiosyncratic practices (especially his drafting of elaborate manifestos for color patterning in his films), Storaro proselytized for the cinematographer as auteur; the February 1995 issue of *American Cinematographer* featured his credo on the subject, "The Right to Sign Ourselves as 'Authors of Cinematography,'" in which he claimed the status of equal collaborator with the director on the visual look of a film.[97]

Though most practitioners held to the traditional position, stressing their professional subservience to the director and to the story, several directors of photography spoke of maintaining a consistent aesthetic approach, here continuing the discourse of cinematographers-as-auteurs that emerged in the art-genre period. As Christopher Lucas's following chapter argues, cinematographers would continue to engage in debates about the place of cinematographic authorship over the next decade—debates that would take on heightened significance in a time when the nature of cinematography itself would be put into question by emerging technologies.

The developments in American cinematography of the 1980s and 1990s encompassed both technologies (new film stocks, Steadicams, digital cinematography) and techniques (high-contrast lighting, saturated and patterned color, extremes of deep and shallow focus, and play with mobile cameras). More broadly, cinematographers employed these tools to develop a hyperbolic, eclectic, often allusion-laced, frequently authorially driven visual style—a style that goes above and beyond narrative function as an aesthetic goal. As much as techniques and technologies change, I would suggest that this stylization is a point of continuity in American film style from the 1970s through the present. If, as David Bordwell has remarked, films of the 1980s are like films of the 1960s only more so,[98] so I would suggest that the films of the 2000s and 2010s are much like the films of the 1980s and 1990s. Only more so.

6

THE MODERN ENTERTAINMENT MARKETPLACE, 2000–PRESENT

Christopher Lucas

In the late 1990s, Hollywood cinematography entered a period of profound technological disruption, arguably greater than any previous era in its history, greater than the dislocation and burst of invention that followed the rise of television and color cinema in the 1940s and 1950s, or even the temporary hardships and stylistic responses to the coming of sound in the 1930s. Through the 2000s, new tools and techniques, such as the digital intermediate (also known as digital grading), high-definition video and digital cameras, stereoscopic 3-D, and the commonplace mingling of live-action images with computer-generated images (CGI) disrupted long-standing hierarchies of creative authority and craft practice. Amid these disruptions, four stylistic tendencies emerged as distinctive of the period: the persistence of film, the new experiments with low-resolution imaging, the attempts to re-create film-look using video or data cameras, and the development of hybrid looks that treat each medium as a distinctive "stock" to be mingled within a single project.

Offscreen, the cinematographer was fighting to maintain status within the digital division of labor. Given their considerable aesthetic and technical authority in the production process, cinematographers proved instrumental in

translating, innovating, demonstrating, and establishing the value of many of the new technical and aesthetic practices, even as many in their number resisted digital tools and argued that the photochemical legacy of film and "film-look" should be preserved. As in generations past, the craft responded to these challenges by revising familiar practices to fit the new regime, such as exploring the aesthetic limitations and possibilities of high definition video and digital movie cameras, seeking a balance of aesthetic authority with newly powerful specialists such as colorists and digital effects creators, and helping standardize the quality of projected images for the benefit of film audiences. On the set, the traditional division of labor in professional camera crews was largely unchanged by these developments, although a few positions were created to manage new devices and processes. However, the prospect of assembling minimal crews, or even (alarmingly, for cinematographers) dropping the designated "director of photography" entirely became an intriguing possibility for some producers and directors. As of this writing, troubling questions remain for the future of cinematography as an art form and a profession, but the new millennium can be seen as a fertile time for cinema imaging, a time of debate and controversy, but also a period featuring many examples of beautiful and memorable cinematography to mark the start of a new technological era.

The Digital Turn

Digital Hollywood had many origins. Certainly, the perceived cost-benefits of digital distribution and projection played a large role, driving the major studios to coordinate an industry-wide transition to digital exhibition that accelerated after 2005 and moved the industry decisively away from its legacy technology, 35mm film stock and its numerous iterations.[1] The roots of the transition go farther back. Efficiencies in editing and visual effects integration, seen first in television and commercial production in the 1980s, demonstrated the viability of digitization in moving image production, applicable to cinema once higher resolution imaging could be achieved.[2] Through the 1990s, a transition to digital television distribution was coordinated on a national and supra-national level and, with the growth of the Internet, a presumed rise of online distribution played a significant part as well.[3] Digitization, in an increasing number of ways, was becoming the future of media.

Technology companies such as Sony, Texas Instruments, and Kodak (among others) invested enormous sums in the research and development of digital imaging for consumer and professional applications through the 1980s and 1990s. These efforts produced new digital techniques for scanning, revising, and reprinting film-based images, as well as high-definition video cameras that captured images suitable for large-screen presentations in music or corporate venues. By

the late 1980s, the Disney Corporation was using digital restoration to prepare its valuable library of children's titles for theatrical re-releases, and producers were using digital techniques for the remediation of scratched negatives, removing visible wires and other special effect apparatus.[4] Advanced visual effects houses like Digital Domain and Industrial Light and Magic focused on creating photorealistic digital animation, such as the dinosaurs in *Jurassic Park* (Steven Spielberg, 1993, d.p. Dean Cundey) and space shots in *Apollo 13* (Ron Howard, 1995, d.p. Dean Cundey), demonstrating the possibilities for virtual cinematography.[5]

For cinematographers, though, the digital intermediate or DI (also known as digital grading) was the first clear threat to the traditional practice of cinematography.[6] DIs added a new step in the postproduction process: a finished or nearly finished movie (photographed on film) could be scanned frame by frame as a computer file, permitting revisions and close "micromanipulations" of colors from shot to shot, or even within shots, for expressive effect.[7] In the late 1990s, the DI demonstrated that film-based moving images could be almost as malleable as photographic and video-based images. By allowing changes to color, shade, tone, and other visual qualities, it took a heretofore less complicated technical role, that of the color timer in a film lab, and gave it a range of creative possibilities, leading to an important new specialization, the colorist (as well as making visual effects personnel more instrumental to the finishing process). The DI undermined the cinematographers' familiar locus of authority, the film set, by shifting important creative decisions into digital grading suites or other postproduction locations where—and when—the cinematographer was typically "off" the project. Moreover, even if cinematographers were invited to participate in this process, they could not rely on being compensated for this additional work, which typically was not included in their contracts.[8]

Two films helped establish the craft discourse around digital grading at the end of the 1990s: *Pleasantville* (Gary Ross, 1998, d.p. John Lindley) and *O Brother, Where Art Thou?* (Joel and Ethan Coen, 2000, d.p. Roger Deakins). On *Pleasantville* a prototype application of digital grading was used to "de-colorize" and "re-colorize" portions of key shots, which centered on the intrusion of modern life (in color) on the black-and-white world of a 1950s sitcom. Although cinematographers had been among the loudest critics of manipulating color in the colorization debates of the mid-1980s, they generally accepted this new application of the technology.[9] To cinematographers, while *Pleasantville*'s use of color was a cinematographic gimmick, the technique of draining color from select scenes or objects was clearly motivated by the narrative; in realization it was more akin to a special effect than cinematography.

Pleasantville demonstrated the possibilities of digital grading in dramatic fashion, but it was the work of Roger Deakins on *O Brother, Where Art Thou?* that became the watershed moment for the DI process as a part of cinematographic art. In *O Brother*, the palette of the entire film was shifted, using a DI to create

a washed-out sepia tone that supported the Depression-era milieu of the story. Deakins, already an award-winning cinematographer and member of the BSC and ASC by 1998 (when production of film began), was a five-time collaborator with the film's writer/director/producer team, the Coen brothers. Deakins ultimately won several awards for his work on the film, and many cinematographers point to *O Brother* as demonstrating the value of the DI for cinematographers. Together, *O Brother* and *Pleasantville* were important moments for cinematography because the films pointed toward future debates over cinematographers' authority within digital modes of production. *Pleasantville* illustrated the need for cinematographers to adopt more flexible attitudes about the relationship of a film's look to its narrative. Meanwhile, *O Brother* asserted a traditional kind of craft authority in this setting, as Deakins, a respected cinematographer, shaped a consistent but still highly manipulated look using the DI process.[10]

The new cinematography would feature a multitude of such looks, complicated by a need to maintain unusual or difficult looks (on film) through an increasingly complex workflow. Within a few years, digital grading was a commonplace technique among studio pictures.[11] It was used to manage contrast effects and create surreal or hyper-real color effects, but also to establish a consistent look throughout a film—or even across multiple films, as in the case of the *Lord of the Rings* franchise (Peter Jackson, 2001–2003, d.p. Andrew Lesnie), which relied heavily on digital grading to maintain a consistent palette across the three films with a complex mix of live action and computer-generated imagery.[12]

By the early 2000s it was clear that cinematography could not be confined to principal photography if it were to retain its traditional authority. This new, broader definition was hardly a universally held conviction among cinematographers, for whom cinematography still meant the work of a crew, film cameras, and lighting instruments on the set. But it was clear to many cinematographers that in order to maintain any claims to authorship of a film's look they would have to find, or fight for, a role in postproduction, and, to the extent that such "postproduction" planning was taking place earlier in the process, in emergent stages such as pre-visualization as well. As Charles Swartz, director of USC's Entertainment Technology Center, put it:

I've said to friends, "I think we should call it the 'process that was formerly called postproduction,'" because it is a misnomer now. The role of the cinematographer was to create the image with the crew on the set and then pretty much guard that what ended up in the eventual movie as shown was what was intended on the set. And that is why we were sequential. There was production and then there was postproduction. But that doesn't exist anymore. With digital postproduction, you can do just about anything to that image that you want to without loss of quality.[13]

As these discussions of digital grading occupied cinematographers, the first generation of "non-professional" movie cameras also emerged as an alternative to film-based production for feature films. Consumer and high-definition video cameras were used to produce some notable film festival hits, notably *The Blair Witch Project* (Daniel Myrick and Eduardo Sánchez, 1999, d.p. Neal Fredericks), *The Cruise* (Bennett Miller, 1998, d.p. Miller), and *Chuck and Buck* (Miguel Arteta, 2000, d.p. Chuy Chavez), and a few television productions in the late 1990s. Cinematographers typically belittled or dismissed these cameras as far inferior to film and film cameras. After 1999, though, the so-called "film is dead" debate roiled the trade, spurred by George Lucas's investment in digital imaging as a solution to visual effects integration for the continuation of his Star Wars saga.[14] Lucas and acolytes like Robert Rodriguez adopted aggressive marketing efforts based on their "digital" cinema, and they struck an alliance with Sony Corporation, whose promotion of high-definition video equipment as a replacement for film soon rankled cinematographers as well.[15] The vociferous and heated reaction among cinematographers was at once an effort to protect the still-superior imaging quality of 35mm film, but also a growing recognition that their craft authority rested on film and its related techniques, a specialized technical knowledge suddenly threatened with obsolescence.

By 2002, the struggles over digital grading and high-definition video cameras (and prototype digital data cameras) had made it clear that digitization was rapidly overtaking cinematographers' craft practice. That year, Steven Poster, then president of the American Society of Cinematographers (ASC), reinvigorated that group's Technology Committee under the leadership of an experienced, tech-savvy cinematographer, Curtis Clark. Clark assembled a committee of cinematographers, colorists, digital imaging technicians, color and imaging scientists, and technology executives, and in doing so opened up the ASC's formerly narrow definition of membership to welcome a wider range of authorities on motion imaging.[16] The ASC Technology Committee included several members who also sat on the Academy of Motion Picture Arts and Sciences (AMPAS) Science and Technology Council, which had a relatively low profile in the early stages of digital cinema, surprisingly so considering their historical role as a promoter of technological innovation and change.[17]

Through its Technology Committee, the ASC sought to intervene in Hollywood's digital turn in several ways. Most significantly, it collaborated with Digital Cinema Initiatives (DCI), the consortium created by MGM, Paramount, Sony, Twentieth Century–Fox, Universal, Disney, and Warner Bros. to establish a common framework for digital exhibition. ASC cinematographers produced a test strip, the StEM (Standard Evaluation Material) mini-movie, used by manufacturers in their research and development efforts for digital cinema.[18] The StEM mini-movie was a fascinating visual artifact, carefully designed to be technically demanding on exhibition equipment, yet also laden

with an emotionally complex narrative context. It thus extended cinematographers' traditional conception of cinema—a big-screen experience with film-look aesthetics—as the benchmark for digital cinema. The first DCI Specification, released in 2005, provided criteria that shaped technical standards for projectors set by SMPTE (such as 4K resolution and color gamut) and enabled an industry-wide transition to digital exhibition that began in earnest in the latter half of the decade.[19]

With the release of the DCI Specification, digital Hollywood gained significant momentum. However, the specification pointedly refrained from prescribing standards for production technologies. Aesthetic experimentation, manufacturer R&D, and intense intra-industry competition raged among camera rental houses, postproduction and visual effects firms, and the whole range of dedicated vendors eager for a place in the new digital ecosystem. DCI had no interest in mediating that chaos, but the studios did jointly finance a Digital Cinema Lab, located in the old Hollywood Pacific Theatre and operated by USC's Entertainment Technology Center.[20] By sponsoring a venue to showcase new technology, as well as the DCI Specification to define technical limits, the studios served to organize the efforts of vendors that soon would be vying for the eyes and expense accounts of cinematographers. Numerous camera vendors joined Sony in attempting to establish a foothold in the digital movie camera business, including Dalsa, Thomson Electronics, and Red. Somewhat belatedly, ARRI and Panavision (by partnering with Sony) joined the digital fray but quickly assumed commanding positions, thanks to their specialized knowledge of cinema production and a legacy of relationships with cinematographers.

As a profession deeply invested in the particulars of its "gear," cinematography saw numerous less dramatic but significant technological developments through the decade in addition to new cameras, such as portable motion-control rigs, remote-control lenses, and the widespread adoption of electronic monitors to review takes on-set. The adoption of Kino Flo lighting through the 1990s—a lightweight, power-efficient form of fluorescent illumination—was followed in the 2000s by the rise of even lighter and more efficient LED (light-emitting-diode) instruments. Smaller, less power-hungry instruments made it easier to add professional touches such as eye lights or effects lighting for productions strapped for time or money. These technological developments increased the creative options available to cinematographers in what has been historically a profession with significant logistical challenges.

As these and other critical parts of the digital infrastructure fell into place (such as reliable storage, data transport and security methods, and on-set practices for managing new shooting routines and data handling), digital techniques began to supplant film in most areas of production. Panavision, ARRI, and Aaton announced they would no longer manufacture film cameras except by special order.[21] In July 2011, the two dominant film-based service providers in North

America, competitors Technicolor and Deluxe, took the remarkable step of creating cooperative subcontracting agreements that allowed each to shut down major portions of their film processing and printing operations, drastically reducing their film-based staffing and facilities in the process. "The death knell for 35mm film production," *Variety* reported, "has just gotten a lot louder."[22] In 2012, Kodak reduced its line of motion picture film stocks, and Fujifilm announced that it would discontinue manufacturing film entirely, shifting its energy to digital product lines.[23] To bring exhibitors into the digital fold, the studios established virtual-print-fee contracts that allowed exhibitors to finance new equipment, and, as the virtual-print-fee contracts were poised to expire in 2013, exhibition was well on its way to a complete digital changeover.[24]

Post-2000s Cinematography

By far the most controversial and widely debated development in cinematography over the last ten years has been the decline of film as the dominant capture medium. Since the late 1990s Hollywood studios have focused intently on developing big-budget "four quadrant" franchises in the mold of *Harry Potter* and *The Hunger Games*, while constantly scouting the market for independently produced mid-range pictures to fill out their schedule with star vehicles, well-crafted genre series, or prestige pictures.[25] In most of these production contexts, film remained the medium of choice (albeit quickly digitized for postproduction). If we consider independent productions and the rise of 3-D and animated movies, though, it becomes clear that a significant number of important movies through this period were the product of video or digital imaging. In choosing alternative formats, some pioneering filmmakers, such as Dogme 95 adherents Lars Von Trier and Harmony Korine, claimed lofty philosophical goals; others, like members of the so-called "mumblecore" movement mid-decade, cited the cost benefits of avoiding photochemical stock and processing.[26] Whatever the rationale, alternative production techniques and the stylistic innovations that accompanied them were, for many filmmakers, useful signifiers of independence from Hollywood's traditional mode of production at a time when conglomerate Hollywood seemed more monolithic than ever.

With a few notable exceptions, film-look remained an important touchstone for filmmakers and cinematographers through this period. As Tom Gunning has written, despite the anxiety and debate over new imaging technologies, film and video sometimes appeared to be "converging," rather than diverging over the decade.[27] David Rodowick describes one of the conceptual difficulties with the emergence of digital capture as the "paradox of perceptual realism." The achievement of ever-better photographic realism has driven the science of digital imaging (be that in camera or CGI), even as the objects of our photography

have become more malleable and "virtual"—that is, with no real-world analogue. Certainly the concerns of cinematographers were shaped by this imperative to improve the tool box for photographic realism rather than challenge it.[28] Still, a survey of notable films produced in the nascent days of digital cinema reveals four principal responses to the new technological regimes: the valorization of film (and film-look) with an accompanying resistance to new formats and looks; the adoption of a low-resolution "digital" realism that to some extent did subvert traditional notions of perceptual realism; the integration of special effects that valued spectacular artificial world-building over realism; and the experimentation with hybrid looks that sought to combine film-look with alternative looks. In addition to these four, virtual cameras, stereoscopic 3-D, and high-frame-rate motion imaging further blurred the boundaries between cinematography and other craft areas in the post-celluloid era.

The Persistence of Film

There was some irony in the obsessive attention paid to digital technique after 2000, because film manufacturers were making remarkable improvements to film stocks even as digital capture threatened them with obsolescence. New stocks, including Kodak's VISION (1996) and VISION2 (2002) and Fuji's Super-F (1990) and Eterna (2004) lines, offered improved latitude and dense grain structure that allowed new capacities for designing looks, as well as new flexibility in postproduction. The quality of these stocks, when coupled with the digital intermediate in the early 2000s, extended the viability of film as a capture medium while other parts of the workflow were turning to digital, and presented filmmakers with exciting creative options. Many modern films showcased remarkable photography in a stylistic environment freed up by digital experimentation and new digital postproduction tools.[29] For example, films such as *The Man Who Wasn't There* (Joel and Ethan Coen, 2001, d.p. Deakins) and *Good Night, and Good Luck* (George Clooney, 2005, d.p. Robert Elswit) featured crystalline black-and-white photography, a throwback to an earlier age of cinematography, although both films were shot on color film stock and desaturated in post (the former photochemically, the latter with a DI). Some directors, notably Steven Spielberg and Christopher Nolan, proclaimed that they would never abandon film, sentiments echoed by their favored cinematographers, Janusz Kaminski and Wally Pfister, respectively. This resistance was not surprising as the flexibility of film was demonstrated many times over the decade by broad application across genres, periods, and creative visions. Film captured the beautiful landscapes of *Brokeback Mountain* (Ang Lee, 2005, d.p. Rodrigo Prieto) and *True Grit* (Coen, 2010, d.p. Deakins), as well as sharply different urban environments like those found in *Michael Clayton* (Tony Gilroy,

FIGURE 6.1: A complex composition in the midst of an extended fight scene in *The Dark Knight Rises* (2012).

2007, d.p. Elswit) or *The Dark Knight* franchise (Nolan, 2005–2012, d.p. Pfister). *The Dark Knight* films, in particular, shot on film with sequences in the IMAX format, demonstrated that effects-heavy studio franchises did not have to forgo sophisticated visual design, offering a wide variety of looks: grim prison tableaux, romantic dinners, daylight street scenes, slashing chiaroscuro (see figure 6.1), and more.

Hong Kong–based cinematographer Christopher Doyle was one of the most outspoken defenders of film, leveling occasionally intemperate broadsides against new cameras and early adopters.[30] Doyle's much-admired work in Asian and Australian cinema gave him considerable voice in these debates. Still, it was the frontier where film met digital post-techniques where the most memorable cinematography was being created. Epic dramas as varied as *Cold Mountain* (Anthony Minghella, 2003, d.p. John Seale) and *The Aviator* (Martin Scorsese, 2004, d.p. Robert Richardson) used digital intermediates supervised by their cinematographers to create distinctive palettes suggestive of their periods. *The Aviator*'s vibrant Technicolor-inspired hues were the product of specially created "look-up tables" of color information applied in postproduction, memorably supporting the mid-century setting in narration and form alike (color plate 14).

Dark fantasies like *Children of Men* (Alfonso Cuarón, 2006, d.p. Emmanuel Lubezki) and *Black Swan* (Darren Aronofsky, 2010, d.p. Matthew Libatique) also co-mingled film with digital methods to suggest remarkable new possibilities for the look of cinema. In *Children of Men*, separate shots were stitched together to simulate long takes that would have been physically impossible to stage with film cameras; in *Black Swan*, Libatique used the mobility of the 16mm camera and the visible grain of the small gauge stock, in conjunction with digital post-processing of colors and cameras "painted out" of the film's many mirror shots, to create a distinctively fluid and gothic feel (figure 6.2).[31]

FIGURE 6.2: Visible grain and intrusive close-ups are combined with digital effects in *Black Swan* (2010).

Low-Resolution Realism

Black Swan was notable for combining low-budget grit with advanced digital techniques in a film-based context. Earlier in the decade, video-based photography had often demonstrated, and even celebrated, a similar lack of visual polish. Cinematographer M. David Mullen has used the term "low-resolution realism" to describe this technique of underscoring the authenticity of a drama through nonprofessional formats.[32] The style has clear historical precedents in Italian Neorealism, French New Wave, *cinéma vérité*, and the American independents. Of course, all these movements developed within film-based cinematography, although each took advantage of technological developments that eased the burdens of the film-based workflow. Starting in the late 1980s some well-known films, such as *Sex, Lies, and Videotape* (Steven Soderbergh, 1989, d.p. Walt Lloyd) and *JFK* (Oliver Stone, 1991, d.p. Richardson), deployed video-look as a device for connoting flashbacks and a psychological or historical authenticity. By the late 1990s, though, video was used increasingly as a look of its own that often suggested a sort of anti-style, or even hostility to Hollywood polish.

The Danish Dogme 95 movement (1995) codified such a position in its so-called "vows of chastity" that prescribed handheld cameras, 35mm film, and natural light, while rejecting filtration or other manipulations of the cinema image. Tellingly, and in spite of the rule stipulating the use of 35mm, three of the early "certified" Dogme films were shot using video: *Dogme #1: Festen* (Thomas Vinterberg, 1998, d.p. Anthony Dod Mantle), *Dogme #2: The Idiots* (Von Trier, 1998, d.p. Von Trier), and *Dogme #4: The King Is Alive* (Kristian Levring, 2000, d.p. Jens Schlosser). Meanwhile, in the United States, *The Blair Witch Project* adopted an aggressively uncrafted look using handheld cameras, high-contrast video, and grainy 16mm in the service of a horrific "faux-documentary." A

genuine box office phenomenon, *Blair Witch* inaugurated a popular new genre of "found footage" narratives and made a strong case for the power of gripping scenarios over traditional visual gloss, at least for some kinds of stories.

Several video-based dramas were released by influential American independent filmmakers in the years that followed, most notably *Julien Donkey-Boy* (Korine, 1999, d.p. Dod Mantle), *Bamboozled* (Spike Lee, 2000, d.p. Ellen Kuras), and *Tape* (Richard Linklater, 2001, d.p. Maryse Alberti). Distinct in tone and style, these films ranged from Korine's kaleidoscopic, experimental multimedia collage, to Lee's stylized send-up of television's zero-degree style, to Linklater's low-key theatrical drama. Mike Figgis, a British director best known for the breakout 16mm drama *Leaving Las Vegas* (1995, d.p. Declan Quinn), also created two experimental feature films using video: *Timecode* (2000) and *Hotel* (2001), both photographed by Patrick Alexander Stewart. *Timecode* represents one of this period's more radical experiments with video-look, featuring four simultaneous narratives unfolding on the screen at once (figure 6.3).

Photographed in real time with newsgathering cameras by four camera operators (including Figgis), the entire story was performed and recorded fifteen times before achieving a satisfactory "take." The low-key, documentary-style look makes unique demands of the viewer, forced to move screen to screen to follow four points of view that crisscross Los Angeles before converging on a single location, guided only by a subtle privileging of the sound track and pre-arranged framing choices. *Timecode* was in many ways a triumph of camera operating rather than cinematography, but it represents Figgis's auteurist resistance to what he considered cinematographers' entrenched conservatism and

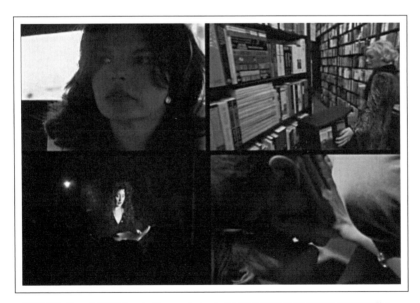

FIGURE 6.3: In *Timecode* (2000), four simultaneous ninety-minute takes converge on the dramatic climax in a film director's office.

worship of film-look. For cinematographers in whatever medium, Figgis said, "Excellence would be defined as clarity, as representational authenticity, color rendition, absence of grain."[33] With the decline of film, he hoped, cinema might become more "impressionistic."

After 2000, cinematographers on video-based features were nominated routinely for awards in the increasingly visible Independent Spirit Awards, including Dod Mantle for *Julien Donkey-Boy*, Ellen Kuras for *Personal Velocity: Three Portraits* (Rebecca Miller, 2002), and Derek Cianfrance for *Quattro Noza* (Joey Curtis, 2004), a fact not lost on younger cinematographers. Steven Soderbergh was a prominent and prolific early adopter of low-resolution realism, shooting a series of low-budget naturalistic dramas on video, including *Full Frontal* (2002) and *Bubble* (2005). While he continued to produce popular entertainment through this period (such as the *Ocean's 11* series), Soderbergh developed a virtual parallel career using highly independent, digitally based production methods to make less commercial projects. These films often veered into experimental territory, as with *Che, Parts 1 and 2* (2008) and *The Girlfriend Experience* (2009), but he continued to explore this style in genre fare such as *Contagion* (2011) and *Haywire* (2012), often borrowing liberally from documentary and *cinema vérité* (see color plate 15). All of the above titles were photographed by the director himself, using the pseudonym Peter Andrews. Like Mike Figgis, Soderbergh was keen to operate his own camera and move quickly, often eschewing preset lighting. Critics Andrew deWaard and R. Colin Tait have described an oscillation in Soderbergh's films between classical formalism and a "chaotic" style focused on speed, mobility, and independence from the traditional mode of production.[34] An underlit look, liberal use of silhouette and tinted frames, and a noted lack of flattering modeling on the actors' faces, eye lights, or other stylistic niceties have become signatures in Soderbergh's low-budget work. For the most part, Soderbergh's video- or digitally based films performed modestly at the box office, until *Magic Mike* (2012), a sprightly star-is-born tale whose combination of light comedy, romance, and brush-by prurience surprised many as a sleeper hit. Despite a mixed record with audiences, these and other video-based features continued to receive considerable critical notice, thanks largely to their celluloid-free novelty and the "auteur" directors standing behind them.

The Search for Film-Look on Video

Alongside low-resolution realism, some films demonstrated what would become a prevailing theme over the decade: the effort to obscure the cinematography's origins in video. *The Anniversary Party* (Alan Cumming and Jennifer Jason Leigh, 2001, d.p. John Bailey) and *Jackpot* (Michael Polish, 2001, d.p. M. David Mullen) were dramatic features in which the filmmakers did their best to hew to

classical form and re-create film-look. Video cameras had a tendency to "blow out" highlights, were ill suited for creating depth of field effects, and usually suffered poor color rendition compared to film. Stuck with such limitations, these movies may seem examples of "low-resolution realism" in action, but rather they showed that a thoughtful shooting plan and careful avoidance of certain lighting situations made it possible to bridge the gap between serious video- and film-based cinematography.

Jackpot was one of the first features to use a new 24-frame-per-second high-definition video camera (a collaboration between Sony and Panavision marketed as CineAlta). The shift to 24 fps was seen by many as a qualitative improvement over video's usual 30 fps. The most widely seen features in this period used the CineAlta, not for dramas but to better integrate live-action photography with extensive visual effects workflows. George Lucas used the CineAlta in his move to video-based photography for *Star Wars: Attack of the Clones* (2002) and *Star Wars: Revenge of the Sith* (2005).[35] In remounting the *Star Wars* franchise, Lucas hired a trusted collaborator, cinematographer David Tattersall. Tattersall had experience with film-based photography on Lucas's *Radioland Murders* (Mel Smith, 1994) and with creating cost-sensitive combinations of film- and visual-effects workflows on the Lucasfilm-produced television series *The Adventures of Young Indiana Jones* (1992–93). Despite the professional pedigree of its creators, the look of the *Star Wars* prequels only served to confirm the fears of many cinematographers, who judged them to be unattractively flat and unexpressive. The look was more akin to television than cinema, and the cinematography was subservient to visual effects processes such as integrating live actors with CGI characters like Yoda or Jar Jar Binks (figure 6.4).

Robert Rodriguez, with encouragement from Lucas, used the CineAlta for *Spy Kids 2: Island of Lost Dreams* (2002), *Once Upon a Time in Mexico* (2003, shot in 2001), and several later films, filling the role of cinematographer himself. Cinematographers watched these developments with great interest and considerable

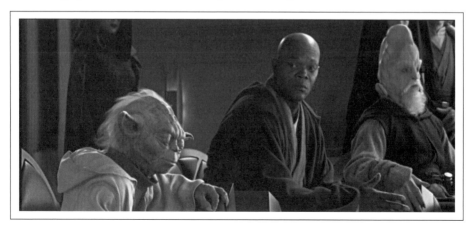

FIGURE 6.4: Video-based cinematography facilitated the inclusion of CGI characters in *Star Wars: Attack of the Clones* (2002).

skepticism, especially as Lucas adopted the role of digital evangelist, vouching for the new technology across the Hollywood trade press.[36] The more cynical among them noted Lucas's longstanding relationship with Sony and Sony's enormous advertising budget in the trades. However, unlike Rodriguez, who ceased to hire professional cinematographers after *Once Upon a Time in Mexico* and (like Figgis and Soderbergh) began operating his own camera, Lucas continued to use seasoned professionals such as Tattersall for the *Star Wars* films and other projects. This difference revealed much about Lucas and Rodriguez's vastly different relationships with the Hollywood studios and the greater production community. Lucas continued to work closely with craft guilds, the trade press, and other institutions, spinning a story of digital inevitability, while Rodriguez was most visible as an antagonist to traditional production methods, decrying Hollywood in a series of interviews and engaging in public battles with the craft unions—battles discussed below.[37]

Considerable press attention was lavished on new cameras in this period, especially their frame rates, resolution, light sensitivity, and other specifications of their high-tech sensors, often leading to widespread confusion as to where the lines between video, digital, and digital-video should be drawn. Less attention was paid to the lack of professional quality lenses for the new generation of cameras. Without quality "glass," the cameras were limited by lenses developed for the video-based sensors, with inferior resolving power, less ability to pass light through to the imaging chips, and distortion problems profoundly unappealing to professional cinematographers. The next generation of Sony/Panavision cameras, the Genesis (2004), sought to correct these problems by adopting a larger sensor (the same size as a 35mm frame) and a new design configured to accept Panavision's Cine Primo lenses, leading to depth-of-field performance much closer to film-based cinematography and further reducing the distance between video-look and film-look. Generations of lenses and imaging chips that followed continued to bring video and digital cameras closer to the affordances of film imaging.[38]

Low-resolution auteurs and special-effects integrators demonstrated to audiences and filmmakers alike the new possibilities of digital cinema. Despite the wide discussion of those films, though, critics and professional cinematographers largely dismissed the photography of these early video features as experimental dead-ends, amateurish, or worse: recalling the flat, overlit style of some series television. Cinematographers pointed to most of these films as examples of producers' misguided rush to adopt video and digital production methods for dubious cost benefits and the burst of free press they received for joining the "digital cinema" revolution.[39] The complaints weren't unfounded, but they also ignored an important point. In many cases the low-resolution realists and special-effects integrators alike were breaking with traditional production structures, challenging the impersonal, market-tested storytelling conventions of the studio system and testing new divisions of labor. In doing so, they demonstrated,

for better or worse, how efficiencies in the production workflow could increase authority for the producer or director, and how malleability of the image through postproduction might outweigh the aesthetic benefits of careful cinematography and film-based imaging.

From Video-Looks to Digital-Looks

From early in the decade, some filmmakers had been using the different visual qualities of video, digital, and film photography, at times co-mingling them to create novelty and visual contrast. Richard Linklater's *Waking Life* (2001, d.p. Linklater and Tommy Pallotta) and *A Scanner Darkly* (2006, d.p. Shane Kelly) used consumer video as the basis for a digital rotoscoping process that merged live action with animation to create colorful, dreamlike scenes and landscapes.[40] Similarly, Jonathan Caouette's *Tarnation* (2003, d.p. Caouette) was a mélange of visual media, animation, stills, film, and video that seemed, by turns, documentary, fiction, and therapeutic hallucination. An update of the pandemic disaster movie, UK import *28 Days Later* (Danny Boyle, 2002) was shot by Anthony Dod Mantle (often associated with the Dogme movement) using an adapted Canon XL-1, a camera typically used for industrial applications. Dod Mantle's cinematography used the jittery, low-resolution, and desaturated images of the low-grade camera to enhance the mood of fear and imperfect visibility that pervades that film. Dod Mantle later won an Academy Award for his work on *Slumdog Millionaire* (Boyle, 2008), a film that freely mingled film, video, and digital imaging to shift spatial and temporal contexts as the story moves through the Indian city of Mumbai and its environs. These films were neither low-resolution realism nor special effects spectacles, but they explored the new formats as the basis for looks unto themselves.

Studio filmmakers also experimented with video movie cameras to create novel cinematic looks within predominantly film-based movies. A few boxing scenes in *Ali* (2001, d.p. Emmanuel Lubezki) featured video-based photography, a decision described by director Michael Mann as an "experiment," and a way to distinguish the boxing scenes from the rest of the film.[41] A few years later, Mann directed *Collateral* (2004), having his cinematographers Paul Cameron and Dion Beebe use a combination of film, video, and a recently developed digital data camera, the Viper FilmStream (data cameras recorded visual images as raw data files rather than encoding them in a video format). Mann drew inspiration from the muddy blacks provided by the cameras, which supported the grim plot of a working-class taxi driver conscripted by a high-end assassin.[42] As the characters work their way across Los Angeles over the course of a single night, the sensitivity of the camera's sensors allowed for very low light conditions in a variety of settings while holding the movie's urban backdrop in relatively sharp focus (color plate 16). The hybrid look of *Collateral* received mixed reviews, but the

predominantly data-driven workflow of the film attracted much attention within the craft community, as did Mann's later digitally originated films *Miami Vice* (2006, d.p. Dion Beebe) and *Public Enemies* (2009, d.p. Dante Spinotti). As Gerald Sim has noted, Mann was willing to use "digital-looking images in disruptive ways," well outside the mainstream of cinematographic practice and, by being an exception to a rule, may have demonstrated the persistence of film-look as an aesthetic benchmark for the industry.[43] Still, what links the cinematography of these films is their use of video or digitally originated images as a new kind of imaging "stock." Rather than rejecting video as inferior to film or trying to mask the alternative medium, producers, directors, and cinematographers were becoming more open to the visual possibilities of new formats.

Most cinematographers saw this as consistent with the continuing "evolution" of film language, rather than a dramatic break with past practice. As Stephen Lighthill remarked:

> There's a sort of deconstructionism in a sense, of the visual language, that there wasn't a generation ago. You see slow motion being used extensively. It's very much part of the language now. You need to know how you can put the movement and shutter out of sync [to create the influential "strobe" effect Janusz Kaminski utilized in the battle scenes in *Saving Private Ryan* (Spielberg, 1998)], and they are manufacturing cameras with that built into just because it's part of the language now.[44]

In evoking "deconstructionism" here, Lighthill is alluding to how the affordances of film as a capture medium were coming under scrutiny, with new technologies seen as creative tools rather than just cheap alternatives. Video- or digital-based cinematography was being re-imagined as a particular "look" that might have value in particular narrative contexts. Rejecting the tale of obsolescence, some cinematographers began to welcome a plethora of new cameras into their creative portfolio.

Zodiac (2007) was the first Hollywood live-action feature to use digital data cameras exclusively. Directed by David Fincher and photographed by Harris Savides, *Zodiac* portrayed the fruitless search for a serial killer in 1970s San Francisco and featured a murky, low-light atmosphere that recalled other Fincher films like *Se7en* (1995, d.p. Darius Khondji) and *Fight Club* (1999, d.p. Jeff Cronenweth) in tone and visual style. Savides's account of preparing to photograph the film with the data camera stresses the work of adapting to the new technology. *Zodiac*'s production was beset by technical issues, including problems with unstable storage media, electronic interference on-set, and dead pixels in the camera sensors.[45] Savides expressed frustration with the ergonomics of the camera, including a poor viewfinder (in digital cinematography most crucial decisions shift to the "video village" tent where banks of calibrated monitors show captured images in better detail than a viewfinder), the encumbrance of umbilical cables between

FIGURE 6.5: In *Zodiac* (2007), cinematographer Harris Savides worried that the high-resolution images felt "synthetic."

camera and recording decks, and the constant presence of the "digital imaging technician" to manage the machines. He describes extensive testing with the Viper camera, doing "as many things 'wrong' as I possibly could," such as over- and underexposures, extreme contrasts in a single frame, the range of possible key-to-fill ratios, and printing test footage all the way through the release-print stage to map the entire workflow.[46] The need to pretest equipment in this way has become a standard expectation for cinematographers, building each workflow anew with every project. Savides told *American Cinematographer* that he lit the scenes as he would for film, striving for "invisible," "naturalistic" light, but also described the Viper's images as "hyper-real" and working against the period setting of the film, while (perhaps contradictorily) also feeling "synthetic," like a cibachrome photo, albeit with such high resolution that the hair and pores of the performers were distractingly visible (see figure 6.5).

Fincher's account of the camera's look is strikingly different, arguing that its synthetic quality could be seen as a feature, which "came to support what we were doing with this particular film. It feels like a news report, not a Hollywood movie."[47] Savides and Fincher are both noted stylists, and such disagreements are hardly new in film production. But the capacities of the new digital cameras, especially when they clashed with cinematographers' traditional conceptions of beauty and realism, made the mid-2000s a period of significant discontent for cinematographers and generated much creative friction between collaborators.

Computer-Generated Imagery

Even as Hollywood cinematographers adapted to the potential of new looks with new cameras, they grappled with the capacities of photorealistic imaging. The rise of CGI through the 1990s meant that visual effects designers were increasingly

responsible for landscapes, objects, color palettes, lighting, and other decisions that cinematographers in the past would reasonably expect to consult on, if not take the lead in creating. As visual effects techniques became more sophisticated, visual effects personnel turned to the challenge of creating photorealistic images to better integrate with live-action photography. The largest strides in this area came in the mid-1990s, when films like *Jurassic Park*, *Babe* (Chris Noonan, 1995, d.p. Andrew Lesnie), and *Twister* (Jan De Bont, 1996, d.p. Jack Green) demonstrated almost seamless integration of visual effects with live-action images. Artifacts of movie photography such as motion blur, lens flare, camera shake, and depth-of-field effects were increasingly replicated in CGI after 2000.[48] While some of these effects (such as lens flare) had some precedent in film language, others would have been seen by past generations of cinematographers as a mark of poor craftsmanship. In a CGI-dominated cinema, they increasingly connoted photorealism, film-look, and a mark of authenticity, yet another adjustment to film language cinematographers would have to adopt.[49]

The virtual camera was another example of synthetic imagery combined with live-action photography. The notion of a disembodied camera eye performing remarkable if physically impossible moves originated in art photography and various CGI contexts, most prominently in video games. An increasingly ubiquitous form of visual culture through the 1990s, console and PC games often utilized cinematic language in cut scenes and game play, although, by virtue of their "virtual" locations and built worlds, game designers could deploy novel and spectacular camera moves and perspectives unavailable to cinematographers. *The Matrix* (Andy and Larry Wachowski, 1999, d.p. Bill Pope) was one of the first films to adopt a virtual camera effect, soon widely replicated in other movies and in television commercials, becoming what Bob Rehak has described as a "microgenre" unto itself.[50] CGI-assisted camera movement became increasingly commonplace after 1999. In Fincher's *Panic Room* (2002, d.p. Conrad W. Hall and Darius Khondji), the camera executes several virtuosic moves in long takes that defy physics as the camera passes through walls, windows, and, most memorably, the handle of a teapot. The aforementioned *Children of Men* used a similar technique stitching dramatic camera moves into elaborate action set pieces, as in the "web-slinging" sequences in *Spiderman* (Sam Raimi, 2002, d.p. Don Burgess) and its many sequels, some battle scenes in the *Lord of the Rings* series, and the shot in *Rise of the Planet of the Apes* (Rupert Wyatt, 2011, d.p. Lesnie) in which the lead ape, Caesar, flings himself to the top of a forest canopy as the camera follows. The place of the cinematographer in the visual design of such sequences varies from project to project, yet in most cases the look of the movies in question was credited in the trade press as a product of the director of photography, even as credit sequences portrayed a much more complicated landscape of authorship. Devising techniques for managing the ambiguities of this situation has preoccupied cinematographers for much of the last decade.

3-D Cinematography

As cinematographers grappled with digital grading and new cameras, virtual or otherwise, digital-based stereoscopic 3-D filmmaking was emerging out of the more specialized branches of the industry—large-format nature documentary and theme park rides—into feature production. *T2 3-D: Battle Across Time* (1996), a theme park attraction produced by James Cameron for Universal Studios, was an important early test for large-format stereoscopic 3-D. The short had two credited cinematographers: Russell Carpenter, ASC, an experienced director of photography who had collaborated with Cameron on *True Lies* (1994) and was already engaged for *Titanic* (1997), and Peter Anderson, a cinematographer who specialized in 3-D production. *T2 3D* was photographed on 70mm film, with considerable difficulty. However, high-resolution video cameras, with better on-set control, image registration, and postproduction correction tools, reduced the cost and hassle of 3-D considerably after 2000.[51] In 2003, Rodriguez released *Spy Kids 3-D: Game Over*, the third installment of his popular franchise, surpassing the domestic box office for *Spy Kids 2* and almost equaling that of the original film.[52] Wider diffusion of DCI-compliant digital projectors enabled neighborhood cinemas to program digital 3-D titles, and over the next few years more 3-D films were released. *The Polar Express* (Zemeckis, 2004, d.p. Burgess) was the first studio feature to use 3-D and the first to rely on motion-capture for all its performances.[53] The next year, Disney's *Chicken Little* (Mark Dindal, 2005) became the first major animated film released in 3-D. All these 3-D films were judged successful enough to spawn follow-ups, including Rodriguez's *Sharkboy and Lavagirl* (2005) and Zemeckis's *Beowulf* (2007, d.p. Robert Presley). Many drew large audiences despite a lukewarm critical reception and, at a time of general box office decline, provided a rare bright spot for exhibitors. The promise of 3-D helped spur the transition to digital projection in the multiplexes after 2007.[54]

The cinematographic prospects for 3-D—as photography rather than special effect—were not widely discussed among cinematographers until the emergence of studio-produced live-action 3-D spectacles, most notably *Journey to the Center of the Earth* (Eric Brevig, 2008, d.p. Chuck Shuman). Before shooting *Journey*, Shuman had been a long-time visual effects cinematographer and head of the miniatures unit on the *Lord of the Rings* series. In April 2008, ASC associate member Rob Hummel, an influential technologist and former executive, wrote a feature on 3-D in *American Cinematographer* entirely devoted to the science and logistics of the technique. Much discussion around 3-D centered on the degree to which 3-D glasses worn by audiences dimmed the brightness of the cinema screen, affecting contrast and color rendition. Working within firmly established genres like action-adventure, 3-D cinematography largely adhered to the norms of classical style, though with an added emphasis on the virtual camera and

other spectacular effects, such as "gotcha" shots in which objects leapt "out" of the frame toward the viewer.

The production of *Avatar* (2009) demonstrated greater, and more prestigious, possibilities for 3-D cinematography, as producer-director James Cameron and cinematographer Mauro Fiore focused on using 3-D to more fully engage the audience in the movie's setting, the alien moon Pandora. As characters in *Avatar* slipped back and forth between a live-action military base and Pandora's CGI-rendered wilderness, so too did the camera slip between live action with embodied actors and animated action with motion-captured performances of the native population in a virtual location. 3-D imaging helped link the contrasting visual registers of the story and added verisimilitude to the fantastical environments through faux-photorealistic photography and the use of depth effects. The visual spectacle of *Avatar* was widely praised, and Fiore won a 2010 Academy Award for his cinematography. Two years later the Academy Award for Cinematography went to another 3-D film, *Hugo* (Scorsese, 2011). A predominantly live-action period adventure, *Hugo* was set in a whimsical, dreamlike Paris at the dawn of the age of movies. Scorsese, working with his frequent cinematographer Robert Richardson, used 3-D to create depth effects that generally avoided clichéd 3-D "gotcha" shots. Repeatedly, Richardson composes complex frames with fore-, middle-, and background action that emphasize the depth of the frame, reinforced by effects (like billowing smoke and extras, some real, some virtual) to evoke the busy, lived-in world of a nineteenth-century train station (see figure 6.6). The story, which centered on the relationship between an orphaned boy and cinema pioneer Georges Méliès,

FIGURE 6.6: In *Hugo* (2011), compositions in depth emphasize 3-D without the "gotcha" effects commonplace in 3-D adventure movies.

thematically linked the wonders of early moving pictures with the marvels of cinema's technological progress, including 3-D.

Despite the success of some post-*Avatar* 3-D cinematography, there remains considerable ambivalence about 3-D's contribution to the craft. The recent rush to convert conventionally photographed movies into 3-D in postproduction (as in the widely panned *Clash of the Titans* [Louis Leterrier, 2010, d.p. Peter Menzies, Jr.]) and to convert old studio hits into 3-D titles for re-release (as with recent Pixar reissues) presented yet another troubling case in which cinematographers saw their work as manipulated or reimagined without their input. While the so-called "Z-space" can add to the perception of depth within the frame, cinematographers have questioned the assumption that this contributes to better audience identification or involvement with the story. As Ben Walters writes, the technical grammar of 3-D presented problems for classical cinematography. Whereas lens and focal distance choices were traditionally made in light of narrative motivation, continuity, and shot variety, now the impact on the 3-D effect had to be considered as well. Shot duration and camera movement were effected, as rapid cutting, panning, or zooming can easily become disorienting in 3-D space. Lastly, some reliable cinematography "cheats," such as foreshortening stage combat and eye-line matching, could be ruined with the addition of 3-D space. New variables such as interocular distance had to be considered. The classical goal of drawing audiences into the narrative—that is, the cinematographers' search for images that support, but do not overwhelm, the story—often conflicted with the impulse to use 3-D for spectacular effects, such as chase scenes, explosions, or "roller coaster" moments.

Cinematographers often find themselves working in tension between classical principles and the development of less coherent, more spectacular styles present in much big-budget, effects-driven blockbuster and genre filmmaking. David Bordwell has argued that classical Hollywood style persists in this cinema through an "intensified continuity" style of shorter takes, a variety of focal distances, and greater camera mobility.[55] To the extent that cinematographers design such shots and continue to conceive of their visual choices as driven by narrative, they have been in a position to influence changes in style through the New Hollywood and blockbuster eras. Indeed, it is in these big-budget effects-driven films where cinematographers' influence is typically at a nadir, where they are most often charged with realizing, rather than conceiving, the visual design of cinema, and this may help explain some of the eclectic, sometimes disharmonious, looks in modern cinema. This isn't to say that cinema depended upon cinematographers for narrative coherence, but it suggests that craft work, as organized by the narrative plan of a script and the interpretative priorities of a director, has mediated the development of new techniques and has contributed, to some extent, to the persistence of Hollywood classical style.

Cinematographers and the Digital Division of Labor

Amid these challenges to the style and presentation of cinema in the digital era, cinematographers faced growing uncertainty about their authority in the traditional division of labor of movie production. We have seen how digital grading, pre-visualization, photorealistic visual effects, and other techniques undermined the cinematographer's position as primary visual architect of the look of films. As digital techniques became more widespread, the cinematographer's role has shifted from one of relatively unquestioned singular authority (if in close consultation with the director and production designer) to one of more diluted authority among several members of a visual design team. Certainly cinematographers are still valued for their eye for color and composition and skill at interpreting narrative moments into visual language. Nonetheless, cinematographers have felt compelled to assert their relevance to the production process as the malleability of digital cinematic images opened the field to more "collaborators" and opportunities to revise the visual design of a picture elongated into pre-production and postproduction phases.

Union rules and the continued reliance on networks of freelance labor in work teams have protected camera departments to some degree from dramatic upheavals in the digital era, although, as Susan Christopherson has written, studios' search for non-union, offshore, and less scripted forms of production has put enormous pressure on all craft areas, including cinematographers.[56] Increased affordances of the new generation of cameras and the broader acceptance of non-classical images in some genres meant that near-professional imaging could be achieved with less crew on some projects. Some noted directors, such as the aforementioned Soderbergh and Rodriguez, ceased using cinematographers and operators at all. A minimal crew and the relatively unlimited recording "magazine" that video and digital cameras provide led to some new production practices, such as increasing numbers of takes and more spontaneous shooting plans. Some cinematographers expressed a feeling of loss in this new free-form style and claimed that filmmakers, freed by higher shooting ratios, had lost a feel for the decisive moment, when crew, technique, performance, and direction converge to create a scene of indelible cinema, captured only at great cost and effort by everyone involved. However we choose to assess the romantic notion of a cinema of decisive moments, we can detect in it a fear for the future of the craft. Even as cinematographers proclaimed loudly that rumors of the death of film were greatly exaggerated, they were quick to grasp the threat of de-skilling and automation to render them replaceable and make their finely tuned professional eye an expensive option rather than an unavoidable necessity.

The contours of this struggle can be seen in discussions that erupted among cinematographers over *Avatar*. At issue was the extent to which the film was "photographed," and whether Mauro Fiore, the credited director of photography, was

the cinematographer in the traditional sense. When Fiore was nominated—then won—an Oscar for his work on the film, the debate was given new urgency. *Avatar* struck nerves already exposed by digital cinematography's potential threat to the authorship of cinema images: concerns about extensive pre-visualization of a film's scenes and look, control of the dominant palette, virtual sets and illumination, digital movie cameras, and post-processing. There was ambiguity around Fiore's role in all these processes. On professional discussion boards frequented by cinematographers, the professionals asked: What was possible to know about Fiore's creative contribution to this project? Was this ambiguity the future of cinematography writ for all to see? Discussions like these led to the ASC introducing a "virtual cinematography" category to its annual awards program in 2011.[57]

Even as cinematographers questioned the nature of Fiore's work, they were loath to suggest that he was not in some sense an author of the film. A typical defense rested on the idea that as one of the "supervisors" of the visual design of the movie, he deserved his credit. Cinematography, several people noted, was a role that rested as much on leadership and managerial skill as it did on aesthetic sensibility and knowledge of film language. Management and efficiency have been important to the craft of cinematography from its early days, even more so in the highly rationalized division of labor of the studio era. Still, cinematographers have long resisted descriptions of their work as administrative, managerial, or supervisory; their self-descriptions have been deeply invested in aesthetic practice, as "painters with light," as "visual storytellers." Within the craft, management meant the producer or studio brass, and cinematographers carefully separated those "bean counters" from the work of the talent, including themselves.

Since the digital turn, however, the language of management has become more embedded in cinematographers' practice; many emergent techniques are framed managerially: "color management," "look management," "workflow management," and, crucially, "asset" or "data management" have become key terms of the craft. These tools offered to extend and protect cinematographers' "intent," or authorial presence, throughout the production process, a presence that had previously been assured by the affordances of 35mm film but, thanks to digitization, could no longer be guaranteed. "Managing" the look of a picture is a synonym for defining and protecting key aspects of the overall visual design and, as an industry practice, has come to encompass a variety of contributions and contributors; but as the historically predominant protectors of the key "asset" of the film—the film negative—cinematographers had the most at stake as these new terms of art came into use. Much of the managerial lingo was linked to hard- and software-based solutions for digital production and trumpeted by vendors eager to play on the insecurities of cinematographers. Marketing materials for Kodak's "Look Manager" software, for example, promised to maintain "the integrity of the DP's visual style more easily throughout production." We might see such terminology as an attempt to reposition cinematography within the

complex authorial systems of cinema, protecting its place as "first collaborator" among equals.

Collaboration has long been the worry stone of cinematographers' craft discourse. For this craft culture the director-cinematographer collaboration is in the very DNA of motion pictures, story and image intertwined together.[58] Accordingly, collaborations between directors and their regular cinematographers are among the most remarked aspect of the craft (e.g., Spielberg's eleven collaborations with Kaminski). Compare, for example, the questioning of Mauro Fiore's authority on *Avatar* with the general absence of debate over Robert Richardson's authority in the production of *Hugo*, another Oscar-winning, effects-heavy, 3-D project. While Fiore was a respected cinematographer and a member of the ASC, he didn't have the seniority of Richardson (with his seven Oscar nominations and three wins, going back to 1987). Perhaps more significantly, Richardson had collaborated with Scorsese, *Hugo*'s director, on four other features, including *The Aviator*, a film that relied heavily on digital postproduction techniques to achieve its faux-Technicolor palette. In contrast with *Hugo*'s production story, *Avatar* was Fiore's first, and possibly last, collaboration with producer, writer, and director James Cameron. Whereas Fiore's participation on *Avatar* looks suspiciously like "work for hire," Richardson's conforms to the traditional conception of the director-cinematographer creative marriage. Somewhere between these poles we might place Roger Deakins's contributions to the animated films *WALL-E* (Andrew Stanton, 2008), *How to Train Your Dragon* (Dean DeBlois and Chris Sanders, 2010), and *Rango* (2011). *Rango*, directed by Gore Verbinski, stands out among these as a quirky and stylish send-up of several classic genres. Like most animated films, *Rango* has no credited director of photography; rather, "the look," however we choose to conceive of it, is credited to a phalanx of lighting technicians and visual effects specialists. In this case, though, Deakins, a respected, award-winning member of the ASC and BSC, is credited as a visual consultant. The movie has an unusually complex visual language, including a variety of

FIGURE 6.7: Artful cinematography draws on genre tropes and pays homage to cinematography from the past in *Rango* (2011).

daring angles, unusual camera moves, long takes, and instances of effects lighting that stand out from the typical animated studio product (figure 6.7). *Rango* is the only credited "collaboration" between Deakins and Verbinski, but as such it may mark a return to a form of cinematographic labor last seen with the use of color consultants in the era of Technicolor.[59]

Historically the director-cinematographer coupling does significant discursive work for cinematographers: note the assumed peerage—or at least masked power differential—and the way it highlights directors' reliance on a collaborative "family." It emphasizes the continuity of craft, expressing it in the reliable, productive pairing of these distinct talents, working together against the "machine" of the specialized division of labor. Over the last decade, though, the term collaboration has taken on new shadings in the professional discourse of cinematography, moving toward a sharper focus on collaboration with other departments and, especially, the "managerial" skills and values associated with collaboration and consultancy. In 2004, ASC president Richard Crudo wrote a pointed series of editorials arguing that cinematographers are better "managers" than most studio personnel: "Though it's not surprising that this rundown [of tasks] specifies no less than 131 separate components of our job, what's remarkable is that 75 of these responsibilities—*a full 55 percent*—have nothing at all to do with lighting, lab work, telecine or any of the other things most people associate with cinematography. Instead, they deal with management issues, an aspect of our work that usually slips under everyone's radar."[60] Starting in 2007, ASC vice president (and future president) Michael Goi convened a series of high-profile "Authoring Images" panels of cinematographers, production designers, and directors to discuss the "Triangle of Collaboration."[61] Over the four-part series, the Triangle was squared to include visual effects producers. For a craft that had long seen itself in a principled dyad with the director, this was a notable shift in its stance toward other departments. The image of the cinematographer, long promoted by the craft as an individualistic, virtuosic "painter with light," is complicated by this new vision of cinematography as the product of many hands. Initiatives like these roundtables may seem a simple matter of promoting associational visibility, yet the felt need to discuss the limits and boundaries of collaboration among the craft areas raises interesting questions about the complex negotiations that necessarily attend the creative process within Hollywood cinema and how these structures shift over time.

Cinematographers' reimagining of collaboration and adoption of managerial discourses was largely forced by Hollywood's digital turn, especially the inexorable decline of the 35mm standard. The cantankerous, fussy affordances of film and the filmic "mystique" that followed had served cinematographers well as a bulwark of creative authority. Ironically, despite widespread rhetoric about the democratization of cinema, the new digital systems preserved much of the old opacity—high-end digital cameras are often more complicated and

temperamental than their film camera forebears and required more caretakers—but, significantly, much of the mystique had passed to new magicians, new specialists, and new collaborators. In short, the radical malleability of digital imaging eroded cinematographers' craft authority in its traditional form over the last decade. The ability to make "creative contributions" has expanded dramatically to other role players and into new production workspaces. There are new cameras, new media, new lighting instruments, and new techniques to tie all these tools together. For cinematographers, the future of imaging must look rich with new looks and new ways to tell stories with images. Critics and historians, though, are losing the ability—slight as it was—to trace the webs of decision and creativity that go into producing cinema; there are more decisions, more people, and less transparency than ever. The future of cinematography and the study of the craft offer no guarantees for the central collaborative relationship that had defined cinematography—that with the director—to clarify and protect the cinematographers' claims to authorship and, indeed, artistry. Some directors may retain those relationships, to be sure, and so long as they are included in award show programs, some cinematographers will walk briefly through the spotlight. But the splintering of imaging into specializations like 3-D or animation and the proliferation of types of cameras suggest that more, rather than less, specialization is in store for cinematography. Of course, this shift also unmasks the degree to which cinematography has always been a form of labor, a set of specializations within the Hollywood division of labor. Perhaps we will retain the romantic notion of the cinematographer for a while longer—the "painter with light"—but it seems equally likely that the cinema-imaging worker will take on a more anonymous character in the years to come—still creative, still aesthetic, but one eye among many, the artisan rather than the artiste.

ACADEMY AWARDS FOR CINEMATOGRAPHY

All information is drawn from Oscars.org, the Academy's website.

1927/28	Charles Rosher, Karl Struss	*Sunrise*
1928/29	Clyde De Vinna	*White Shadows in the South Seas*
1929/30	Joseph Rucker, Willard Van Der Veer	*With Byrd at the South Pole*
1930/31	Floyd Crosby	*Tabu*
1931/32	Lee Garmes	*Shanghai Express*
1932/33	Charles Lang	*A Farewell to Arms*
1934	Victor Milner	*Cleopatra*
1935	Hal Mohr*	*A Midsummer Night's Dream*

* Mohr was not nominated, but he won as a write-in candidate.

1936 Tony Gaudio *Anthony Adverse*
 Special Award to W. Howard Greene and Harold Rosson for color cinematography on The Garden of Allah

1937 Karl Freund *The Good Earth*
 Special Award to W. Howard Greene for color cinematography on A Star Is Born

1938 Joseph Ruttenberg *The Great Waltz*
 Special Award to Allen Davey and Oliver Marsh for color cinematography on Sweethearts

1939 BLACK AND WHITE: Gregg Toland *Wuthering Heights*
 COLOR: Ernest Haller, Ray Rennahan *Gone with the Wind*

1940 BLACK AND WHITE: George Barnes *Rebecca*
 COLOR: Georges Périnal *The Thief of Bagdad*

1941 BLACK AND WHITE: Arthur Miller *How Green Was My Valley*
 COLOR: Ray Rennahan, Ernest Palmer *Blood and Sand*

1942 BLACK AND WHITE: Joseph Ruttenberg *Mrs. Miniver*
 COLOR: Leon Shamroy *The Black Swan*

1943 BLACK AND WHITE: Arthur Miller *The Song of Bernadette*
 COLOR: W. Howard Greene, Hal Mohr *Phantom of the Opera*

1944 BLACK AND WHITE: Joseph LaShelle *Laura*
 COLOR: Leon Shamroy *Wilson*

1945 BLACK AND WHITE: Harry Stradling, Sr. *The Picture of Dorian Gray*
 COLOR: Leon Shamroy *Leave Her to Heaven*

1946 BLACK AND WHITE: Arthur Miller *Anna and the King of Siam*
 COLOR: Arthur Arling, Leonard Smith, Charles Rosher *The Yearling*

1947 BLACK AND WHITE: Guy Green *Great Expectations*
 COLOR: Jack Cardiff *Black Narcissus*

1948 BLACK AND WHITE: William Daniels *The Naked City*
 COLOR: Winton Hoch, William Skall, Joseph Valentine *Joan of Arc*

1949 BLACK AND WHITE: Paul Vogel *Battleground*
 COLOR: Winton Hoch *She Wore a Yellow Ribbon*

1950 BLACK AND WHITE: Robert Krasker *The Third Man*
 COLOR: Robert Surtees *King Solomon's Mines*

1951 BLACK AND WHITE: William Mellor — *A Place in the Sun*
COLOR: John Alton, Alfred Gilks — *An American in Paris*

1952 BLACK AND WHITE: Robert Surtees — *The Bad and the Beautiful*
COLOR: Winton Hoch, Archie Stout — *The Quiet Man*

1953 BLACK AND WHITE: Burnett Guffey — *From Here to Eternity*
COLOR: Loyal Griggs — *Shane*

1954 BLACK AND WHITE: Boris Kaufman — *On the Waterfront*
COLOR: Milton Krasner — *Three Coins in the Fountain*

1955 BLACK AND WHITE: James Wong Howe — *The Rose Tattoo*
COLOR: Robert Burks — *To Catch a Thief*

1956 BLACK AND WHITE: Joseph Ruttenberg — *Somebody Up There Likes Me*
COLOR: Lionel Lindon — *Around the World in 80 Days*

1957 Jack Hildyard — *The Bridge on the River Kwai*

1958 BLACK AND WHITE: Sam Leavitt — *The Defiant Ones*
COLOR: Joseph Ruttenberg — *Gigi*

1959 BLACK AND WHITE: William Mellor — *The Diary of Anne Frank*
COLOR: Robert Surtees — *Ben-Hur*

1960 BLACK AND WHITE: Freddie Francis — *Sons and Lovers*
COLOR: Russell Metty — *Spartacus*

1961 BLACK AND WHITE: Eugen Shuftan — *The Hustler*
COLOR: Daniel Fapp — *West Side Story*

1962 BLACK AND WHITE: Jean Bourgoin, Walter Wottitz — *The Longest Day*
COLOR: Freddie Young — *Lawrence of Arabia*

1963 BLACK AND WHITE: James Wong Howe — *Hud*
COLOR: Leon Shamroy — *Cleopatra*

1964 BLACK AND WHITE: Walter Lassally — *Zorba the Greek*
COLOR: Harry Stradling, Sr. — *My Fair Lady*

1965 BLACK AND WHITE: Ernest Laszlo — *Ship of Fools*
COLOR: Freddie Young — *Doctor Zhivago*

* For unknown reasons the Academy lists only two winners for *The Longest Day*, even though the film's credits list four cinematographers: Bourgoin, Wottitz, Henri Persin, and Pierre Levent.

1966	BLACK AND WHITE: Haskell Wexler	*Who's Afraid of Virginia Woolf?*
	COLOR: Ted Moore	*A Man for All Seasons*
1967	Burnett Guffey	*Bonnie and Clyde*
1968	Pasqualino De Santis	*Romeo and Juliet*
1969	Conrad Hall	*Butch Cassidy and the Sundance Kid*
1970	Freddie Young	*Ryan's Daughter*
1971	Oswald Morris	*Fiddler on the Roof*
1972	Geoffrey Unsworth	*Cabaret*
1973	Sven Nykvist	*Cries and Whispers*
1974	Joseph Biroc, Fred Koenekamp	*The Towering Inferno*
1975	John Alcott	*Barry Lyndon*
1976	Haskell Wexler	*Bound for Glory*
1977	Vilmos Zsigmond	*Close Encounters of the Third Kind*
1978	Nestor Almendros	*Days of Heaven*
1979	Vittorio Storaro	*Apocalypse Now*
1980	Ghislain Cloquet, Geoffrey Unsworth	*Tess*
1981	Vittorio Storaro	*Reds*
1982	Ronny Taylor, Billy Williams	*Gandhi*
1983	Sven Nykvist	*Fanny & Alexander*
1984	Chris Menges	*The Killing Fields*
1985	David Watkin	*Out of Africa*
1986	Chris Menges	*The Mission*
1987	Vittorio Storaro	*The Last Emperor*

1988	Peter Biziou	*Mississippi Burning*
1989	Freddie Francis	*Glory*
1990	Dean Semler	*Dances with Wolves*
1991	Robert Richardson	*JFK*
1992	Philippe Rousselot	*A River Runs Through It*
1993	Janusz Kaminski	*Schindler's List*
1994	John Toll	*Legends of the Fall*
1995	John Toll	*Braveheart*
1996	John Seale	*The English Patient*
1997	Russell Carpenter	*Titanic*
1998	Janusz Kaminski	*Saving Private Ryan*
1999	Conrad Hall	*American Beauty*
2000	Peter Pau	*Crouching Tiger, Hidden Dragon*
2001	Andrew Lesnie	*The Lord of the Rings: The Fellowship of the Ring*
2002	Conrad Hall	*Road to Perdition*
2003	Russell Boyd	*Master and Commander: The Far Side of the World*
2004	Robert Richardson	*The Aviator*
2005	Dion Beebe	*Memoirs of a Geisha*
2006	Guillermo Navarro	*Pan's Labyrinth*
2007	Robert Elswit	*There Will Be Blood*
2008	Anthony Dod Mantle	*Slumdog Millionaire*

2009	Mauro Fiore	*Avatar*
2010	Wally Pfister	*Inception*
2011	Robert Richardson	*Hugo*
2012	Claudio Miranda	*Life of Pi*
2013	Emmanuel Lubezki	*Gravity*

NOTES

Introduction

1 James Wong Howe, "Lighting," in *The Cinematographic Annual*, vol. 2, ed. Hal Hall (Los Angeles: American Society of Cinematographers, 1931), 47.

2 Vittorio Storaro, quoted in Benjamin Bergery, "Reflections 10: Storaro, ASC," *American Cinematographer*, August 1989, 70.

3 Charles G. Clarke, "How Desirable Is Extreme Focal Depth?," *American Cinematographer*, January 1942, 36.

4 Barry Salt, *Film Style and Technology: History and Analysis*, 3rd ed. (London: Starword, 2009), 28.

5 John Thornton Caldwell, *Production Culture: Industrial Reflexivity and Critical Practice in Film and Television* (Durham, NC: Duke University Press, 2008), 152–153.

6 Jean Oppenheimer, "More Power to Them: Ernest Dickerson," *American Cinematographer*, November 1991, 76–78.

7 Al Harrell, "*Malcolm X*: One Man's Legacy, to the Letter," *American Cinematographer*, November 1992, 29.

8 Graham Petrie, "Alternatives to Auteurs," in *Auteurs and Authorship: A Film Reader*, ed. Barry Keith Grant (Malden, MA: Blackwell, 2008), 117.

9 Robert L. Carringer, *The Making of Citizen Kane*, rev. ed. (Berkeley: University of California Press, 1996). For an essay drawing on Carringer's ideas about collaboration, see Evan

Lieberman and Kerry Hegarty, "Authors of the Image: Cinematographers Gabriel Figueroa and Gregg Toland," *Journal of Film and Video* 62, no. 1–2 (2010): 31–51.

10 James Cutting, Kaitlin L. Brunick, Jordan E. DeLong, Catalina Iricinschi, and Ayse Candan, "Quicker, Faster, Darker: Changes in Hollywood Film over 75 Years," *i-Perception* 2 (2011): 569–576.

11 David Bordwell, Janet Staiger, and Kristin Thompson, *The Classical Hollywood Cinema: Film Style and Mode of Production to 1960* (New York: Columbia University Press, 1985). On cinematography, see especially Bordwell's chapter on "Deep Focus Cinematography" and Thompson's chapter on "Major Technological Changes of the 1920s."

12 Roger Deakins, quoted in Peter Ettedgui, *Cinematography Screencraft* (Woburn, MA: Focal Press, 1998), 162.

13 David Bordwell, "Intensified Continuity: Four Dimensions," in *The Way Hollywood Tells It: Story and Style in Modern Movies* (Berkeley: University of California Press, 2006), 121–139.

14 Scott Bukatman, "Zooming Out: The End of Offscreen Space," in *The New American Cinema*, ed. Jon Lewis (Durham, NC: Duke University Press, 1998), 265.

15 For a clear outline of the various positions in this debate, see Murray Smith, "Theses on the Philosophy of Hollywood History," in *Contemporary Hollywood Cinema*, ed. Steve Neale and Murray Smith (New York: Routledge, 1998), 3–20.

16 Patrick Keating, *Hollywood Lighting from the Silent Era to Film Noir* (New York: Columbia University Press, 2009).

17 Janey Place and Lowell Peterson, "Some Visual Motifs of Film Noir," in *Film Noir Reader*, ed. Alain Silver and James Ursini (New York: Limelight, 1996), 64–75.

18 Tom Gunning, "The Cinema of Attractions: Early Film, Its Spectator, and the Avant-Garde," in *Early Cinema: Space, Frame, Narrative*, ed. Thomas Elsaesser (London: British Film Institute, 1990), 58.

19 Although it is standard format in the literature of film studies to list the director's name and the release year in parentheses after a film's title, this volume will adopt a modified format, adding the cinematographer's name after the year. Here, "d.p." is short for "director of photography," another term for cinematographer.

1 The Silent Screen, 1894-1927

The author would like to thank Lisa Jasinski and Michael Aronson for their help on this essay.

1 Charles Musser, *The Emergence of Cinema: The American Screen to 1907* (Berkeley: University of California Press), 81.

2 Barry Salt, *Film Style and Technology: History and Analysis*, 3rd ed. (London: Starword, 2009), 34; Musser, *Emergence of Cinema*, 72.

3 Charles Musser, "Pre-Classical American Cinema: Its Changing Modes of Production," in *Silent Film*, ed. Richard Abel (New Brunswick, NJ: Rutgers University Press, 1996), 86–87.

4 Tom Gunning, "The Cinema of Attractions: Early Film, Its Spectator, and the Avant-Garde," in *Early Cinema: Space, Frame, Narrative*, ed. Thomas Elsaesser (London: British Film Institute, 1990), 58.

5 For background on the fair itself, see David E. Nye, *Electrifying America: Social Meanings of a New Technology* (Cambridge, MA: MIT Press, 1990), 41; for a discussion of the film, see Musser, *Emergence of Cinema*, 317.

6 Salt, *Film Style and Technology*, 50.

7 Musser, *Emergence of Cinema*, 386.

8 Salt, *Film Style and Technology*, 57.

9 Musser, *Emergence of Cinema*, 458.

10 David Bordwell, Janet Staiger, and Kristin Thompson, *The Classical Hollywood Cinema: Film Style and Mode of Production to 1960* (New York: Columbia University Press, 1985), 97.

11 Gunning, "Cinema of Attractions," 57.

12 Tom Gunning, "Modernity and Cinema: A Culture of Shocks and Flows," in *Cinema and Modernity*, ed. Murray Pomerance (New Brunswick, NJ: Rutgers University Press, 2006), 312.

13 "Biograph's Western Studios," *MPW*, July 10, 1915, 243.

14 Salt, *Film Style and Technology*, 44.

15 For a detailed analysis of staging techniques in the silent period and beyond, see David Bordwell, *Figures Traced in Light* (Berkeley: University of California Press, 2005).

16 Patrick Keating, *Hollywood Lighting from the Silent Era to Film Noir* (New York: Columbia University Press, 2010), 31.

17 Salt, *Film Style and Technology*, 130.

18 "Studio of the Peerless Company," *MPW*, September 26, 1914, 1781.

19 Musser, *Emergence of Cinema*, 337.

20 "Biograph's Western Studios," 243.

21 "Selznick Leases Great Biograph Studio," *MPW*, November 11, 1916, 871.

22 "Cooper Hewitt Have New Specialty," *MPW*, May 10, 1919, 918.

23 "Winter Stories," *MPW*, October 17, 1914, 329.

24 "New Studio at Universal City," *MPW*, September 11, 1915, 1818.

25 "Thomas A. Edison at Universal City," *MPW*, November 13, 1915, 1288.

26 "Goldwyn's Glass Roof Painted Black," *MPW*, January 5, 1918, 83.

27 "East Should Be Producing Center," *MPW*, April 19, 1919, 371.

28 "Picture Plays and Their Production," *MPW*, April 23, 1910, 636. The term "candlepower" is now obsolete.

29 "First National Studios," *MPW*, March 26, 1927, 401.

30 Salt, *Film Style and Technology*, 73–74.

31 "Getting Belasco Atmosphere," *MPW*, May 30, 1914, 1271.

32 Lea Jacobs, "Belasco, DeMille, and the Development of Lasky Lighting," *Film History* 5, no. 4 (1993): 416.

33 Wyckoff quoted in "'Lighting for Temperament' Is the Newest Wrinkle in Cinematography," *MPW*, February 11, 1922, 673.

34 With a detectable note of bitterness, Bitzer reports the hiring of Sartov in his autobiography, *Billy Bitzer: His Story* (New York: Farrar, Straus and Giroux, 1973), 201.

35 Keating, *Hollywood Lighting*, 30.

36 Keating, "The Birth of Backlighting in the Classical Cinema," *Aura* 6, no. 2 (2000): 49; Salt, *Film Style and Technology*, 127.

37 Kevin Brownlow, *The Parade's Gone By . . .* (Berkeley: University of California Press, 1968), 230.

38 Salt, *Film Style and Technology*, 169.

39 Barry Salt, "From Caligari to Who?," in *Moving into Pictures* (London: Starword, 2006), 55; Marc Vernet, "Film Noir on the Edge of Doom," in *Shades of Noir*, ed. Joan Copjec (New York: Verso, 1993), 9–10.

40 Salt, *Film Style and Technology*, 185.

41 On orthochromatic film, see Kristin Thompson's discussion in Bordwell, Staiger, and Thompson, *The Classical Hollywood Cinema*, 281–285.

42 An early account of the ASC's origins can be found in Lyman H. Broening, "How It All Happened: A Brief Review of the Beginnings of the American Society of Cinematographers," *AC*, November 1, 1921, 13.

43 Foster Goss, "The Editor's Lens: A Rose by Any Other Name, But—," *AC*, February 1925, 11.

44 Clark quoted in "Cinematographers as Economy Unit in Production," *AC*, June 1926, 7.

45 Dan Clark, "Composition in Motion Pictures," in *The Cinematographic Annual*, vol. 1, ed. Hal Hall (Los Angeles: American Society of Cinematographers, 1930), 87.

46 Keating, *Hollywood Lighting*, 29.

47 Victor Milner, "Painting with Light," in *The Cinematographic Annual*, vol. 1, ed. Hal Hall (Los Angeles: American Society of Cinematographers, 1930), 91.

48 H. D. Hineline, "Composite Photographic Processes," *Journal of the Society of Motion Picture Engineers*, April 1933, 288.

49 Carl Gregory, "Motion Picture Photography," *MPW*, August 21, 1915, 1315.

50 See Kristin Thompson's detailed account in Bordwell, Staiger, and Thompson, *Classical Hollywood Cinema*, 287–293.

51 "Photo by Arthur Miller Wins Salon Distinction," *MPW*, October 30, 1920, 1291. Similarly, the pictorialist photographer Karl Struss continued to shoot artful stills after his move to Hollywood.

52 Norton's comments appear in George Meehan, Stephen S. Norton, Jackson J. Rose, and L. Guy Wilky, "Uses and Abuses of Gauze," *AC*, July 1923, 12.

53 Read, "'Unnatural Colours': An Introduction to Colouring Techniques in Silent Era Movies," *Film History* 21, no. 1 (2009): 16.

54 Ibid., 13.

55 Karl Brown, *Adventures with D. W. Griffith* (New York: Da Capo Press, 1976), 226–227.

56 Joshua Yumibe, *Moving Color: Early Film, Mass Culture, Modernism* (New Brunswick, NJ: Rutgers University Press, 2012), 132.

57 Kim Tomadjoglou, "Introduction: Early Colour," *Film History* 21, no. 1 (2009): 3.

58 Nicola Mazzanti, "Colours, Audiences, and (Dis)continuity in the 'Cinema of the Second Period,'" *Film History* 21, no. 1 (2009): 69.

59 Ibid., 67–70.

60 Ibid., 87.

61 Yumibe, *Moving Color*, 35.

62 Ibid., 77.

63 Ibid., 137.

64 Barry Salt provides good explanations of the various technologies employed by Technicolor over the years. For information on the two-color system, see Salt, *Film Style and Technology*, 165.

65 Bitzer, *Billy Bitzer*, 135.

66 "The Regeneration," *Wid's Films and Film Folk*, September 23, 1915, page unknown.

67 "The Silent Voice," *Wid's Films and Film Folk*, September 23, 1915, page unknown.

68 Salt, *Film Style and Technology*, 174.

69 Walter Lundin, "Drama Treatment Enters Comedy Photography," *AC*, June 1924, 9; L. Guy Wilky, "Behind the Camera for William de Mille," *AC*, February 1926, 7.

70 "Camera Dynamics," *Film Daily*, June 27, 1926, 25.

71 Karl Struss, "Dramatic Cinematography," *Transactions of the Society of Motion Picture Engineers*, April 1928, 318.

72 Caitlin McGrath, *Captivating Motion: Late-Silent Film Sequences of Perception in the Modern Urban Environment* (Ann Arbor, MI: UMI Dissertation Publishing, 2010), 222.

73 Ibid., 230.

74 Gunning, "Modernity and Cinema," 312.

75 Read, "Unnatural Colours," 12.

76 Salt, *Film Style and Technology*, 200, 216.

77 For an authoritative discussion of these widescreen technologies and their promise of an immersive experience, see John Belton, *Widescreen Cinema* (Cambridge, MA: Harvard University Press, 1992). See especially "Spectator and Screen," 183–210.

78 Nestor Almendros, *A Man with a Camera* (New York: Farrar, Straus and Giroux, 1986), 169.

79 I offer a case study of institutional conflicts in Patrick Keating, "Shooting for Selznick: Craft and Collaboration in Hollywood Cinematography," *The Classical Hollywood Reader*, ed. Steve Neale (London: Routledge, 2012), 280–295.

2 Classical Hollywood, 1928-1946

This essay has benefited greatly from the comments that Patrick Keating, Jennie Hirsh, Nora Alter, and Franklin Cason provided on previous drafts.

1 Victor Milner, "The Cinema in 1932—a Prophesy," *AC*, August 1922, 8.

2 "Riddle Me This," *AC*, December 1932, 12.

3 John T. Caldwell, *Production Culture: Industrial Reflexivity and Critical Practice in Film and Television* (Durham, NC: Duke University Press, 2008).

4 There are a number of versions of this trade-identity-as-ideology approach. See David Bordwell and Janet Staiger, "Technology, Style, and Mode of Production," in Bordwell, Staiger, and Kristin Thompson, *The Classical Hollywood Cinema: Film Style and Mode of Production to 1960* (New York: Columbia University Press, 1985), 243–261; and Paul Kerr, "Out of What Past? Notes on the B Film Noir," *Screen Education* 32–33 (Autumn/Winter 1979–80): 45–65.

5 Bert Glennon, "Cinematography and the Talkies," *AC*, February 1930, 7.

6 Donald Crafton, *The Talkies: American Cinema's Transition to Sound*, vol. 4, History of American Cinema Series (Berkeley: University of California Press, 1997), 3.

7 Charles Higham, interview with Leon Shamroy, *Hollywood Cameramen: Sources of Light* (Bloomington: Indiana University Press, 1970), 23–24.

8 Frank Lawrence, "The War of the Talkies," *AC*, January 1929, 11.

9 Howard E. Campbell, "Let Us Have Peace," *AC*, April 1929, 9.

10 William Stull, "Solving the 'Ice Box' Problem," *AC*, September 1929, 7, 36.

11 David Bordwell, "The Introduction of Sound," in Bordwell, Staiger, and Thompson, *The Classical Hollywood Cinema*, 305.

12 Hal Hall, "Cinematographers and Directors Meet," *AC*, August 1932, 10.

13 Bordwell, "The Introduction of Sound," 299.

14 William Stull, "Development of Mobile Camera-Carriages and Cranes," *AC*, May 1933, 12–13, 36–37; "Crane Mechanical Marvel" *AC*, May 1929, 14.

15 William Stull, "Solving the 'Ice Box' Problem"; Stull, "Evolution of Cinema Tripods for Studio Use," *AC*, April 1933, 6–7, 34; "Progress in the Motion Picture Industry," *Journal of the Society of Motion Picture Engineers*, February 1930, 228; Gregg Toland, "Practical Gadgets Expedite Camera Work," *AC*, May 1939, 215, 218.

16 David Bordwell, "The Mazda Tests of 1928," in *Classical Hollywood Cinema*, 296.

17 Ibid., 294.

18 Hal Mohr, "Large Sets Call for Arc Lights," *AC*, November 1935, 469, 478–479.

19 "Cinematic Progress during 1933: A Technical Review," *AC*, April 1934, 490–491, 494–496; "Taking the Click Out of Cameras," *AC*, May 1929, 18; A. S. Howell and Joseph A. Dubray, "New Silent High-Speed Intermittent Mechanism for B&H Camera," *AC*, June 1929, 3.

20 For more on this, see Patrick Keating, *Hollywood Lighting from the Silent Era to Film Noir* (New York: Columbia University Press, 2010), chap. 1.

21 A. Lindsay Lane, "Cinematographer Plays Leading Part in Group of Creative Minds," *AC*, February 1935, 49.

22 Ernst Lubitsch as told to William Stull, "Concerning Cinematography," *AC*, November 1929, 5, 21.

23 Keating, *Hollywood Lighting*, 3.

24 Ibid. For a contemporary version of figure and genre lighting, see George W. Hesse, "Shadows," *AC*, June 1932, 37, 50.

25 Tino Balio, *Grand Design: Hollywood as a Modern Business Enterprise, 1930–1939*, vol. 5, History of American Cinema Series (Berkeley: University of California Press, 1996).

26 Leonard Maltin, interview with Arthur Miller, *The Art of the Cinematographer: A Survey and Interviews with Five Masters* (New York: Dover Publications, 1978), 64.

27 For instance, Perry Ferguson, "More Realism from 'Rationed' Sets?," *AC*, September 1942, 390–391, 430; Peter Furst, "The Russian Influence in Hollywood," *AC*, August 1943, 288–289.

28 "Technical Progress in the Industry during 1936," *AC*, December 1936, 502–503, 510.

29 Barry Salt, *Film Style and Technology: History and Analysis*, 3rd ed. (London: Starword Press, 2009), 215–216.

30 "Cinematic Progress during 1933: A Technical Review," *AC*, April 1934, 490–491, 494, 496.

31 Keating, *Hollywood Lighting*, 223–227.

32 John Raeburn, *A Staggering Revolution: A Cultural History of Thirties Photography* (Urbana: University of Illinois Press, 2006).

33 Lea Jacobs, *The Decline of Sentiment: American Film in the 1920s* (Berkeley: University of California Press, 2008).

34 Miriam Hansen, "The Mass Production of the Senses: Classical Cinema as Vernacular Modernism," *Modernism/modernity* 6, no. 2 (April 1999): 59–77. Thanks to Patrick Keating for suggesting the affinity with Hansen's argument.

35 David Bordwell, "Deep Focus Cinematography," in *Classical Hollywood Cinema*, 343.

36 Salt, *Film Style and Technology*, 229; Bordwell, "Deep Focus," 344.

37 Charles G. Clarke, "How Desirable Is Extreme Focal Depth?," *AC*, January 1942, 14, 36; see also "How Green Was My Valley [review]," *AC*, February 1942, 66.

38 "Technical Progress in the Industry during 1936," *AC*.

39 Scott Higgins, *Harnessing the Technicolor Rainbow: Color Design in the 1930s* (Austin: University of Texas Press, 2007).

40 Stull, "Summing up Modern Studio Lighting Equipment," *AC*, October 1935, 424–425, 435.

41 "More recently, [Tony Gaudio] has pioneered such modern techniques as the use of 'Dinky Inkies,' and 'precision lighting,' using spotlights almost to the exclusion of floodlighting units." From "Aces of the Camera: Tony Gaudio, A.S.C.," *AC*, March 1942, 138.

42 Harry Burdick, "Mother Nature Knows Best Is Nick Musuraca's Creed," *AC*, July 1935, 287, 295.

43 Keating, *Hollywood Lighting*, 240.

44 Keating, *Hollywood Lighting*, chap. 9; *Visions of Light: The Art of Cinematography*, directed by Arnold Glassman, Todd McCarthy, and Stuart Samuels (1992; Beverly Hills, CA: Twentieth Century Fox Home Entertainment, Image Entertainment, 2000), DVD.

45 James Wong Howe, "The Documentary Technique in Hollywood," *AC*, January 1944, 10, 32.

46 "*The Human Comedy* [review]," *AC*, March 1943, 45.

47 Scott Eyman, interview with Joseph Ruttenberg, *Five American Cinematographers: Interviews with Karl Struss, Joseph Ruttenberg, James Wong Howe, Linwood Dunn, and William H. Clothier* (Metuchen, NJ: Scarecrow Press, 1987), 46.

48 Thomas Schatz, *The Genius of the System: Hollywood Filmmaking in the Studio Era* (New York: Pantheon Books, 1988), 136. Similar readings in popular histories include *Visions of Light* and Ethan Mordden, *The Hollywood Studios: House Style in the Golden Age of the Movies* (New York: Alfred A. Knopf, 1988).

49 Schatz, *The Genius of the System*, 133.

50 Jerome Christensen, *America's Corporate Art: The Studio Authorship of Hollywood Motion Pictures* (Stanford, CA: Stanford University Press, 2012), 7.

51 Ibid., 2.

52 For a fuller interrogation of style as a cluster concept, see Berys Gaut, "Art as a Cluster Concept," in *Theories of Art Today*, ed. Noël Carroll (Madison: University of Wisconsin Press, 2000), 25–44; and Colin Burnett, "Arnheim on Style History," in *Arnheim for Film and Media Studies*, ed. Scott Higgins (London: Routledge, 2011), 229–248.

53 Salt, *Film Style and Technology*, 216.

54 William Stull, "Twentieth Century-Fox Holds Preview for Big Camera," *AC*, September 1940, 396–398.

55 Eyman, interview with James Wong Howe, *Five American Cinematographers*, 76.

56 Leon Shamroy, "The Future of Cinematography," *AC*, October 1947, 358.

57 Salt, *Film Style and Technology*, 222.

58 Ibid.

59 "Photography of the Month," *AC*, January 1933, 18–19.

60 Kyle Crichton, "Camera!," *Collier's Weekly*, June 12, 1937, 19, 38–40.

61 Todd Rainsberger, *James Wong Howe, Cinematographer* (San Diego: A. S. Barnes, 1981), 60–73.

62 Charles Higham, interview with James Wong Howe, *Hollywood Cameramen: Sources of Light*, 23–24, 78–79.

63 Howe, "The Documentary Technique in Hollywood."

64 Rainsberger, *James Wong Howe*, 206.

65 "*Kings Row* [review]," *AC*, April 1942.

66 Higham, interview with James Wong Howe, 88.

67 Walter Blanchard, "Aces of the Camera: Rudy Maté," *AC*, August 1942, 352, 375–376.

68 Higham, interview with Leon Shamroy, 27–28.

69 Ibid., 29.

70 Maltin, interview with Arthur Miller, 64.

71 Herb Lightman, "Painting with Technicolor Light," *AC*, June 1947, 201.

72 Rainsberger, *James Wong Howe*.

73 Rosalind Galt, *Pretty: Film and the Decorative Image* (New York: Columbia University Press, 2011).

3 Postwar Hollywood, 1947 –1967

1 Thomas Schatz, *Boom and Bust: American Cinema in the 1940s* (Berkeley: University of California Press, 1997), 329–333, 463.

2 David Bordwell, Janet Staiger, and Kristin Thompson, *The Classical Hollywood Cinema: Film Style and Mode of Production to 1960* (New York: Columbia University Press, 1985), 330–332.

3 "Hollywood: The Shock of Freedom in Films," *Time*, December 8, 1967, 74–83.

4 John Alton, *Painting with Light* (Berkeley: University of California Press, 1995), 134–135.

5 Patrick Keating, *Hollywood Lighting from the Silent Era to Film Noir* (New York: Columbia University Press, 2010), 223–227.

6 Ibid., 229–243.

7 Bordwell, Staiger, and Thompson, *The Classical Hollywood Cinema*, 350.

8 Herb A. Lightman, "*The Naked City*, Tribute in Celluloid," *AC*, May 1948, 178.

9 Joseph V. Noble, "Development of the Cinematographic Art," *AC*, January 1947, 26.

10 Herb A. Lightman, "*13 Rue Madeleine*, Documentary Style in the Photoplay," *AC*, March 1947, 88.

11 Ibid., 89.

12 Ezra Goodman, "Lights! Action! Jimmy Howe!," *Pageant* 4, no. 5 (November 1948): 100.

13 Herb A. Lightman, "Uninhibited Camera," *AC*, October 1951, 425.

14 Robert Surtees, "The Story of Filming *Act of Violence*," *AC*, August 1948, 282.

15 Herb A. Lightman, "Realism with a Master's Touch," *AC*, August 1950, 286.

16 Leigh Allen, "New Speed for Films," *AC*, December 1949, 440, 456; Lightman, "Realism with a Master's Touch," 287–288.

17 Emery Huse, "Tri-X—New Eastman High-Speed Negative Motion Picture Film," *AC*, July 1954, 335.

18 Herb A. Lightman, "Filming *Blackboard Jungle*," *AC*, June 1955, 334–335.

19 Charles Higham, *Hollywood Cameramen: Sources of Light* (Bloomington: Indiana University Press, 1970), 115.

20 Herb A. Lightman, "Changing Trends in Cinematography," *AC*, January 1949, 33–34.

21 Frederick Foster, "Economy Lighting with Photofloods," *AC*, January 1950, 10–11, 20.

22 Barry Salt, *Film Style and Technology: History and Analysis*, 2nd ed. (London: Starword, 1992), 230.

23 Joseph V. Mascelli, "Portable Lighting Equipment Sparks Trend toward More Location Filming," *AC*, November 1957, 732–733, 749.

24 Walter Strenge, "Realism in Real Sets and Locations," *AC*, October 1957, 651.

25 Benjamin Berg, "Éclair Camerette Makes U.S. Debut," *AC*, September 1949, 321, 332.

26 Joseph V. Mascelli, "Mitchell Introduces New 35mm Reflex Camera," *AC*, June 1960, 360, 372.

27 "Moving Camera Shots," *AC*, January 1961, 28–29; Salt, *Film Style and Technology*, 231, 257–258.

28 Salt, *Film Style and Technology*, 257.

29 "Keeping Up with Photography: Helicopter Shots," *AC*, August 1948, 262.

30 Salt, *Film Style and Technology*, 258.

31 Strenge, "Realism in Real Sets and Locations," 650–651.

32 Herb A. Lightman, "The Photography of *Hud*," *AC*, July 1963, 409.

33 Arthur E. Gavin, "Location-Shooting in Paris for *Gigi*," *AC*, July 1958, 425, 440, 442.

34 Frederick Foster, "High Key vs. Low Key," *AC*, August 1957, 506, 532–533.

35 *Variety*, January 10, 1962, 2.

36 David Bordwell, *Poetics of Cinema* (New York: Routledge, 2008), 287.

37 Keating, *Hollywood Lighting*, 215–218.

38 Herb A. Lightman, "Painting with Color," *AC*, June 1947, 201.

39 Keating, *Hollywood Lighting*, 218–220.

40 "New Eastman Color Film Tested by Hollywood Studios and Film Labs," *AC*, March 1950, 95, 102; Bordwell, Staiger, and Thompson, *The Classical Hollywood Cinema*, 357.

41 Peter Lev, *Transforming the Screen: 1950 to 1959* (Berkeley: University of California Press, 2003), 108.

42 Bordwell, Staiger, and Thompson, *The Classical Hollywood Cinema*, 356.

43 Arthur Gavin, "The Incomparable Photography of *My Fair Lady*," *AC*, November 1964, 622–624, 659–660.

44 John Belton, *Widescreen Cinema* (Cambridge, MA: Harvard University Press, 1992), 187–196.

45 *This Is Cinerama*, (yellow) program booklet, n.d. (ca. 1952).

46 Lev, *Transforming the Screen*, 112–115; Bordwell, *Poetics*, 284–286; "Movie Revolution," *Time*, October 13, 1952, 106.

47 Charles Barr, "CinemaScope: Before and After," *Film Quarterly* 16, no. 4 (Summer 1963): 24.

48 Lev, *Transforming the Screen*, 110; "Is 3-D Dead . . . ?," *AC*, December 1957, 609–610.

49 Gavin, "The Incomparable Photography of *My Fair Lady*," 135.

50 Charles G. Clarke, "Practical Filming Techniques for Three-Dimensional and Wide-Screen Motion Pictures," *AC*, March 1953, 107, 128.

51 "Is 3-D Dead . . . ?," 610.

52 Letter from Darryl F. Zanuck to Spyros Skouras, January 27, 1953, reproduced in Rudy Behlmer, ed., *Memo from Darryl F. Zanuck* (New York: Grove Press, 1993), 223.

53 Belton, *Widescreen Cinema*, 155–157; Bordwell, Staiger, and Thompson, *The Classical Hollywood Cinema*, 361.

54 M. K. Shinde, *Shinde's Dictionary of Cine Art and Film Craft* (Bombay: Popular Prakashan, 1962), 23.

55 Higham, *Hollywood Cameramen*, 54.

56 Walter Lassally, "The BIG Screens," *Sight and Sound* 24, no. 3 (January-March, 1955): 126.

57 Charles G. Clarke, "CinemaScope Photographic Techniques," *AC*, June 1955, 336–337, 362–364.

58 Arthur Rowan, "Todd-AO—Newest Wide-Screen System," *AC*, October 1954, 526.

59 Virginia Yates, "*Rope* Sets a Precedent," *AC*, July 1948, 230–231, 426.

60 Herb A. Lightman, "*The Lady from Shanghai:* A Field Day for the Camera," *AC*, June 1948, 200.

61 Alton, *Painting with Light*, 56, 44.

62 Todd McCarthy, "Through a Lens Darkly: The Life and Films of John Alton," in Alton, *Painting with Light*, xxix.

63 Ibid., xix.

64 Barry Salt, "From Caligari to Who?," *Sight and Sound* 48 (Spring 1979): 119–123; Frank Krutnik, *In a Lonely Street: Film Noir, Genre, Masculinity* (New York: Routledge, 1991); Marc Vernet, "Film Noir on the Edge of Doom," in *Shades of Noir*, ed. Joan Copjec (New York: Verso, 1993), 1–31; Thomas Elsaessar, *Weimar Cinema and After: Germany's Historical Imaginary* (New York: Routledge, 2000); Steve Neale, *Genre and Hollywood* (New York: Routledge, 2000).

65 Keating, *Hollywood Lighting*, 247–264.

66 McCarthy in Alton, *Painting with Light*, xxvi.

67 Herb A. Lightman, "The Photography of *West Side Story*," *AC*, December 1961, 754.

68 Ibid.

69 Nick Hall, "Closer to the Action: Post-War American Television and the Zoom Shot," in *Television Aesthetics and Style*, ed. Jason Jacobs and Steven Peacock (London: Bloomsbury Academic, 2013), 277–287; John Belton, "The Bionic Eye: Zoom Esthetics," *Cineaste* 11, no. 1 (Winter 1980/1): 20–27.

70 Salt, *Film Style and Technology*, 244; Joseph Brun, "Odds Against Tomorrow," *AC*, August 1959, 478–479.

71 Nick Hall, "The Development and Use of the Zoom Lens in American Film and Television: 1946–1974" (Ph.D. diss., University of Exeter, 2012), 230–233, 261; Salt, *Film Style and Technology*, 244, 258–259.

72 Richard Moore, "A New Look at Zoom Lenses," *AC*, July 1965, 439.

73 Hal Mohr, "Zoom Uses," *AC*, August 1965, 491.

74 Hall, "Closer to the Action," 287.

75 Herb A. Lightman, "The Dramatic Photography of *Who's Afraid of Virginia Woolf?*," *AC*, August 1966, 530.

76 Mark Harris, *Pictures at a Revolution: Five Movies and the Birth of the New Hollywood* (New York: Penguin Press, 2008), 253–254.

77 *Revolution! The Making of Bonnie and Clyde* (Laurent Bouzereau, 2008).

4 The Auteur Renaissance, 1968–1980

The author would like to thank David Mullen for his help with this essay.

1 Peter Krämer, "Post-classical Hollywood," in *The Oxford Guide to Film Studies*, ed. John Hill and Pamela Church Gibson (Oxford: Oxford University Press, 1998), 294.

2 "Hollywood: The Shock of Freedom in Films," *Time*, December 8, 1968, http://www.time.com/time/magazine/article/0,9171,844256,00.html.

3 "Big Rental Films of 1969," *Variety*, January 7, 1970, 15.

4 Bill Butler, "Photographing *Grease*," *AC*, August 1978, 762–763.

5 Dennis Schaefer and Larry Salvato, *Masters of Light: Conversations with Contemporary Cinematographers* (Berkeley: University of California Press, 1984), 157.

6 Hal Trusell, "Lighting *Goin' South*," *AC*, March 1979, 260.

7 "Kodak: Chronology of Motion Picture Films," Eastman Kodak, accessed May 27, 2013, http://motion.kodak.com/motion/About/Chronology_Of_Film/1940-1959/index.htm.

8 *Barry Lyndon* also was pushed one stop, a process to be discussed below.

9 "Filming *The Exorcist*," *AC*, February 1974, 230.

10 Schaefer and Salvato, *Masters of Light*, 199.

11 Ibid., 301.

12 "Photographing Stanley Kubrick's *Barry Lyndon*," *AC*, March 1976, 274.

13 Herb Lightman, "Photographing without Arc Lighting," *AC*, April 1970, 307.

14 Barry Salt, *Film Style and Technology: History and Analysis*, 2nd ed. (London: Starwood, 1992), 271.

15 David A. Cook, *Lost Illusions: American Cinema in the Shadow of Watergate and Vietnam, 1970–1979* (Berkeley: University of California Press, 2000), 369.

16 Salt, *Film Style and Technology*, 271.

17 "Photographing Stanley Kubrick's *The Shining*," *AC*, August 1980, 781.

18 Salt, *Film Style and Technology*, 275.

19 The result was a shifting of the EI (Exposure Index) from 100 to 200. Rand Layton, "Filming *The Candidate* on Location Calls for Some Fast 'Natural Habitat' Decisions," *AC*, September 1972, 1022.

20 "Filming *The Exorcist*," 229.

21 "The Challenges of Photographing *MacArthur*," *AC*, July 1977, 768–769.

22 Herb A. Lightman, "Best Achievement in Cinematography: *Butch Cassidy and the Sundance Kid*," AC, May 1970, 438.

23 Vilmos Zsigmond, "Lights! Camera! Action! For *CE3K*," *AC*, January 1978, 64–65. For more on the complicated history of this film stock, see also "Kodak Announces New, Improved 5247/7247 Eastman Color Negative," *AC*, January 1973, 46–47; "Kodak: Chronology of Motion Picture Films," Eastman Kodak, accessed May 27, 2013, http://motion.kodak.com/motion/About/Chronology_Of_Film/1960-1979/index.htm; and Salt, *Film Style and Technology*, 269.

24 Gregg Steele, "On Location with *The Godfather*," *AC*, June 1971, 569.

25 Schaefer and Salvato, *Masters of Light*, 288.

26 Peter Cowie, *The Godfather Book* (London: Faber & Faber, 1997), 53.

27 Steele, "On Location with *The Godfather*," 570; Schaefer and Salvato, *Masters of Light*, 288.

28 Cowie, *The Godfather Book*, 96.

29 Mitchell Zuckoff, *Robert Altman: The Oral Biography* (New York: Alfred A. Knopf, 2009), 215.

30 Herb A. Lightman, "The New Panaflex Camera Makes Its Production Debut," *AC*, May 1973, 619.

31 David Thompson, ed., *Altman on Altman* (London: Faber & Faber, 2006), 60.

32 Conrad Hall, "Photographing *Day of the Locust*," *AC*, June 1975, 722.

33 "An American Film Institute Seminar with Haskell Wexler, ASC. Part 1," *AC*, June 1977, 663.

34 Herb A. Lightman, "On Location with *Fiddler on the Roof*," *AC*, December 1970, 1210.

35 Vilmos Zsigmond, "Behind the Cameras on *Heaven's Gate*," *AC*, November 1980, 1110.

36 Ibid.

37 Patrick McGilligan, "William Fraker's Magic Camera," *American Film*, April 1979, 50.

38 Schaefer and Salvato, *Masters of Light*, 197.

39 Ibid., 31.

40 "Photographing Stanley Kubrick's *Barry Lyndon*," AC, March 1976, 320.

41 "*Lost Horizon*: How It Was Filmed," AC, April 1973, 453.

42 László Kovács, "Photographing *The Runner Stumbles*," AC, November 1979, 1102.

43 Clarke Taylor, "Cameraman of *Heaven* Says 'Let There Be Light,'" *Los Angeles Times*, September 17, 1978, L34.

44 Schaefer and Salvato, *Masters of Light*, 16–18.

45 Zsigmond, "Lights! Camera! Action!," 98.

46 "Photographing *The Black Hole*," AC, January 1980, 95.

47 David Schwartz, "That '70s Look," Moving Image Source, accessed May 27, 2013, http://www.movingimagesource.us/articles/that-70s-look-20100326.

48 Eclair advertisement, AC, November 1969, 1067.

49 Paul Ramaeker, "A New Kind of Movie: Style and Form in Hollywood Cinema, 1965–1988" (Ph.D. diss., University of Wisconsin–Madison, 2002), 180–181.

50 J. S. Bernstein, "The Zooms in *Barry Lyndon*," accessed May 27, 2013, www.jeffreyscottbernstein.com/kubrick/ . . . /BARRY%20LYNDON.pdf.

51 Vincent LoBrutto, *Stanley Kubrick: A Biography* (New York: Da Capo, 1999), 390.

52 Cook, *Lost Illusions*, 362.

53 McGilligan, "William Fraker's Magic Camera," 303, 435.

54 Cook, *Lost Illusions*, 363.

55 Schaefer and Salvato, *Masters of Light*, 239.

56 Herb A. Lightman, "Filming *Planet of the Apes*," AC, April 1968, 260.

57 "Filming in the Time Warp of Two Different Eras," AC, July 1980, 688.

58 Schaefer and Salvato, *Masters of Light*, 196.

59 David Bordwell, *On the History of Film Style* (Cambridge, MA: Harvard University Press, 1997), 248–249.

60 "*The Last Picture Show: A Study in Black and White*," AC, January 1972, 55.

61 Ibid., 101, 103.

62 Paul Ramaeker, "Notes on the Split-Field Diopter," *Film History* 19 (2007): 180.

63 Ibid., 192–193.

64 Ibid., 186.

65 Malte Hagener, "The Aesthetics of Displays: How the Split-Screen Remediates Other Media," *Refractor,* December 2008, http://refractory.unimelb.edu.au/2008/12/24/the-aesthetics-of-displays-how-the-split-screen-remediates-other-media---malte-hagener.

66 Victoria Duckett, "Pictures and Prizes: Le Grande Prix de Rome and *Grand Prix*," in *A Little Solitaire: John Frankenheimer and American Film*, ed. Murray Pomerance and R. Barton Palmer (New Brunswick, NJ: Rutgers University Press, 2011), 139, 140.

67 Jeffrey Stanton, "Experimental Multi-Screen Cinema," *Westland.net*, accessed May 27, 2013, http://www.westland.net/exp067/map-docs/cinema.htm.

68 Bill Kretzel, "A Place to Stand: Canadian 70mm Short Films," last updated March 4, 2012, http://www.in70mm.com/news/2011/canadian_short/place/index.htm.

69 Vincent Canby, "Charly," *New York Times*, September 24, 1968, 55.

70 Mel Gussow, "Movies Leaving Hollywood Behind," *New York Times*, May 27, 1970, 36.

71 Schaefer and Salvato, *Masters of Light*, 320.

72 "Hollywood's Image Makers," *Newsweek*, July 22, 1974, 65–66; Taylor, "Cameraman of *Heaven* Says 'Let There Be Light,'" L34.

73 Richard Maltby, *Hollywood Cinema*, 2nd ed. (Malden, MA: Blackwell, 2003), 465.

74 Robin Wood, *Hollywood: From Vietnam to Reagan . . . and Beyond* (New York: Columbia University Press, 2003), 30.

75 Edward Lipnick, "Creative Post-Flashing Technique for *The Long Goodbye*," *AC*, March 1973, 328–329.

76 "The First Feature Use of Steadicam-35 on *Bound for Glory*," *AC*, July 1976, 788–791, 778–779.

77 David W. Samuelson, "Introducing the Louma Crane," *AC*, December 1979, 1260–1261.

78 Steven Spielberg, "Directing *1941*," *AC*, December 1979, 1274.

79 Robert B. Ray, *A Certain Tendency of the Hollywood Cinema, 1930–1980* (Princeton, NJ: Princeton University Press, 1985), 294.

80 "*Network* and How It Was Photographed," *AC*, April 1977, 402.

81 John A. Alonzo, "Behind the Scenes of *Chinatown*," *AC*, May 1975, 564.

82 Herb A. Lightman, "*The Wrath of God* on Location," *AC*, March 1972, 320.

83 Herb A. Lightman, "Photographing *They Shoot Horses, Don't They?*," *AC*, July 1969, 701.

84 Alan J. Pakula, "Making a Film about Two Reporters," *AC*, July 1976, 821.

85 Mike Waddell, "Cinema Verite and the Documentary Film," *AC*, October 1968, 754, 788–789, 796–798; Edmund Bert Gerard, "The Truth about Cinema Verite," *AC*, May 1969, 474, 502; Charles Groesbeek, "Cinema Verité: What It's All About," *AC*, October 1970, 992–994, 1034–1038.

86 Karl Malkames, "To Zoom or Not to Zoom," *AC*, June 1974, 712–713.

87 Noel Murray, "Interview: Richard Rush," *AV Club*, last updated June 13, 2011, http://www.avclub.com/articles/richard-rush,57414.

88 Vincent Canby, "Ten Worst Movies of 1970," *New York Times*, January 3, 1971, II:1.

89 On *The French Connection* (1971), Owen Roizman was told that director William Friedkin "didn't especially care if the audience were aware of the camera." See "Photographing *The French Connection*," *AC*, February 1972, 161.

90 Lightman, "The New Panaflex," 617.

91 Ibid., 616.

92 William Fraker, "Photographing *1941*," *AC*, December 1979, 1208.

5 The New Hollywood, 1981–1999

Thanks to Teri Higgins for her research assistance, and to Patrick Keating for his invaluable editorial input.

1 Tino Balio, "Responding to New Television Technologies," in *Hollywood in the Age of Television*, ed. Balio (Boston: Unwin Hyman, 1990), 268.

2 Rosenfeldt, quoted in Alexander Taylor, "Bad Days at the Box Office," *Time*, June 1, 1981, 49.

3 Herb A. Lightman and Richard Patterson, "*Blade Runner*: Production Design and Photography," *AC*, July 1982, 720.

4 Ibid., 684.

5 Ron Magid, "*Labyrinth* and *Legend*: Big Screen Fairy Tales," *AC*, August 1986, 67.

6 Chris Pizzello, "Bedlam on the Basepaths: Filming *The Fan*," *AC*, September 1996, 54.

7 Richard Patterson, "Classic Lighting for *Hammett*," *AC*, November 1982, 1168.

8 Thomas McKelvey Cleaver, "*Scarface*," *AC*, December 1983, 59.

9 Lloyd Kent, "The Cinematography of *E.T.*," *AC*, January 1983, 87.

10 Ron Magid, "*Terminator 2*: He Said He'd Be Back," *AC*, July 1991, 48.

11 Pat Hilton, "Fun Filled Fantasy for *Delirious*," *AC*, February 1991, 39.

12 Michael X. Ferraro, "Global Village Idiot: Filming *The Cable Guy*," *AC*, July 1996, 78.

13 Benjamin Bergery, "Reflections 11: Elmes," *AC*, October 1989, 68.

14 Stephen Pizzello, "*Suture*: A Balancing Act in Black & White," *AC*, July 1994, 46.

15 "Mating Film with Video for *One from the Heart*," *AC*, January 1982, 24, 92; and Vittorio Storaro, "Photographic Aims: *Reds*," *AC*, May 1982, 487, 490–491.

16 Stephen Pizzello, "*Batman Forever* Mines Comic-Book Origins," *AC*, July 1995, 35–36.

17 David E. Williams, "Galactic Antics: *Mars Attacks!* Adds Camp to Alien Invasion," *AC*, December 1996, 41–42.

18 Jay Padroff, "Lachman Films *Desperately Seeking Susan*," *AC*, July 1985, 29.

19 George Turner, "Revenge Served Cold," *AC*, October 1996, 36.

20 Lear Levin, "*Nine and One-Half Weeks*, a Love Story," *AC*, August 1985, 63.

21 Andrew O. Thompson, "Psycho Killer: Serial Killer Spreads Paranoia in *Summer of Sam*," *AC*, June 1999, 40–41.

22 David E. Williams, "The Sins of a Serial Killer," *AC*, October 1995, 37.

23 Jean Oppenheimer, "Revolutionary Images: Filming *Michael Collins*," *AC*, October 1996, 81.

24 David E. Williams, "Mad-Dog Englishman," *AC*, November 1999, 61.

25 David Heuring, "*Indiana Jones and the Last Crusade*," *AC*, June 1989, 58.

26 Ron Magid, "*Alien 3*: In Space, They're Still Screaming," *AC*, July 1992, 54.

27 Stephen Pizzello, "Between 'Rock' and a Hard Place," *AC*, September 1995, 36–46.

28 Stephen Pizzello, "*Natural Born Killers* Blasts Big Screen with Both Barrels," *AC*, November 1994, 37.

29 Ibid., 38.

30 Ibid., 40.

31 Ric Gentry, "A Splintered Vision of America," *AC*, March 1996, 38.

32 Marc Daniel Schiller, "Wacky Style for *Throw Momma from the Train*," *AC*, February 1988, 62.

33 David E. Williams, "Extraterrestrial Escapades: Filming *Men in Black*," *AC*, June 1997, 57.

34 Kutzera, "*Drugstore Cowboy* Set Against Bleak Landscape," *AC*, June 1989, 84; Bob Fisher, "*Night on Earth*: Quirky Cab Fare," *AC*, June 1992, 30; Fisher, "*Apollo 13* Orbits Cinema's Outer Limits," *AC*, June 1995, 44; and Eric Rudolph, "This Is Your Life," *AC*, June 1998, 78.

35 Christopher Probst, "Cold-Blooded Scheming," *AC*, March 1996, 29.

36 Ric Gentry, "Shooting the Curl," *AC*, August 1991, 48.

37 Bob Fisher, "The Heat Is On in *Backdraft*," *AC*, May 1991, 44; Stephen Pizzello, "*True Lies* Tests Cinema's Limits," *AC*, September 1994, 41; Fisher, "Camelot in Shadows: The Filming of *First Knight*," *AC*, July 1995, 62; Christopher Probst, "Cinematic Transcendence," *AC*, June 1996, 78; Eric Rudolph, "Flying the Unfriendly Skies," *AC*, June 1997, 72.

38 Pizzello, "Between 'Rock' and a Hard Place," 43–44.

39 Eric Rudolph, "*The Rock* Offers No Escape," *AC*, June 1996, 72.

40 David E. Williams, "When Worlds Collide," *AC*, July 1998, 42.

41 Stephen Pizzello, "The War Within," *AC*, February 1999, 48.

42 Ted Churchill, "Steadicam: An Operator's Perspective," *AC*, April 1983, 113.

43 Ibid., 117.

44 Ibid., 118.

45 Ibid., 120.

46 Bob Fisher, "*Born on the Fourth of July*," *AC*, February 1990, 30.

47 Paula Parisi, "Long Nights and *Strange Days*," *AC*, November 1995, 67.

48 Brooke Comer, "From the Gardens of Georgia: *Fried Green Tomatoes*," *AC*, March 1992, 30.

49 Robbie Greenberg, "Conversation: Examining *The Pelican Brief*," *AC*, January 1994, 38.

50 Ric Gentry, "Louma Crane and William Friedkin," *AC*, August 1985, 82.

51 Gentry, "Shooting the Curl," 52; Pizzello, "*True Lies* Tests Cinema's Limits," 41; Christopher Probst, "Roger Deakins, ASC, BSC: *The Shawshank Redemption*," *AC*, June 1995, 67; David E. Williams, "An Oceanic Odyssey," *AC*, August 1995, 45.

52 Thomas McKelvey Cleaver, "Adam Greenberg on *The Terminator*," *AC*, April 1985, 51.

53 Christopher Probst, "The Last Great War," *AC, August 1998, 34.*

54 Ron Magid, "Playing for Keeps: *Patriot Games*," *AC*, June 1992, 67.

55 Rudolph, "*The Rock* Offers No Escape," 64.

56 Eric Rudolph, "Run-and-Gun Style Propels *Eraser*," *AC*, July 1996, 72.

57 Ric Gentry, "Painterly Touches: Filming *Portrait of a Lady*," *AC*, January 1997, 52.

58 Pizzello, "Between 'Rock' and a Hard Place," 43.

59 Barry Sonnenfeld, "Shadows and Shivers for *Blood Simple*," *AC*, July 1985, 71.

60 Chris Pizzello, "Fountain of Youth: Filming *Box of Moonlight*," *AC*, July 1997, 70.

61 David Heuring, "When 'Post' Becomes the Main Event," *AC*, September 1992, 25.

62 See, for example, Marji Rhea, "Bridging the Gap between Production and Post," *AC*, March 1993, 57–60; and Steven Poster, "Filmmaker's Forum," *AC*, November 1993, 104.

63 See, for example, Jay Holben, "Rendering New Worlds: Part 1," *AC*, September 1997, 76–88; and Holben, "Rendering New Worlds: Part 2," *AC*, December 1997, 106–112; or coverage of the Arri 435 and 535, which in 1994 and 1995 began to feature its built-in computer and digital features.

64 Jay Holben, "Visions of the Future," *AC*, April 1998, 30–36.

65 Debra Kaufman, "Warner Digital Creates Glacial Gales," *AC*, July 1997, 38–39.

66 Debra Kaufman, "Crossing Over in Post," *AC*, September 1998, 68–76.

67 See, for example, Eric Rudolph, "Color Timing Comes to the Fore," *AC*, November 1997, 115–116.

68 Ron Magid, "Techno Babel," *AC*, April 1999, 52.

69 Ron Magid, "Master of His Universe," *AC*, September 1999, 32d.

70 Jay Holben, "Shooting Digital," *AC*, September 1999, 28.

71 David Bordwell, *The Way Hollywood Tells It: Story and Style in Modern Movies* (Berkeley: University of California Press, 2006), 121.

72 Heuring, "*Indiana Jones and the Lost Crusade*," 58.

73 Ibid., 59.

74 Noël Carroll, "The Future of Allusion: Hollywood in the Seventies (and Beyond)," in *Interpreting the Moving Image* (Cambridge: Cambridge University Press, 1998), 240–264.

75 Thomas Elsaesser, "Specularity and Engulfment: Francis Ford Coppola and *Bram Stoker's Dracula*," in *Contemporary Hollywood Cinema*, edited by Steve Neale and Murray Smith (New York: Routledge, 1998), 191–208.

76 See Richard Maltby, "Taking Hollywood Seriously," in *Hollywood Cinema: An Introduction*, 2nd ed. (Malden, MA: Blackwell, 2003), 5–32.

77 Linda Trefz, "Photography for *Liquid Sky*," *AC*, February 1984, 63.

78 Rudolph, "Flying the Unfriendly Skies," 70.

79 George Turner, "Steven Spielberg and *E.T.*," *AC*, January 1983, 80–81.

80 Bob Fisher, "*Jurassic Park*: When Dinosaurs Rule the Box Office," *AC*, June 1993, 39.

81 "Mating Film with Video for *One from the Heart*," 92.

82 Burum, quoted in George Turner, "*War of the Roses* Fought on Many Cinematic Fronts," *AC*, January 1990, 50.

83 David E. Williams, "Reintroducing Bond . . . James Bond," *AC*, December 1995, 44.

84 Stephen Pizzello, "Cinematic Invention Heralds *The Age of Innocence*," *AC*, October 1993, 38.

85 Rick Baker, "Almendros Illuminates *Billy Bathgate*," *AC*, November 1991, 28.

86 Bob Fisher, "Don Peterman and *Flashdance*," *AC*, April 1984, 64.

87 Pizzello, "Bedlam on the Basepaths," 55.

88 Joseph Ebben, "Music Video Cinematography: A New Film Grammar," *AC*, February 1992, 88.

89 David Tolsky, "*Gremlins 2: The New Batch*," *AC*, June 1990, 70.

90 Stephen Pizzello, "Photographic Grandmaster Shows Moves in *Searching for Bobby Fischer*," *AC*, February 1994, 51.

91 Stephen Pizzello, "Five-Star General," *AC*, August 1998, 45.

92 Williams, "Mad-Dog Englishman," 65.

93 Pizzello, "Between 'Rock' and a Hard Place," 38.

94 Chris Pizzello, "High Noon Hits the Jersey Turnpike," *AC*, September 1997, 56.

95 Gentry, "Shooting the Curl," 47.

96 Williams, "The Sins of a Serial Killer," 38.

97 Vittorio Storaro, "The Right to Sign Ourselves as 'Authors of Cinematography,'" *AC*, February 1995, 96.

98 Bordwell, *The Way Hollywood Tells It*, 147.

6 The Modern Entertainment Marketplace, 2000–Present

1 David Hancock and Charlotte Jones, "12 D-Cinema Timeline," *Digital Cinema: Rollout, Business Models, and Forecasts to 2010* (London: Screen Digest Ltd., 2006); David Cohen, "Lab Pact Heralds Twilight of Film," *Variety*, July 18, 2011, http://www.variety.com/article/VR1118040041.

2 See David Bordwell, *The Way Hollywood Tells It* (Berkeley: University of California Press, 2006), 155; Scott Kirsner, *Inventing the Movies* (n.p.: CinemaTech Books, 2008), 80; Michele Pierson, "No Longer State-of-the-Art: Crafting a Future for CGI," *Wide Angle* 21, no. 1 (January 1999): 43; also see Piers Brozny, *Digital Domain* (New York: Billboard Books, 2001); and Michael Rubin, *Droidmaker: George Lucas and the Digital Revolution* (Gainesville,

FL: Triad Publishing, 2006), for descriptions of the development of special effects as a sub-industry.

3 NCTA, "The Transition to Digital Television," Washington, D.C., *National Cable & Telecommunications Association*, 2002.

4 See "Off to Work We Go: Disney's Restoration Project," *AC*, September 1993, 48; and Bob Fisher, "Digital Cinematography: A Phrase of the Future?," *AC*, April 2003, 50.

5 Julie Turnock, "The ILM Version: Recent Digital Effects and the Aesthetics of 1970s Cinematography," *Film History* 24, no. 2 (2012): 158–168.

6 The digital intermediate process was labeled many different ways over the decade. "Digital film mastering" was used in some *AC* articles, and, as described in Kristin Thompson's *The Frodo Franchise*, "selective digital grading." In *Harnessing the Technicolor Rainbow*, Scott Higgins calls it "digital color grading." Digital intermediate emerged as the common term, however, a coinage that highlighted its role within a film-based, photochemical workflow (a way station between negative and release print) and thus the cinematographers' role in maintaining that workflow. Material in this section is drawn from Fisher, "Digital Cinematography," 50; Joe Leydon, "Pleasantville," *Daily Variety*, September 21, 1998, 104; "Digital Post and Graphics," *AC*, May 1995; Kristin Thompson, *The Frodo Franchise* (Berkeley: University of California Press, 2007), 280; Bob Fisher, "Black and White in Color: The Comedic Fantasy *Pleasantville* Provides a Unique Opportunity for the Digital and Photochemical Production Worlds to Merge," *AC*, November 1998, 60–67; Bob Fisher, "Escaping from Chains," *AC*, October 2000, 36–49; and Bob Fisher, "Images for the Ages: Roger Deakins: *O Brother Where Art Thou*," *AC*, June 2001, 102.

7 Aylish Woods, "Digital Intermediates and Micromanipulation of the Image," *Film Criticism* 32, no. 1 (Fall 2007): 72–94.

8 This complaint was cited numerous times in field research I conducted in 2005–2006 with cinematographers. For example, Robert Primes, interview by the author, August 23, 2005, transcript; Curtis Clark, interview by the author, August 25, 2005, transcript. See also Peter Caranicas, "Lensers Sharpen Focus on Pay for Post," *Variety*, December 20, 2011, 2.

9 Colorization, a process of adding color to black-and-white films from the studio's back catalogs for re-presentation, was one of the early applications of digital technique to motion pictures. Belton discusses the "discourse of colorization" around the DI and *Pleasantville* specifically, in John Belton, "Painting by Numbers: The Digital Intermediate," *Film Quarterly* 61, no. 3 (Spring 2008): 58–65.

10 Widespread acceptance of the DI was slow among cinematographers, cognizant of the threat it represented. As late as October 2008, Deakins was still defending his adoption of the DI, writing an influential description—and defense—of the DI process entitled "DIs, Luddites, and Other Musings," *AC*, October 2008, 39.

11 After 2007 most of the major studios, including Warner Bros., Fox, Paramount, and Universal, greatly expanded their on-lot postproduction facilities (including digital grading) as profit centers and to better control access to their intellectual property. See David Cohen, "Post-Pendulum Swings to Studios," *Variety*, August 20, 2007, 8; and David Cohen, "The Digital Divide," *Variety*, March 14, 2005, B1.

12 Thompson, *The Frodo Franchise*.

13 Charles Swartz, interview by the author, March 27, 2005, transcript.

14 Ian Austin, "A Galaxy Far Far Away Is Becoming Fully Digital," *New York Times*, May 25, 2000, http://www.nytimes.com/2000/05/25/technology/a-galaxy-far-far-away-is-becoming-fully-digital.html.

15 Jay Holben, "Shooting Digital," *AC*, September 1999, 28; Marc Graser, "Digital Dilemma for 'Wars?," *Variety*, June 14, 1999, 1; Stephanie Argy, "Hi Def Digital Offers Quality," *Daily Variety*, July 30, 1999; "TV Lensers Widen Stylistic Palette," *Variety*, March 6, 1998;

Christopher Probst, "Illuminating Images," *AC*, October 1999, 72; David Weiner, "Sony's Digital Empire," *AC*, May 2001, 113.

16 Jay Holben, "Best and Brightest," *AC*, May 2007, 64.

17 Curtis Clark, interview by the author, July 25, 2005, transcript; also see Dave McNary, "New Focus on Digital," *Daily Variety*, May 28, 2003, 8.

18 Curtis Clark, interview by the author, July 25, 2005, transcript. Other descriptions of the StEM can be found in Bob Fisher, "Tomorrow's Technology: The ASC and DCI Join Forces to Set Standards for Digital Projection," *AC*, January 2004, 121; Dave McNary, "Standardized Digital Projecter Test Bows," *Daily Variety*, September 26, 2003; and "ASC and DCI Creating Digital Cinema Test Film (Press Release)," *DCI, LLC*, January 24, 2003, http://www.dcimovies.com/press/09–24–03.html.

19 Michael Karagosian, "Report on the Transition to Digital Cinema in 2007," *MKPE Consulting*, May 2007, http://www.mkpe.com/publications/d-cinema/reports/May2007_report .php. A longtime consultant, researcher, and observer of digital cinema, Karagosian has published annual industry updates on the state of digital cinema in *SMTPE Magazine* and online.

20 Michael Goldman, "D-cinema Lab Starts Percolating," *Millimeter*, May 2001, 48.

21 Debra Kaufman, "Film Fading to Black," *Creative Cow Magazine*, October 10, 2011, http://magazine.creativecow.net/article/film-fading-to-black.

22 David Cohen, "Lab Pact Heralds Twilight of Film," *Variety*, July 18, 2011.

23 Robin Harris, "Movie Film Era Draws to a Close," *ZNNet*, April 5, 2013, http://www.zdnet.com/movie-film-era-draws-to-a-close-7000013602.

24 John Fithian, "State of the Industry," keynote address, presented at *CinemaCon 2011*, Las Vegas, March 29, 2011, http://www.natoonline.org/pdfs/JF%speech%cinemacon%20 11%–%Distribution%version.pdf.

25 Thomas Schatz, "The Studio System in Conglomerate Hollywood," in *The Contemporary Hollywood Film Industry*, ed. Paul McDonald and Janet Wasko (Malden, MA: Blackwell, 2008), 13–41.

26 Peter Debruge, "Mumblecore Movement Makes Mainstream Moves," *Variety*, March 3, 2008, 10.

27 See Gunning's review of D. N. Rodowick, *The Virtual Life of Film*, in Tom Gunning, "The Sum of Its Pixels: Is the Difference between Film and Digital a Matter of Math?," *Film Comment* 43, no. 5 (September/October 2007): 78.

28 D. N. Rodowick, *The Virtual Life of Film* (Cambridge, MA: Harvard University Press, 2007), 101–103.

29 See Christopher Probst, "Taking Stock: Part 1," *AC*, April 2000, and "Taking Stock: Part 2," *AC*, May 2000; also, Lindsay Gelfand, "What's in Stock," *Independent Film & Video Monthly*, January 2005, 9.

30 I was witness to one of Doyle's fierce, if funny, tirades at a seminar during the Camerimage Film Festival, Lodz, Poland, in November 2006. Recently, he criticized AMPAS's voters for rewarding Claudio Miranda with an Oscar for cinematography for the digitally photographed, effects-heavy film *Life of Pi* (Ang Lee, 2012). Sam Gaskin, "Christopher Doyle: *Life of Pi* Oscar Is an Insult to Cinematography," *Blouin ArtInfo*, March 5, 2013, http://sea.blouinart info.com/ news/story/874483/christopher-doyle-interview-part-2-life-of-pi-oscar-is-an#.

31 Stephen Pizzello, "Danse Macabre: Directing *Black Swan*," *AC*, December 2010, 30.

32 M. David Mullen, interview by the author, August 15, 2004, transcript.

33 Mike Figgis, interview by the author, November 29, 2004, transcript.

34 Andrew de Waard and R. Colin Tait, *The Cinema of Steven Soderbergh: Indie Sex, Corporate Lies, and Digital Videotape* (New York: Wallflower Press, 2013), 17.

35 Lucas's willingness to push this R&D process was considerable, dating back to the mid-1990s. When he was unsatisfied with Panavision's slow move to cinema-style lenses after Episode I, he shifted to a relationship with Plus8 video, allowing them to build a camera for him around the Sony sensor. Panavision responded by creating the Genesis camera, and Lucas switched back.

36 Lucas appeared repeatedly in the trade press. See, for example, in *AC* between 1999 and 2002: Ron Magid, "Master of His Universe," *AC*, September 1999, 26; Magid, "Phantom Camerawork," *AC*, September 1999, 53; Benjamin Bergery, "Digital Cinema, by George," *AC*, September 2001, 66; Bergery, "Framing the Future," *AC*, September 2001, 76; Magid, "Brave New Worlds," *AC*, September 2002, 50; Magid, "Exploring a New Universe," *AC*, September 2002, 40.

37 Jonathan Bing, "H'W'D's Old Spool Ties," *Variety*, August 19, 2002; Michael Goldman, "The HD Rebel: Robert Rodriguez Explains Why He Abandoned Film and Converted to HD," *Millimeter*, August 2002, 23.

38 See Roland Sterner, *The EDCF Guide to Digital Cinema Production*, ed. Lars Svanberg (Burlington, MA: Focal Press, 2004), 18; and Jon Silburg, "ICG Focuses on Latest Lenses for Film and Digital Productions," *ICG Magazine*, February 2006.

39 The perfidy of producers on this score was a constant refrain in my interviews with cinematographers. In particular, Robert Primes, interview by the author, August 23, 2005, transcript; Curtis Clark, interview by the author, August 25, 2005, transcript; Bill Bennett, interview by the author, August 22, 2005, transcript.

40 Alison Macor, *Chainsaws, Slackers, and Spy Kids: 30 Years of Filmmaking in Austin, Texas* (Austin: University of Texas Press, 2010), 305.

41 Jay Holben, "Ring Leader: Emmanuel Lubezki and Director Michael Mann Revisit a Turbulent Era in *Ali*," *AC*, November 2001, 34.

42 See Mark Olsen, "Michael Mann: Paint It Black," *Sight and Sound* 14, no. 10 (2004): 16; "Collateral," *Daily Variety*, January 7, 2005 (special section), A16; and Jay Holben, "Hell on Wheels," *AC*, August 2004, 40.

43 Gerald Sim, "When and Where Is the Digital Revolution in Cinematography?," *Projections* 6, no. 1 (2012): 82.

44 Stephen Lighthill, interview by the author, August 20, 2005, transcript.

45 Greg Marcks, "The Future of Film Capture," *Film Quarterly* 61, no. 1 (2007): 8, and Michael Goldman, "Going Tapeless: David Fincher Spearheads a Hard-Drive-Based Data Workflow for Zodiac," *Millimeter*, August 2006, 9.

46 David Williams, "Cold Case File," *AC*, April 2007, 32.

47 Ibid., 41.

48 Pierson, "No Longer State-of-the-Art," 43.

49 Turnock, "The ILM Version," 158; and Caetlin Benson-Allot, "Slants of Light," *Film Quarterly* 65, no. 1 (2011): 10.

50 Bob Rehak, "The Migration of Forms: Bullet Time as Microgenre," *Film Criticism* 32, no. 1 (Fall 2007): 26.

51 Ben Walters, "The Great Leap Forward," *Sight and Sound* 19, no. 3 (March 2009): 38–43.

52 Charlotte Huggins, "The Three-Dimensions of 3-D," *Produced By*, Spring 2008, 20.

53 David Rooney, "Review: *The Polar Express*," *Variety*, November 1, 2004, 28.

54 Walters, "The Great Leap," 38.

55 David Bordwell, "Intensified Continuity: Visual Styles in Contemporary American Film," *Film Quarterly* 55, no. 3 (Spring 2002): 16.

56 Susan Christopherson, "Labor: The Effects of Media Concentration on the Film and

Television Workforce," in McDonald and Wasko, *The Contemporary Hollywood Film Industry*, 155–165.

57 "Ascending Cinematography's Summit," *AC*, July 2011, 62.

58 For a typical example of this discourse see David Heuring, "Two Men, One Vision," *Daily Variety*, January 7, 2005, Special Section A3.

59 See Scott Higgins, *Harnessing the Technicolor Rainbow: Color Design in the 1930s* (Austin: University of Texas Press, 2007).

60 Richard Crudo, "President's Desk," *AC*, October 2004, 10.

61 David Williams, "Roundtable Q&A: Production: Methods in the Madness," *AC* (supplement), May 2007, 26.

GLOSSARY

Academy ratio: an aspect ratio (width-to-height) of 1.37 to 1, the standard film proportion for sound films prior to the adoption of widescreen technologies in the 1950s.

anamorphic lens: a camera lens that squeezes a widescreen composition onto a regular piece of film while filming; alternately, a lens that unsqueezes such an image during projection. CinemaScope popularized the use of anamorphic lenses, still employed in some widescreen systems.

anti-halation stock: a film stock with a special coating to prevent unwanted flares.

aperture: the opening in a lens, allowing light to pass through to the film or video element. Measured in F-stops.

arc lamp: a lamp producing light from the discharge between two electrodes. The carbon arc was the most prominent instrument in the silent period, producing bright, hard lighting on the blue end of the color spectrum.

ASA: *See* film speed.

ASC: American Society of Cinematographers, an honorary organization formed in 1919.

aspect ratio: the width-to-height ratio of a film image.

available light: the illumination present on a location without the film crew's additional lights.

backlight: a light positioned behind the subject, pointing toward the camera; typically produces a rim of light around the subject, separating the foreground from the background.

bleach-bypass: a process in which the lab partially or entirely skips a routine bleaching stage in the developing process, thereby leaving some silver on the negative or positive and affecting the contrast, grain, and saturation of the image. Similar in effect to ENR.

blimp: a cover placed on a film camera in order to make it quieter by absorbing the sound of the machine when it operates.

booth: large windowed box built to house the overly loud camera during the transition to sound.

car mount: a device allowing the camera to be attached to a moving vehicle.

CGI: computer-generated imagery; visual effects designed with digital technology, such as the dinosaurs in *Jurassic Park* (1993).

CinemaScope: widescreen process using an anamorphic lens to squeeze the image onto a regular piece of 35mm film; the image is then unsqueezed in projection, producing an image more than twice as wide as it is tall.

cinematographer: an individual supervising the camera and lighting crews working on a film, and responsible for determining artistic and technical decisions related to the image. Also called a director of photography (d.p.).

Cinerama: widescreen process employing three cameras and three projectors to produce an image with an aspect ratio of 2.59 to 1.

color grading: the postproduction process of correcting the colors using digital tools. Similar to color timing, but with an increased ability to change the appearance of the image.

color temperature: a measurement of the light's color, ranging from the warm (redder) colors at the lower end of the scale to the cooler (bluer) colors near the top. Measured in degrees Kelvin. Tungsten sources often are listed at 3200°K, with daylight sources at 5600°K.

color timing: the postproduction process of correcting colors using photochemical tools, by controlling the light passing through the negative or inter-negative.

contrast: the difference between the light and dark areas of the image, with low-contrast images often described as "high-key" and high-contrast images as "low-key."

Cooper-Hewitt: type of lamp, common in the silent period, consisting of mercury vapor tubes and producing soft light similar to daylight.

crab-dolly: a type of dolly (vehicle for the camera) in which the wheels can be rotated together, allowing the dolly grip to shift the direction of the movement in the middle of a shot.

crane: a device for moving the camera in which the camera is placed at the end of a long counterweighted arm that can be raised and lowered by the grip team.

cucoloris: a piece of grip equipment, typically a flat object with holes in it, placed in front of a lamp to produce interesting shadows on a wall. Also known as a "cookie."

d.p.: director of photography, another term for cinematographer.

daylight-balanced: this term may refer to light that has been adjusted to match the approximate color temperature of daylight, often measured at 5600° Kelvin; alternatively, the term may refer to film stock that has been designed to produce colors most faithfully when working with daylight or its equivalent.

deep focus: a style of shooting in which the foreground, middleground, and background planes are all captured in reasonably sharp focus.

depth of field: the range in which objects in front of the lens can be photographed in acceptable focus; several factors work together to define depth of field, including the size of the aperture and the focal length of the lens.

diffusion (lamp): material placed in front of a lamp in order to soften the light; for instance, a sheet of white silk-like fabric may be used as diffusion.

diffusion (lens): an object placed in front of the lens in order to soften the image; the object may be a piece of fabric similar to a stocking or a specially designed filter.

digital data camera: a recent invention that records the scene as a raw data file, rather than as a video signal.

digital intermediate (DI): a step in the postproduction process in which an image, typically shot on film, is scanned as a computer file, allowing a colorist, under the supervision of the cinematographer, to adjust the visuals using digital tools. The image could then be reconverted to film for 35mm projection. *See also* color grading.

dolly: a wheeled vehicle on which the camera is mounted in order to facilitate camera movement. *See also* tracking shot.

effect lighting: general term for the technique of imitating the appearance of light coming from a particular source, such as a "fireplace" effect or a "cigarette lighter" effect.

ENR: a process in which silver is reintroduced to the film (typically, the positive print) by the laboratory, to control contrast, grain, and saturation; similar to bleach-bypass.

exposure index: *See* film speed.

eyelight: a point of light reflected in the subject's eyes; the cinematographer may rely on existing lights to produce this effect or introduce a small additional light to create the reflection.

F-stop: a measurement of the aperture of the lens, in relation to its focal length. A smaller number, such as F/2, indicates a wider aperture (i.e., one that lets in more light) in comparison to a larger number, such as F/8. *See also* T-stop.

fast lens: a lens capable of opening to a wider than normal aperture, thereby letting in more light.

figure lighting: the set of techniques for lighting actors, such as three-point lighting.

fill light: illumination that brightens the shadows created by the key light, without being so bright as to eliminate those shadows.

film speed: a measure of a film stock's sensitivity to light. Often measured according to an arithmetic scale, whereby a speed of 100 is twice as fast as 50, and a speed of 200 is twice as fast as 100. Though their meanings and histories differ, ASA, EI (Exposure Index), and ISO are all measures of film speed.

film stock: in photochemical cinema, the strip of material on which the image is exposed.

flashing: the technique of exposing the negative to a controlled amount of light before processing; can be done before or after shooting. One typical result is reduced contrast. Flashing also could be applied to a release print.

flat lighting: frontal illumination that casts no visible shadows from the camera's point of view, reducing the modeling of the subject.

flood light: a lamp that spreads its beam over a large area, in contrast to the more focused beam of the spotlight.

focal length: the distance, commonly measured in millimeters, between the lens's optical center and the point where the light rays at infinity are brought into focus; focal length provides a measure of the lens's angle of view, ranging from wide-angle to telephoto.

fog filter: a piece of treated glass placed in front of the lens, creating strong diffusion that looks like fog.

4K: a common standard for high-definition digital cinematography and projection; the term refers to the number of horizontal pixels in the image, in this case approximately 4,000.

fps: frames per second. Since the conversion to sound, the standard for film has been 24 fps. The norm for video was approximately 30 fps for decades, though digital video often employs 24 fps.

gaffer: a member of the film production crew responsible for the arrangement and powering of the lights; answers to the cinematographer.

gauge: the width, in millimeters, of the film strip. Since 35mm is the standard, anything larger than that is considered wide-gauge.

grip: a member of the film production crew responsible for setting up non-electrical equipment, such as stands or dollies; the leader of this crew, the key grip, answers to the cinematographer.

hard lighting: illumination that produces crisp, undiffused shadows, normally produced by small, point-sized sources.

high-angle shot: a shot in which the camera is above the subject, pointing in a downward direction.

high-key lighting: most generally, this term can refer to any lighting scheme with a bright overall tonality; more specifically, it refers to a low-contrast lighting arrangement in which the fill light is relatively bright, minimizing the darkness of the shadows.

HMI: abbreviation for hydrargyrum medium-arc iodide, a type of lamp used in film production since the 1970s. Typically daylight-balanced, these lamps are more energy efficient than normal incandescents.

IMAX: a large-format camera and projection system, most commonly used in special venues but recently featured in some big-budget features as an alternative to 3-D. The film, typically 65mm, runs through the camera horizontally, allowing for an even larger frame area.

incandescent lamp: a form of lighting equipment using a hot metal filament to produce light; adopted throughout the industry after the conversion to panchromatic film in the 1920s, since the new stocks were more sensitive to the warm end of the light spectrum.

ISO: *See* film speed.

key light: the primary source of illumination in a scene; in the three-point lighting system, the key light produces the shadows that are brightened (but not eliminated) by the fill light.

kicker: a light, often placed in a side-back position, that illuminates the edge of an actor's face.

Kino Flo: fluorescent lamps designed in the 1980s with bulbs designed for film and video use; a popular tool for producing soft lighting.

latensification: a process enabling cinematographers to shoot in low-light conditions by exposing the negative to additional light before the developing stage. *See also* flashing.

low-angle shot: a shot in which the camera is positioned below its subject, pointing in an upward direction.

low-key lighting: most generally, this term can refer to any lighting scheme with a dark overall tonality; more specifically, it refers to a high-contrast lighting arrangement in which the fill light is weak or nonexistent, emphasizing the darkness of the shadows.

matte: a device that blocks off one portion of the image in order to allow two or more elements to be combined in a single frame; can be used in original photography or in postproduction.

monopack: a type of color film stock in which the different color layers are combined in one piece of film, in contrast to the "three-strip" system of classic Technicolor.

motion-control camera: a camera that has been configured to allow its movements to be controlled by computer, ensuring precise repetition of an identical motion over multiple takes.

multiple-camera shooting: a filming strategy employing more than one camera to record the scene, as opposed to the single-camera approach that was the norm for the majority of years covered by this book; multiple-camera shooting, originally associated with the early sound period, has enjoyed a resurgence recently, especially in action films.

orthochromatic: a type of black-and-white film stock that was sensitive to the blue end of the light spectrum but insensitive to reds and other warm colors; common for most of the silent period.

pan: a type of camera movement in which the camera swivels laterally on the tripod.

panchromatic: a type of black-and-white film stock that was sensitive to most of the color spectrum, in contrast to blue-sensitive orthochromatic.

photoflood: a light bulb that burns more brightly than the ordinary household bulb, albeit for a shorter amount of time; often used on location shooting, since it can be screwed into a normal socket.

prime lens: a lens with a fixed focal length, as opposed to the variable focal length of the zoom.

pulling: underdeveloping the film stock, often to compensate for deliberate or accidental overexposure.

pushing: overdeveloping the film stock, often to compensate for deliberate or accidental underexposure.

rack focus: the technique of shifting the lens's focus from the foreground to the background, or vice versa, during a shot.

reflector: a piece of grip equipment that bounces sunlight or artificial light back onto the scene; typically, a flat shiny panel.

reflex viewfinder: an optical system allowing the operator to look through the lens during shooting, enabling accurate monitoring of framing; previous viewfinders, such as the parallax, offered the operator an approximation of the view through the lens.

resolution: the amount of detail a particular medium can record; in video, this is measured by the number of pixels (or lines of pixels) the image contains.

reversal: a type of film stock that is processed differently than negative stock; whereas negative is rephotographed to produce a positive print, reversal is processed in such a way that the original camera stock itself yields a positive image.

70mm: a widescreen format using larger-than-normal strips of film; typically, the camera is loaded with 65mm film, and the final print plays on a 70mm projector.

shallow focus: a style of shooting with narrow depth of field; only one plane (foreground, middleground, or background) is in focus, with the other planes appearing blurry.

single-source lighting: illumination on the subject that appears to come from one lamp, with one visible shadow.

slow motion: the effect of action moving slowly onscreen. Slow motion is produced by running the camera faster than normal and shooting additional frames per second; the result looks slow when projected at normal speed.

soft lighting: illumination that produces gentle gradations between highlights and shadows, normally produced by large sources, or by smaller hard sources that have been softened with diffusion.

split-field diopter: a device placed in front of a lens allowing the camera to photograph the foreground and background in sharp focus; the effect is similar to deep-focus photography, but not identical, since each half of the split-field image has its own (typically shallow) depth of field.

split-screen: the process of combining two or more distinct images within one frame; originally executed in-camera, split-screen effects now are produced more often in postproduction.

spotlight: a lamp with a focused beam, often employing a lens to control the illumination.

Steadicam: a device, mounted to an operator's body, allowing the operator to execute smooth camera movements, even in situations where dollying would be impossible.

stereoscopy: three-dimensional filmmaking, typically using two cameras to provide two different images to the spectator's two eyes, thereby creating an enhanced experience of depth.

Super-35: a system of filming in which the camera focuses the image onto a larger frame than usual by including the area normally used for an optical sound track. Though the process often requires additional lab work, Super-35 is a viable method of producing widescreen images without using anamorphic lenses.

T-stop: a measurement of the lens's aperture; similar to an F-stop, though the T-stop takes into account such factors as the light lost inside the lens.

Telecine: a laboratory process converting film to video.

telephoto lens: a long focal-length lens. Shots photographed with a telephoto lens often are described as having a flat sense of space, with little difference in scale between the foreground and background.

three-point lighting: a routine lighting arrangement featuring a key light that illuminates the primary subject, a fill light that reduces the darkness of the shadows, and a backlight that creates a rim of light separating the subject from the background.

three-strip Technicolor: a color system in which three separate pieces of film are run through a large camera at the same time, producing a record of the scene's color information that can be used to produce a color print on a single piece of film. First appearing in a complete feature in 1935, the system was replaced by less cumbersome monopack systems in the 1950s.

tinting and toning: two distinct processes of adding color to black-and-white film, both common in the silent period. Whereas toning primarily affects the shadow areas, tinting is most visible in the highlights.

tracking shot: a moving shot in which the dolly is placed on tracks to guide the motion of the camera.

tungsten-balanced: light that has been adjusted to match the approximate color temperature of an incandescent lamp with a tungsten filament, often measured

at 3200° Kelvin; alternatively, film stock that has been designed to produce colors most faithfully when working with tungsten light or its equivalent.

24P: a video format operating at approximately 24 frames per second, mimicking the standard shooting rate of film.

video assist: a device attached to a film camera allowing the director and/or other crew members to see the image being photographed by the camera without having to look through the viewfinder.

wide-angle lens: a short focal length lens. Shots photographed with a wide-angle lens often are described as having an exaggerated sense of space, with noticeable differences in scale between foreground and background figures.

wide-gauge film: any film strip that is larger than 35mm.

zoom lens: a lens with a variable focal length, allowing it to shift (e.g.) from wide angle to telephoto in the middle of a shot.

Sources: Alexander Ballinger, *New Cinematographers* (New York: HarperCollins, 2004); Benjamin Bergery, *Reflections: Twenty-one Cinematographers at Work* (Hollywood: ASC Press, 2002); David Bordwell and Kristin Thompson, *Film Art: An Introduction, 10th ed.* (New York: McGraw-Hill, 2012); and Barry Salt, *Moving into Pictures* (London: Starword, 2006).

SELECTED BIBLIOGRAPHY

The bibliography includes a selection of articles from trade journals (e.g., *American Cinematographer*) rather than a complete list of the hundreds of trade citations that can be found throughout the endnotes.

Almendros, Nestor. *A Man with a Camera*. New York: Farrar, Straus and Giroux, 1986.

Alton, John. *Painting with Light*. 1949; rpt. Berkeley: University of California Press, 1995.

Balio, Tino. *Grand Design: Hollywood as a Modern Business Enterprise, 1930–1939*. Berkeley: University of California Press, 1996.

———. "Responding to New Television Technologies." In *Hollywood in the Age of Television*, edited by Tino Balio. Boston: Unwin Hyman, 1990.

Ballinger, Alexander. *New Cinematographers*. New York: HarperCollins, 2004.

Barr, Charles. "CinemaScope: Before and After." *Film Quarterly* 16, no. 4 (1963): 4–24.

Belton, John. "The Bionic Eye: Zoom Esthetics." *Cineaste* 11, no. 1 (1980/1981): 20–27.

———. "Painting by Numbers: The Digital Intermediate." *Film Quarterly* 61, no. 3 (Spring 2008): 58–65.

———. *Widescreen Cinema*. Cambridge, MA: Harvard University Press, 1992.

Benson-Allot, Caetlin. "Slants of Light." *Film Quarterly* 65, no. 1 (2011): 10–11.

Bergery, Benjamin. *Reflections: Twenty-one Cinematographers at Work.* Hollywood: ASC Press, 2002.

Bitzer, G. W. *Billy Bitzer: His Story.* New York: Farrar, Straus and Giroux, 1973.

Bordwell, David. *Figures Traced in Light.* Berkeley: University of California Press, 2005.

———. *On the History of Film Style.* Cambridge, MA: Harvard University Press, 1997.

———. *The Way Hollywood Tells It: Story and Style in Modern Movies.* Berkeley: University of California Press, 2006.

Bordwell, David, Janet Staiger, and Kristin Thompson. *The Classical Hollywood Cinema: Film Style and Mode of Production to 1960.* New York: Columbia University Press, 1985.

Bordwell, David, and Kristin Thompson. *Film Art: An Introduction.* 10th ed. New York: McGraw-Hill, 2012.

Broening, Lyman H. "How It All Happened: A Brief Review of the Beginnings of the American Society of Cinematographers." *American Cinematographer*, November 1, 1921.

Brown, Karl. *Adventures with D. W. Griffith.* New York: Da Capo Press, 1976.

Brownlow, Kevin. *The Parade's Gone By. . . .* Berkeley: University of California Press, 1968.

Brozny, Piers. *Digital Domain.* New York: Billboard Books, 2001.

Bukatman, Scott. "Zooming Out: The End of Offscreen Space." In *The New American Cinema*, edited by Jon Lewis, 248–272. Durham, NC: Duke University Press, 1998.

Burnett, Colin. "Arnheim on Style History." In *Arnheim for Film and Media Studies*, edited by Scott Higgins, 229–248. London: Routledge, 2011.

Caldwell, John Thornton. *Production Culture: Industrial Reflexivity and Critical Practice in Film and Television.* Durham, NC: Duke University Press, 2008.

Carringer, Robert L. *The Making of Citizen Kane.* Rev. ed. Berkeley: University of California Press, 1996.

Carroll, Noël. "The Future of Allusion: Hollywood in the Seventies (and Beyond)." In *Interpreting the Moving Image*, 240–264. Cambridge: Cambridge University Press, 1998.

Christensen, Jerome. *America's Corporate Art: The Studio Authorship of Hollywood Motion Pictures.* Stanford, CA: Stanford University Press, 2012.

Christopherson, Susan. "Labor: The Effects of Media Concentration on the Film and Television Workforce." In *The Contemporary Hollywood Film Industry*, edited by Paul McDonald and Janet Wasko, 155–165. Malden, MA: Blackwell, 2008.

Churchill, Ted. "Steadicam: An Operator's Perspective." *American Cinematographer*, April 1983.

Clarke, Charles G. "CinemaScope Photographic Techniques." *American Cinematographer*, June 1955.

———. "How Desirable Is Extreme Focal Depth?" *American Cinematographer*, January 1942.

Cook, David A. *Lost Illusions: American Cinema in the Shadow of Watergate and Vietnam, 1970–1979.* Berkeley: University of California Press, 2000.

Cormack, Mike. *Ideology and Cinematography in Hollywood, 1930–1939.* New York: St. Martin's Press, 1994.

Crafton, Donald. *The Talkies: American Cinema's Transition to Sound.* Berkeley: University of California Press, 1997.

Cutting, James, Kaitlin L. Brunick, Jordan E. DeLong, Catalina Iricinschi, and Ayse Candan. "Quicker, Faster, Darker: Changes in Hollywood Film over 75 Years." *i-Perception* 2 (2011): 569–576.

Debruge, Peter. "Mumblecore Movement Makes Mainstream Moves." *Variety,* March 3, 2008.

De Waard, Andrew, and R. Colin Tait. *The Cinema of Steven Soderbergh: Indie Sex, Corporate Lies, and Digital Videotape.* New York: Wallflower Press, 2013.

Duckett, Victoria. "Pictures and Prizes: Le Grande Prix de Rome and *Grand Prix.*" In *A Little Solitaire: John Frankenheimer and American Film,* edited by Murray Pomerance and R. Barton Palmer, 129–142. New Brunswick, NJ: Rutgers University Press, 2011.

Ebben, Joseph. "Music Video Cinematography: A New Film Grammar." *American Cinematographer,* February 1992.

Elsaessar, Thomas. "Specularity and Engulfment: Francis Ford Coppola and Bram Stoker's *Dracula.*" In *Contemporary Hollywood Cinema,* edited by Steve Neale and Murray Smith, 191–208. New York: Routledge, 1998.

———. *Weimar Cinema and After: Germany's Historical Imaginary.* New York: Routledge, 2000.

Ettedgui, Peter. *Cinematography Screencraft.* Woburn, MA: Focal Press, 1998.

Eyman, Scott. *Five American Cinematographers.* Metuchen, NJ: Scarecrow Press, 1987.

Finler, Joel. *The Hollywood Story.* London: Wallflower Press, 2003.

Fisher, Bob. "Digital Cinematography: A Phrase of the Future?" *American Cinematographer,* April 2003.

———. "Images for the Ages: Roger Deakins: *O Brother Where Art Thou.*" *American Cinematographer,* June 2001.

Galt, Rosalind. *Pretty: Film and the Decorative Image.* New York: Columbia University Press, 2011.

Gaut, Berys. "Art as a Cluster Concept." In *Theories of Art Today,* edited by Noël Carroll, 25–44. Madison: University of Wisconsin Press, 2000.

Glassman, Arnold, Todd McCarthy, and Stuart Samuels, dirs. *Visions of Light: The Art of Cinematography.* 1992. Image Entertainment, 2000. DVD.

Glennon, Bert. "Cinematography and the Talkies." *American Cinematographer,* February 1930.

Groesbeek, Charles. "Cinema Verité: What It's All About." *American Cinematographer,* October 1970.

Gunning, Tom. "The Cinema of Attractions: Early Film, Its Spectator, and the Avant-Garde." In *Early Cinema: Space, Frame, Narrative,* edited by Thomas Elsaesser, 56–62. London: British Film Institute, 1990.

———. "Modernity and Cinema: A Culture of Shocks and Flows." In *Cinema and Modernity*, edited by Murray Pomerance, 297–315. New Brunswick, NJ: Rutgers University Press, 2006.

Hagener, Malte. "The Aesthetics of Displays: How the Split-Screen Remediates Other Media." *Refractor*, December 2008, http://refractory.unimelb.edu.au/2008/12/24/the-aesthetics-of-displays-how-the-split-screen-remediates-other-media—malte-hagener.

Hall, Nick. "Closer to the Action: Post-War American Television and the Zoom Shot." In *Television Aesthetics and Style*, edited by Jason Jacobs and Steven Peacock, 277–287. London: Bloomsbury Academic, 2013.

Hansen, Miriam. "The Mass Production of the Senses: Classical Cinema as Vernacular Modernism." *Modernism/Modernity* 6, no. 2 (1999): 59–77.

Harris, Mark. *Pictures at a Revolution: Five Movies and the Birth of the New Hollywood.* New York: Penguin Press, 2008.

Higgins, Scott. *Harnessing the Technicolor Rainbow: Color Design in the 1930s.* Austin: University of Texas Press, 2007.

Higham, Charles. *Hollywood Cameramen: Sources of Light.* Bloomington: Indiana University Press, 1970.

Holben, Jay. "Visions of the Future." *American Cinematographer*, April 1998.

"Hollywood: The Shock of Freedom in Films." *Time*, December 8, 1967.

Howe, James Wong. "The Documentary Technique in Hollywood." *American Cinematographer*, January 1944.

———. "Lighting." In *The Cinematographic Annual*, vol. 2, edited by Hal Hall, 47–59. Los Angeles: American Society of Cinematographers, 1931.

Huggins, Charlotte. "The Three-Dimensions of 3-D." *Produced By*, Spring 2008.

Jacobs, Lea. "Belasco, DeMille, and the Development of Lasky Lighting." *Film History* 5, no. 4 (1993): 404–418.

Kaufman, Debra. "Crossing Over in Post." *American Cinematographer*, September 1998.

———. "Film Fading to Black." *Creative Cow Magazine*, October 10, 2011. http://magazine.creativecow.net/article/film-fading-to-black.

Keating, Patrick. "The Birth of Backlighting in the Classical Cinema." *Aura* 6, no. 2 (2000): 45–56.

———. *Hollywood Lighting from the Silent Era to Film Noir.* New York: Columbia University Press, 2010.

———. "Shooting for Selznick: Craft and Collaboration in Hollywood Cinematography." In *The Classical Hollywood Reader*, edited by Steve Neale, 280–295. London: Routledge, 2012.

Kerr, Paul. "Out of What Past? Notes on the B Film Noir." *Screen Education* 32–33 (1979–80): 45–65.

Kirsner, Scott. *Inventing the Movies.* N.p.: CinemaTech Books, 2008.

Krämer, Peter. "Post-Classical Hollywood." In *The Oxford Guide to Film Studies*, edited by John Hill and Pamela Church Gibson, 289–309. Oxford: Oxford University Press, 1998.

Kretzel, Bill. "A Place to Stand: Canadian 70mm Short Films." Last updated March 4, 2012. http://www.in70mm.com/news/2011/canadian_short/place/index.htm.

Krutnik, Frank. *In a Lonely Street: Film Noir, Genre, Masculinity.* New York: Routledge, 1991.

Lev, Peter. *Transforming the Screen: 1950 to 1959.* Berkeley: University of California Press, 2003.

Lieberman, Evan, and Kerry Hegarty. "Authors of the Image: Cinematographers Gabriel Figueroa and Gregg Toland." *Journal of Film and Video* 62, no. 1–2 (2010): 31–51.

"'Lighting for Temperament' Is the Newest Wrinkle in Cinematography." *Moving Picture World*, February 11, 1922.

Lightman, Herb A. "Changing Trends in Cinematography." *American Cinematographer*, January 1949.

———. "Painting with Technicolor Light." *American Cinematographer*, June 1947.

Lightman, Herb A., and Richard Patterson. "*Blade Runner*: Production Design and Photography." *American Cinematographer*, July 1982.

Lipnick, Edward. "Creative Post-Flashing Technique for 'The Long Goodbye.'" *American Cinematographer*, March 1973.

Lucas, Chris. "Crafting Digital Cinema: Cinematographers in Contemporary Hollywood." Ph.D. diss., University of Texas, 2011.

Macor, Alison. *Chainsaws, Slackers, and Spy Kids: 30 Years of Filmmaking in Austin, Texas.* Austin: University of Texas Press, 2010.

Malkames, Karl. "To Zoom or Not to Zoom." *American Cinematographer*, June 1974.

Malkiewicz, Kris. *Film Lighting: Talks with Hollywood's Cinematographers and Gaffers.* Rev. ed. New York: Touchstone, 2012.

Malkiewicz, Kris, and M. David Mullen. *Cinematography.* 3rd ed. New York: Fireside, 2005.

Maltby, Richard. *Hollywood Cinema.* 2nd ed. Malden, MA: Blackwell, 2003.

Maltin, Leonard. *The Art of the Cinematographer: A Survey and Interviews with Five Masters.* New York: Dover Publications, 1978.

Marcks, Greg. "The Future of Film Capture." *Film Quarterly* 61, no. 1 (2007): 8–9.

Mazzanti, Nicola. "Colours, Audiences, and (Dis)continuity in the 'Cinema of the Second Period.'" *Film History* 21, no. 1 (2009): 67–93.

McGrath, Caitlin. *Captivating Motion: Late-Silent Film Sequences of Perception in the Modern Urban Environment.* Ann Arbor, MI: UMI Dissertation Publishing, 2010.

Milner, Victor. "Painting with Light." In *The Cinematographic Annual*, vol. 1, edited by Hal Hall, 91–108. Los Angeles: American Society of Cinematographers, 1930.

Mohr, Hal. "Zoom Uses." *American Cinematographer*, August 1965.

Moore, Richard. "A New Look at Zoom Lenses." *American Cinematographer*, July 1965.

Musser, Charles. *The Emergence of Cinema: The American Screen to 1907.* Berkeley: University of California Press, 1990.

———. "Pre-Classical American Cinema: Its Changing Modes of Production." In *Silent Film*, edited by Richard Abel, 85–108. New Brunswick, NJ: Rutgers University Press, 1996.

Neale, Steve. *Genre and Hollywood*. New York: Routledge, 2000.

———. "'The Last Good Time We Ever Had?': Revising the Hollywood Renaissance." In *Contemporary American Cinema*, edited by Linda Ruth Williams and Michael Hammond, 90–108. Berkshire, UK: Open University Press, 2006.

Nye, David E. *Electrifying America: Social Meanings of a New Technology*. Cambridge, MA: MIT Press, 1990.

Petrie, Graham. "Alternatives to Auteurs." In *Auteurs and Authorship: A Film Reader*, edited by Barry Keith Grant, 110–118. Malden, MA: Blackwell, 2008.

"Photographing Stanley Kubrick's *Barry Lyndon*." *American Cinematographer*, March 1976.

Pierson, Michele. "No Longer State-of-the-Art: Crafting a Future for CGI." *Wide Angle* 21, no. 1 (1999): 29–47.

Pizzello, Stephen. "Between 'Rock' and a Hard Place." *American Cinematographer*, September 1995.

———. "*Natural Born Killers* Blasts Big Screen with Both Barrels." *American Cinematographer*, November 1994.

Place, Janey, and Lowell Peterson. "Some Visual Motifs of Film Noir." In *Film Noir Reader*, edited by Alain Silver and James Ursini, 64–75. New York: Limelight, 1996.

Raeburn, John. *A Staggering Revolution: A Cultural History of Thirties Photography*. Urbana: University of Illinois Press, 2006.

Rainsberger, Todd. *James Wong Howe, Cinematographer*. San Diego: A. S. Barnes, 1981.

Ramaeker, Paul. "A New Kind of Movie: Style and Form in Hollywood Cinema, 1965–1988." Ph.D. diss., University of Wisconsin–Madison, 2002.

———. "Notes on the Split-Field Diopter." *Film History* 19 (2007): 179–198.

Ray, Robert B. *A Certain Tendency of the Hollywood Cinema, 1930–1980*. Princeton, NJ: Princeton University Press, 1985.

Read, Paul. "'Unnatural Colours': An Introduction to Colouring Techniques in Silent Era Movies." *Film History* 21, no. 1 (2009): 9–46.

Rehak, Bob. "The Migration of Forms: Bullet Time as Microgenre." *Film Criticism* 32, no. 1 (Fall 2007): 26–48.

Rodowick, D. N. *The Virtual Life of Film*. Cambridge, MA: Harvard University Press, 2007.

Rubin, Michael. *Droidmaker: George Lucas and the Digital Revolution*. Gainesville, FL: Triad Publishing, 2006.

Salt, Barry. *Film Style and Technology: History and Analysis*. 3rd ed. London: Starword, 2009.

———. *Moving into Pictures*. London: Starword, 2006.

Samuelson, David W. "Introducing the Louma Crane." *American Cinematographer*, December 1979.

Schaefer, Dennis, and Larry Salvato. *Masters of Light: Conversations with Contemporary Cinematographers.* Berkeley: University of California Press, 1984.

Schatz, Thomas. *Boom and Bust: American Cinema in the 1940s.* Berkeley: University of California Press, 1997.

———. *The Genius of the System: Hollywood Filmmaking in the Studio Era.* New York: Pantheon Books, 1988.

———. "The Studio System in Conglomerate Hollywood." In *The Contemporary Hollywood Film Industry,* edited by Paul McDonald and Janet Wasko, 13–41. Malden, MA: Blackwell, 2008.

Sim, Gerald. "When and Where Is the Digital Revolution in Cinematography?" *Projections* 6, no. 1 (2012): 79–100.

Smith, Murray. "Theses on the Philosophy of Hollywood History." In *Contemporary Hollywood Cinema,* edited by Steve Neale and Murray Smith, 3–20. New York: Routledge, 1998.

Stanton, Jeffrey. "Experimental Multi-Screen Cinema." Accessed May 27, 2013. http://www.westland.net/exp067/map-docs/cinema.htm.

Steele, Gregg. "On Location with *The Godfather.*" *American Cinematographer,* June 1971.

Storaro, Vittorio. "The Right to Sign Ourselves as 'Authors of Cinematography.'" *American Cinematographer,* February 1995.

Strenge, Walter. "Realism in Real Sets and Locations." *American Cinematographer,* October 1957.

Taylor, Clarke. "Cameraman of *Heaven* Says 'Let There Be Light.'" *Los Angeles Times,* September 17, 1978.

Thompson, David, ed. *Altman on Altman.* London: Faber & Faber, 2006.

Thompson, Kristin. *The Frodo Franchise: The Lord of the Rings and Modern Hollywood.* Berkeley: University of California Press, 2008.

Tomadjoglou, Kim. "Introduction: Early Colour." *Film History* 21, no. 1 (2009): 3–6.

Turnock, Julie. "The ILM Version: Recent Digital Effects and the Aesthetics of 1970s Cinematography." *Film History* 24, no. 2 (2012): 158–168.

Vernet, Marc. "Film Noir on the Edge of Doom." In *Shades of Noir,* edited by Joan Copjec, 1–32. New York: Verso, 1993.

Walters, Ben. "The Great Leap Forward." *Sight and Sound* 19, no. 3 (March 2009): 38–43.

Williams, David E. "The Sins of a Serial Killer." *American Cinematographer,* October 1995.

Wood, Robin. *Hollywood: From Vietnam to Reagan . . . and Beyond.* New York: Columbia University Press, 2003.

Woods, Aylish. "Digital Intermediates and Micromanipulation of the Image." *Film Criticism* 32, no. 1 (Fall 2007): 72–94.

Yumibe, Joshua. *Moving Color: Early Film, Mass Culture, Modernism.* New Brunswick, NJ: Rutgers University Press, 2012.

Zsigmond, Vilmos. "Behind the Cameras on *Heaven's Gate.*" *American Cinematographer,* November 1980.

NOTES ON CONTRIBUTORS

Chris Cagle is an assistant professor of Film and Media Arts at Temple University. His article "Two Modes of Prestige Film" received the *Screen* award for best essay in 2006/2007. Currently working on a book on the postwar Hollywood social problem film, he also writes the blog Category D (categoryd. blogspot.com).

Lisa Dombrowski is an associate professor in the Department of Film Studies at Wesleyan University. She is the author of *The Films of Samuel Fuller: If You Die, I'll Kill You!* and the editor of *Kazan Revisited*. Her work has appeared in *The Velvet Light Trap, Scope*, and the *New York Times Online*.

Patrick Keating is an associate professor of communication at Trinity University, where he teaches courses in film and media studies. His first book, *Hollywood Lighting to Film Noir*, was recognized with the Best First Book Award from the Society of Cinema and Media Studies. In 2011, he was named an Academy Film Scholar by the Academy of Motion Pictures Arts and Sciences to support his research on the history of camera movement.

Christopher Lucas has taught courses in film, television, and screenwriting at the University of Texas at Austin and Trinity University. He has published essays on broadcasting and radio. A co-founder of *Flow: A Critical Forum on Television and Media Culture*, Lucas currently is adapting his dissertation on digital cinematography in contemporary Hollywood into a book.

Paul Ramaeker is a lecturer in the Department of Media, Film, and Communication at the University of Otago in Dunedin, New Zealand. He has published on contemporary Hollywood directors, including Francis Ford Coppola, Sylvester Stallone, and Stanley Kubrick. He is the author of the blog The Third Meaning (the3rdmeaning.wordpress.com).

Bradley Schauer is an assistant professor in the School of Theatre, Film, and Television at the University of Arizona. He is currently developing his dissertation on science fiction and the exploitation tradition in Hollywood into a book. His work has appeared in *The Velvet Light Trap*, the *New Review of Film and Television Studies*, and the *Quarterly Review of Film and Video*.

INDEX